CW00926721

THE ART OF THE MAYA SCRIBE

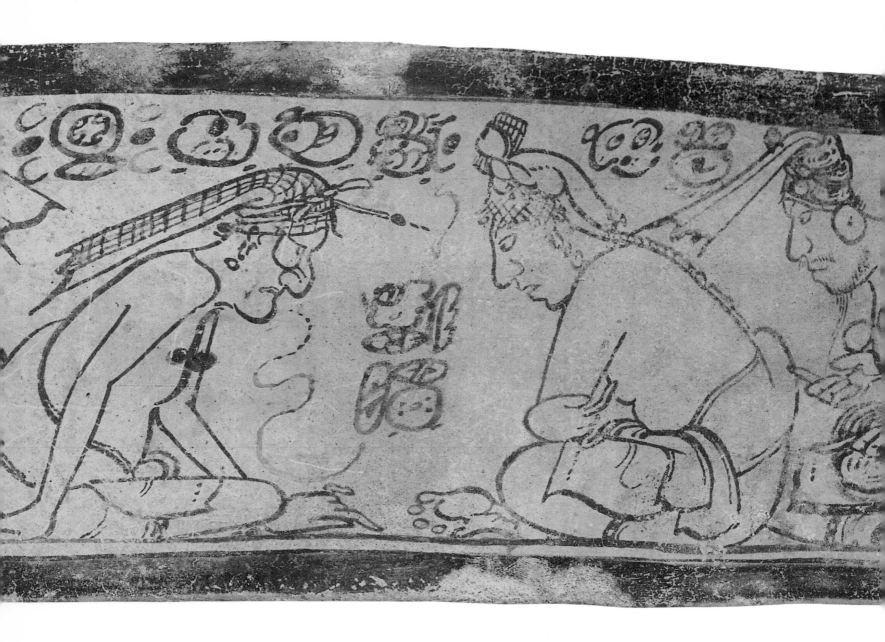

THE ART OF THE MAYA SCRIBE

MICHAEL D. COE · JUSTIN KERR

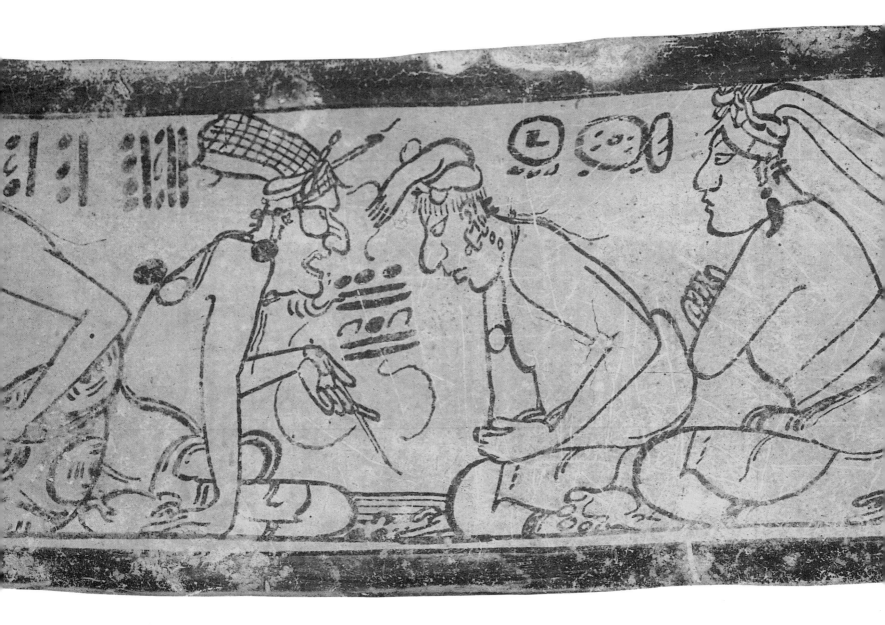

HARRY N. ABRAMS, INC., PUBLISHERS

p. 1 The god Itsamná, inventor of writing and "first scribe"; detail from a polychrome vase (see Fig. 67).

pp. 2–3 The god Pawahtún, patron of scribes, shown twice—wearing his distinctive netted headdress—as teacher in a scribal school; rollout from a Codex-style vase (see p. 104).

Library of Congress Cataloging-in-Publication Data

Coe, Michael D.
 The art of the Maya scribe / Michael D. Coe, Justin Kerr.
 p. cm.
 Includes bibliographical references and index.
 ISBN 0-8109-1988-5 (clothbound)
 1. Mayan languages—Writing. 2. Maya art. 3. Manuscripts, Maya.
I. Kerr, Justin, II. Title.
F1435.3.W75C62 1998
497'.415211—dc21 97-25519

Text and images by Michael D. Coe copyright © 1997 Michael D. Coe
Photographs and text by Justin Kerr copyright © 1997 Justin Kerr

First published in Great Britain in 1997 by Thames and Hudson Ltd., London

Published in 1998 by Harry N. Abrams, Incorporated, New York
All rights reserved. No part of the contents of this book may be reproduced
without the written permission of the publisher

Printed and bound in Singapore

Harry N. Abrams, Inc.
100 Fifth Avenue
New York, N.Y. 10011
www.abramsbooks.com

CONTENTS

PREFACE AND ACKNOWLEDGMENTS

This book is about ancient Maya calligraphy, and the great artists who produced it, and were proud to sign their works. The word "calligraphy" is derived from the Greek kalligraphia, meaning "beautiful writing," and is defined by the Encyclopaedia Britannica as "the art of beautiful or elegant handwriting as exhibited by the correct formation of characters, the ordering of the various parts, and harmony of proportions." Such an aesthetic definition well characterizes the finest Classic Maya writing, as found on the stone monuments, on the murals, on portable objects and—above all—on fine painted and/or carved ceramics placed as offerings in elite tombs. It is also applicable to the texts found in the Late Post-Classic Dresden Codex, the finest of the four surviving screenfold books.

Although writing of one sort or another has been in existence for five thousand years, and is now in use among almost all of the earth's hundreds of distinct cultures, true calligraphic traditions in the sense given above are quite restricted in time and space. To ancient Egyptian, Far Eastern (China and Japan), Islamic, and western European, we must add a fifth tradition: Maya. Until recently, almost all attention devoted to Maya writing has been epigraphic, centering on the decipherment of a complex and seemingly intractable script (see Breaking the Maya Code by MDC). Only Dorie Reents-Budet's pioneering Painting the Maya Universe (1994) concerned itself with the aesthetics and techniques of Maya writing, but her study was confined to the painted texts on polychrome ceramics. We intend to broaden our canvas, to encompass all aspects of the script, wherever and on whatever it is found, above all during its apogee within the AD 250–900 span of the Classic period of Maya history.

Our book is in every sense a true collaboration. The two of us first met in 1970; then again in 1971 at the time when MDC was organizing the exhibit The Maya Scribe and His World for the Grolier Club in New York, and was hoping to find a photographer who knew and appreciated the beauty of Maya ceramics. Even though JK and his wife Barbara were mainly involved with fashion photography at that time, they were getting deeper and deeper into the world of Maya scholarship, enlarging their knowledge by frequent trips to Yucatán and other parts of the Maya realm. We have been exchanging ideas and working together on books ever since. JK's development of a camera which would roll out the scenes and texts on Classic vases (instead of having them laboriously copied by artists, as was the case with our Grolier catalogue of 1973) resulted in publications which were really collaborative, in spite of the fact that their texts were by MDC: Lords of the Underworld: Masterpieces of Classic Maya Ceramics (1978), and Old Gods and Young Heroes: The Pearlman Collection of Maya Ceramics (1982).

The present volume owes its inception to a suggestion made to MDC by Colin Ridler of Thames and Hudson; it has been several years in the making, due to the unexpected death of MDC's wife Sophie, and his commitment to the completion of her projected book, The True History of Chocolate (1996). The preparation of The Art of the Maya Scribe has involved constant consultation between us, by telephone, fax, and e-mail, and frequent trips by MDC from his Massachusetts hilltop farm to visit JK in his Manhattan studio. It should be noted that although MDC wrote most of the text and all of the captions, JK reviewed both and suggested many changes and additions. Conversely, while JK took most of the photographs, MDC was able to add material from his own files of 35 mm. color slides. Many of the images in this volume were scanned digitally in both places, and further processed by us using the Adobe Photoshop 4.0 program.

Many persons gave us invaluable help during the completion of this project. In particular, we would like to thank Lewis Ranieri and Sandy Noble Bardsley of the Foundation for Mesoamerican Studies, Inc., in Crystal River, Florida, for their generosity in making the Foundation's superb collection of Maya ceramics available for detailed study and photography. Our friend Andrea Stone was extremely kind to loan us the original photographs of the extremely important corpus of texts within the cave of Naj Tunich. We also wish to acknowledge the liberality of all those many scholars and institutions who have provided the picture material cited in the List of Illustrations at the end of this book, but particularly Lin Crocker Deletaille and Nicholas Hellmuth.

We would like to thank the staff at Thames and Hudson for superb editorial work and design. They also deserve to be called collaborators.

This is a fast-changing field. The picture which we now have of the ancient Maya is very different from what it was when MDC was a graduate student forty years ago, and each month brings new advances. Constant intellectual exchange with some of the most active and innovative scholars in Maya studies has, we hope, kept us reasonably up-to-date in the subject matter of this book. In particular, we are greatly indebted for advice and information to Mary Miller, Linda Schele, Karl Taube, Stephen Houston, Nikolai Grube, Simon Martin, and David Stuart, although none of these bears any responsibility for our own errors. Most recently, MDC attended an exciting conference and seminar on Classic Maya religion at Brigham Young University in Provo, Utah, during which Houston, Stuart, and the linguist John Robertson presented incontrovertible evidence that the language of most, if not all, Classic Maya inscriptions (including those in Yucatán) was Choltí, a now extinct language. Choltí had become, in fact, a prestige literary language much as Sumerian had been in the Near East, or Latin in Europe, even far away from its place of origin. Some personal names of rulers, nonetheless, seem to have been given in the local tongue. Readers of the section on the language recorded in the script should keep this in mind.

Except for the names of sites, we have given Maya words in the orthography in current use among linguists and other scholars specializing in Maya studies.

One final nota bene. It is quite clear that women as well as men could be, and almost surely were, scribes. Instead of giving "he/she" or "him/her" each time we discuss the role of scribes, we have simply given "he." But women had very high status among the Maya elite, and that included the production of texts. The actual number of women engaged in scribal activities may have been far lower than the number of men, but some of the most beautiful examples of writing in this book might well have been done by them rather than by their male counterparts.

The organization of the book is simple. The archaeological and cultural setting in which Maya calligraphy arose and flourished are set out in Chapter 1. In Chapter 2 we describe the script (and its decipherment), and current ideas and data regarding its origin. Chapter 3 treats the scribes themselves—the painters and carvers who were responsible for the calligraphy—including their appearance, their titles and roles in Classic Maya palace society, and the gods they worshipped. The materials of Maya calligraphy, the kinds of surfaces the scribes wrote on (from temple walls to screenfold codices), and the development of scribal styles are presented in Chapter 4. Chapter 5 deals with the extant Maya books (all of them postdating the end of the Classic). Finally, in Chapter 6 we examine what happened to Maya writing during and following the Spanish Conquest; how the hieroglyphic was replaced with an alphabetic tradition; and how the Maya scribe was transformed into the Colonial-period maestro cantor ("choirmaster") still to be found in remote Maya villages, and still functioning as the guardian of ancient Maya texts and lore.

MDC Heath, Massachusetts
JK New York, New York
1997

1

THE MAYA UNIVERSE

1 Classic Maya city-states in the southern lowlands were headed by powerful hereditary rulers known as "holy kings." The late eighth-century king of Bonampak, Chan Muwan, is shown in this detail from Stela 1; the splendid murals for which the city is famed (see Pl. 47 and Fig. 12) were created under his patronage.

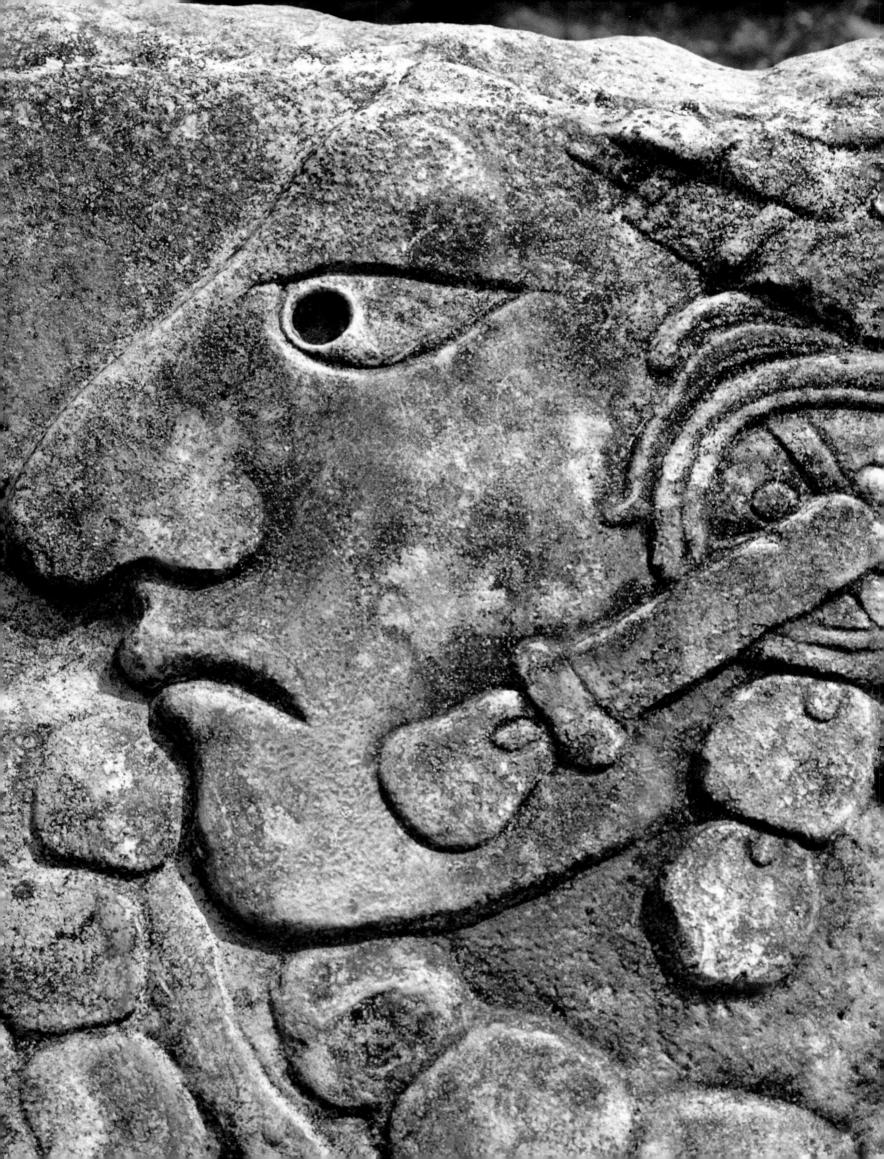

2 Aerial view of the central part of Tikal, one of the largest known Classic cities. To the left is the North Acropolis, possibly the palace complex of the Tikal kings and their entourages. The two temple-pyramids on the right (Temples I and II) were dedicated to the cult of the divine rulers.

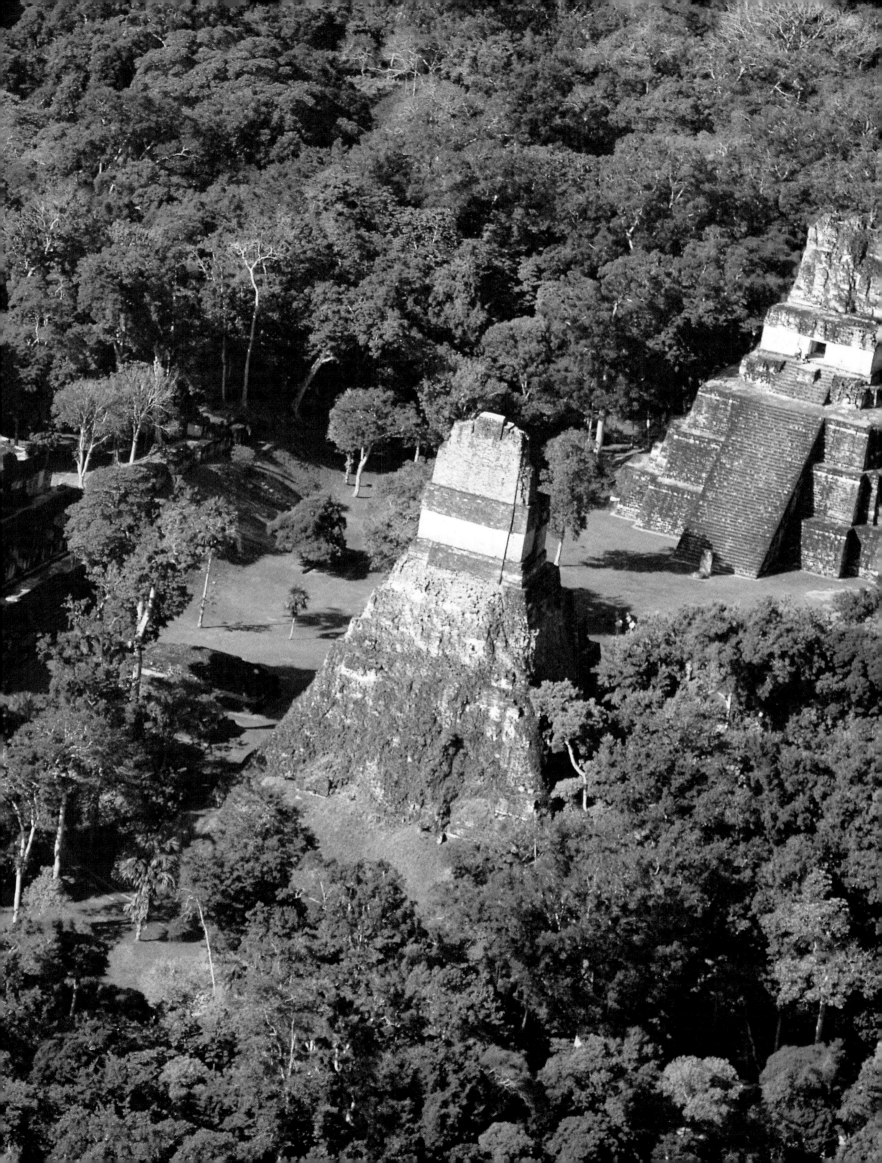

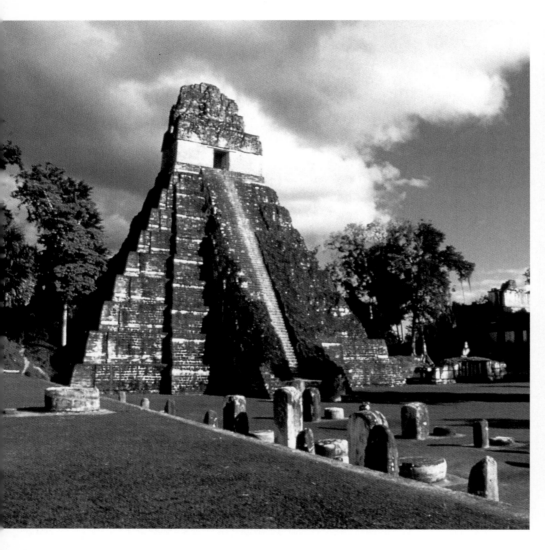

3 ABOVE Temple I, Tikal, erected by an early eighth-century king over the tomb of his predecessor, the warlike ruler Hasaw Cha' an K'awil. The latter is commemorated by an elaborate carved wooden lintel spanning the outer doorway of the room at the top (see Fig. 100). In the foreground are rows of carved stelae celebrating earlier sovereigns.

4 RIGHT An even more elaborate royal funerary pyramid is the Temple of the Inscriptions at Palenque, housing the burial chamber and richly stocked sarcophagus of Pakal, who died in AD 683 at age 80 (see Fig. 8). The king's history and important events of his long reign are written on three tablets in the upper chamber.

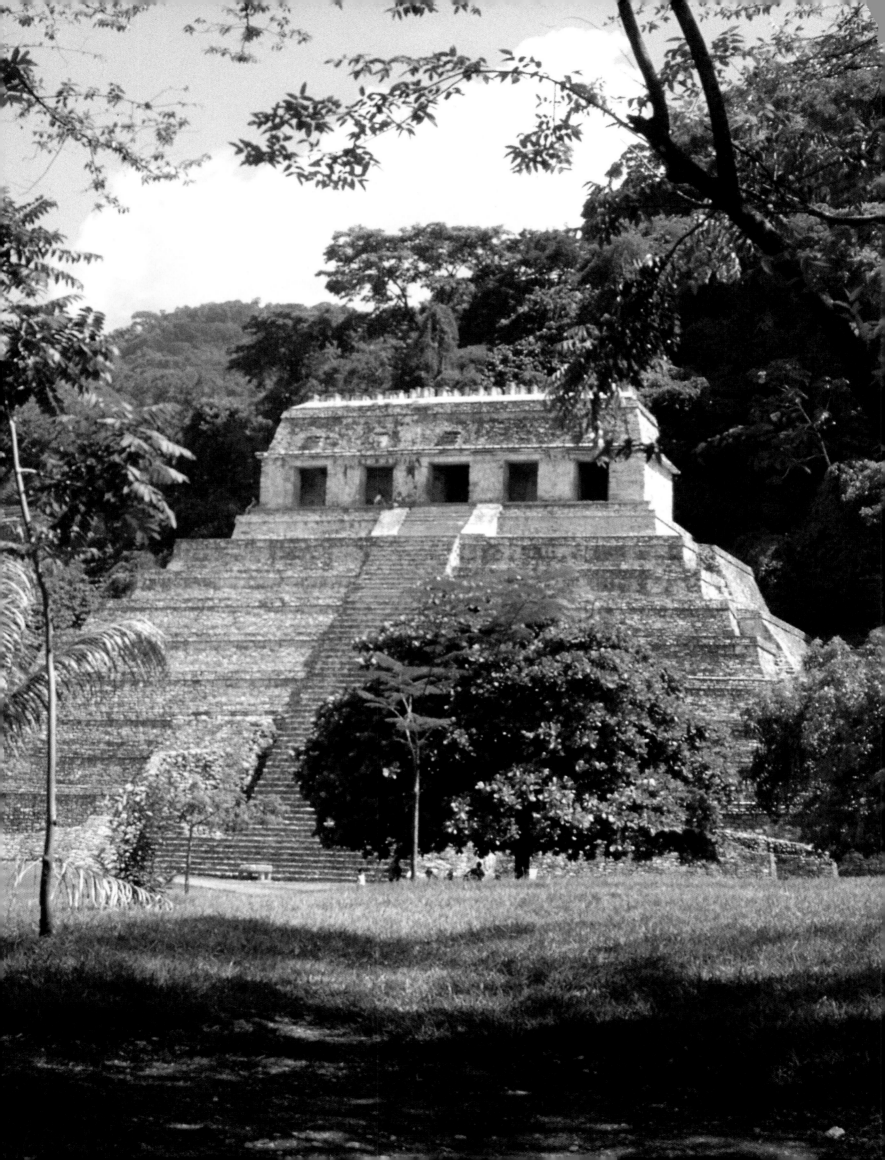

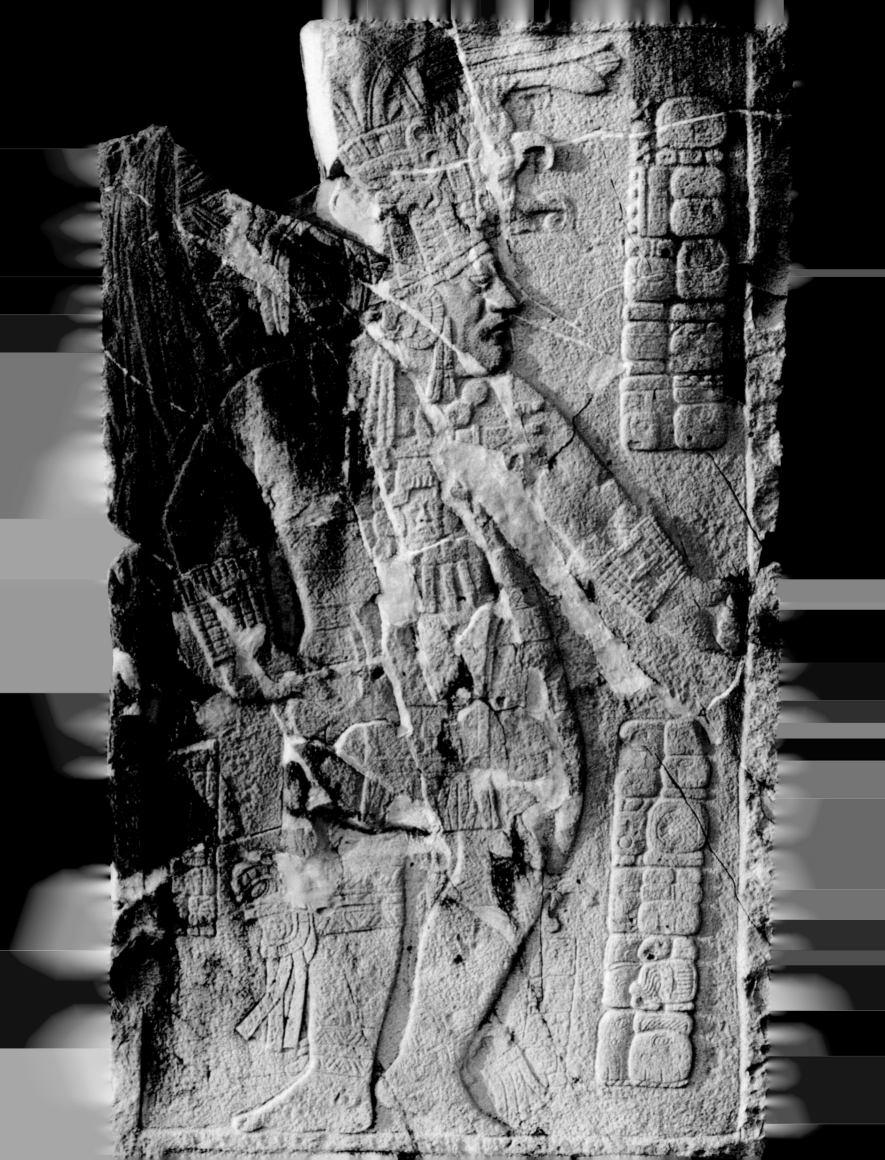

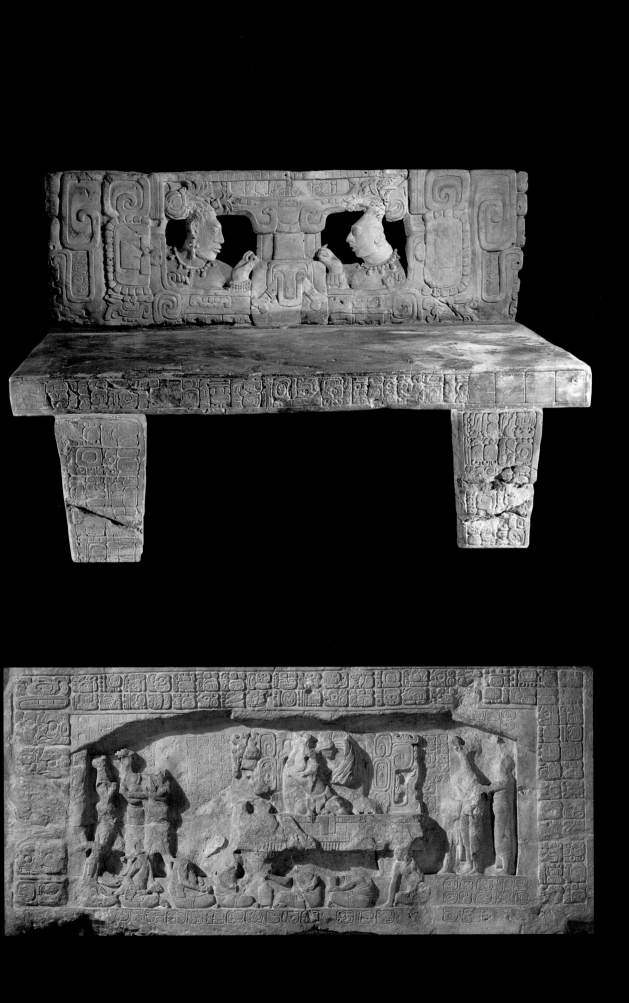

5 OPPOSITE Maya rulers were not only warriors but ballplayers as well. On this stone panel from La Amelia, Guatemala, a late eighth-century king of Dos Pilas is dancing in his ballgame costume, complete with kneepads and protective belt, probably following victory in the ballcourt.

6, 7 LEFT The riverine city of Piedras Negras has many beautifully carved dynastic inscriptions. Throne 1 (TOP) was dedicated by the seventh king on 6 November 785; the long text (signed by two sculptor/scribes) gives the date of his birth as well as his accession to the rulership. The busts of what may be ancestors appear within the eyes of a gigantic mask representing a mountain. "Lintel" 3 (BELOW)—actually a wallpanel—depicts a nighttime chocolate-drinking feast which took place in 749, during which the fourth king celebrated his one-*k'atun* (20-year) jubilee in the presence of court officials, including an *ah k'u hun* (see Fig. 52) and a royal visitor from Yaxchilán.

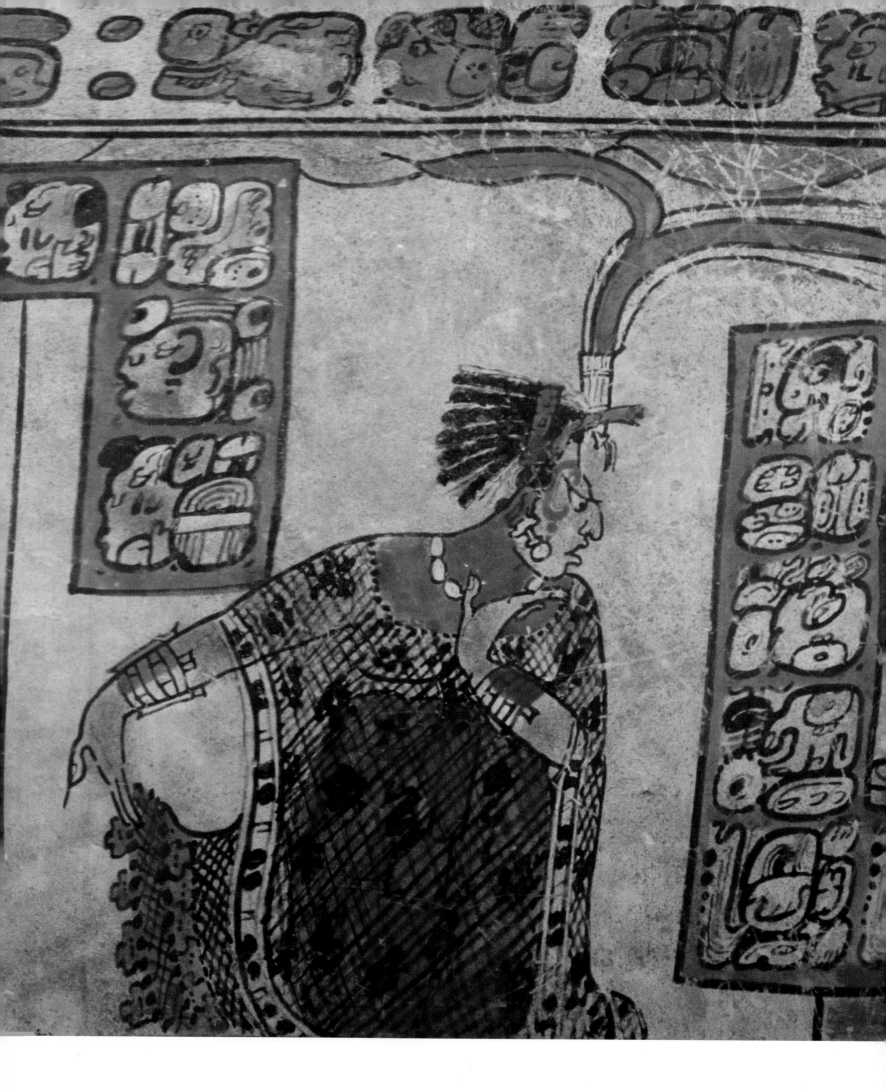

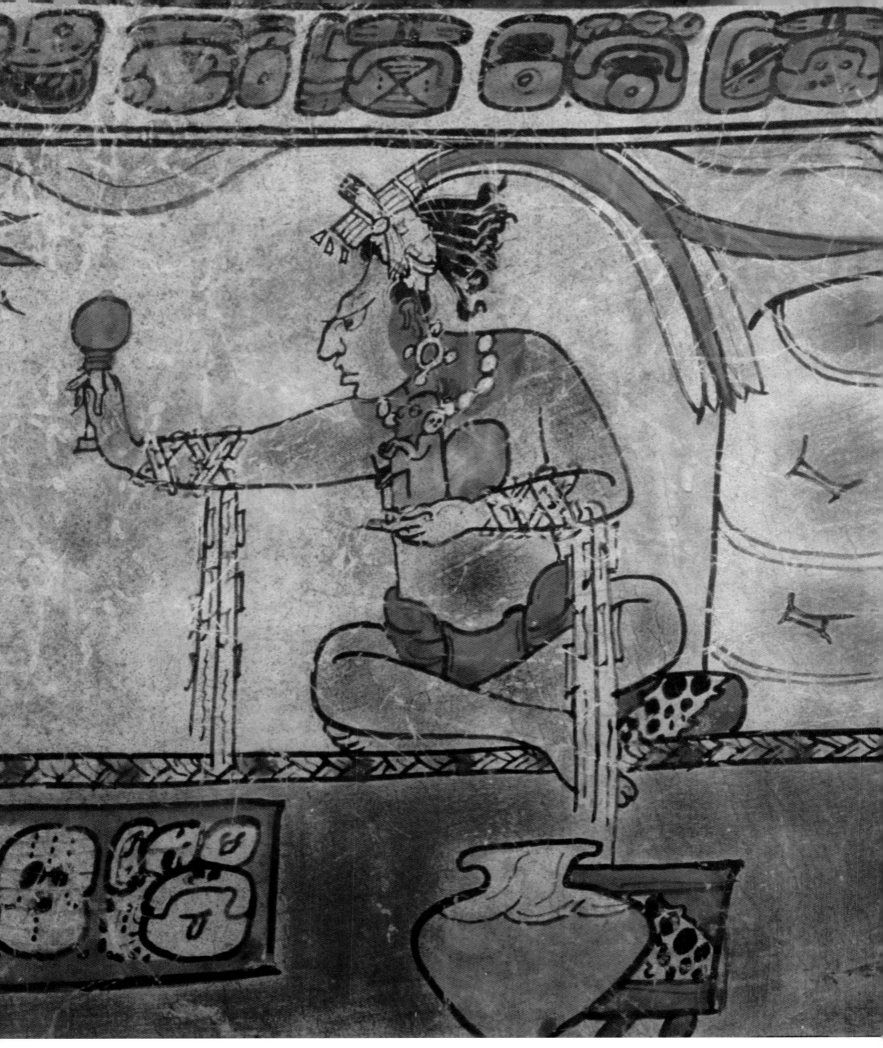

8 An enthroned king and his wife (a lady from Tikal) on an eighth-century polychrome vase from an unidentified city in northern Guatemala. "Stick bundles" in their headdresses indicate that they were also scribes. In the ruler's right hand is what appears to be a rattle, but it could also be a syringe used by royalty to administer an intoxicating or hallucinogenic enema. Within each L-shaped panel are the name and titles of the individual to the right.

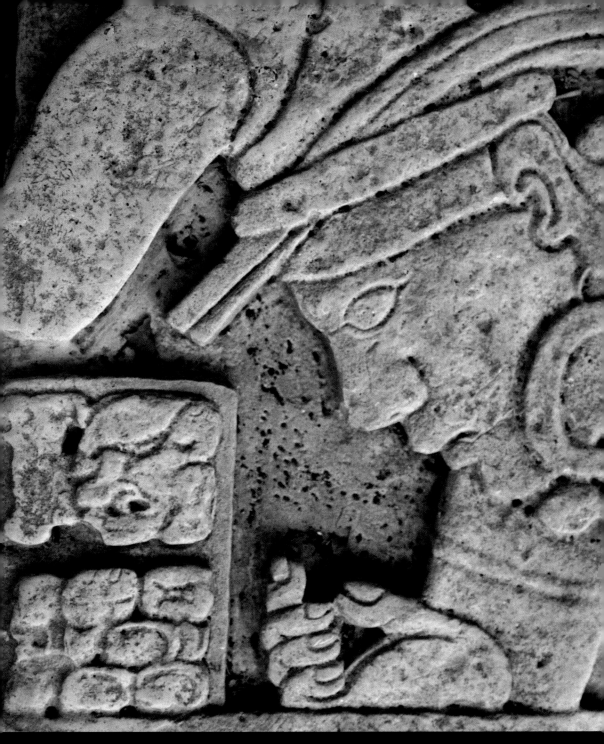

Warfare between rival Maya city-states was endemic throughout the Classic period.

9 ABOVE Detail from Stela 16, Dos Pilas, showing Paw Jaguar, the king of Seibal, humiliated by being forced to wear a servant's hat and crouch down below the feet of the ruler of Dos Pilas, who captured him and his city on 29 November 735; Paw Jaguar was beheaded the next day. The two glyphs give his name (Yich'ak Balam) and his title, "holy king of Seibal."

10 OPPOSITE On a Late Classic polychrome vase three bound prisoners await their fate at the hands of their spear- and shield-bearing captors.

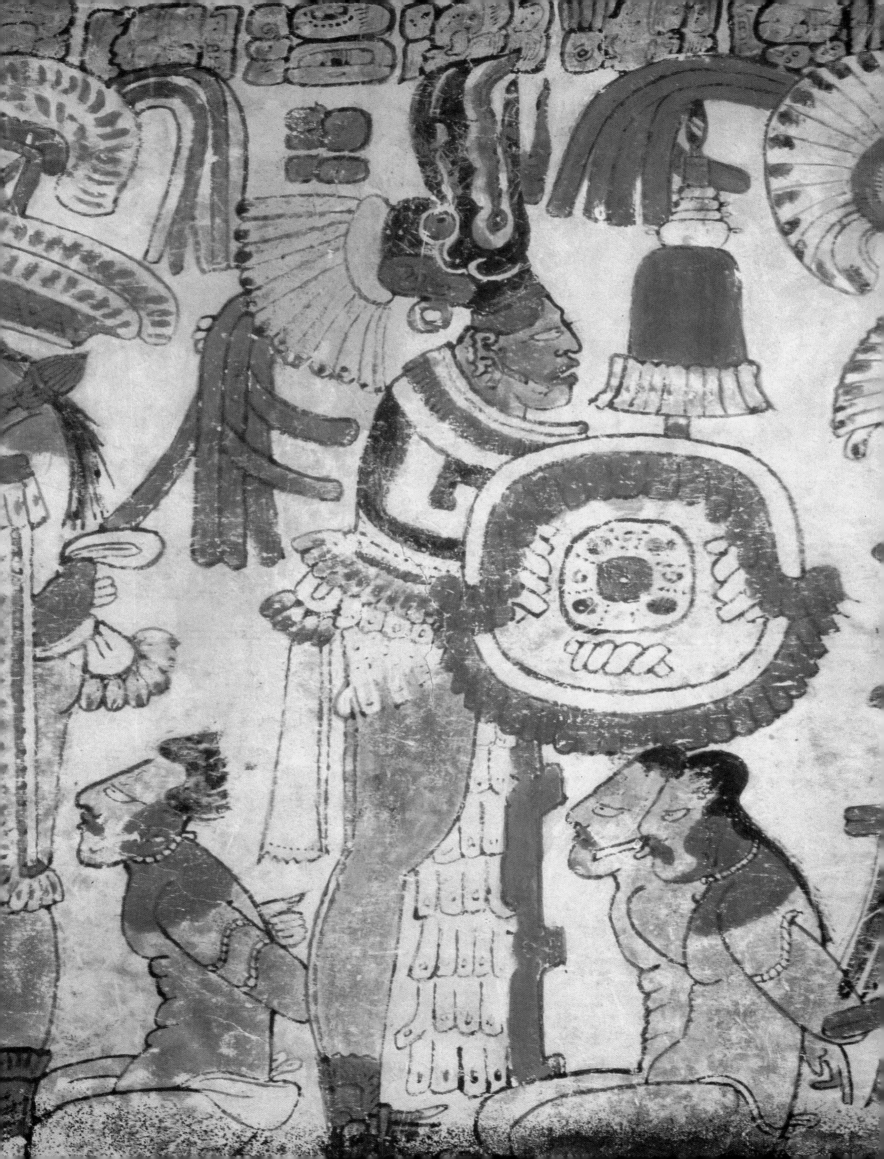

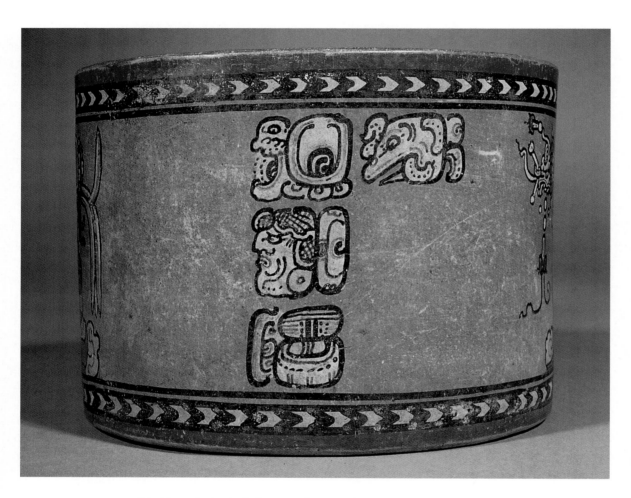

11, 12 The Young Maize God, shown on this Late Classic polychrome cylinder from Chamá, Guatemala, was one of the patron deities of the scribes, and also the epitome of Maya rulership, here indicated by the richness of his jewelry and by his royal headdress. The painted inscription (ABOVE) is an abbreviated version of the Primary Standard Sequence or PSS, dedicating the vessel; the glyph at the bottom is the possessed noun *ts'ib*, "writing."

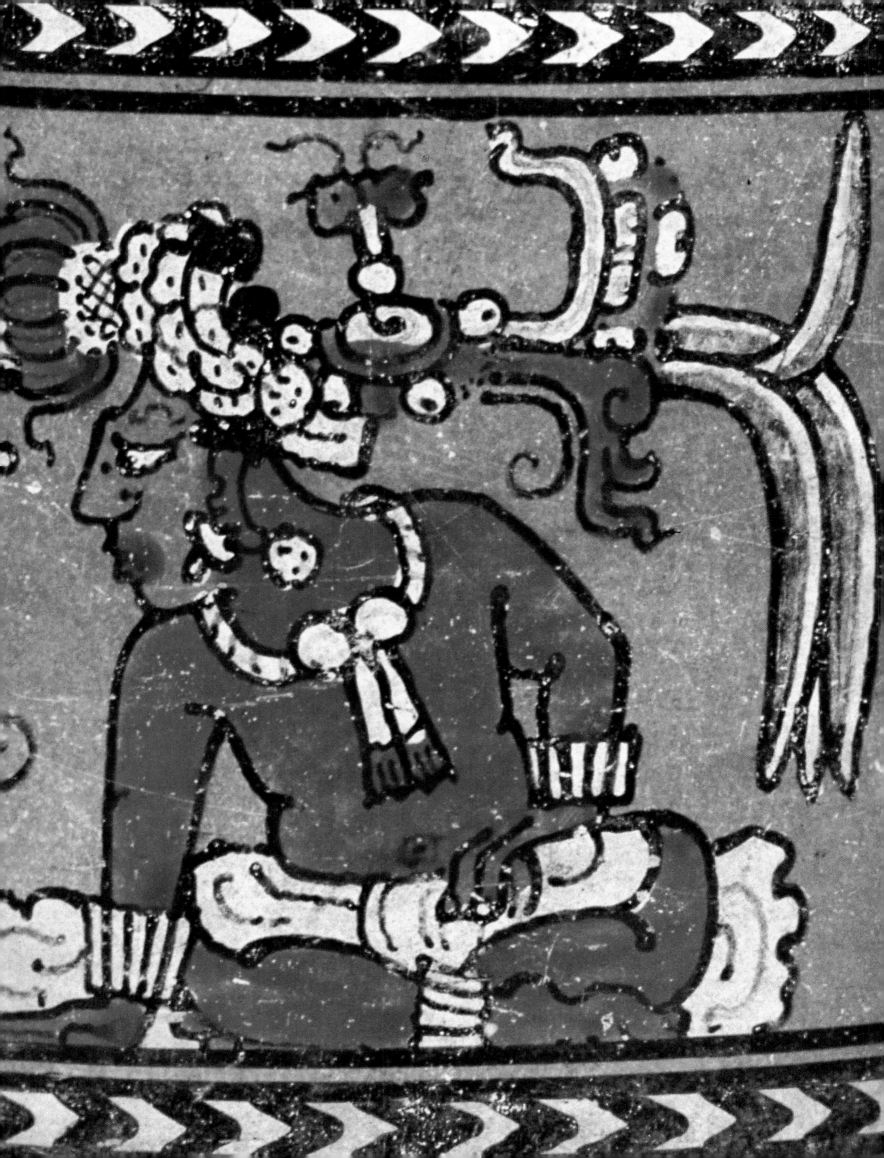

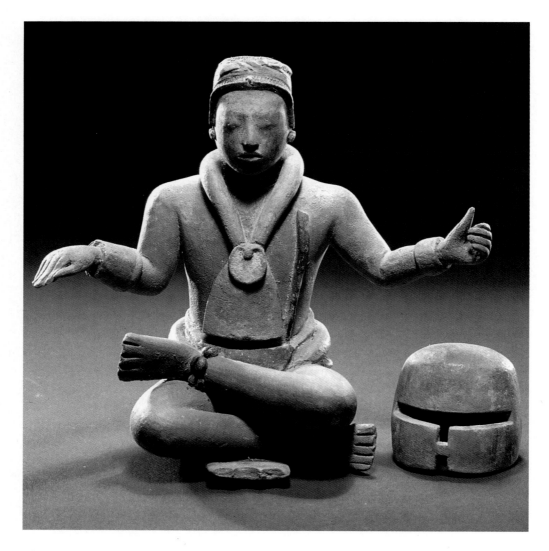

The ballgame, played with a large rubber ball in a masonry court, was "the sport of kings," but it had a martial aspect: prominent war captives were forced to play a losing game with the victors, after which they were beheaded.

13 ABOVE A fine Classic clay figurine from the Petén, Guatemala, depicting a seated ruler; the removable helmet was probably worn during the ballgame.

14 OPPOSITE The king in this Late Classic figurine is garbed as both warrior and ballplayer; his heavy, padded belt was for protection on the ballcourt, while the shield on his left arm served the same purpose on the battlefield. In his headdress appears the mask of the Rain God Chak.

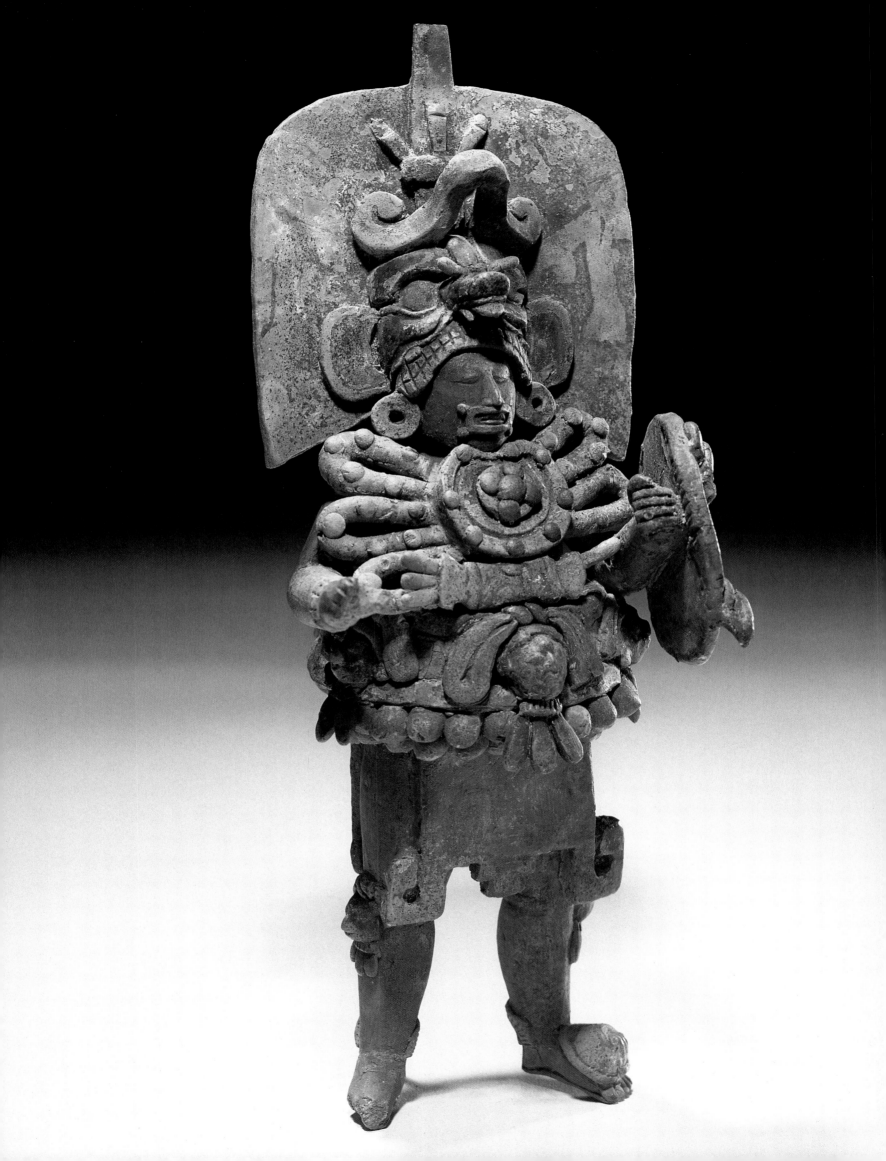

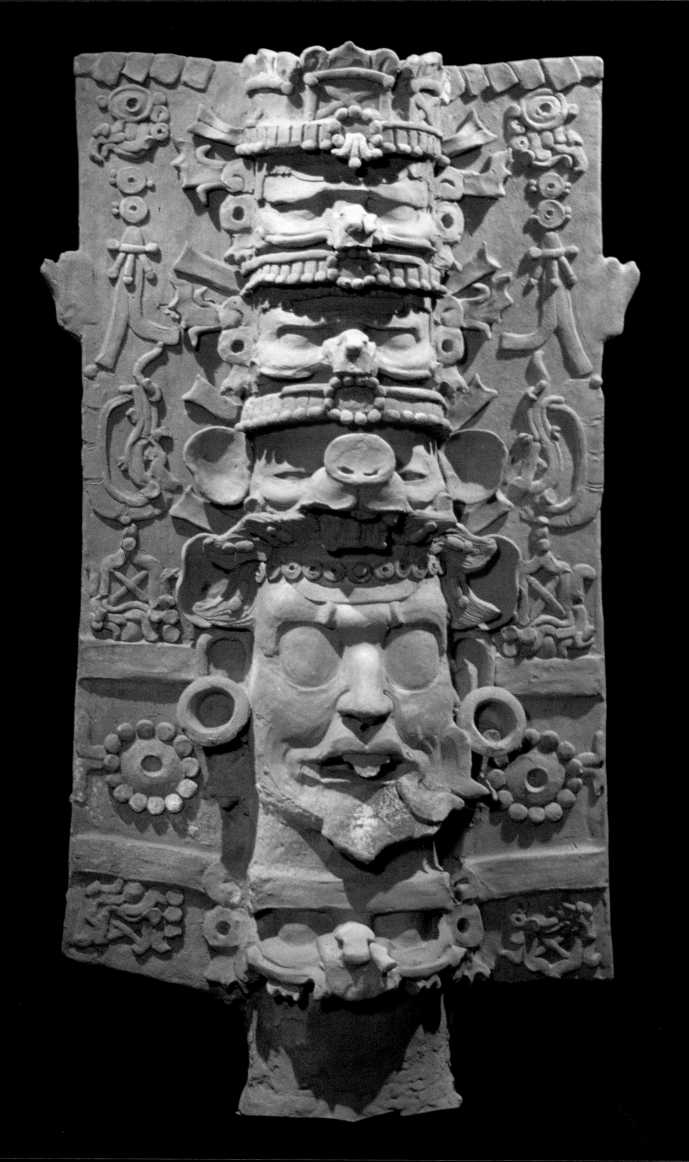

THE MAYA UNIVERSE

It was on 29 August, in the year AD 767, 3,880 years since Maya creation had begun in the starry fastnesses of the Milky Way, that a richly clad yet barefoot party of noble pilgrims with their retinues, bearing torches, firewood, and ritual equipment, entered the fearsome, stalactite-encrusted maw of the great cavern of Naj Tunich [*Fig. 1*]. These were lords and their palace retinues from the nearby Maya cities of Ixkun, Sacul, Caracol, and an as-yet-to-be-discovered place bearing the ancient name of *tok'tun* ("Flint Stone"). Included in the party may have been an even more august personage, the king of Calakmul, a huge metropolis lying some 200 kilometers (125 miles) north-northwest of Naj Tunich, and the most powerful city-state of its time. There could have been little doubt in their minds that they were penetrating one of the main accesses to Xibalbá, "The Place of Fright": the Maya Underworld, the abode of the fearsome death gods and of their own royal ancestors.

Along the main passageway of this deep cavern, they must have paused from time to time to offer incense and prayers to the Xibalban deities and to the Hero Twins, who had tricked, humbled, and defeated the Underworld lords in the interests of humankind. One half kilometer (500 yards) in from the entrance, in the midst of a Stygian darkness penetrated only by their torches, they reached an overhang which presented an ideal natural surface for a written testimony of their visit [*Fig. 2*]. This task was carried out by a royal scribe—one who merited the coveted titles of *ah ts'ib*, "he of the writing," *its'at*, "learned one," and *ah k'u hun*, "keeper of the holy books"—a noble specialist skilled in writing and painting, perhaps even from the great court of Calakmul itself. Plucking one of the brushes inserted in his headdress [cf. *Figs. 56, 71*], he dipped it into *sabak*, carbon-black ink contained in an inkpot made from half a conch shell which had been cut lengthwise [cf. *Pl. 66*]. Then he deftly and neatly painted a text of sixteen hieroglyphs across the overhang, beginning with an account of the "bringing of fire" to this remote spot exactly twenty-three years earlier by the "Sun-eyed" Muyowa, eighth king of Caracol; he concluded his statement with the present date, and the names of the noble participants. Their labor completed, the pilgrims then cast copal incense into a fire kindled at the base of the overhang, and departed the dread realm for the world above.

We have no name for this scribe, for he failed to sign his own work, but he was an accomplished calligrapher and almost certainly a painter of *hun'ob*, the bark-paper, screenfold, illuminated books [*Pls. 70–76*] which must have existed by the thousands in the royal libraries of the eighth century in the southern Maya lowlands; here was a region in which flourished a Native American culture as brilliant in the arts and sciences—and calligraphy—as the contemporary civilization of Tang Dynasty China, on the other side of the Pacific.

Scribes were held in the highest esteem among the ancient Maya, as they were in those other great calligraphic civilizations: Ancient Egypt, China and Japan, Islam, and Western Europe. So highly were they regarded that they were recruited from the nobility and even from the royal house itself. Like other officials who directed the city-states of the southern lowlands during the Classic period, they wore their own distinctive costume and headdress, in which were prominently displayed the tools of their profession—their brush pens and their carving tools [e.g. *Pls. 28, 68*]. Even further, they often proudly signed their own works, their signatures appearing on relief sculptures [*Fig. 3*] —especially among the cities in the drainage of the

15 Tall pottery incense burner of the Late Classic period, from the Palenque region. The principal visage is that of the Jaguar God of the Underworld, the night aspect of the sun as it passes beneath the earth. Maya rulers placed such objects in deep caverns–entrances to the realm of the dead.

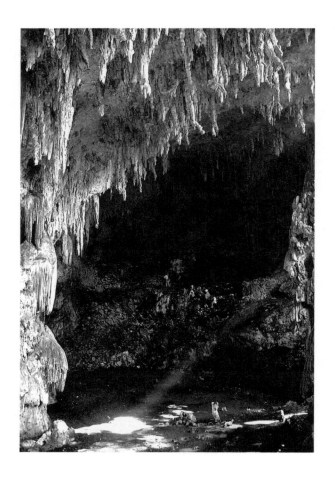

Usumacinta River—and on fine decorated pottery, both painted and carved [*Fig. 57*]. We therefore sometimes know these gifted artists as distinctive personalities with their own styles, a cultural trait that goes along with the Maya interest in portraiture. This markedly contrasts with the impersonality and near abstraction of so much pre-Conquest art elsewhere in the Western Hemisphere.

Maya civilization has its own distinctive character, and certainly in literacy, science, and mathematics achieved unusual heights (it is the only ancient culture of the hemisphere of genuine interest to historians of science).[1] Yet it arose and flourished in a larger context, that of Mesoamerica. With other Mesoamerican cultures, it shared many traits including a group of cultigens centering on maize, beans, squashes, and chili peppers; large and complex markets; towns and cities with major public architecture, especially temple-pyramids [*Pls. 2–4*]; human sacrifice (other peoples favored the extraction of hearts, but the Classic Maya preferred decapitation); a large pantheon of gods, many with agricultural associations; and a highly developed ritual calendar. The last-named is

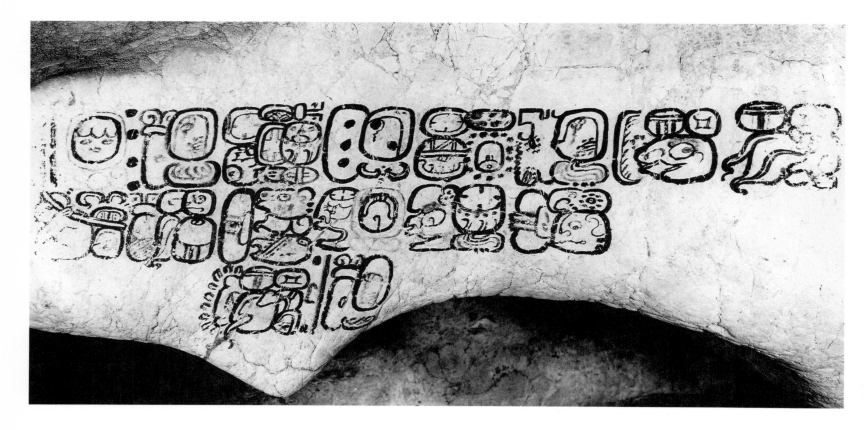

of overwhelming importance, for it is essentially the same throughout Mesoamerica. Every one of the diverse Mesoamerican cultures had, and in some cases still has, a sacred round of 260 days [*Fig. 18*], which permutates with the approximate solar year of 365 days: a line drawn around the distribution of the ritual calendar in Mexico and Central America would essentially demarcate the boundaries of Mesoamerica. To it the Classic Maya added a day-to-day count (similar to the Julian Day Numbers of modern astronomers) in which they recorded historical events—births, accessions, marriages, deaths—as well as ritual and astronomical matters.

THE MAYA PEOPLE AND THEIR LANGUAGES

There are thirty-one distinct languages still spoken by the five or six million surviving Maya (some of these tongues on the verge of extinction, but others in full vigor); all belong to the Mayan family, which itself is distantly related to other native languages in Mesoamerica and North America.[2] The Mayan languages with the largest number of speakers are Yucatec, covering most of the Yucatán Peninsula; Tzeltal and Tzotzil in the state of Chiapas; and Quiché and Cakchiquel in the highlands of Guatemala. All have been the subject of intensive linguistic study for a very long time, and scholars have had great success in reconstructing earlier, ancestral forms of Mayan, a subject of particular significance to epigraphers attempting to decipher hieroglyphic inscriptions almost a millennium and a half old. Even though Mayan has not changed as much as English over the same span of time (remember that an English-speaker has to resort to a translation to read that early English classic, *Beowulf*—roughly contemporary with

OPPOSITE

1 Entrance chamber of the immense cavern of Naj Tunich in the eastern Petén; much deeper inside the cave, during the Late Classic, scribal pilgrims left many texts and figural drawings on the rock walls (Figs. 2, 96).

2 Drawing 82, the most beautiful text of Naj Tunich, painted in 767 (see p. 25). The second glyph from the right, top line, is the Calakmul Emblem Glyph.

3 Signature of the sculptor/scribe responsible for the carving of Stela 1, Bonampak. At the top is the glyph for yuxul, "the carving of..." (see Fig. 45); the Emblem Glyph at the bottom of this small panel indicates that he "belonged" to the ruler of Yaxchilán.

Mexican states
International boundaries

MOTUL

YUCATÁN

Chichén Itzá

Mayapán

Uxmal

Jaina

Kabah
Labná

Xcalumkin

Cozumel I.

PUUC HILLS

GULF OF CAMPECHE

QUINTANA ROO

CAMPECHE

CARIBBEAN
SEA

Comalcalco

TABASCO

Calakmul

Altún Ha

MEXICO
GUATEMALA

Río Azul

El Mirador

Nakbé

BELIZE
GUATEMALA

Palenque

El Perú

Uaxactún

R. Usumacinta

Tikal

CHIAPAS

PETÉN

Ucanal

Naranjo

Yaxchilán

Tayasal

Chiapa de Corzo

Toniná

Bonampak

Caracol

MAYA MOUNTAINS

Dos Pilas

Seibal

Altar de Sacrificios

Aguateca

Naj Tunich

R. Pasión

Cancuén

Chamá

Nebaj

Quiriguá

GUATEMALA
HONDURAS

R. Motagua

Izapa

Copán

Abaj Takalik

Kaminaljuyú

El Baúl

GUATEMALA
EL SALVADOR

N

0 50 100 150 kilometres
0 50 100 miles

the Naj Tunich inscription —, and perhaps even to read Chaucer), present-day Mayan dictionaries, while useful, are not always an accurate guide to the ancient tongue spoken and used by the Classic Maya scribes. The modern Yucatec Maya, for instance, have lost the native words for all numbers above five, using their Spanish equivalents instead—and this in a culture which at one time was hardly without peers in knowledge of mathematics!

There are now, and probably always have been, significant differences between the Maya living in the temperate highlands of Chiapas and Guatemala, and those occupying the humid, jungle-covered lowlands of northern Guatemala, Belize, and Mexico's Yucatán Peninsula. These differences must be due in part to the contrasting ecological situations of each sub-area. In the lowlands, shifting cultivation—so-called "*milpa* agriculture"—was and still is the norm. In this, a plot of tropical forest is cut down during the dry season and later burned; maize and other seeds are then planted with digging sticks, in anticipation of the rains which generally come in late May or early June. After ten or so years of continuous cultivation, weed competition becomes severe, and yields have declined, so that the farmer must then pick a new plot or *milpa* to start the cultivation over again, allowing the old one to lie fallow and the trees to regenerate. In the highlands, the soils are deeper and more fertile (they are often of volcanic origin), and the vegetation cover less of a problem, so fields are more permanent and in general far more fertile than in the lowlands, and settlements are more permanently rooted in the landscape. The consequence is that population densities are today far greater here than in the lowlands.

On the other hand, modern archaeological and ecological studies have proven beyond a shadow of a doubt that the post-Conquest and modern situation in the lowlands is misleading. During the first millennium AD, the lowland Maya had practiced not only slash-and-burn agriculture, but far more intensive and productive systems of cultivation, with extensive terracing of the more hilly slopes, and—most importantly—the creation of raised plots in low-lying,

4 Map of the Maya area, showing topography and principal sites mentioned in the text.

swampy areas known today as *bajos*. Ancient population figures, far from being light as an earlier generation of Mayanists had thought, were extremely high (even dangerously high). It is now realized that what appears to modern eyes as primary rainforest, surrounding the ancient cities and towering above their ruins, is actually *secondary* growth: by the end of the eighth century, the lowland Maya of the Petén and surrounding regions had apparently levelled *all* of the forest, with consequences that shall be described below.

Since the horrific era of the Conquest in the early sixteenth century, all of the Maya peoples have been forcibly enculturated by the Spanish invaders and their descendants. They have resisted these alien forces (military, civil, and religious) in various ways, ranging from flight into impenetrable jungles (e.g. the several hundred modern Lacandón) to the incorporation of the Christian cross and saints, along with European civil/ecclesiastical hierarchies, into their own way of life. By way of syncretism, most Maya communities have preserved their cultural integrity through centuries of oppression. It has only been since 1980, under various American-supported military regimes in Guatemala, that Maya survival—at least in the highlands of that troubled country—has been called into doubt.[3] But the Maya are an incredibly resilient people, and it now appears that even in Guatemala, after a shameful era marked by genocide and ethnocide, Maya political and cultural rights are in resurgence. Whether this will also be true of those millions of Maya under Mexican rule, particularly those living in Chiapas, remains to be seen.

TIME AND CULTURAL EVOLUTION

In the course of the twentieth century, thanks in large part to the invention of radiocarbon dating, archaeologists have gradually come to realize the broad outlines of culture history in Mesoamerica, and, in a more restricted sense, of the Maya area. Initially, following the end of the Pleistocene or Ice Age, the earliest occupants of Mexico and Central America were hunters and gatherers, not very different from the earliest primitive bands who had migrated into North America from Siberia. These simple peoples had begun to

tame some of the wild plants in their environment, and by about 5000 BC had domesticated maize, which was to be—as it still is—the Mesoamerican "staff of life," the source of food energy which made all subsequent cultural evolution possible.

Three thousand years later, the first true villages appeared, especially along the broad Pacific coastal plain leading down from Chiapas along the Guatemalan littoral. This development initiated the Pre-Classic or Formative period, which endured until the advent of the Classic civilizations. Pre-Classic villagers manufactured sophisticated ceramics and clay figurines, which were heretofore unknown in Mesoamerica. At one time the Pre-Classic used to be thought of as a sort of Mesoamerican counterpart to the Old World Neolithic, but archaeological research has shown it was far more complex: contemporary with these simple farming settlements were the huge centers of the Olmec civilization, distributed throughout Mexico's southern Gulf Coast. Beginning by about 1500 BC, in the Early Pre-Classic, sites like San Lorenzo were producing stone sculpture on a gigantic scale, such as the famous colossal heads (actually portraits of their rulers) and the multi-ton "altars" (actually thrones for those same rulers). Somewhat later, after the downfall of San Lorenzo around 900 BC, the Olmec of the Middle Pre-Classic period began working a wonderful blue-green jade into masks and celts incised with the figures and symbols of their gods [*Pl. 4*].[4]

It is one of the archaeological puzzles of our times that there little or no evidence for an Early Pre-Classic presence in the Maya lowlands; perhaps the techniques for "taming" the dense tropical forest had just not been worked out by that time. It is not until about 1000 or 900 BC that we have evidence for pottery-using villages in this region. But before 400 BC, that is, still within the Middle Pre-Classic, the first large-scale temple platforms were constructed in the northern Petén, as evidenced by the earliest levels at the imposing site of Nakbé. These platforms presaged the astonishing, Late Pre-Classic florescence of Maya civilization beginning about 250 BC; at the nearby site of El Mirador, for instance, a great city had sprung up, with towering temple-pyramids of limestone and lime plaster placed atop massive basal platforms—one of these may

in its total bulk be the largest pre-Columbian structure in the entire New World![5]

The origins of many of the great cities of the lowlands, such as Tikal, Uaxactún, and Copán, lie in the Late Pre-Classic. Towards the end of the era, that is, before AD 250, writing had made its appearance in both lowlands and highlands, and we have at sites like Tikal the first stelae carved with the historical records of Maya kings, a topic that will be more fully explored in the next chapter; but here it can be said that the institution of the Maya scribe had already begun before the Classic.

The brilliant Classic period marks the height of ancient Maya civilization. Minimally defined as the time span during which the Maya were erecting stelae bearing historical dates in the system known as the Long Count (see pp. 52–53), it begins about AD 250 and terminates shortly after AD 900. The Classic falls into two neat halves, at about AD 600. Before that, during the Early Classic, there was powerful cultural influence, especially in militaristic matters, from the city of Teotihuacan in central Mexico; in most of the Late Classic, especially after the destruction of Teotihuacan, that influence was negligible, and the Maya went their own cultural way. With the exception of the four extant codices [*Pls. 70–76*], almost all of the fine calligraphy which we examine in this book is Classic; and just about all of the imposing architecture which the tourist sees at great Maya sites like Palenque [*Pl. 4*], Tikal [*Pls. 2, 3*], and Copán belongs to the second half of the era, even though usually covering up much earlier construction dating to the Early Classic and even the Pre-Classic.

By the ninth century, something was profoundly wrong among the peoples of the southern Maya lowlands, and city after city failed to erect dated monuments and was abandoned to the ever-waiting forest. Debates raged for years among Mayanists about the cause or causes of the so-called "Maya Collapse," but there is now overwhelming evidence for a deep ecological crisis: the population of the region had far outstripped the carrying capacity of the land, regardless of the intensity of various cultivation methods, such as raised fields. There are ample data now for environmental degradation and even severe erosion, coupled with epigraphic evidence for greatly stepped up warfare

between rival states (seemingly in competition over dwindling land resources).⁶ Eventually, in one of the greatest cultural debacles of all time, most of the Petén and its surroundings were deserted.

However, the ninth century saw not only this vast human tragedy, but also the rise of vigorous city-states in northern Yucatán, during what has become known as the Terminal Classic. Centers like Uxmal, Kabah, and Labná (all in the Puuc Hills of the peninsula), and the great city of Chichén Itzá, saw not only the construction of some of the finest architecture ever built by the Maya (it was admired and imitated by Frank Lloyd Wright), but also the continuation of Maya records written on stone—even though the Long Count was in disuse. Compared to the southern cities, such records are few, but the lintels of Chichén [Fig. 27] present a system of joint rule, probably by brothers, in place of the single dynastic rulers celebrated by centers such as Copán and other cities of the south.

After AD 900, the lowland Maya area enters the Post-Classic. This was at one time thought to have been a period marked by widespread militarism, in part brought on by an influx of Toltec from the central highlands of Mexico, taking the place of the supposed peaceful theocracies of the Classic era. But it is now realized that the latter were neither peaceful nor theocratically organized. Even further, many archaeologists doubt whether there ever was a Toltec invasion. In the absence of any serious modern excavation of the key site of the period, Chichén, it is unlikely that this puzzle will be solved. Yet it cannot be denied that there is strong central Mexican influence visible not only at Chichén but at later centers like the densely occupied, walled city of Mayapán. What is new is the appearance of metallurgy, which was unknown to the earlier Maya; during the Post-Classic, many fine objects of gold and copper, along with jade, incense pellets, and human sacrifices were hurled into Chichén's famed Sacred Well or Cenote as offerings to the Rain God, Chak. By the time of the Spanish Conquest, beginning in 1527, northern Yucatán was organized into sixteen independent states of modest size, not significantly different in kind from the city-states of the Classic southern lowlands; this marked decentralization of power made the Conquest an extremely slow and difficult process.

Compared with the Classic, there is very little visible calligraphy from late times. Most of it was probably in books, but the Spanish missionaries made sure that very few codices have survived. It is a sad fact that there are only four Maya hieroglyphic books in existence; all four are Post-Classic, with one—the Madrid Codex—apparently even being early Colonial in date (see Chapter 5). But if the Late Post-Classic Dresden Codex is at all representative [Pls. 72, 73, Figs. 137–139], many of the screenfold books burned by the Franciscan friars must have been masterpieces of the scribal art.

THE CLASSIC ACHIEVEMENT

Thanks in large part to the decipherment of the Maya script since the 1950s, there is now a history available for the Classic period Maya which extends back to the third century of our era. Even further, a close study of the monumental inscriptions of the major Maya sites has revealed entirely unexpected details not only of the social and political organization of particular Maya cities, but of the relationships—often but not always hostile— between them. Numerous city-states, as many as forty of them, dotted the Maya lowlands; each was ruled by a single dynasty or lineage which appeared to claim descent from a founder, and perhaps from the gods as well. We know about such entities since each was characterized by its own "Emblem Glyph," which was always written following the personal name of a ruler (and his wife or wives), and which originated as a local place name [Fig. 30].

Maya city-states were small, rather similar in size to their counterparts in Renaissance Italy: the frontier with another state was seldom more than a day's march from the city center. In spite of the small scale of the polity, the centers themselves must have been magnificent to behold, with towering temple-pyramids [Pls. 2–4], lower structures with multiple rooms (called "palaces" by archaeologists), and various lesser structures for the bureaucracy and leading families built of masonry around their own courtyards. Rooms were constructed on the principle of the corbelled arch [Fig. 8]; those atop the pyramids were little more than narrow slots, but others were more spacious. The upper

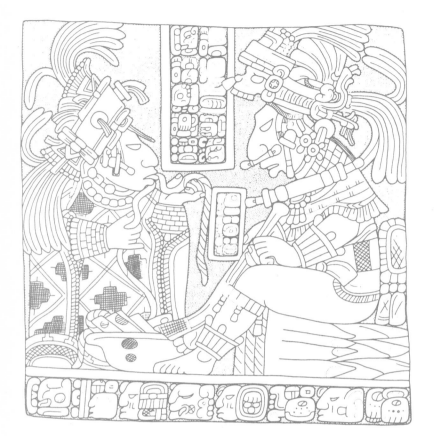

façades of important buildings were embellished with stucco and painted, as were the "roof combs" which rose above them.

All Mayanists are agreed that much of the life in the Classic cities revolved around religion and ceremony. It is difficult to generalize, but Maya religion seems to have arisen from a syncretism between a cult centered on natural forces and the agricultural cycle—rain and maize, above all—and a cult focused upon the divine king and his lineage. At regular intervals, usually at the close of major calendrical cycles and the beginning of new ones, it was necessary for the ruler and his immediate family to shed their own blood in honor of their deified ancestors, males by piercing the penis with a stingray spine, females by piercing the tongue, and by burning incense to the gods [*Pl. 90, Fig. 5*]. Such acts of state ceremony, along with other significant happenings such as royal accessions and major conquests, were recorded on stelae set up in prominent places in the city's principal plaza [*Fig. 6*], and on stone lintels [*Pl. 90, Fig. 17*] spanning doorways of "palaces."[7]

In some of the larger and more important lowland cities, such as Tikal [*Pls. 2, 3, Fig. 7*], whole temple complexes were located in two or more of the cardinal directions, and connected to the core and sometimes to each other by broad

5 *Lintel 17, Yaxchilán, 752. Bird Jaguar and his wife (a lady from Tikal) are engaged in drawing blood from their bodies, a rite celebrating the birth of an heir. (Ian Graham and Eric von Euw,* Corpus of Maya Hieroglyphic Inscriptions, Volume 3, Part 1, Yaxchilan. *Peabody Museum of Archaeology and Ethnology. Copyright 1977 by the President and Fellows of Harvard College.)*

6 *Two stelae of the Copán king "18 Rabbit." The one on the left (Stela B) was dedicated in 731, the one on the right (Stela C) a year earlier.*

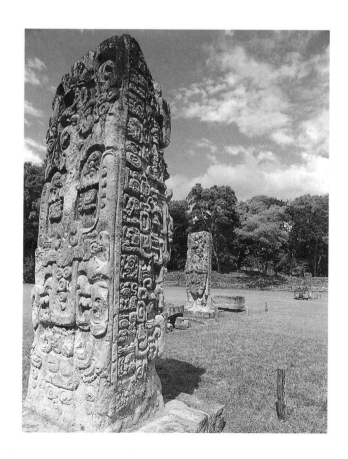

masonry causeways, over which mighty processions would have passed on auspicious occasions. One can only imagine the magnificence of Maya ceremony—the vivid polychrome murals of Bonampak [*Pl. 47*] give an indication of the richness of costume and the variety of musical instruments played, but time and the tropical climate have decreed that extremely few perishable objects were to survive to our time. Even the game which the Maya played with a rubber ball in a special court had religious overtones: there is reason to believe that the ball was equated with the sun, and the court (like caves) with a way into the Underworld.

Any serious archaeological program in a Maya site of any size will soon encounter burials and tombs in profusion. Maya interments vary all the way from the simple graves of commoners inside the house platforms on which they had once dwelt to great royal tombs inside temple pyramids, such as the yet-to-be-surpassed tomb chamber and sarcophagus of King Pakal [*Fig. 8*] inside Palenque's Temple of the Inscriptions [*Pl. 4*]. In a certain sense, from the beginning of the Early Classic on, Maya pyramids were as much funerary monuments as those of Pharaonic Egypt, for whatever might have been their secondary function, the majority must have been built to house the remains of great kings.

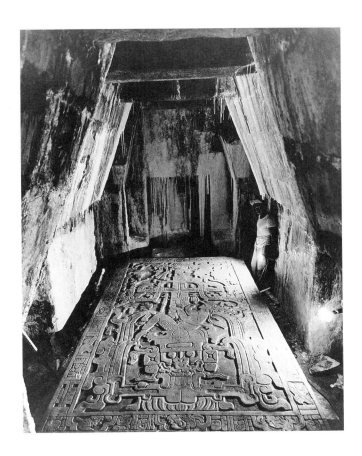

7 *Plan of the central part of Tikal (cf. Pls. 2, 3), showing the causeways linking major temple groups. The area shown here covers slightly more than 1 sq. m. (2.6 sq. km.). 1–5 Temples I–V; 6 Temple of the Inscriptions; 7 Great Plaza. Shaded areas are reservoirs.*

8 *Funerary crypt of Pakal, beneath the Temple of the Inscriptions, Palenque. When this great king died in 683, he was entombed under the huge carved slab with a treasure trove of jade.*

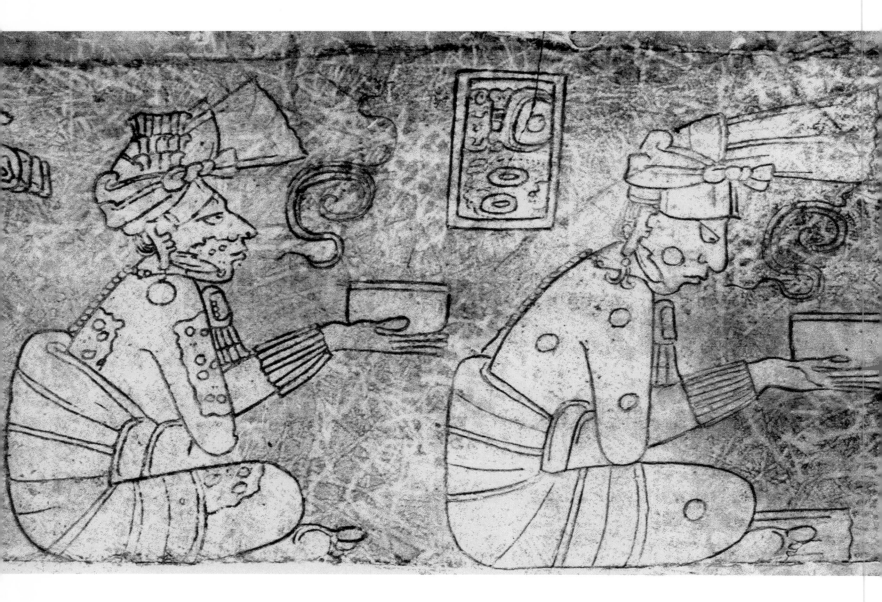

Unlike ordinary Maya, the elite caste which ran the city-states may have considered itself immortal. In this case, the great paradigm would have been the myth of the Hero Twins [*Pls. 34–37, Figs. 9, 78–80*] recounted in the pages of the Quiché Maya epic, the *Popol Vuh* ("The Book of Counsel"), which tells of the descent of a pair of handsome brothers to Xibalbá, the Underworld, their triumph over the lords of death, their resurrection of their father, and their apotheosis as the sun and the moon.[8] This is a theme, along with a host of associated detail, that is pictured on many Classic Maya objects, above all on magnificent vases placed with the royal and noble dead in their tombs: high-ranking individuals who may have died and passed to Xibalbá, destined, too, to overcome death and achieve immortality.

9 The Hero Twins hold bowls (probably containing maize gruel) on this Late Classic incised vase; Hunahpú, with his distinctively spotted face and body, is on the right, Xbalanque on the left, his face and body marked by patches of jaguar skin.

OPPOSITE

10 Incised travertine vase from the Late Classic period, with two bound captives awaiting sacrifice, almost surely by decapitation, the favorite Maya method of despatching prisoners.

11 Bird Jaguar of Yaxchilán arraigns a group of captives on Stela 11; he wears the mask of Chak, the Rain God, and wields an axe in the shape of K'awil, patron of the royal house.

In a tour-de-force of iconographic analysis, Karl Taube has shown that this myth of death and resurrection symbolically celebrates the planting of the maize seed in the earth (sending it to Xibalbá), and its resurrection when the rains finally arrive and it sprouts on the earth's surface.[9]

To return to the political picture reconstructed by epigraphers for the Classic Maya, it appears that warfare among these little city-states was almost incessant [*Pls. 9, 10, Figs. 10–12*]: to gain a royal captive from an enemy state, and to decapitate him after lengthy torture, was a goal often achieved by Maya dynasts on the testimony of the inscriptions. Yet territorial aggrandizement seems hardly to have mattered, since as far as can be seen boundaries remained fairly stable; only towards the end of the Classic can competition for arable land have been a major cause of hostilities. At the same time, much diplomacy was carried out, by royal marriages and state visits—a mix of friendly and unfriendly relations with near and distant neighbors paralleling the political situation in Renaissance Europe.

During the first half of the twentieth century, Mayanists such as Sylvanus G. Morley claimed that there was an "Old Empire" in the southern lowlands during the Classic, with perhaps Tikal as its capital. The discovery of multiple, independent city-states through the study of Emblem Glyphs (see pp. 59–60) changed this simplistic picture. But is the newer understanding completely correct? Were all the Classic states truly equal? Two young epigraphers—Simon

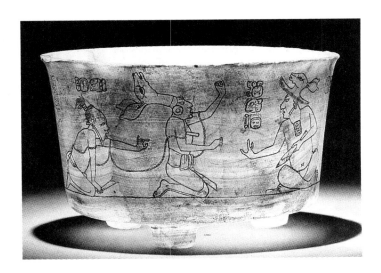

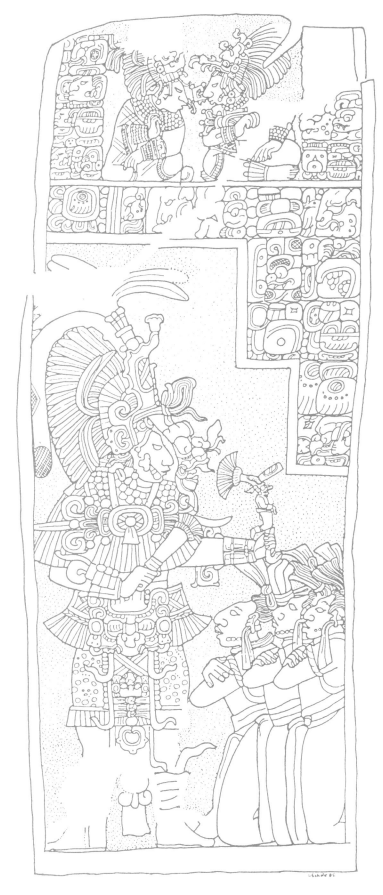

Martin of Great Britain and Nikolai Grube of Germany—have proposed that a few of the greater cities had won control over others, and kept them in a patron-client relationship.[10] The greatest of the "super-powers" was Calakmul, which by AD 546 had been able to place a client-ruler on the throne of Naranjo, and later at Cancuén, El Perú, and Dos Pilas. But the political landscape was a fluctuating one, and the client polities would sometimes slip from political control, in spite of marriage alliances and royal visits. Calakmul's great and bitter rival was Tikal, another super-power: Tikal's moment of triumph occurred on 5 August 695, when its king, Hasaw Cha'an K'awil (the man buried in the great Tomb 116 under Temple I [*Pl. 3, Fig. 100*]) defeated King Jaguar Paw of Calakmul.

As Martin and Grube have said, "The picture that is emerging is neither one of a centralized administration of regional states nor one of a political vacuum populated by weak ones. Instead it would appear that a few powerful kingdoms held lesser ones in their sway, a system not unlike others seen throughout ancient Mesoamerica."[11] They compare this with the well-known Aztec Empire of the Late Post-Classic, which although considerably centralized as compared with the Maya, nevertheless exhibits the same brand of hegemonistic relationships with client states; there, too, the native rulers were left in place after they had been conquered—a situation which led many of them, although sometimes closely linked to the Aztec ruling family through marriage, to desert their Aztec masters for the Spaniards once the latter appeared on the political scene.

THE CONTEXT OF CLASSIC MAYA WRITING

Almost all of the best surviving Maya calligraphy is Classic, and objects embellished by it were produced in an elite context. The high-status persons of each city lived in or near its center, as the able but cruel sixteenth-century Bishop Diego de Landa tells us in his *Relación de las Cosas de Yucatán* ("Account of the Things of Yucatán")[12] was the case with the towns of the late pre-Conquest Maya. From the Bonampak murals, from stone lintels and panels, and from scenes on fine ceramics [e.g. *Pls. 7, 28, 91, Figs. 12, 13*] one can gain a fragmentary picture of the size and complexity of the palace staff, which was probably as enormous as those described by early Spanish sources for the Aztec rulers. A Classic ruler's retinue would have included his immediate family, by principal and secondary wives; his military staff, led by the *sahal*, probably a near-relative who could be assigned as governor of a provincial city; his dancers and musicians [*Pl. 47*]; his kitchen and other domestic staff; and, of most importance to this book, his royal librarian (and chief scribe) who headed a cohort of lesser scribes, painters, and sculptors, most or all of whom belonged to the noble class. Over these, the ruler himself presided, seated on a royal throne underneath a canopy with swagged curtain. In addition to the palace, the city center almost surely contained a "school for scribes," where the younger sons of rulers, or sons by secondary wives and concubines, would have been trained in the art of writing; and, since a few of the scribes pictured in Classic Maya art and mentioned in hieroglyphic texts are plainly female [*Fig. 54*], some daughters must have attended such schools along with their brothers and male cousins.

Who could actually read and write in Classic Maya society? How widespread was literacy?[13] This is a question difficult or impossible to answer for any civilization before the modern age, including ancient Egypt and even Classical Greece and Rome. Landa and other early Spanish sources state that it was a skill reserved to the elite—that only a relative few could handle the writing system. But that information, if true, would apply only to the last stage of the Maya story, not necessarily to the Classic.

The idea has been promulgated by some specialists in ancient Greek and Roman cultures (such as the late Eric Havelock), and even by the anthropologist Jack Goody,[14] that non-alphabetic scripts impede literacy, and that literacy in non-alphabetic societies is confined to a lucky few. But how difficult would it actually have been to read a logosyllabic script like Maya? In her Maya seminars held annually at the University of Texas, Linda Schele teaches complete neophytes how to read simple texts in the space of a single weekend. In scripts like those of the Maya, Egyptians, and Chinese, there is a strong phonetic component which is ignored by those who mistakenly denigrate them as purely "ideographic" or "pictographic,"

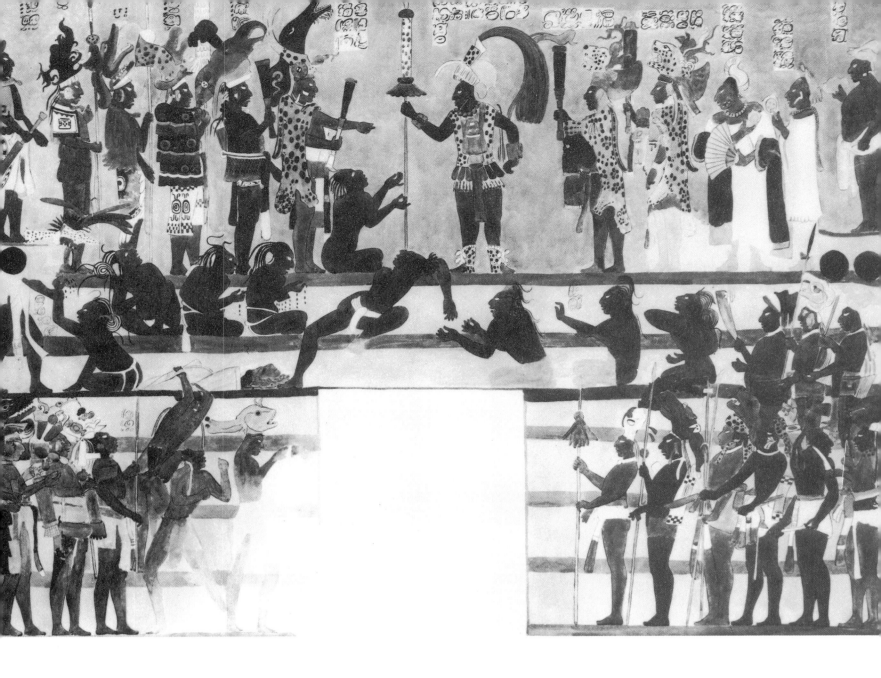

12 A ruler of Bonampak and some of the members
of his large court appear in this mural in Room 2, of
about 790. Courtiers stand with him on a terraced
platform (among them are two women, at the right);
on the ground below are files of soldiers. In between
are captives, who are being tortured by having their
fingernails removed. Glyphs at the top provide
identifications and commentary.

13 A ruler giving instructions to his sahal, on an incised
vase. The accompanying text (see also Fig. 107) gives
their names and titles, along with the names of the two
artists who made the vase, Ah Pasan and Kan Hixal,
carvers of Xcalumkin in western Yucatán.

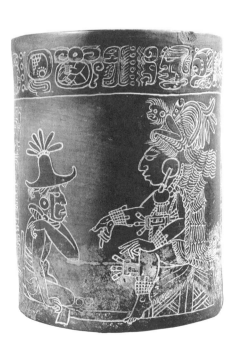

and which greatly helps in their reading. The fact of the matter is that if the Classic Maya kings had felt it necessary that everyone in the society be literate, more than 90 per cent would have been so.

Given the highly aristocratic nature of ancient Maya society, however, it is doubtful whether more than 25 per cent of the many millions who lived in the lowlands were truly literate. Probably many more could read than write, for the latter requires special skills. Stephen Houston[15] has proposed testing the extent of writing literacy by the cataloguing and analysis of graffiti from the plastered inner rooms of buildings; but very few of them have been recorded, and those that have may date from the period of the Classic Collapse, and thus not be representative. However, there are many graffiti on the

fired bricks out of which the site of Comalcalco is built; only a few have what appear to be Maya glyphs, written very ineptly and usually garbled [*Fig. 14*]. Furthermore, on the painted ceramics of very minor Classic sites, there are other attempts to write, in this case to use the same meaningful and beautifully drawn glyphs which appear on the finest Classic vessels from elite tombs; those attempts by "boondock potters" are usually pitiful, consisting of pseudo-glyphs in meaningless repetitions.

What this means is that away from the political centers of the Classic city-states, and among the lower classes (such as Comalcalco brickyard workers), there was not much literacy. The reality is that the sophisticated calligraphy found on the objects pictured in this book was the work of scribal artists of aristocratic, noble, and even royal blood.

14 Fired brick from a Late Classic construction at Comalcalco. Many of these bricks—unique for the Maya area—have crude graffiti; below the human profile is a rare attempt at writing, an unreadable imitation of a calendrical sign by a probably illiterate brickyard worker.

2

THE MAYA SCRIPT: ITS CHARACTER AND ORIGINS

16 By some time after 400 BC, the Zapotecs of the Valley of Oaxaca had developed a system
of writing that was distantly related to the earliest known Maya writing. This Late Preclassic
danzante ("dancer") from Monte Albán, the Zapotec capital, is actually a portrait of
a slain enemy: the glyph in front of his face is probably his name.

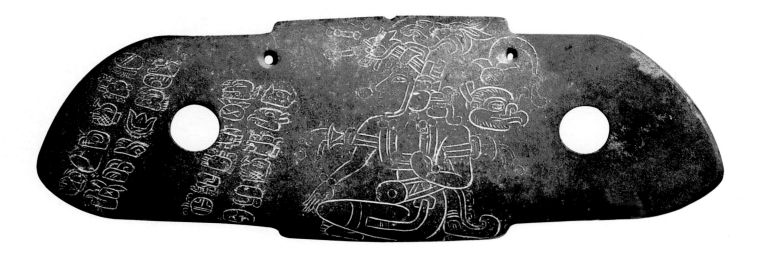

17 ABOVE Early Maya writing appears on the Dumbarton Oaks Pectoral: of greenstone, it is incised with the figure of a Late Pre-Classic Maya king; four columns of text on the left give his name and describe his accession to rulership.

Such writing may have had its roots in a symbolic form of "proto-writing" without phonetic content which characterized the Early and Middle Pre-Classic Olmec of southeastern Mesoamerica.

18 BELOW A bowl carved with the Olmec creation god, a dragon-like creature.

19 OPPOSITE A jade celt from Arroyo Pesquero, incised with the Maize God and related symbols.

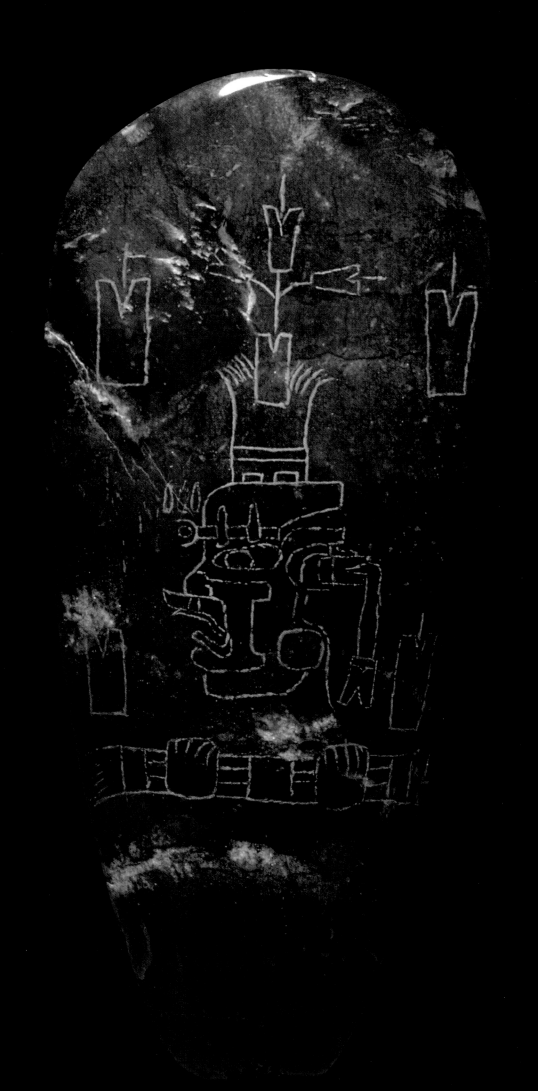

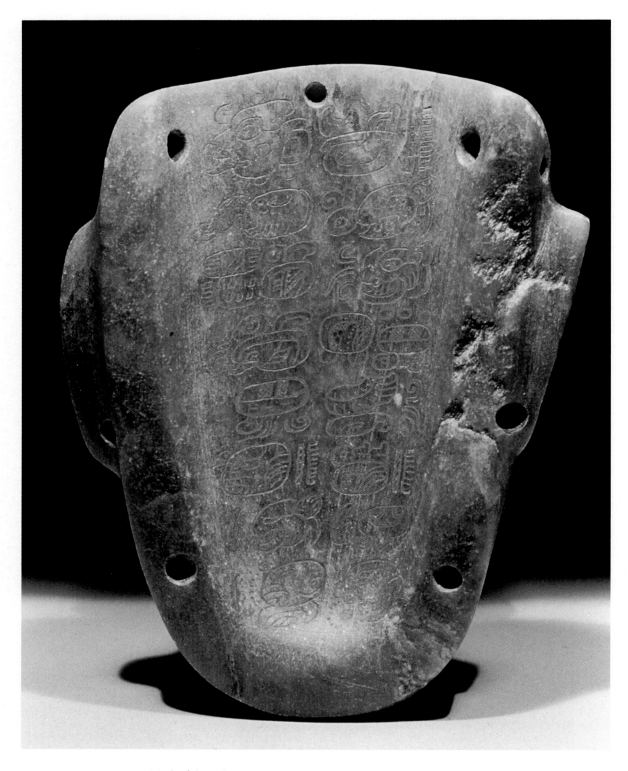

20, 21 Much of the earliest Maya writing appears as incision on portable jade objects. On the reverse (ABOVE) of this fourth-century jade mask of the rain divinity Chak is a 16-glyph text, arranged in two paired columns; it seems to deal with a ruler of the Río Azul city-state. The northeast to southwest slant of the Maya script, dictated by the scribes' use of brush pens, is already apparent.

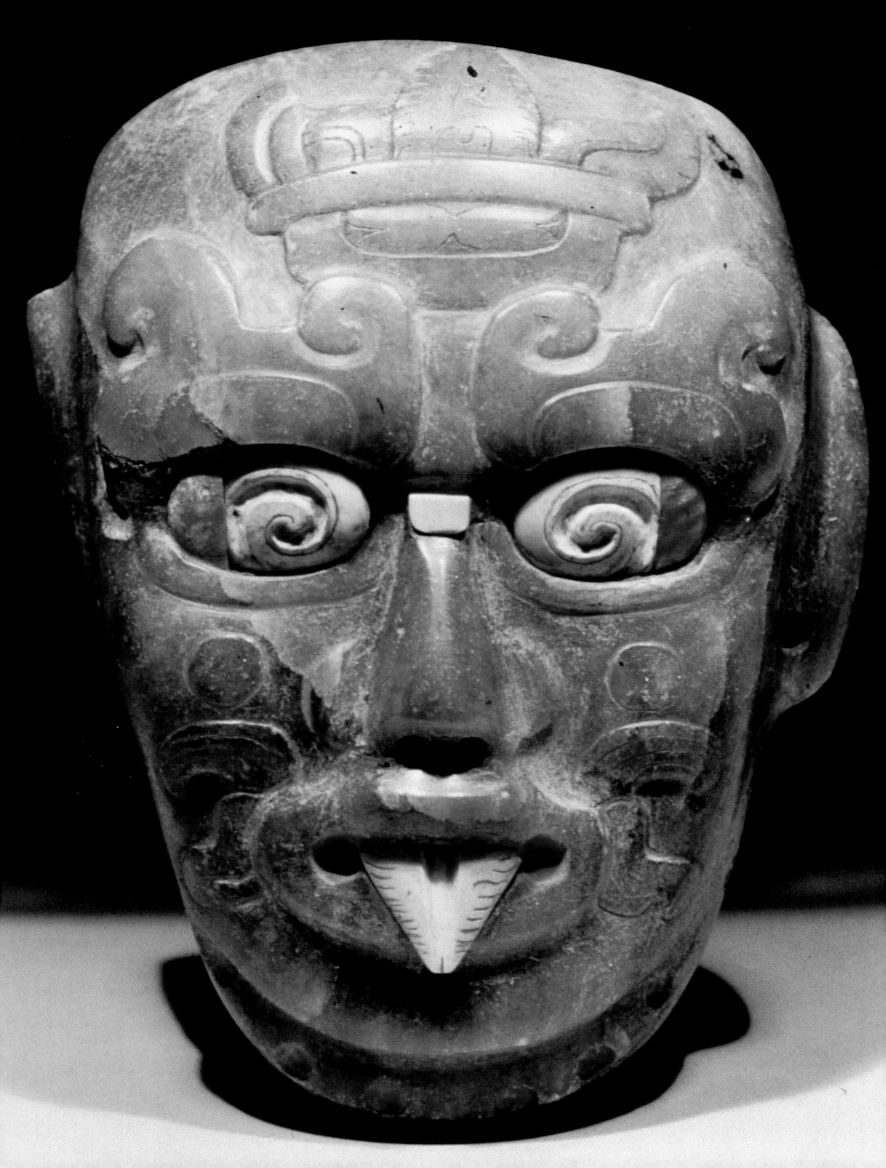

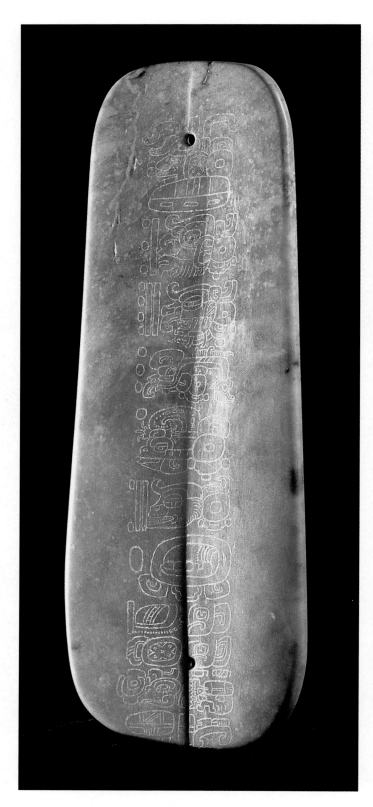

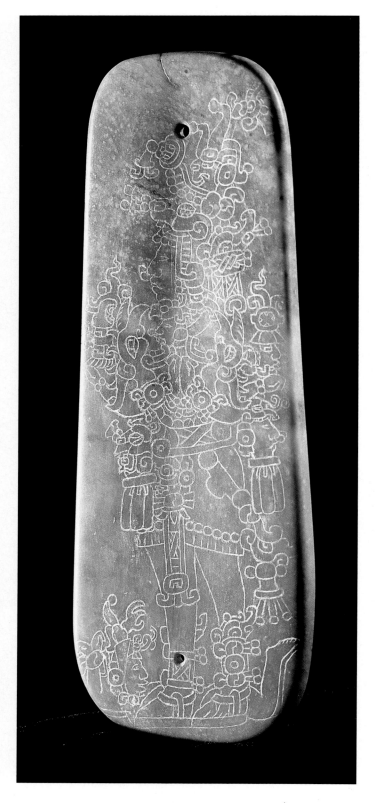

22, 23 At the beginning of the Early Classic, the jade belt pendant known as the Leiden Plate was incised with the figure of a standing Tikal ruler trampling a bound captive. On its reverse appears a complete Long Count date corresponding to 17 September 320, the day on which this king—whose name is as yet undeciphered—acceded to the throne.

24 OPPOSITE Another jade belt pendant, from an unknown site in the northern Petén, is similarly incised on the reverse with an Early Classic dynastic text which gives the parentage of the ruler shown on the reverse (Pl. 25). Red coloring is rubbed into the lines to make them more legible. Probably late fourth century AD.

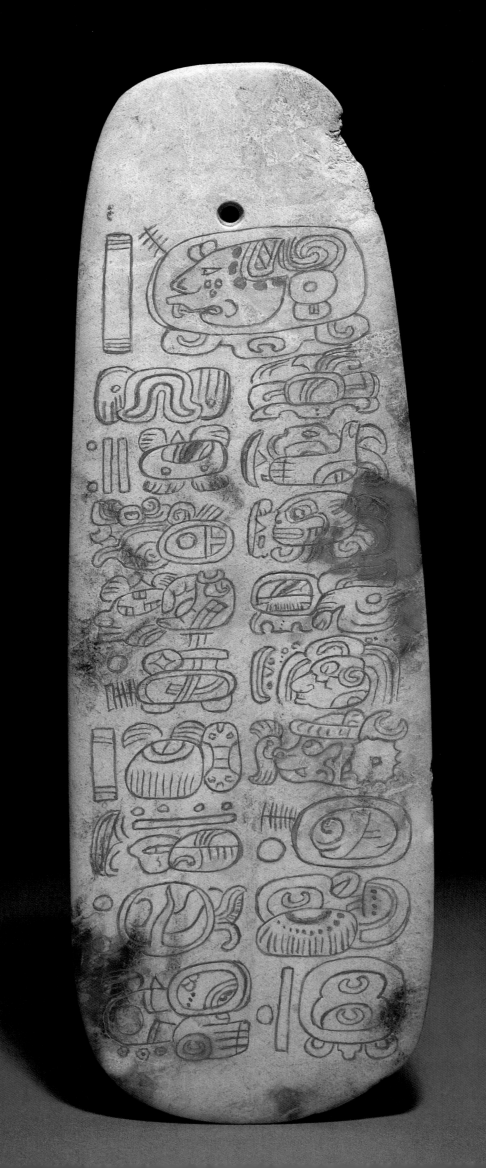

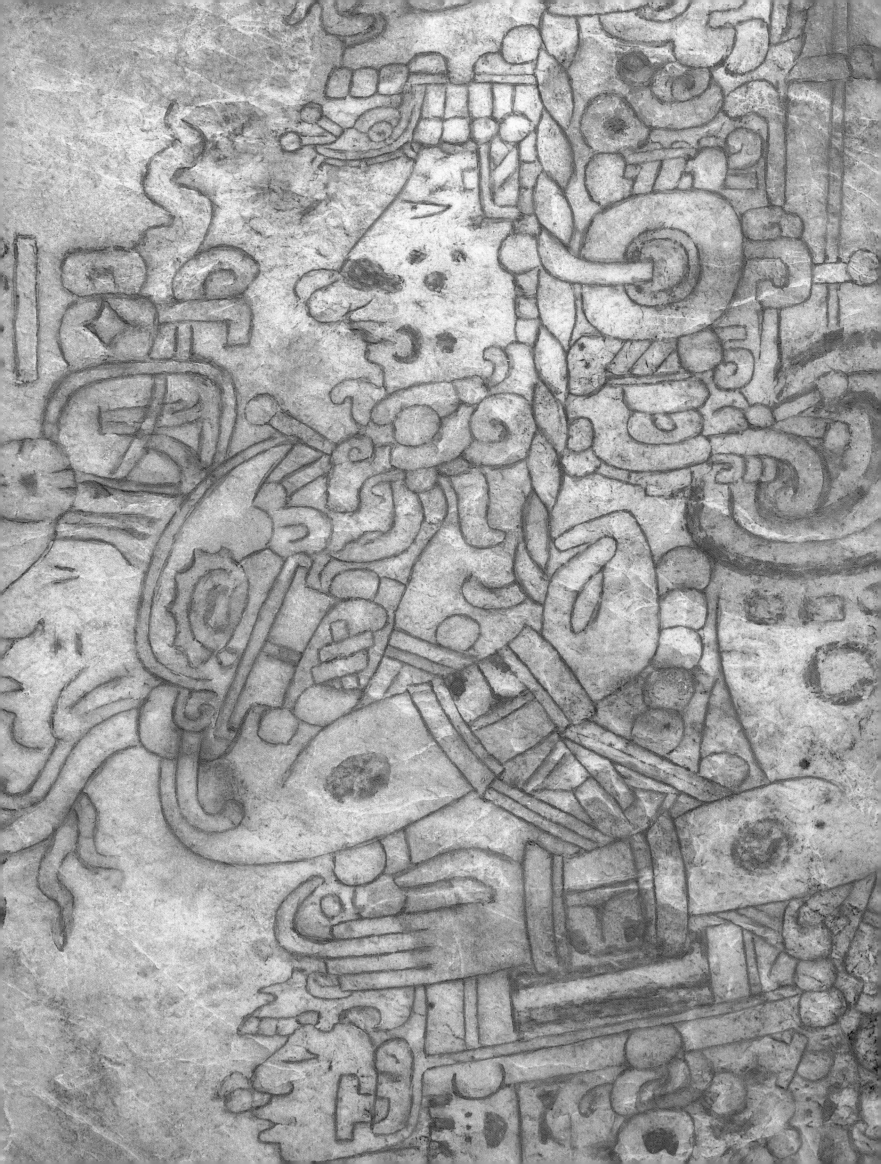

THE MAYA SCRIPT:
ITS CHARACTER AND ORIGINS

STRUCTURE AND CONTENT

READING ORDER

The original discoverers of the ancient Maya cities—
pioneers like John Lloyd Stephens and Frederick
Catherwood in the 1830s and 1840s[1]—were struck by the
highly pictorial appearance of the hieroglyphs carved on
the stone monuments there [*Fig. 148*]: heads, bodies, and
body parts of humans and animals were frequent among
the signs of the yet-undeciphered Maya writing system,
as they were on the more familiar monuments of ancient
Egypt. A glance at any Maya inscription will show that the
heads almost always face left. We know that in early scripts
which feature pictorially based signs, such as Egyptian and
Anatolian Hieroglyphic, the order in which the signs are to
be read is opposite to the way they apparently face. Thus,
even without the ability to actually *read* Maya writing,
on the basis of his knowledge of the newly deciphered
Egyptian script, Stephens might have correctly surmised
that the general reading order was from left to right—in
contrast to Egyptian, which for the most part is to be
scanned from right to left.

Another general rule of the Maya script is that with some
exceptions the texts are ordered on an imaginary or actual
grid in which the reading is from left to right and top to
bottom in paired columns [*Fig. 15*]. Thus, if we conceive
of this grid as a chessboard with lettered columns and
numbered rows (in chess, these would be the "files" and
"ranks"), the reading procedure of glyphs would be A1, B1,
A2, B2, A3..., until the bottom of column B; then, the next
glyphs would be C1, D1, C2, D2, C3..., until the end of
column D, and so on. Most of the formal, monumental
inscriptions of the Classic Maya are arranged in this way.

Shorter texts on monuments as well as on portable
objects of pottery, bone, shell, jade or other materials
may appear as single horizontal lines (read A1, B1, C1...)
[e.g. *Pl. 35*] or as single vertical columns (A1, A2, A3...)
[e.g. *Pl. 34*]; quite frequent are brief texts arranged like a
flipped and/or inverted L [e.g. *Pls. 29, 89, 90*]. One finds
texts painted in unpaired columns on some fine ceramics
and in the cave of Naj Tunich; although more-or-less
arranged on the usual invisible grid, each column is to
be read *in toto* from top to bottom before proceeding to
the next (as in traditional Chinese writing), a situation
which the reader could discover through context. Another
variation, although preserving the left-to-right rule, consists
of circular texts on the upper surface of ballcourt markers
and altars [*Fig. 16*]; again, the context indicates where the
inscription begins (usually a Maya date). In the Classic cities
of Copán and Quiriguá, stelae and other stone monuments
may exhibit far more complex programs, such as criss-
crossed texts intricately laid out like mat-weaving; probably
such convoluted glyphic statements could only have been
read and understood by a select few.

Particularly intriguing are those rare texts on stone or
pottery that proceed from right to left, instead of the usual
order. It is a mystery why a few finely carved stone lintels,
such as Yaxchilán's magnificent Lintel 25 [*Fig. 17*], have such
reversed glyphs; but in the case of certain painted vases
from the Guatemalan highlands and the northern Petén,
the scribes/artists seem to have been left-handed, since the
form of the individual glyphs has a northwest-southeast
slant (opposite to the usual bias of Maya glyphs, which is
from northeast to southwest), and the principal figures in

25 Detail of the obverse of the pendant seen on p. 47; the king, whose cheek is marked
with the spots of Hunahpú (one of the Hero Twins), holds his badge of office, a stylized
double-headed sky serpent.

A B C D E F G H I J K L

1 2 3 4 5 6

the associated scenes, as well as the glyphs, face right. One never finds such a maverick reading order on the grandly formal, public texts displayed on monumental stelae—such calligraphic experiments would have been as out of place there as they would have been on a Roman triumphal arch, or on the Lincoln Memorial in Washington, D.C.

Only one case of right-to-left script appears in the ancient books, and that is in pages 21–24 of the Paris Codex [*Pl. 75*], but that cannot be ascribed to left-handedness, as the scribe wrote the rest of the manuscript in normal fashion.

15 The Kuná-Lacanhá Lintel, a relief depicting an important sahal *or* war leader *seated on a symbolic mountain, during a period-ending celebration on 4 June 746 (see also ill. p. 39); he carries a "ceremonial bar" with double heads of the god K'awil as a symbol of rulership. The dates on the relief and associated historical information appear in glyphs laid out on a grid pattern, read in the sequence A1, B1, A2, B2, etc.*

17 A rare right-to-left text appears on Lintel 25, Yaxchilán, dedicated in 723. Shield Jaguar's queen, Lady Xok, gazes at a Vision Serpent; from the monster's jaws appears a dynastic ancestor in war gear. In this reversed text, the Calendar Round date 5 Imix 4 Mak (23 October 681), appears on the upper right.

THE FORM OF MAYA GLYPHS

One of the nineteenth-century pioneers of Maya epigraphy, the French linguist Léon de Rosny, described the general form of individual Maya glyphs as *calculiforme*, "pebble-shaped," which is more-or-less accurate.[2] However, it was quickly seen by these early scholars that a glyph was more complex than this, usually consisting of a larger "main sign" to which are attached smaller, flatter "affixes" either in front, on top, at the rear, or underneath [see p. 154 and

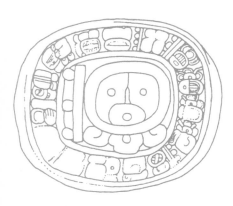

16 Circular text on an altar from Tikal, with a Long Count date corresponding to 18 March 692; at the center is the day reached by the Long Count, 8 Ahaw.

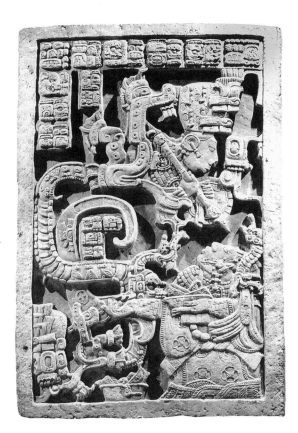

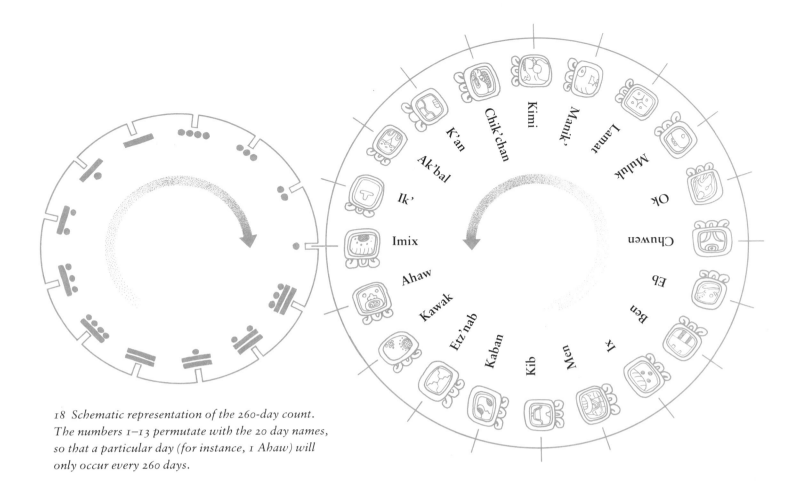

18 *Schematic representation of the 260-day count. The numbers 1–13 permutate with the 20 day names, so that a particular day (for instance, 1 Ahaw) will only occur every 260 days.*

Fig. 123]. It was believed for a very long time that the main sign carried the general meaning of the glyph collocation, while the affixes acted as modifiers.

It is certainly true that the signs for the colors are always written as affixes, but ever since the decipherment of the past quarter-century, it has become evident that there is no major functional difference between main signs and affixes: the logographs and phonetic signs that will be described below can appear in both categories. Rather, it is clear that the Maya calligrapher, particularly in Classic times, could change the "design" of individual glyph blocks as he saw fit, and even convert main signs into affixes and vice versa, as long as the basic reading order was not too seriously violated, and as long as the collocation fitted easily into the assigned glyph block. In the usual order, the affix at the front (left) was read first, then the one on the top, followed by the main sign; the reading finished with the affix at the back, then the one on the bottom [see *Fig. 23*].

There was, in fact, a great deal of latitude allowed to the Maya scribe, both in terms of showing his virtuosity with the structure of the script, and of adapting his writing to the prevalent style favored by his royal patron. There were, it is true, some basic calligraphic rules which arose during the Early Classic from the use of the brush pen; these will be examined in detail in Chapter 4.

NUMBERS AND DATES[3]

Chronological expressions are found throughout Maya hieroglyphic writings, so much so that earlier generations of epigraphers were able to claim that there was little in these texts beyond statements about time periods and astronomy. It is now known that most Classic inscriptions deal with dynastic history, embedded in a complex and rigid chronological system: a typical monumental text consists of a series of historical statements, each statement immediately following a calendrical (and sometimes astronomical) expression.

Basic to reading and understanding Maya texts is he concept of cyclical time—events take place at points set within cycles of specific duration. These cycles are contained within larger cycles of ever-increasing magnitude, until one reaches super-cycles so enormous (in some instances of millions of years) that time becomes effectively linear and non-repetitive. Other kinds of cycles, such as the 365-day year and an "almanac year" of 260 days [*Fig. 18*], mesh with this super-cycle system. Each time a cycle is named, it is preceded by a numerical coefficient representing the value it must be multiplied by [*Fig. 21*]; further, the days within the 20-day "months" of the solar year, and the coefficients accompanying the days in the 260-day count, must all be expressed.

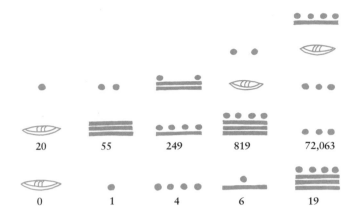

20 55 249 819 72,063

0 1 4 6 19

19 Examples of figures written in Maya bar-and-dot numeration. The system was vigesimal (base-20) rather than decimal (base-10).

20 BELOW Head variants for the Maya numbers, with equivalents in Colonial Yucatec.

It is no surprise that the Maya number system has gained the admiration of Western mathematicians over the past century, for it is a unique achievement: operating with only three digits in contrast to our ten, and using positional numeration and vigesimal or base-20 counting rather than decimal or base-10, the Maya scribes could express any number they wished [*Fig. 19*]. The first step in understanding this system was taken in 1832 by the eccentric Franco-American *savant* and polymath Constantine Rafinesque.[4] On examining some pages of the Dresden Codex (the most important surviving Maya book) which had been published sixteen years before by Alexander von Humboldt,[5] Rafinesque became intrigued by the numerous black or red bars and dots that appeared in them [*Pl. 72*]; noting that the dots never exceeded four in number, he correctly surmised that a dot stood for one and a bar for 5. Thus, to write the number 6, the ancients would have written a bar with a dot. Later, when the Dresden Codex was analyzed in more detail by Ernst Förstemann (librarian and curator of the manuscript), the third digit was identified—a stylized shell standing for zero, a necessity in positional numeration. Only the binary numeration of the modern computer age has improved on the parsimony and elegance of this system.

While bar-and-dot numeration is the rule in the codices and on most stone monuments, the great calligraphic sculptors of the Classic period were not content with this utilitarian simplicity, and began elaborating on it, especially at Quiriguá and Copán. Since each number from 0 to 9 had a patron deity, heads or even full figures of these gods could substitute for the more Spartan bar-and-dot coefficients, and could even baroquely intertwine with full-figure representations of the time cycles they were modifying [*Figs. 20, 85, 92*]. Again, like the "matted" texts, while they are certainly beautiful, such masterpieces of the scribal art are low in legibility (also a trait of the great architectural calligraphy of the Islamic world).

The typical Classic Maya inscription is studded with dates [e.g. *Pl. 94*]—so prevalent are they that it was once speculated that the worship of time was the basis of Maya religion. Now it is clear that the Maya were obsessed with royal histories, not with time *per se*. The first date on a stela is part of a very long expression known to epigraphers as the Initial Series; in it, the day to be commemorated is given in two distinct, but concurrently running, systems—the Long Count and the Calendar Round. The Long Count [*Fig. 21*] is a day-to-day count from a point in the distant past, expressed in terms of calendrical cycles of various magnitudes, along with the coefficients by which they are

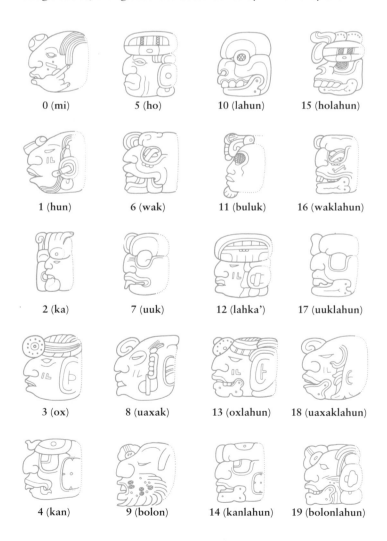

0 (mi) 5 (ho) 10 (lahun) 15 (holahun)

1 (hun) 6 (wak) 11 (buluk) 16 (waklahun)

2 (ka) 7 (uuk) 12 (lahka') 17 (uuklahun)

3 (ox) 8 (uaxak) 13 (oxlahun) 18 (uaxaklahun)

4 (kan) 9 (bolon) 14 (kanlahun) 19 (bolonlahun)

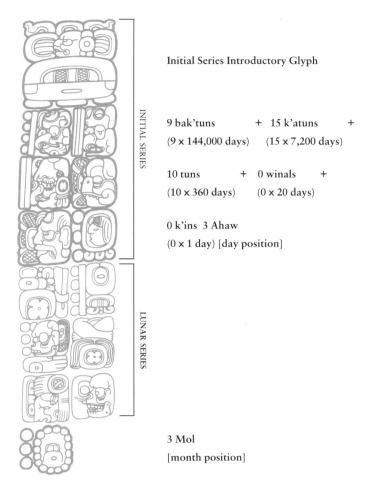

Initial Series Introductory Glyph

9 bak'tuns + 15 k'atuns +

(9 × 144,000 days) (15 × 7,200 days)

10 tuns + 0 winals +

(10 × 360 days) (0 × 20 days)

0 k'ins 3 Ahaw

(0 × 1 day) [day position]

3 Mol
[month position]

to be multiplied. Of course, any particular day in the Long Count was also a day in the 365-day year, *and* a day in the 260-day cycle, and both of these are given following the Long Count. As if that were not enough, the calligraphic sculptors added the head or figure of a god ruling in a cycle of nine gods, along with complex calculations concerning the moon (the Lunar Series). We now realize that the whole point of the Initial and Lunar series is to fix in time the action being undertaken by the royal figure sculpted on the monument—an act of accession, a war, a ceremony marking the conclusion of a great time cycle, etc. Other dates, usually later, but sometimes earlier, are placed on the same stela, often even the birth date of the ruler; these are preceded by glyphic statements which can be translated as "it came to pass," or "it will come to pass." Such dates are given not in the Long Count, but in the so-called Calendar Round, which is a 52-year permutation cycle made up of the 365-day and 260-day cycles. Calendar Round dating is also characteristically found on smaller monuments like stone lintels [*Fig. 17*], on which Long Count expressions are rare, and on portable objects such as ceramic vases and incised jades; here, the knowledgeable reader was expected to fill in the Long Count date by context.

21 The Long Count date 9.15.10.0.0 on Stela 1, Piedras Negras, counted forward from the starting date in the year 3114 BC to reach 3 Ahaw 3 Mol in the Calendar Round. The Supplementary or Lunar Series gives information on the moon.

THE STRUCTURE OF THE SCRIPT

For almost a century, the non-calendric part of the Maya script stubbornly resisted all attempts at decipherment, until the solution was found in the early 1950s by Yuri Knorosov, a young Soviet specialist in ancient writing systems.[6] Ironically, his great breakthrough was based on a Colonial manuscript that had been in the hands of Maya scholars since the middle of the last century, but no one had recognized its full significance. It is as though the Rosetta Stone had been known for a century before anyone got around to using it to decipher the Egyptian script. This document was the already-mentioned *Relación de las Cosas de Yucatán* by the sixteenth-century Bishop of Yucatán, Fray Diego de Landa [*Fig. 146*].[7]

In his *Relación*, Landa had given a detailed presentation of what he thought was the native alphabet, with examples of how it was used to write words and sentences. Unlike almost all earlier researchers, Knorosov grasped that what Landa had given was not an alphabet, but a partial *syllabary*, in which—apart from the "pure" vowels—each sign stood for a consonant (C) followed by a vowel (V). To write a monosyllabic word of the CVC sort (common in Maya; an example would be *k'uk'*, "quetzal"), the scribes would have used two CV syllabic signs, with the vowel of the final sign silent, but usually agreeing with the first vowel. Mayanists tend to be a fairly conservative lot, and when this product of an Iron Curtain regime published his findings at the height of the Cold War, he met with near-universal condemnation. But time proved Knorosov absolutely right.

His critics, particularly the formidable and influential Sir Eric Thompson, claimed that Knorosov was arguing for a completely phonetic Maya script; but in actuality, the picture that Knorosov had presented in his early articles was of a writing system that was *logosyllabic*, with many points of resemblance with hieroglyphic systems elsewhere in the world, such as Egypt, Sumer, and China. Logosyllabic scripts combine logographic signs expressing whole words or morphemes (the smallest meaningful elements of speech) with phonetic ones expressing syllables. Because the

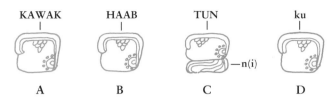

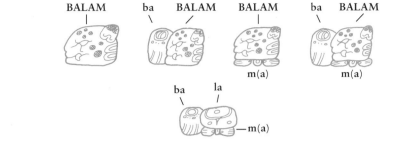

KAWAK HAAB TUN ku

A B C D

BALAM ba BALAM BALAM ba BALAM

m(a) m(a)

ba la

m(a)

22 ABOVE *In Maya script, some signs can have more than one value. Here, logographs are in upper case, phonetic signs in lower case. A = Kawak (day-sign); B = haab (365-day year); C = tun (360-day cycle); D = ku (syllabic sign).*

23 ABOVE RIGHT *Alternative spellings for* balam, *"jaguar." The scribe could write this logographically (top left); logographically with phonetic-syllabic complements; or purely syllabically (bottom).*

logographs [see *Figs. 97, 98*] are sometimes ambiguous for the reader, to help in the reading, the scribe often added phonetic signs as "phonetic complements"; these are frequent in Maya writing, and have been of inestimable value in the decipherment of the logographs.

The Maya system is not a simple one, and could not have been easy to master for either the writer or the reader (although less taxing for the latter). Complicating the Maya script is the fact that many of the syllabic signs are *polyvalent*: one sign can have more than one phonetic value, and some speech sounds can be represented by more than one syllabic sign. A few syllabic signs can also be employed as logographs; for example, the sign read as syllabic *ku* can also be read as *Kawak* (a day name), *haab* (the 365-day year), and *tun* ("stone") [*Fig. 22*]. And how did the reader know which of these was the one meant by the scribe? Again, by context, and, in the case of logographs, by looking for one or more phonetic complements.

The scribe had a few other complexities to inflict upon his audience, most notably *conflation*—the merging or melding of two distinct glyphs into one, obviously for aesthetic effect and balance, where required. The more we understand the script, the more we realize that an astonishing range of choices was available to an accomplished scribe in the writing of words and sentences. All sorts of substitutions were possible, between equivalent phonetic signs, or between phonetic and logographic signs, or between conflated and unconflated forms; in a well-

known example [*Fig. 23*], the Yucatec Maya calligrapher could write the word *balam*, "jaguar," as a pure logograph (with the head of a jaguar), as a logosyllabic compound, or with purely syllabic signs. This was true aesthetic play, and gave to Maya writing an extraordinary flexibility of expression. Some scribes were more adept in this than others; and some Classic period cities—particularly Copán—were more favorable to scribal experiments than stodgier ones like the deeply conservative Tikal [contrast *Fig. 90* with *Pl. 94*].

Epigraphers have come to realize that Maya hieroglyphic writing is far more phonetic than even Knorosov had thought: a number of signs that were once considered purely logographic now turn out to have been polyvalent, and used mainly for their phonetic-syllabic values. Yet it is abundantly clear that that the ancient Maya could have written everything that was in their language phonetically. So why didn't they? The Japanese today still use Chinese-derived logographs (*kanji*) side-by-side with a phonetic-syllabic script (*kana*), and one might ask the same question about them. The answer is that in these sophisticated, literate cultures, logographs have a prestige value that guarantees their survival and use even when practical considerations would suggest their abolition.

It has long been argued by would-be reformers and even by anthropologists that writing systems which are partially or even highly logographic rather than phonetic impede literacy, but this reasoning is fallacious: Japan, which has one of the most refractory scripts ever developed, enjoys one of the world's highest rates of literacy (99 per cent of the population over fifteen can read), while Yemen, with its purely phonetic Arabic writing, has one of the lowest (38 per cent). All claims to the contrary notwithstanding, whether or not children learn to read and write is correlated with factors *other* than the culture's particular type of writing system.

THE LANGUAGE OF THE ANCIENT MAYA SCRIPT

Which of the thirty-one languages of the Mayan linguistic family are represented in hieroglyphic writing? What is the language of the stone monuments of Tikal, Palenque, or Copán? If a Maya priest on the eve of the Conquest were to read out loud from pages of the Dresden Codex, what language would you hear?

It seems unlikely that any of the highland Maya languages, such as Quiché, Cakchiquel, or Tojolabal, were involved: what few inscribed monuments have been found in the highlands all belong to the Pre-Classic period, and some may not even have been written in Maya. If the highlanders did write, they did so in perishable books that have not survived the vicissitudes of time. It seems that the only Classic hieroglyphic texts from the highlands appear on polychrome ceramics of the Late Classic period; some of these are from tombs at Nebaj, an Ixil Maya settlement in the hills of west-central Guatemala, but their texts do not seem to be in Ixil (which belongs to the Mamean branch of Mayan) but in a Cholan language (of which more anon). Pottery texts are also known for the Chamá region of the Guatemala highlands, in a region populated by the Kekchi Maya, but they are few in number and extremely terse, suggesting that literacy was highly restricted here in Classic times.

Many years ago, Eric Thompson suggested that the language spoken by the creators of the Classic monuments of the southern lowlands was an ancestral form of Cholan, an opinion that was adopted (and is still held) by most epigraphers.[8] Thompson had taken note of the fact that Chol Maya is yet spoken in the area around the great site of Palenque, in the western Maya lowlands, and Chortí Maya near the ancient city of Copán, in the southeast. Since both languages are modern descendants of proto-Cholan, it seems reasonable to assume that Cholan tongues were once spoken across the whole of the southern lowlands, but had died out in the Petén with the Classic Maya downfall. It is equally evident that the inscriptions of the northern low lands—especially at Chichén Itzá, Uxmal, and Xcalumkin —must be in Yucatec Maya, since no other language has ever been recorded for that part of the Maya realm. (For the latest thoughts see the Preface, p. 6.)

It is therefore not surprising that the participants in the first Palenque Mesa Redonda ("Round Table"), held in 1973, prematurely talked themselves into assigning modern Chol rather than Yucatec equivalents to the hieroglyphic names of the Palenque kings. The name of one of these rulers—the son of the mighty Pakal, the seventh-century king who was interred inside the Temple of the Inscriptions—is a logograph which conflates the head of a snake (*chan*, in Chol) with that of a jaguar (Chol *bahlum*). In much of the literature on Palenque iconography and epigraphy, you will see this king referred to as "Chan Bahlum." But some years after this meeting, a monument came to light on which his name is written quasi-phonetically [*Fig. 24*]: it is clearly *Kan Balam*, the Yucatec version of "Snake Jaguar."[9] The linguistic situation for the Classic Maya is thus somewhat more complex than had been assumed: while the elite in the more southerly of the lowland cities may have spoken and written Cholan alone, there seemingly was an intermediate buffer zone in which the ruling lineages were bilingual in both Cholan and the more northerly Yucatec (as the medieval kings of England had been bilingual in French and English).

And what about the four codices? The Grolier Codex is restricted to calendrical glyphs only, and the Paris Codex is too fragmentary to give out much information about its language, so both of these are out of the picture. It used to be thought that the text of the Madrid Codex was entirely in Yucatec. However, the Spanish epigrapher Alfonso Lacadena has recently shown that some, but not all, of it is Cholan; he is uncertain whether the scribe was a Yucatec-

24 Name glyph of a major ruler of Palenque. The phonetic complement (ka) at left indicates that it had the Yucatec pronunciation "Kan Balam" rather than the Cholan one of "Chan Bahlum," as scholars had previously believed. The logograph combines the head of a snake (kan) with that of a jaguar (balam).

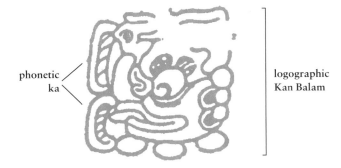

phonetic
ka

logographic
Kan Balam

speaker transcribing a Cholan original, or the reverse.[10] As for the Dresden, which on internal evidence was compiled from many older sources with the addition of newer material, while some of it is in Yucatec, a number of readings make sense only in Cholan. For these reasons, working epigraphers make sure that they have at hand both Yucatec and Cholan dictionaries, for they need both in the process of decipherment.

WHAT THE INSCRIPTIONS SAY

A pivotal 1960 paper on the stelae of Piedras Negras by the Russian-American scholar Tatiana Proskouriakoff[11] made it clear that the inscribed stone monuments of the Classic Maya deal almost exclusively with historical events—at least, with events that the Maya themselves considered to be historical, including the mythological creation of the universe thousands of years in the past. Usually present in a more-or-less standard inscription are one or more events considered significant in a ruler's life and reign [*Fig. 25*]: birth, accession to power, marriage, the birth of offspring, the presentation of an heir-apparent, warfare, the taking of distinguished captives (and their sacrifice), as well as the celebration of calendrically ordained rituals and anniversary rites connected with previous events (often associated with the ceremonial shedding of one's own blood). Now that most of these texts can be read, the Classic Maya rulers seem far more similar to their Old World counterparts, such as the Egyptian pharaohs and the kings of Assyria, than they did before the "Great Decipherment" of the last few decades.

Monuments of a later king might well hark back to the death of the previous one. Consider the twenty-four glyphs of Yaxchilán's Stela 12 [*Fig. 26*]: the text begins with the Calendar Round date of 6 Ix (the day of the 260-day cycle) 12 Yaxk'in (the day of the 365-day cycle), which the educated elite of the city would have known corresponded to the Long Count date 9.15.10.17.14—19 June 742 in our Gregorian Calendar. The verb should immediately follow, and so it does: "he died." Being intransitive, it is in turn followed by the subject, in this case the great ruler and warrior *Itsam Balam* (nicknamed "Shield Jaguar" by

Proskouriakoff).[12] Then the text moves on to state that 3,606 days hence, on 11 Ahaw 8 Sek (9.16.1.0.0 or 3 May 752) it came to pass that his son *Yaxum Balam* ("Bird Jaguar" to Mayanists), the captor of an enemy named *Ah Kawak*, was "seated" (i.e. enthroned) as "holy king" of Yaxchilán and as *Bakab* (a title implying rulership over one of the world-directions). This is a more-or-less standard monumental text; others are shorter, and some are much longer—like the Tablet of the Cross at Palenque—but all are fairly terse, eschewing adjectives and adverbs, and pretty much sticking to third-person statements.

Thus, the cities of the southern lowlands celebrated the doings of kings, the reigning families, and the royal courts, at least until environmental, social, and political disaster began overtaking them during the course of the ninth century. But at the time that the city-states of the south were falling into decline and abandonment, something very different was taking place in the northern half of the Yucatán peninsula. Instead of progressive disintegration, Maya culture prospered in this region during this "Epi-Classic" period—at Xcalumkin in the northwest, in the hilly region known as the Puuc (particularly at the beautiful city of Uxmal), and at the enormous and cosmopolitan city of Chichén Itzá in the exact center of the peninsula. Whatever the reason for this Terminal Classic flowering, it was based on a sociopolitical system which would have been completely alien and possibly repellent to the city-states of the south.

According to the inscribed stone lintels [*Fig. 27*] and panels of the northern centers, no one dynast held the reins

25 *Dynastic event glyphs identified by Proskouriakoff: (left) birth; (right) accession to the throne.*

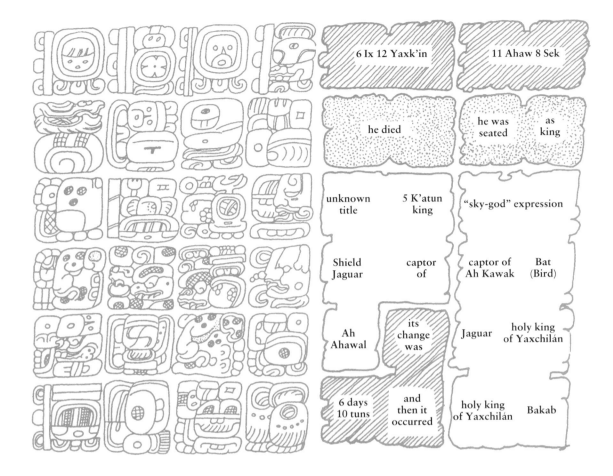

6 Ix 12 Yaxk'in	11 Ahaw 8 Sek
he died	he was seated / as king
unknown title / 5 K'atun king	"sky-god" expression
Shield Jaguar / captor of	captor of Ah Kawak / Bat (Bird)
Ah Ahawal / its change was	Jaguar / holy king of Yaxchilán
6 days 10 tuns / and then it occurred	holy king of Yaxchilán / Bakab

26 Dynastic inscription on Stela 12, Yaxchilán, shown with a diagrammatic "translation." The text records the death of Shield Jaguar on 19 June 742, and the accession of his son Bird Jaguar almost ten years later.

27 Lintel 4, Temple of the Four Lintels, Chichén Itzá, late ninth century. Like other inscriptions from northern Yucatán, there is no accompanying picture, and the crudely carved text relates not to a single king, but to joint rule by several noble kinsmen.

of power in his hands, as at Tikal and Copán; rather, there was joint rule, sometimes by up to four persons at any one time. This kind of councillor rulership was described in Colonial-period documents under the Yucatec term *multepal*, meaning "rule by many," and was mentioned by Bishop Landa in his famous account, when he talked of three brothers reigning in Yucatán in the late pre-Conquest period.[13] The northern inscriptions closely reflect that state of affairs: there are no life histories carved on these stones, and in fact stelae are rare to absent. What the lintel texts talk about are such things as fire ceremonials and other rites; and the dedication of buildings, parts of buildings, and even the lintels themselves. Yet there are plenty of names, spelled phonetically, of important persons in the collective government, and of individual artists and priests, who were surely also members of the elite class. It is indeed curious that these texts cover such extremely short time-spans: the inscriptions of Xcalumkin [*Fig. 88*] seem to fall between AD 728 and 761, while those of Chichén Itzá [*Fig. 27*] can be dated between 842 and 884—only a few decades, a mere moment compared to the six-century span covered by the stelae and lintels of the more southerly cities.[14]

One more peculiarity of the northern inscriptions, when compared with the southern ones, must be mentioned. Even a cursory glance at the monuments of the southern lowlands will show the close connection between text and picture: if these were not carried out by the same hand, at least both scribe and sculptor (or sculptors) worked together to produce the finished result. And the linkage is more than visual: as with the reliefs of ancient Egypt, it is difficult to decide if the text is a commentary on the picture, or the picture on the text. By contrast, in contemporary northern monuments there is very little pictorial content: if there are human representations, the figures are seldom shown doing anything, a result of the basically ahistorical nature of the texts.

WARFARE, CAPTIVES, AND HUMAN SACRIFICE

Most of the great Mayanists of fifty or a hundred years ago—men like Eduard Seler, Sylvanus Morley, and Eric Thompson—firmly believed that the Classic Maya were a relatively peaceful people, living an Arcadian life under the guidance of their allegedly benevolent priests. Today, thanks to the decipherment of the Classic texts, a totally different situation appears: warfare was endemic to the city-states of the Maya lowlands, and increased in pace as the Classic neared its end. Some scholars are of the opinion that it may even have hastened that end.

Many monumental texts and accompanying scenes (and even a few on pictorial ceramics) describe successful military actions and their gruesome aftermaths [e.g. *Pls. 9, 10, Figs. 10–12*]. While there is continued debate over the ultimate aim of these bellicose dynasts in initiating hostilities against rival polities—territorial aggrandizement and gaining control over trade routes or important economic resources have been suggested—the public texts and pictures concentrate on the taking of important captives for humiliation and eventual sacrifice, a combination meant to invoke awe and pride among the ruler's followers, and terror in the hearts of his enemies. The horrific Stela 2 at Aguateca, a small city lying atop an escarpment in the southwestern Petén, is a good example of the genre [*Fig. 28*].[15] The spear-carrying king, named

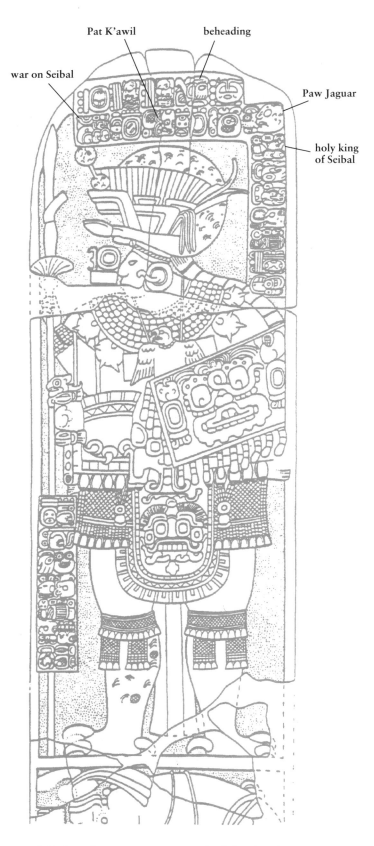

28 *Stela 2, Aguateca, a war record celebrating the conquest of Seibal by the Dos Pilas polity on 29 November 735, and the subsequent beheading of Seibal's king, Paw Jaguar. The stela was dedicated during a period-ending rite described in the vertical text to the left of the victorious Pat K'awil's leg.*

as Pat K'awil, is arrayed with headdress and loincloth bearing the war symbols of the militaristic empire of Teotihuacan, in central Mexico, and he wears jaguar-paw boots. Above him, the text begins with a Calendar Round corresponding to a day in the year 735, immediately followed by the verb, a concatenation which we know means warfare. The object of the war is next, which is the Emblem Glyph of the far greater city of Seibal, on the Río Pasión [cf. *Fig. 30, I*]. Next, we are told to count forward one day, when there is a beheading of an individual named "Paw Jaguar," identified as the *k'ul ahaw* or "holy king" of Seibal. Crouching below Pat K'awil is the bound figure of the unfortunate Paw Jaguar himself.

Pat K'awil's capital city was not Aguateca, but Dos Pilas, and it was at Dos Pilas that he chose to have erected another monument celebrating the same great event [*Pl. 9*]; but there the sculptor/calligrapher wrote out the date of the war in a more complete, "official" form, as an Initial Series with Long Count and all of the appropriate lunar data.

Recent research suggests that the Maya glyph for warfare—the logograph for Venus over another sign—was no accident, for apparently the timing for major military campaigns was set astrologically by the movements of that planet, a heavenly body in which the Maya had deep interest (five remarkable pages of the Dresden Codex are devoted to tables detailing its 584-day cycle as seen by an earth-bound observer [*Pl. 73, Fig. 139*]).

NAME-TAGGING

For a people so deeply concerned with the heavens, cycles of time, and other philosophic and even esoteric matters, the Classic Maya had a remarkably down-to-earth way of dealing with the material world: almost everything that was of any moment to them—be it an everyday object, a building, a stela, a mountain, or whatever—was given a name, and that name had a hieroglyphic counterpart. Apparently the very act of naming things gave the Maya a degree of control over their universe. Name-tagging [*Fig. 29*] was discovered in 1979 by the young Australian epigrapher Peter Mathews, who deciphered a short text engraved on an obsidian ear flare from a royal tomb at Altún Ha, in Belize;

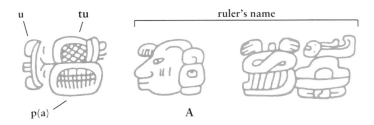

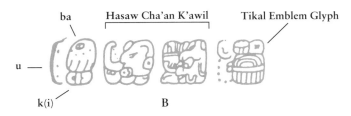

29 Name-tagging: (A) u tup, *"his ear flare"; (B)* u bak, *"his bone."*

this opened with the phrase *u tup*, "his ear flare," written phonetically, followed by the name of the royal owner.[16] Later on, Stephen Houston and Karl Taube found that some of the remarkable incised bones [cf. Figs. 103, 104] from the great tomb of Hasaw Cha'an K'awil beneath Temple I at Tikal began with the expression *u bak*, "his bone."[17] They then went on to show that in one position in the formulaic ceramic text known as the Primary Standard Sequence or PSS (see below), there were three possible substitutions. One of these is read as *u lak* ("his/her plate"), and only occurs on shallow dishes; another is now read as *u hawte'* ("his/her tripod dish"); the third, *yuch'ab* ("his/her vessel for drinking"), is reserved for cylindrical vases.

Recent research has shown that it was not only small, portable objects that received name tags, but also stelae ("great stones") and lintels; important rooms and buildings, as well as plazas and ballcourts, could be and often were individually named. Toponyms, that is, place-names, form a special and extremely interesting sub-class of name-tagging.[18] Ever since the discovery of Emblem Glyphs by Heinrich Berlin in the 1950s, it had been surmised that they represented either the name of the lineage that dominated a particular city-state, or the name of the city-state itself. Stephen Houston and David Stuart have conclusively shown that the main sign of the Emblem Glyph really does represent a place name, with the addition of affixes (glyphic

30 *Emblem Glyphs: (A, B) Palenque; (C, D) Yaxchilán;*
(E) Copán; (F) Naranjo; (G) Machaquilá; (H) Piedras
Negras; (I) Seibal; (J) Tikal.

elements) at left and top describing the ruler as "holy king"
(*k'ul ahaw*), so that it means "holy king of such-and-such
a polity" [*Fig. 30*]: the rulers of the Classic city-states were
divine. There are many other toponyms without such
affixes, and in many cases these seem to refer to significant
places within or near the city. Finally, some toponyms are
clearly supernatural, such as a mysterious "Black Hole"
place which is probably a cave considered by the Maya as
an entrance to Xibalbá, the Underworld.

THE PRIMARY STANDARD SEQUENCE (PSS)

Texts painted or carved on Classic Maya pictorial ceramics
form by far the largest part of the total corpus of Maya
writing. Surprisingly, many pottery texts are longer than
most Maya inscriptions on stone monuments (on one
painted vase [*Pls. 114, 115*], there are no less than 84
glyphs!), and in general cover a far wider range of subject
matter. They may be divided into two categories: (1)
primary, occupying a horizontal band encircling the vessel
exterior just below the rim, or else placed prominently in
a vertical column; and (2) secondary, shorter texts usually
appearing next to the figures in a scene (these are sometimes
connected to the mouths of the principals by a curlicue line,
and must represent spoken phrases—rather like the speech

"balloons" in comic strips [e.g. *Fig. 70*]). For the most part,
the secondary texts describe the actors, or comment on their
actions, while the primary ones have little or nothing to do
with what is in the pictures (as in everything concerning
the Classic Maya, there are always exceptions to the rule).

The Primary Standard Sequence or PSS is a string of
about 35 glyphic signs—in effect a formula—laid out in an
invariable sequence [*Figs. 31, 32*].[19] No one ceramic text
contains them all: there may be as few as 3 or 4 PSS glyphs
on a vessel, or as many as 22, but they are always in the
same order. When the present writer discovered them in
1972, he had thought them to be a ritual formula, perhaps
a chant, recited to accompany the deceased owner of the
vessel into Xibalbá, the Underworld. Since that time,
however, epigraphers have concluded that the PSS is one
more case of name-tagging, in this case for the vessel itself,
with the owner or patron being named, along with his or
her titles, at the end of the PSS string. Considerable progress
has been made in deciphering individual signs within the
PSS [see *Pls. 54–63*], but, possibly because the sequence itself
is so ancient (there are Late Pre-Classic examples on stone
objects), some of it continues to present problems.

The string begins with the Initial Sign [*Pls. 54–56*],
followed either by the head of the aged god Pawahtún [*Fig.
105*], or by a steplike glyph; this part of the text—not yet
read with confidence—is believed to represent the
dedication of the vessel, and can even be used in texts on
stone to dedicate buildings. Then there are one or more
glyphs which indicate whether the surface is painted or
carved, and the shape of the vessel. If it is a cylindrical vase,
the glyphs for the phrase *yu kabe*, "his/her drinking vessel,"
will appear, followed by the syllabically spelled word
kakaw(a), "cacao" [*Pls. 57, 58*], for such vases were used
for the chocolate drink, both in this life and in the next. It
is doubtful that anyone actually drank out of them, since
smaller and more handy calabash cups were probably used
for such a purpose. Rather, these cylinders held a supply of
the liquid, which was poured from a height from one vase
into another, to produce a highly valued frothy "head." If
the clay vessel is bowl-shaped, the "cacao" glyph will be
absent, but might be replaced by the glyph for *ul*, the sacred
white maize gruel of the Maya.

A B C D E F G H I J K L

What is of most interest here is that the name of the artist/calligrapher will sometimes appear in the PSS, generally after the shape and contents are given, after a glyph reading *u ts'ib* ("his writing or painting"), or one indicating sculpture or incising; but some artists' names can be found in the secondary texts as well [*Fig. 57*].[20] The full significance of this important epigraphic discovery will be explored in detail in the next chapter, for it has cast new light on the role that artists and scribes—who may have been the same individuals—played in the complex social world of the Classic Maya.

31 The Primary Standard Sequence or PSS, on a rollout from a bowl (see Pl. 102): (A) Initial Sign (dedication); (B) unknown; (C) u ts'ib, "his writing"; (D, E) "[on] the surface of a drinking vessel"; (F) ti ul, "for maize gruel"; (G–L) titles and name of the vessel's patron or owner.

32 Parallel Primary Standard Sequence texts on two Nakbé-style vessels; the formulaic nature of the PSS allows the comparison of different styles and hands.

SUPERNATURALS AND THE SPIRIT WORLD

The PSS may have been brought down to the more mundane level of name-tagging, but it cannot be denied that many of the scenes on Classic Maya ceramics deal with the supernatural; and ubiquitous death imagery (bones, skulls, Death Gods, and so on [e.g. *Pl. 110*]) suggests a close connection with the Underworld and funerary rites. This is hardly a surprise, since it is likely that almost all of the known pictorial vases in public and private collections were found in tombs or graves.

On some vases, three or more very weird-looking supernaturals—many of them chimeras, combinations of animals with human attributes—are shown in a kind of "Dance of Death," often with secondary texts next to them [*Figs. 33, 126*]. Like the PSS, these texts also are somewhat formulaic, and have been in large part deciphered. They begin with the name of the creature (this is a form of name-tagging, too); the names are quite descriptive of the monsters depicted beside them, such as "scaffold jaguar,"

Initial Sign	ts'ib ("writing")		yu kabe ("his/her drinking vessel")	kakaw(a) ("cacao")

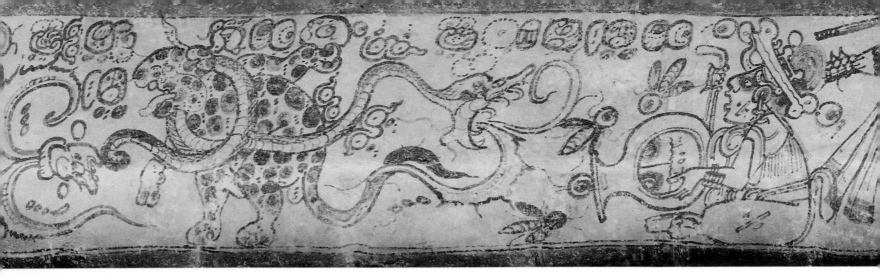

33 Way *spirits on a Codex-style vase; the short texts give their names. On the left is a jaguar with attached star glyphs, in the coils of a boa constrictor. On the right is Mok Chi ("knot mouth"), a Death God associated with self-decapitation and with* balché, *the Maya mead.*

"cloud jaguar," "tapir jaguar," "fire bat," and so forth. Next is a glyph which three young epigraphers (Nikolai Grube, Stephen Houston, and David Stuart) have deciphered independently as *u way* ("his/her *way*"), a reading which clarifies just what the strange beings depicted really are: among both the ancient Maya and their modern descendants in the highlands, the *way* is an alter ego, a kind of personal soul represented by a supernatural counterpart in the form of an animal [*Pl. 52, Figs. 33, 126*]. The texts specify that each *way* is possessed by an individual, a personage described by an accompanying Emblem Glyph as the "holy king" of such-and-such a city-state.[21]

Thus the study of ceramics and their texts leads into realms of ancient Maya thought that the far more restricted world of the "official," public inscriptions seldom touches upon.

A COMMENTARY BY JUSTIN KERR

In actuality, were these pottery cylinders nothing more than "food service" or "drinking cups," as most epigraphers seem to believe? I suggest, on the contrary, that these painted and carved vessels were primarily sacred objects, and that the images on them were messages about beliefs and rituals that were understood by the literate elite, and meant for their gods. If these were mere drinking vessels, then what would have been the purpose of repairing broken vases in ancient times? The repair method used—"crack lacing"—leaves pairs of drilled holes, and the vases would have leaked if filled with liquid. There is ample evidence that vases with the *yu kabe* ("his/her drinking vessel")

legend were often accidentally broken on their way to being buried; it was necessary to repair them so that they could serve their intended purpose, which was to occupy a place in the tomb. If, for example, a vase was sent by a ruler to a subsidiary or a neighbor at the time of his or her death, it had to fulfill its intended funerary function. I would submit, therefore, that the PSS is not just a case of name-tagging, but that it really *was* a hymn said over the vase, and that the mere writing of the text made the vessel something more than a container.

Although the Initial Sign of the PSS has been shown to appear on monuments, it seems to me that the operative text is that of dedication. The PSS text dedicates the vase to the gods; if there is a name on the vase, it is *that* person who is doing the dedication. The well-known Buenavista Vase is a case in point.[22] This was painted by a scribe/artist possibly from Ucanal or attached to that city, who used a different color scheme from his customary work, and who turned the subject—the Young Maize God dancing—to the right rather than to the usual left. It is entirely possible, then, that the painter of the vessel was commissioned to prepare a specific gift to Buenavista (probably a satellite town belonging to the Naranjo polity), and therefore painted it in a distinct palette and stance which would have been more familiar to the Buenavista people. The text itself is a PSS dedicating the vase by the Naranjo king "Scroll Squirrel," who was probably sending it as a gift to be interred with the young man found in the burial.

I conclude that the chocolate mentioned on these vases was not a food for mortals, but food for the gods. Some years ago at the site of El Baúl, on the Pacific plain of Guatemala, I witnessed a Maya burning copal incense before the giant head of an aged deity; in the god's mouth, and in the mouth of a figure on a nearby stela, were small bars of chocolate. The belief that chocolate is food for the gods, so apparent in the PSS, is alive and well among the Maya of today!

BIRTH OF THE MAYA SCRIPT

MESOAMERICAN WRITING: AN OLMEC INVENTION?

While the Maya were the only pre-Conquest people in the New World with a writing system sophisticated enough to express anything that was in their language, modern scholarship has concluded that they were not the first to have writing. That honor is sometimes awarded the Olmec civilization of the Mexican Gulf Coast, which, according to radiocarbon dates, flourished between 1200 and 400 BC.[23] Yet the evidence for Olmec writing of any sort is scanty and uncertain, indeed. At the great and demonstrably early site of San Lorenzo, for instance, not one hieroglyph—not even a bar-and-dot number—appears on the dozens of stone monuments. These monuments (which include colossal heads and gigantic thrones) probably all were carved within the 1200–900 BC time range of the Early Pre-Classic period; but the even larger site of La Venta had an occupation which continued until the demise of Olmec culture toward the end of the fifth century BC. Again, there is an almost total dearth of anything at La Venta that could be considered writing, with one notable exception: a large basalt column (the so-called "Ambassador Monument") is carved on one end with a relief of a striding, bearded man, while next to him are three glyph-like signs, one of them a bird's head, which may stand for his name. Needless to say, they are unreadable.

This is not to say that the Olmec lacked a system of visual communication. A kind of *pars pro toto* (part-for-the-whole) "writing" which appears on carved Olmec pottery and incised celts of jade and serpentine uses a richly iconographic language based on religious symbols and even parts of gods to express or symbolize the major deities of a highly complex pantheon [Pls. 18, 19].[24]

The linguist Geoffrey Sampson has made a distinction between *semasiographic* and *glottographic* writing.[25] In the former, which many linguists and epigraphers, including John DeFrancis,[26] are not even willing to call "writing," symbols or signs, while communicating meaning, do not convey the sounds of a particular language (the International Road Sign system is an often-cited example of semasiography). In contrast, glottographic scripts are linked phonetically to specific languages. By this classification, the Olmec system is pure semasiography. Nonetheless, while Olmec symbols had no phonetic content whatsoever, and thus failed to achieve the status of writing in the strict sense of the word, certain of them—such as the crossed-bands motif—could have been ancestral to some of the signs of Late Pre-Classic scripts, following the demise of Olmec culture (in much the same way that early Egyptian hieroglyphs are presaged by signs and symbols painted on Pre-Dynastic ceramics). It is this kind of "writing" (or system of visual communication) that might have been used in whatever kind of books that the Olmec may have had. Did they have such books? An intriguing piece of evidence suggests such a possibility: incised on the sides of a white-ware ceramic bowl in the collection of the Snite Museum at Notre Dame University are the representations of two objects which appear to be side views of codices, each bound with a ribbon or cord.[27] Although this vessel has no archaeological context, it is identical in style to Olmec pottery made at the site of Tlapacoya, in the Valley of Mexico, during the Early Pre-Classic, and is thus contemporary with the apogee of San Lorenzo. If so, then the screenfold codex made from *amate* bark coated with gesso (see Chapter 5) may already have been present in Mesoamerican culture as early as 1200 BC.

MESOAMERICAN WRITING: A ZAPOTEC INVENTION?

How and why Olmec culture fell into ruin at the end of the Middle Pre-Classic is a problem that may never be solved, for there are no readable Olmec texts to throw light on that event or events. For over eight centuries, this culture had been remarkably uniform across much of what we call "Mesoamerica," with a unified religion as expressed in a wide variety of art objects ranging from enormous stone monuments down to tiny incised jades of jewel-like quality. Only the Maya lowlands, which were very lightly populated in the Early Pre-Classic, seem to have been outside the realm of Olmec presence or influence.

However, with the onset of the Late Pre-Classic period after about 400 BC, the Olmec *oikoumene* was replaced by a series of powerful nascent states with resurgent ethnic identities (in much the same way that the downfall of the Soviet bloc has led to the rise of ethnically based nations in Eastern Europe). One of the most distinctive of these new polities was centered on Monte Albán in Oaxaca, by then the hilltop capital of the Zapotec nation. Best known among its many monuments are the so-called *danzantes* or dancers, reliefs of captives taken and slain by the kings of Monte Albán, powerfully carved in a style derived from the earlier Olmec, and accompanied by signs or glyphs which probably express their names [*Pl. 16*]. Although the Monte Albán I phase in which most were produced is usually dated to 500 BC, a more likely placement of the phase would be 400-200 BC, during the first half of the Late Pre-Classic. On a few other monuments are longer relief-carved texts which contain Calendar Round dates expressed by year signs, day and month glyphs, and bar-and-dot coefficients. The reading order of the longer texts is vertical, from top to bottom, and there are no paired columns: each column is to be read *in toto* before the next is begun. While most of the *danzantes* and whatever texts they contain can be ascribed to the Monte Albán I phase, the tradition of commemorating conquests on stone slabs continues into the Monte Albán II phase, which belongs to the latter half of the Late Pre-Classic. By this time the texts are much longer, and incised rather than relief-carved; conquests are indicated by placing heads of slain rulers immediately below the names of the towns that had fallen into the hands of the Monte Albán warlords.

The Monte Albán script, which continued in use until the end of the subsequent Classic period, has never been "cracked," and only the calendrical glyphs can now be read (or at least interpreted) with any degree of confidence. The Mexican epigrapher Javier Urcid[28] considers that it was probably not only "glottographic" but also logosyllabic like that of the Maya. I doubt that it ever achieved the completeness of Maya writing, or that the Zapotec scribes were able to, or even tried to, develop the phonetic-syllabic side of their system to the extent that it is seen in Maya texts. It is true that no pre-Conquest Zapotec codices

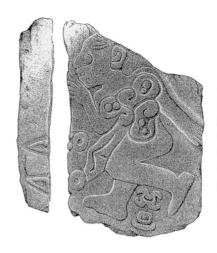

34 *Monument 3, San José Mogote, Oaxaca. The possible calendrical sign between the legs of the* danzante (*really, a slain captive*) *has been claimed to be the earliest writing in Mesoamerica.*

survive at all, and what little of the script appears on monuments may give only a very truncated view of the whole.

In recent years, a candidate for the earliest known writing in Mesoamerica has been put forth: this is Monument 3, a *danzante* stone from San José Mogote in the Valley of Oaxaca [*Fig. 34*]. Found re-used, laid horizontally as a threshold in a building, it shows a rather crude relief of a dead captive with blood streaming from his chest in a stylized trefoil. Between his legs are two signs read by Joyce Marcus and Kent Flannery, the excavators, as the day "1 Earthquake" in the 260-day calendar, possibly the calendric name of the victim.[29] Because the stone was assigned by Marcus and Flannery to the Middle Pre-Classic Rosario Phase (ca. 600-500 BC), the claim has been made by them, and widely endorsed by Mesoamericanists, that Mesoamerican writing began here. But more recently, grave doubts about this early dating have been raised by Robert Cahn and Marcus Winters,[30] who have suggested on both stylistic and stratigraphic grounds that this monument was actually carved during the Monte Albán II period, in the latter part of the Late Pre-Classic—that is, it may be contemporary with, or even later than, several very important examples of Maya and other early non-Zapotec texts, and cannot be in any way ancestral to them.

At present, all one can say is that Zapotec writing seems to be one of a group of early scripts that were developed during the Late Pre-Classic in the aftermath of Olmec civilization, and that it had little or nothing to do with the evolution of Maya writing. In either their Pre-Classic or Classic form, the blocky, somewhat crude texts of the Zapotec bear no resemblance to the highly calligraphic, grid-regulated, painted or carved texts of the Classic Maya; even if the two systems shared common roots, which they almost surely did not, they progressed along increasingly divergent paths.

35 *Stela 2, Chiapa de Corzo, Chiapas, the New World's oldest dated monument. The reconstructed Long Count date on this fragmentary slab corresponds to 8 December 36 BC.*

SOUTHEASTERN MESOAMERICA AND THE ISTHMIAN SCRIPT

The Long Count calendar is generally considered one of the hallmarks of Classic Maya civilization, but outside the Maya area proper there are several inscriptions—including monumental ones—that considerably predate the earliest truly Maya object with a standard Long Count notation (Stela 29 from Tikal [*Fig. 42*], dedicated in AD 292). One may safely conclude, therefore, that this was not a Maya invention. Thus far, the most ancient Long Count date known (corresponding to a day in the year 36 BC) is incised on a broken and re-used monument from Chiapa de Corzo in the state of Chiapas [*Fig. 35*]: the inscription consists of a vertical column of bar-and-dot coefficients (without the cycle glyphs of the later Maya) and the position reached by that date in the 260-day count. If an explanatory text followed, it has disappeared. Five years later the famous Stela C was carved at the old Olmec site of Tres Zapotes in Veracruz, with a similarly cycle-less vertical column of Long Count coefficients. Because these two monuments are unique in themselves, and without good cultural context, they furnish only ambiguous evidence for a very early non-Maya writing tradition in southeastern Mesoamerica during the Late Pre-Classic period.[31]

The situation is different for the newly defined Isthmian (or "Tuxtla" or "La Mojarra") script of southern Veracruz.[32] Since the beginning of this century, scholars have been intrigued by a strange, duck-billed figure of jade in the Smithsonian Institution's National Museum of Natural History in Washington, D.C. Said to come from the Tuxtla Mountains region, the "Tuxtla Statuette" has another vertical Long Count date consisting of coefficients only, corresponding to a day in the year AD 162 [*Fig. 36*]. In fact, this was the first hint that the famous Maya calendar system may have been invented by a non-Maya people. Be that as it may, what is even more significant than the date are eight

vertical lines of text in a script, now called "Isthmian," that has only a vague resemblance to that of the Maya, and which (despite its appearance at a casual glance) totally lacks the paired columns so typical of Maya writing. The only real point of similarity between the glyphs on this object and the Maya writing system is that the "main signs" of the Tuxtla Statuette text have affixes—smaller, horizontally compressed glyphic elements—attached to them.

Like the earlier inscriptions at Chiapa de Corzo and Tres Zapotes, until recent years the script of the Tuxtla Statuette was totally isolated, with no known relatives, rather like the equally undecipherable Phaistos Disk of Crete. The chance discovery in 1986 of a 4-ton basalt stela from a site named La Mojarra, near Acula, Veracruz, changed all that: here was a very long Isthmian text of over four hundred glyphs displayed in twenty-one rigidly ruled, vertical columns [*Fig. 37*].[33] These columns are arranged into two groups, facing inward in mirror fashion towards a majestic, richly attired figure of a ruler; two of the columns, in initial position, contain Long Count dates corresponding respectively to 21 May AD 143 and 13 July AD 156—very close in time to the Tuxtla Statuette. The non-calendrical part of the text must therefore be historical, related to the doings of the personage on the stela.

36 *Incised text on the Tuxtla Statuette, written in the Isthmian script. The Long Count date in the second column corresponds to 14 March 162; the rest of the inscription still cannot be read.*

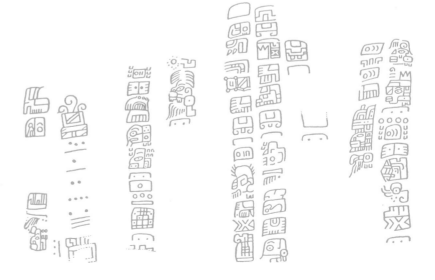

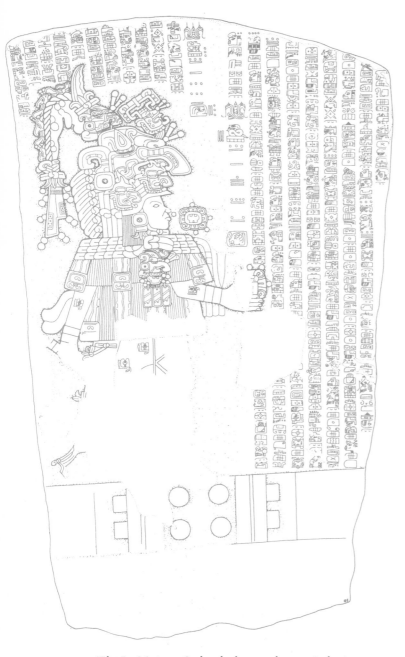

37 The La Mojarra Stela, the longest known Isthmian inscription. The latest of the two Long Count dates in front of the ruler's head corresponds to 13 July 156. The long and finely incised non-calendrical text resists attempts at decipherment.

All that scholars know of the Isthmian script is based on these two objects, along with a rather crudely incised clay mask of unknown provenance, and an incised potsherd from Chiapa de Corzo. Given that the sample is very small, indeed, and that the language represented by the script is itself unknown (an ancestral Mixe-Zoquean has been championed by several scholars on fairly sound grounds),

the Isthmian writing system remains undeciphered and perhaps undecipherable, despite all claims to the contrary. Nevertheless, some general statements can be made about it. According to Sylvia Méluzin,[34] the total Isthmian signary is something more than 150, strongly suggesting that this system is logosyllabic, like Maya and other early scripts in the world. Although some of the signs superficially resemble later Maya ones, and Maya-like affixing was in use, it is clear to Stephen Houston[35] that the two systems are very different indeed. Like Zapotec writing, but unlike Maya, none of the columns are paired, and there is no imaginary grid locking the individual glyphs into horizontal (as opposed to vertical) position. Even the reading order of the columns may be ambidirectional: on the La Mojarra Stela, as on many ancient Egyptian monuments, the signs face in towards the pictorially rendered protagonist of the text. And finally, the few known Isthmian texts are rendered in an incised, angular style reminiscent of the runic writing of northern Europe. Perhaps, like runic, the Isthmian script was first developed on wood rather than stone; in its aesthetic "feel" it is totally non-calligraphic, and certainly not influenced by use of the brush pen so apparent in the Maya style. The art of Maya writing most assuredly did not have Isthmian roots.

ABAJ TAKALIK AND KAMINALJUYÚ

One of the major centers of Mesoamerican culture during the Late Pre-Classic was Izapa, on the Pacific Coast plain in southeastern Chiapas. There, dozens of stone monuments, including stelae, were carved with reliefs in a flamboyant and highly narrative style which has been called Izapan; some of the scenes on the stelae plainly represent episodes relating to the myth of the Hero Twins so vividly described in the great Maya epic known as the *Popol Vuh* (see p. 34). But, strange to say, there is no writing whatsoever on the monuments of Izapa, a situation yet to be explained.

The distinctive Izapan style, however, was widespread among the nascent states of southeastern Mesoamerica: Izapan monuments are found in Guatemala along the Pacific coast and piedmont, and in the highlands at the huge Late Pre-Classic center of Kaminaljuyú (on the outskirts of

Guatemala City). One of these piedmont sites is Abaj Takalik, which boasts two stelae with Long Count dates.[36] On the fragmentary Stela 2, between two standing figures there was once a single-column calendrical notation beginning with an Introductory Glyph (among the Classic Maya, this always precedes the first Long Count in an inscription [*Fig. 21*]), followed by bar-and-dot Long Count coefficients (as in the La Mojarra text); but the Bak'tun 7 coefficient of the Long Count shows that Stela 2 was considerably older than the La Mojarra stela. Stela 5 at Abaj Takalik bears two Long Count dates in Bak'tun 8—corresponding to days in the year AD 126—in two unpaired columns.

Are these Abaj Takalik monuments Maya, as some have thought? This question is impossible to answer at present. In the first place, there is no well-defined corpus of non-calendrical glyphs for Abaj Takalik to compare with the Pre-Classic and Classic Maya corpus. Secondly, there is no evidence for pairing of glyph columns. And thirdly, during the Late Pre-Classic both Abaj Takalik and Izapa—perhaps even much of the Pacific coast of Chiapas and Guatemala—were probably within the large area in which an ancestral form of Mixe-Zoquean, rather than Mayan, was spoken.

Kaminaljuyú reached its florescence during the Late Pre-Classic Miraflores phase, when its powerful and wealthy rulers probably held sway over much of highland Guatemala; they must have been formidable rivals to the overlords of Izapa and of the cities that were beginning to rise in the southern Maya lowlands. It was a center rich in carved monuments, but inscriptions are inexplicably rare. The most significant is a small incised text of forty glyphs which appears on Stela 10, an enormous fragmentary relief of black stone with beautifully carved figures of supernaturals and perhaps also of elite personages [*Fig. 38*].[37] This text, which lacks a Long Count date, is arranged in four columns, but here the columns are paired in Maya style. At present it is undecipherable (except for the bar-and-dot numbers which appear in it). Yet certain glyphs may actually be identical with their Maya counterparts: twice in the text there is a sign which seems to be a *winal* (20-day cycle) glyph, and in one position there is a "Manik-hand" following the number 10 which could be a day "10

38 *Stela 10, a Late Pre-Classic fragmentary monument from Kaminaljuyú. The four-column text at the bottom cannot be read; it might be Maya, but that cannot be proved on the basis of such limited evidence.*

Manik" in the 260-day count. But unless further texts are discovered—an unlikely event since most of the site has already been needlessly destroyed by developers and by the encroachment of Guatemala City—the Stela 10 inscription will remain an enigma. All we can say is that the Kaminaljuyú elite was literate, and possibly literate in some highland Maya tongue.

THE DAWN OF MAYA CALLIGRAPHY

Scholars are generally agreed that the Classic Maya period begins in the lowlands about AD 250, when inscribed and dated stone monuments were first erected, and ends around AD 900, with the great "Maya Collapse" and the very last carved texts with Long Count dates. Yet recent research has shown that Maya writing did *not* begin with the opening of the Early Classic; that there was a remarkably "classic" florescence—even urbanization on a grand scale—in the Late Pre-Classic, particularly in the northern Petén lowlands of Guatemala; and that this florescence had ended in the third century AD with its own "collapse," from which only a few early cities, such as Tikal and Uaxactún, survived. In fact, some Late Pre-Classic cities, like El Mirador and

Nakbé, may have been even larger than most of their Classic counterparts, with towering temple pyramids, often arranged in groups of three atop massive substructures of a size never surpassed in later centuries.[38]

As Nikolai Grube tells us,[39] retrospective histories in Classic Maya texts from the southern lowlands present the Maya's own view of a time (the first three or four centuries of the common era) when most of the royal dynasties were founded. According to these records, Tikal was the oldest, with Yax Moch Xok founding the royal lineage in the first century AD. Yaxchilán's dynasty begins in AD 320, and those of Caracol and Naranjo about 331. At Copán, on the southeastern Maya frontier, the historic founder of the city and the polity in about 426 was Yax K'uk' Mo', piously and proudly invoked by his successors in later centuries; the veracity of the Copán texts has been confirmed by the archaeological discovery not only of his architecture, but of his very tomb.

As Grube has said, "The Maya record of the founding of royal dynasties goes along with the beginning of

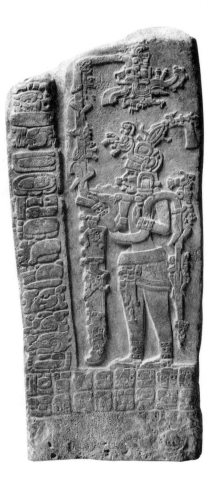

39 The miniature Hauberg Stela, the earliest dated inscription that is surely in the Maya writing system, AD 199. A ruler masked as the Rain God carries a fantastic serpent.

writing....Writing and the beginning of dynastic history are closely connected phenomena in Ancient Egypt and China."[40] The "Late Pre-Classic Collapse" has been mentioned; whatever the form of governance prevailing in the lowlands before it, that mighty event led to the establishment of divine kingship, much as the great "Collapse" at the close of the Late Classic led to the joint rule known as *multepal* during the Terminal Classic period.

The major criterion for the institution of divine kingship among the Maya is the Emblem Glyph (see pp. 59–60), a glyphic compound which can be translated as "holy king of such-and-such a polity"; this almost always immediately follows the personal name of a ruler or his spouse [e.g. *Fig. 29*].[41] While Emblem Glyphs can be found on monuments as early as the beginning of the Early Classic (such as on the famous jade known as the Leiden Plate, AD 320 [*Pls. 22, 23, Fig. 43*]), there is an even earlier example from the Late Pre-Classic: this is the beautifully carved, miniature Hauberg Stela of unknown provenance [*Fig. 39*]. On it, an early king masked as Chak, the Rain God, is draped with the double-headed serpent of Maya rulership, while his sacrificed enemies tumble down towards the Underworld. The single text column has baffled scholars for decades, for while it begins with the Introductory Glyph that should be followed by the usual Long Count date, this has been omitted by the scribe; all that we have is the Calendar Round, the Lord of the Night, and a truncated form of the Lunar Count. Linda Schele[42] has convincingly reconstructed this maverick inscription as a Long Count corresponding to 9 October AD 199, only forty-three years later than the latest date on the La Mojarra stela [*Fig. 37*].

There can be little doubt that this is a Maya text. In the Mayan languages the usual grammatical order for transitive verbal statements is verb-object-subject (VOS); here the date is immediately followed by the verb "he let," then comes the object, "blood," with the subject—the king—closing the statement. This exalted personage is described by an Emblem Glyph as the "holy king" of a polity called "Fire" which has yet to be located by epigraphers.

Thus, dynastic rule—divine kingship—was already present in the southern Maya lowlands by the end of the second century, during the second half of the Late Pre-

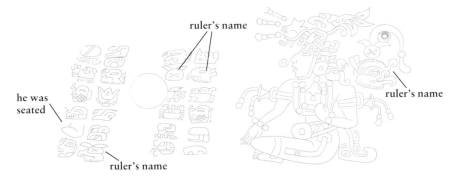

Classic, and so was the extremely sophisticated Maya calendar in all its complexity, a complexity that must have taken several centuries to develop. This would imply that the dawn of incontestably Maya writing was virtually contemporary with the Isthmian and Abaj Takalik scripts, certainly with the Zapotec script of Monte Albán II, and possibly with the final decades of Monte Albán I.

As for Maya monumental calligraphy, the style is fully in place by the time of the Hauberg Stela, and quite distinguishable from the Zapotec and Isthmian writing styles. The glyphs are "calculiform," that is, basically of pebble-like shape, elegantly carved in raised relief, and with details carried out in delicate incising. Of course, these signs appear in very archaic form since they stand at the beginning of a long evolutionary sequence, but they also carry a full symbolic and even mythological load. For instance, the day-sign on the stela is represented by the head of the spotted-cheek Hero Twin known to the Quiché Maya as "Hunahpú" [cf. *Figs. 9, 79*], a day name that corresponds to the lowland "Ahaw" (the last of the thirteen named days within the 260-day count) [cf. *Pl. 45*].

The Hauberg Stela is not alone as an example of very early Maya writing, for there is a handful of much smaller inscribed stone objects in private and public collections which, while not bearing Maya dates, must have been produced within the Late Pre-Classic time span; the texts on all of these are incised, and were probably highlighted by being filled with red pigment. For the history of Maya writing, perhaps the most noteworthy is a pectoral of darkish green quartzite at Dumbarton Oaks [*Pl. 17, Fig. 40*].[43] This had been carved on the obverse with a late Olmec deity face at some time in the Middle Pre-Classic, but found a new use as an heirloom during the Late Pre-Classic, when its flat reverse was incised with the figure of a seated Maya lord and a historical text consisting of twenty-four glyphs arranged Maya-style in four paired columns of six glyphs each. This stone is extremely hard, and while the instrument employed by the scribe had to have been an even harder stylus of jade or some similar material, it must have been virtually impossible to achieve any degree of fluidity.

In content, the text of the Dumbarton Oaks Pectoral is intimately related to the seated personage: his name

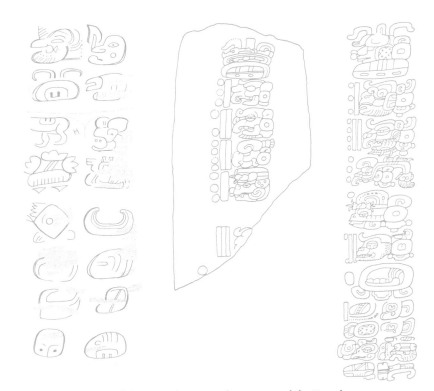

40 TOP *Incised figure and text on the reverse of the Dumbarton Oaks Pectoral (see Pl. 17), Late Pre-Classic. The glyphs in the paired columns contain the name of the seated king, and describe his accession, but no date is given.*

41 ABOVE LEFT *Text incised on the back of a miniature were-jaguar figure, Late Pre-Classic. Some of the glyphs may represent the name and titles of a ruler. The glyph of the bearded head of an old god, top left, resembles that at the top of the third column in the pectoral (Fig. 40).*

42 ABOVE CENTRE *Stela 29, Tikal, thus far the most ancient dated monument from the Maya lowlands proper, with a Long Count date corresponding to 8 July 292.*

43 ABOVE RIGHT *The incision on the Leiden Plate, an Early Classic jade belt pendant, celebrates the accession of a Tikal ruler on 17 September 320 (see Pls. 22, 23). By this time the Maya script was fully developed.*

(a horned owl head surmounted by a crossed-bands sign) can be seen not only beside his left shoulder but twice in the text. Before the first appearance of this nominal is a verbal expression signifying "he was seated," i.e. enthroned, so that the meaning of the inscription and the picture is the accession to power of a very early Maya king. How early? In style and in the type of accoutrements, the royal depiction on the pectoral reverse seems significantly earlier than the Hauberg Stela [*Fig. 39*], and could have been executed (along with the text) as early as 100 BC, or even earlier. The text is remarkably similar in its overall appearance and even in one particular glyph (the bearded head of an old god) to a text of sixteen signs in two paired columns incised on the back of a small black steatite figurine in the Peabody Museum at Yale University [*Fig. 41*]; that object depicts a seated were-jaguar god in the purest Izapan style, and probably was carved not long after 200 BC.[44]

Several jade objects in this very archaic incised style are known [*Pls. 20, 24*]. But the problem with all of these inscriptions (apart from the Hauberg Stela) is that in the absence of calendrical notations there is no direct way to date them. None of them have been found in archaeological contexts with radiocarbon determinations; even if they had been, who could prove that they were not heirlooms from some earlier period? After all, indubitably Olmec portable objects from the Middle Pre-Classic have been found in Late Post-Classic deposits in both central Mexico and the Maya area: in Mesoamerica, the looting and collecting of artifacts has a very long history indeed.

SOME FINAL THOUGHTS ON THE ORIGIN OF MESOAMERICAN SCRIPTS

It now seems that during the Late Pre-Classic period in southern Mexico and the contiguous Maya area, there were several distinctive scripts in use among the nascent states which followed on the decline of Olmec civilization:

- the Zapotec script of Monte Albán
- the Isthmian or La Mojarra script
- the script (still badly known) of Abaj Takalik
- the Kaminaljuyú script (as represented by Stela 10)
- early lowland Maya

I believe that the evidence is still too weak to be sure that any of these was antecedent to the others—and even for Zapotec, because monuments can be re-used and moved around, it is difficult to say that the writing on *danzante* reliefs and associated carvings has temporal priority over, say, the yet-unknown genesis of Maya hieroglyphic writing. It is thus impossible for the time being, at least, to construct a family tree of Mesoamerican scripts.

This is not to deny that there was cross-fertilization between early scripts, for there are a few similarities. The mere fact that bar-and-dot numeration and the Calendar Round were present among all of them, and the Long Count in use by all but the Zapotec and at Kaminaljuyú, would suggest an active interchange between the top-level scribes of the various cultures and polities from earliest times on. And all those writing systems were probably logosyllabic in their structure, the Maya script definitely so.

If the systems described here all arose more-or-less synchronically in the Late Pre-Classic, why did that happen when it did? For a convincing answer, one has to look at the primary function of these scripts: although I feel it would be a mistake to overlook or downplay the religious, perhaps even shamanic, content of these early texts, most are definitely directed towards the legitimization of rulers—by celebrating royal enthronements ("seatings"), by kings boasting of their victories over enemies, by glorifying royal rituals, and the like. As is known from the lowland Maya, the rulers were "divine" kings, and there is no way to separate the religious from the political function. It was the move from what was perhaps the predynastic, chiefly nature of Olmec polities, with their "big men," to the dynastic rulers of the Late Pre-Classic that produced the kinds of "visual language" that we recognize as true writing.

Not all precocious Mesoamerican scripts survived into the Early Classic: Isthmian, for instance, may only have existed for less than a century, and the Abaj Takalik script for a little longer. Only lowland Maya writing survived until the Spanish Conquest. And, as shall be seen, it was only the lowland Maya scribes of the Classic period who achieved a degree of elaboration, sophistication, and beauty in their writing that elevates it to the level of the great calligraphic traditions of the Old World.

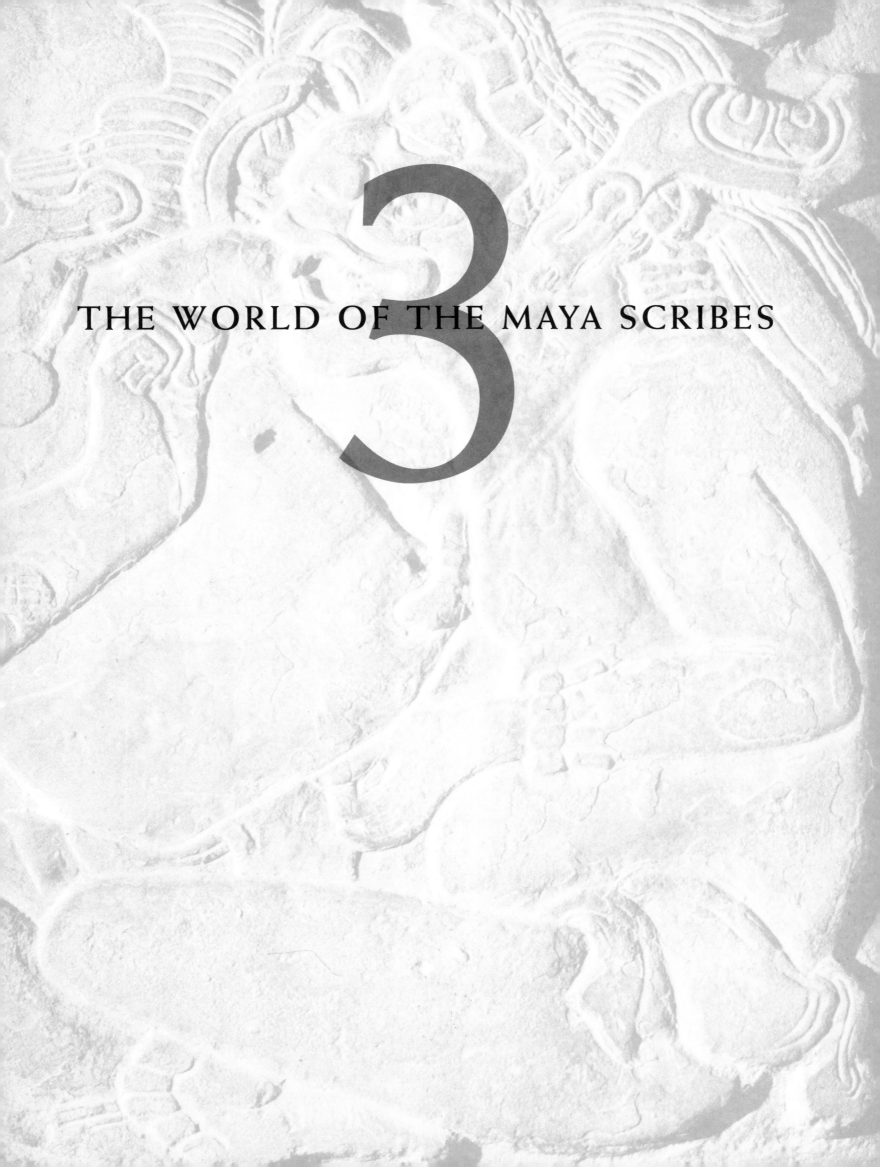

THE WORLD OF THE MAYA SCRIBES

3

26 Maya scribes were not only aristocrats: they could be kings. The ruler on this eighth-century vase wears the "stick bundle"—surely a bundle of pens—in his headdress marking him as an *ah k'u hun*, a "keeper of the holy books." The waterlily thrust at the back of his hair may be symbolic of the brush pen used by Maya calligraphers. Binding his hair is a headcloth touched with Maya Blue, a mixture of indigo and a clay mineral.

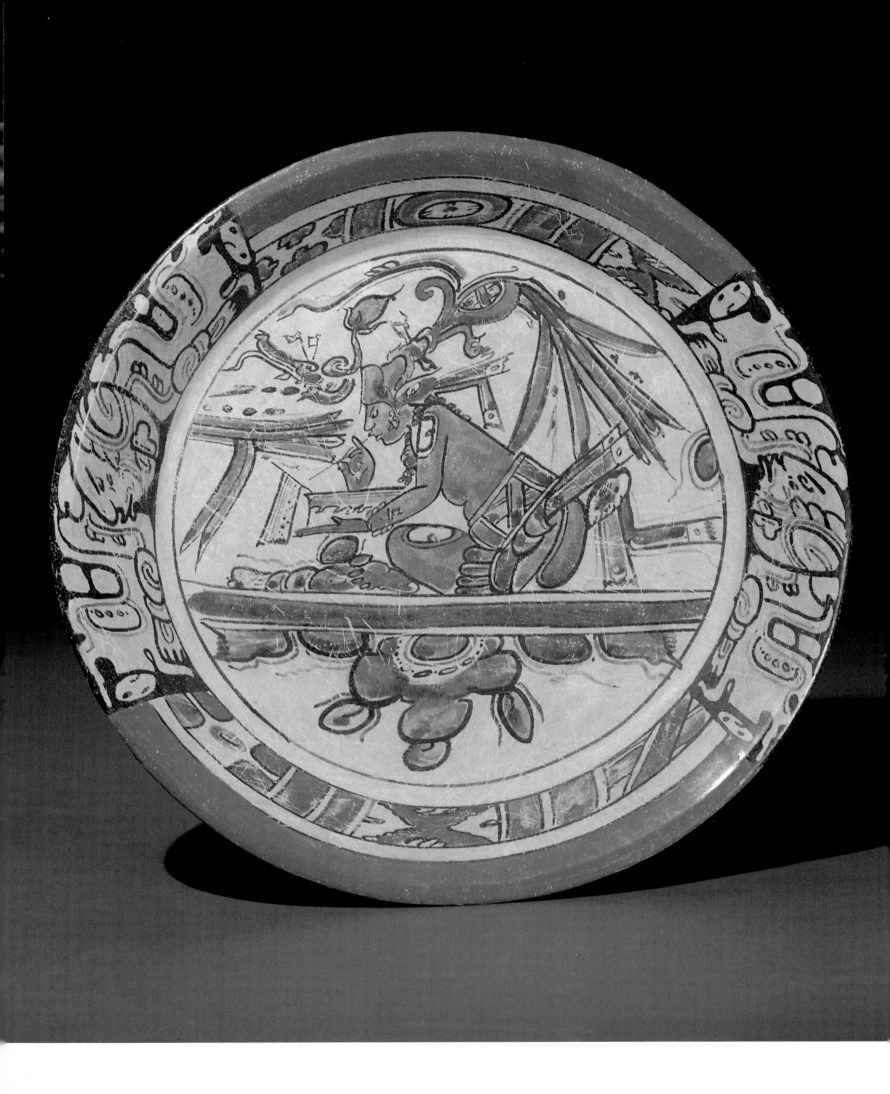

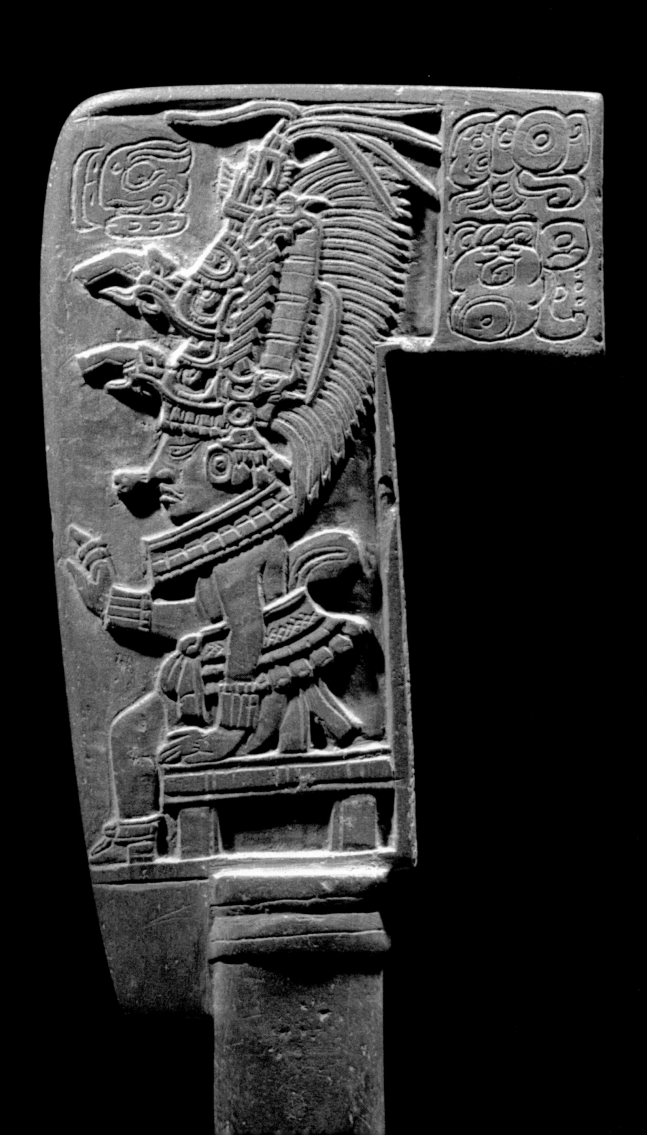

35, 36 A Late Classic slate sceptre from northern Guatemala. The scribal god Hunahpú appears on one side (LEFT) holding his blowgun and apparently smoking a cigar, both activities mentioned in the *Popol Vuh* story of the Hero Twins. The magnificently garbed seated ruler on the other side (OPPOSITE) apparently identified himself with this god and with the east, as described by the beautifully incised text.

34 Another night tableau in a scribal palace, albeit a divine one, appears in this rollout from an eighth-century vase. To the right is the Hero Twin Hunahpú attired as an *ah k'u hun* and ruler. The scene on the left shows the Vulture God, seated on the ground, holding a pen above a conch-shell inkpot and a codex; he wears the "Spangled Turban" headdress. Above him another deity (possibly Xbalanque, Hunahpú's twin) paints a mask.

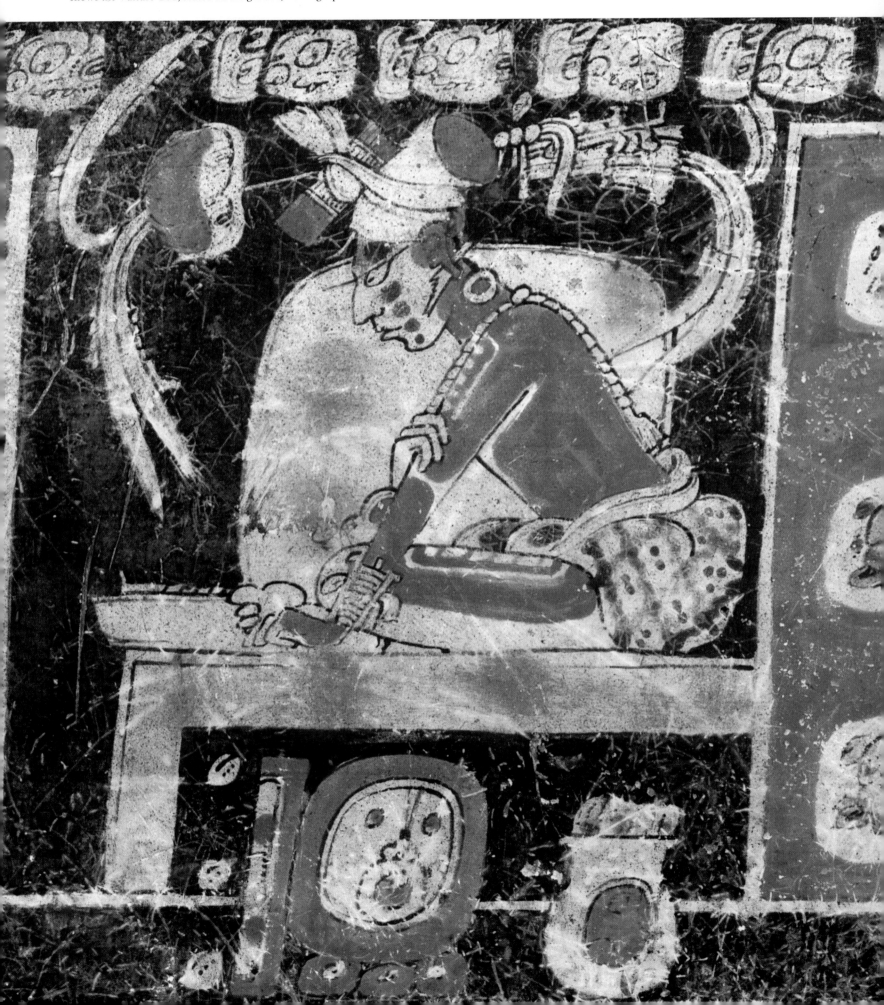

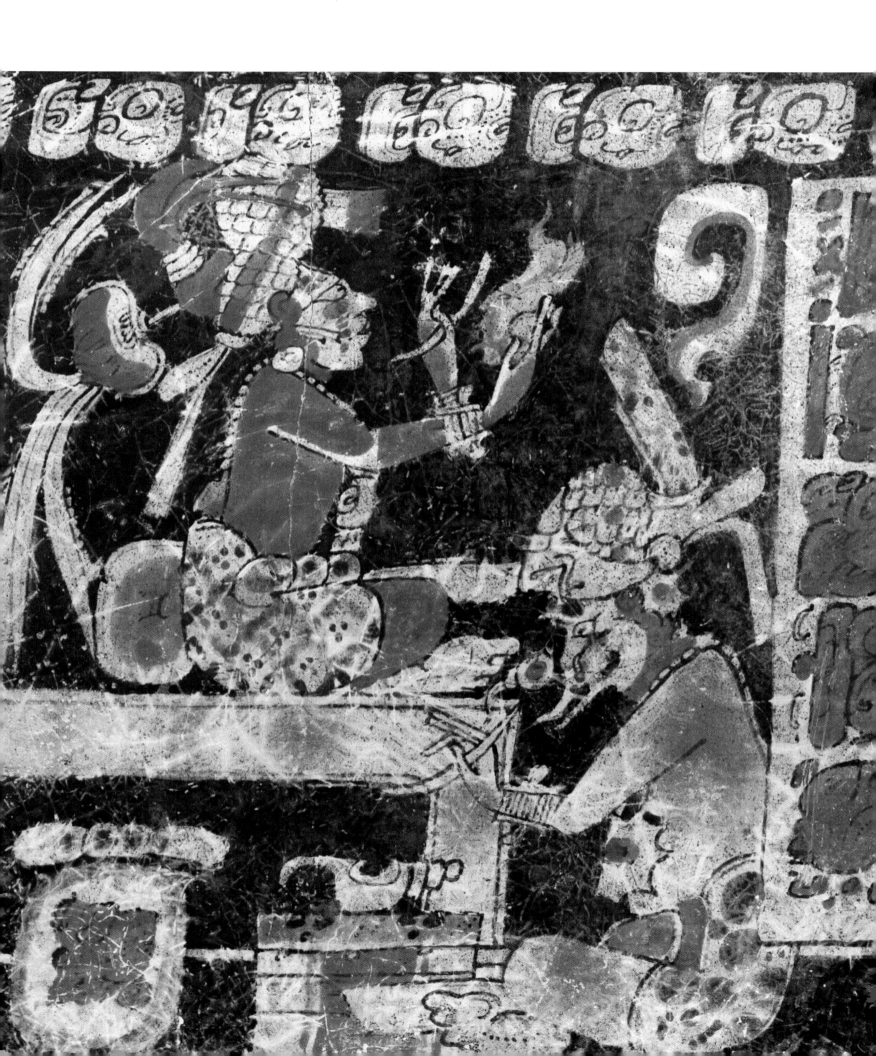

32, 33 Perhaps monkeys became associated with the arts and learning because of their superior intelligence within the animal world; they appear in the *Popol Vuh* as the jealous and scheming half-brothers of the Hero Twins. On a Codex-style vase (ABOVE) a Monkey-man God points out a passage in a screenfold book bound with jaguar skin; he is shown with the distinctive "Spangled Turban" and "Feather Pen" (see p. 105). A polychrome vase (OPPOSITE) shows a dancing Monkey-man God garbed as an *ah k'u hun* (see also Fig. 83).

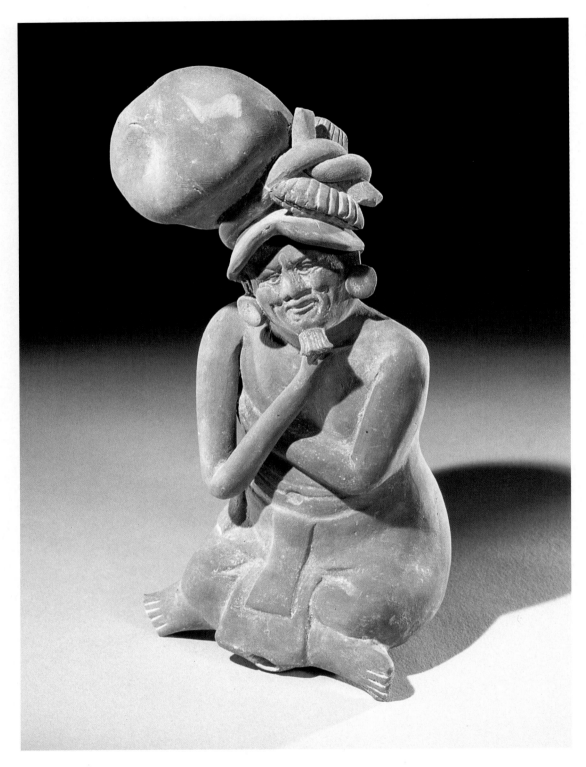

30 OPPOSITE Found in the ruins of a scribal palace in Copán was this unique stone figure of one of the Monkey-man Gods, important patrons of Maya scribes, artists, and musicians. In his right hand he holds a brush pen, and in his left a conch-shell inkpot; he wears the net-like headgear of Pawahtún, another god of writing.

31 ABOVE A Late Classic clay figurine from Jaina, Campeche, depicting an aged *ah k'u hun* scribe; bound by a knot to his balloon-like headdress is the usual pen bundle.

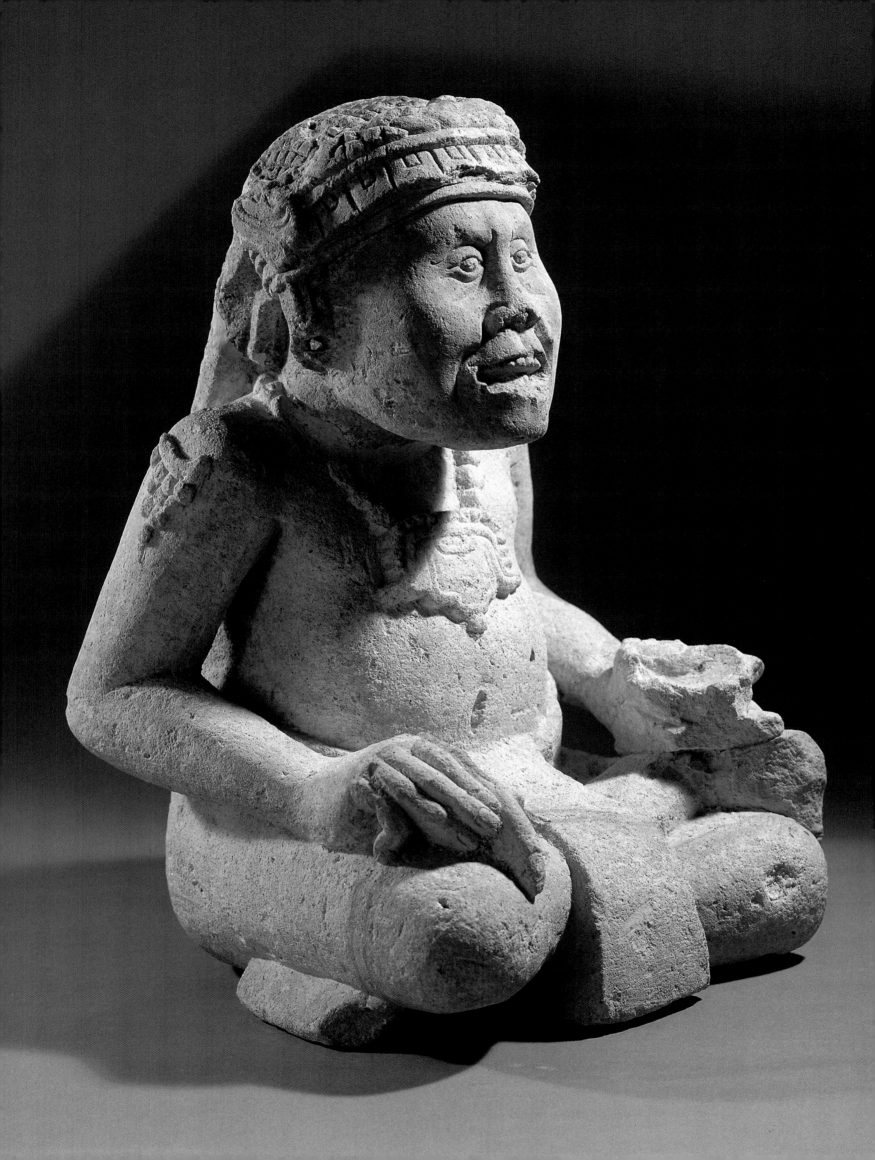

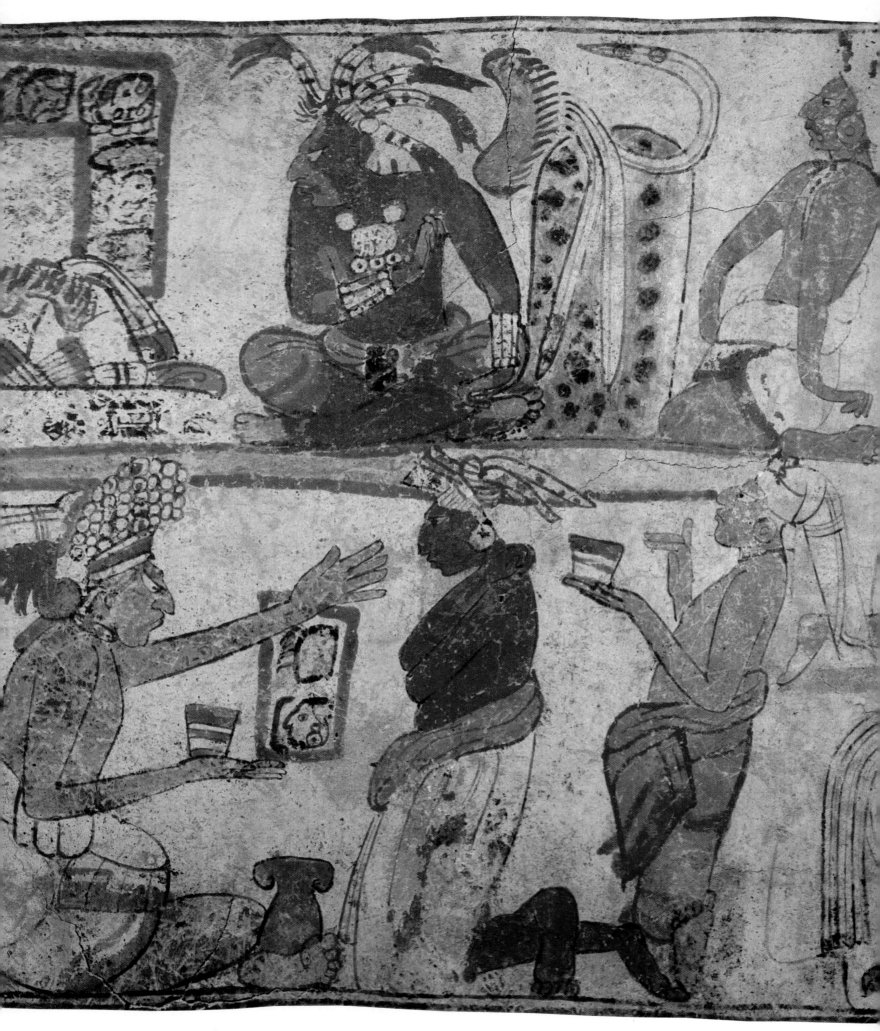

29 A banquet of scribes is the theme of this rollout from a Late Classic vase. Scribes are imbibing intoxicating drink; the one at lower left appears to be inebriated. Before the ruler, seated upper right, is a basket or bowl filled with codices. Such banquets were described by Bishop Landa for late pre-Conquest Yucatán, following "cleansing of the books" ceremonies (see pp. 169–70).

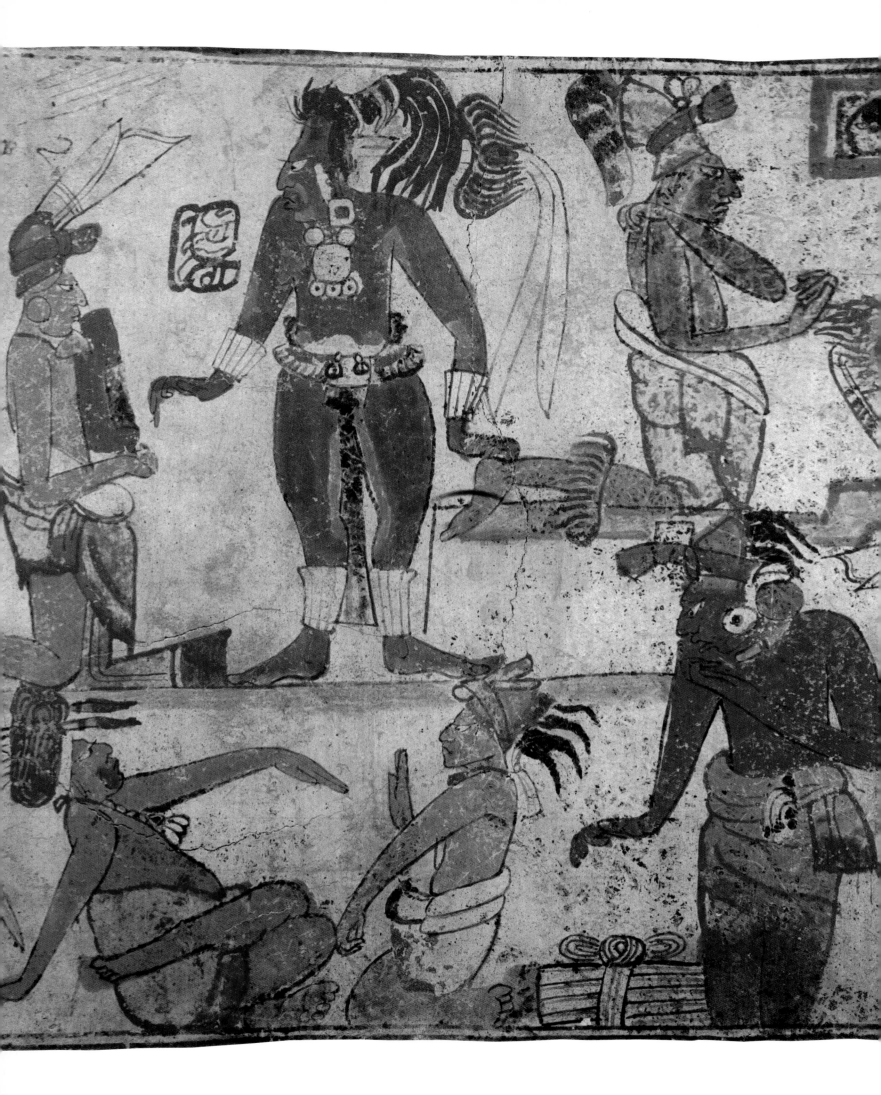

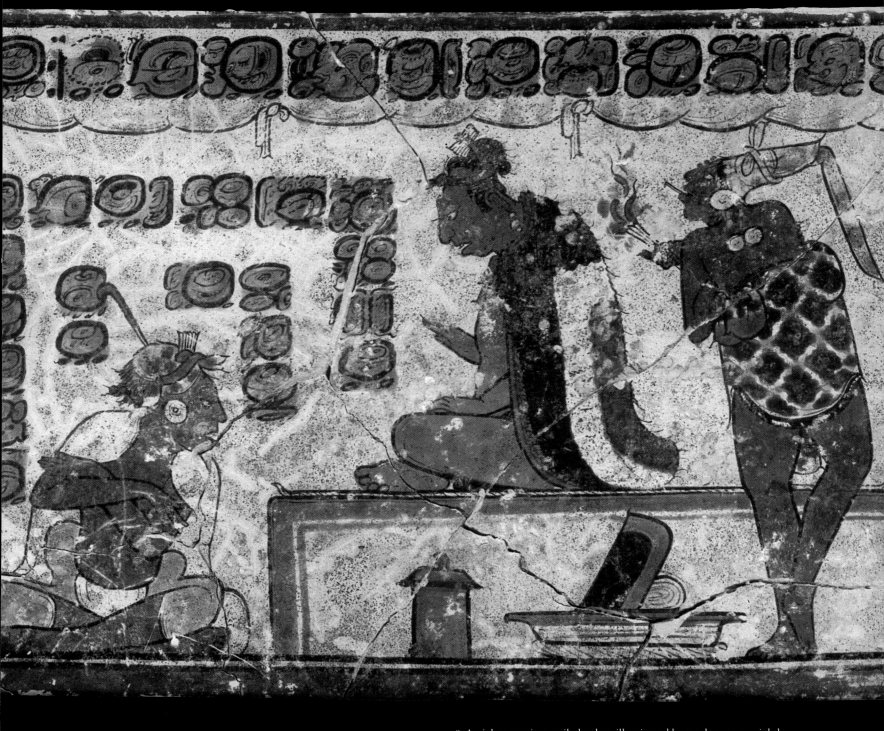

28 A night scene in a scribal palace illuminated by torches, on an eighth-century polychrome vase. Tribute is being brought to the enthroned chief scribe by the *ah k'u hun* on the far left; before the throne are two other *ah k'u huns*, one of them an interpreter. The texts by these figures give their names and titles (see Fig. 55). Running along under the rim is an elegantly painted PSS, ending with the name, titles, and descent of the prince who commissioned the vase.

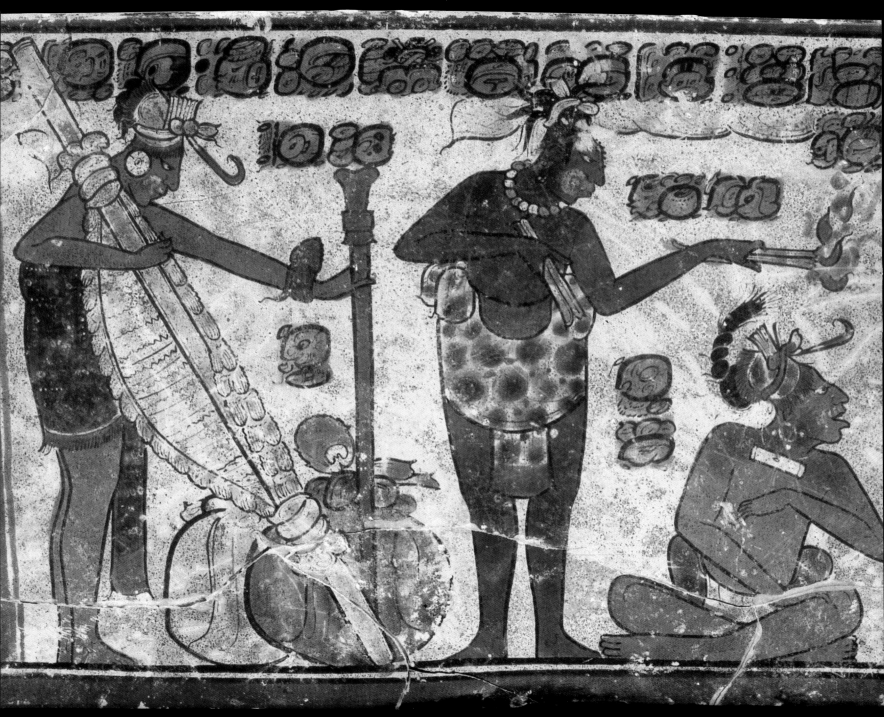

27 Scribes played more than one role in royal courts. In this rollout from a Late Classic vase, showing the same enthroned ruler in two scenes with standing scribes, the scribe on the left holds a nosegay of "ear flowers," used in royal marriage negotiations; on the right, an *ah k'u hun* offers a small container to his lord.

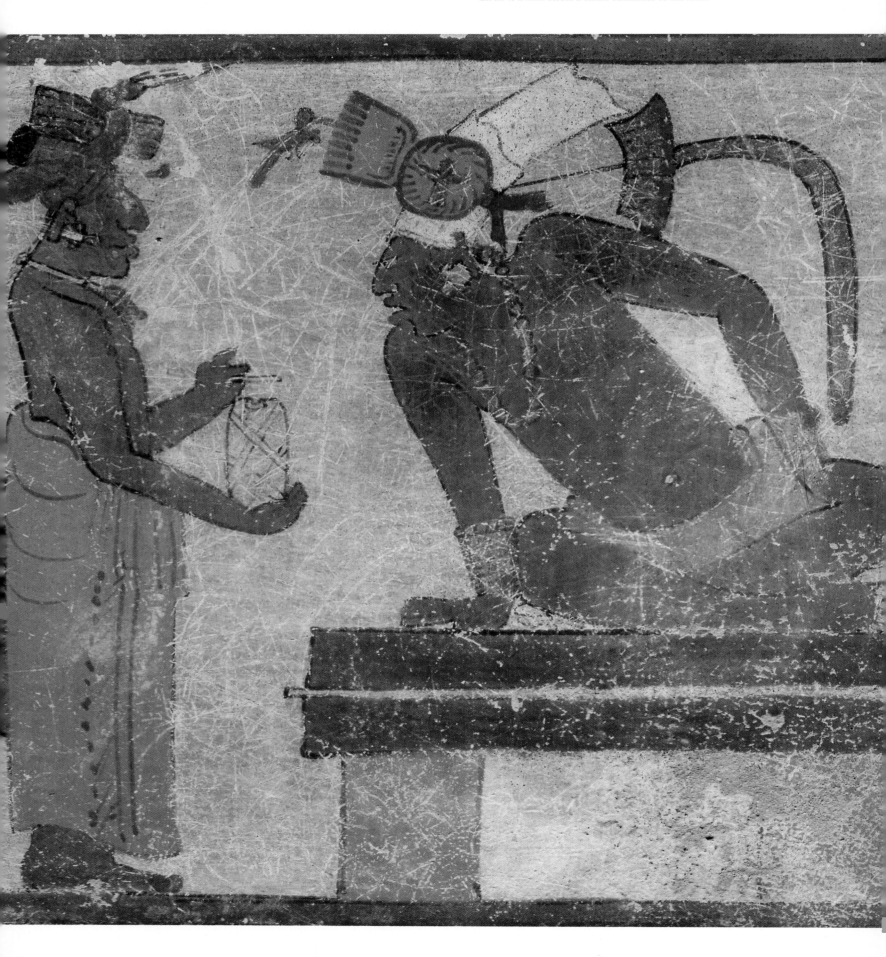

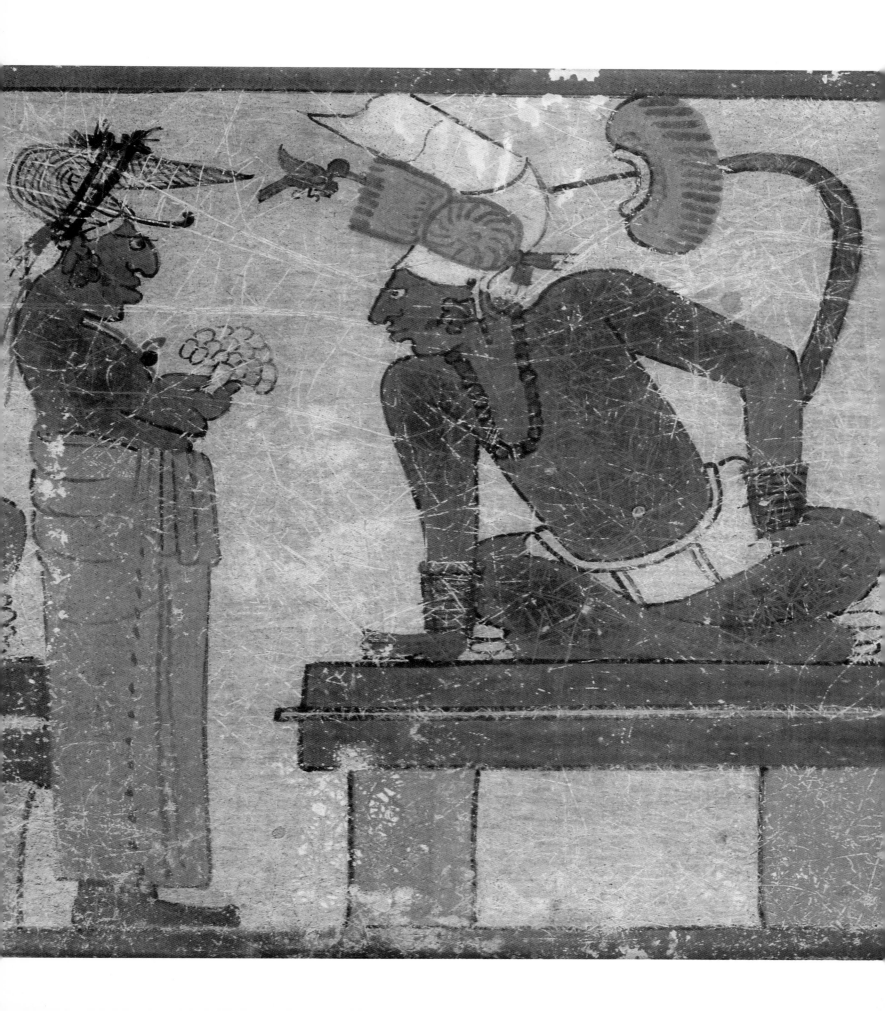

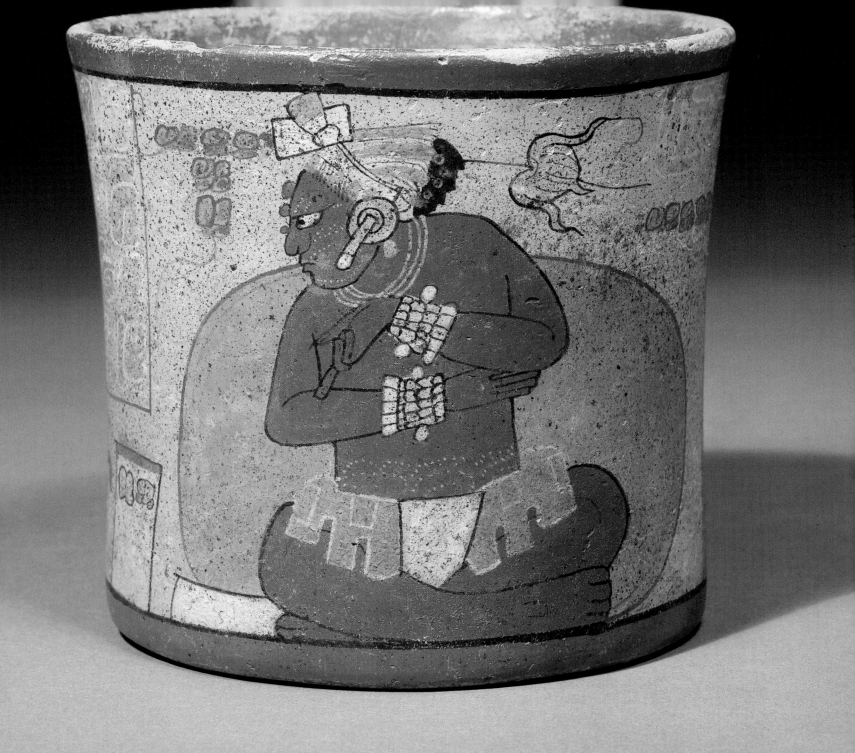

THE WORLD OF THE MAYA SCRIBES

THE ANNIHILATION OF THE BOOKS

We found a large number of books in these characters and, as they contained nothing in which there were not to be seen superstition and lies of the devil, we burned them all, which they regretted to an amazing degree, and which caused them much affliction.[1]

These words were penned in about 1566 by the fanatical Diego de Landa, Franciscan Bishop of Yucatán, a person who played the double role of both the recorder and the destroyer of Maya culture. Landa's single-minded zeal in ridding the land of the Maya of their books (and presumably the libraries which had contained them) was not always shared by his fellow missionaries, as may be witnessed by the observation of the Jesuit Joseph de Acosta, writing in 1590:

This [book-burning] follows from a stupid zeal, when without knowing or even wishing to know the things of the Indies they say…that everything is sorcery and that the peoples there are only a drunken lot and what can they know or understand. The ones who have wished earnestly to be informed of these have found many things worthy of consideration.[2]

Thus did the cataclysm of the Spanish invasion fall upon the mental world of the Maya. One might compare this huge act of cultural vandalism with the famed burning of the Library of Alexandria. Yet just as the Alexandrian destruction was in fact not a single event—the conflagration took place not once, but three times, over a period of centuries—so ruin fell twice on the intellectual structure of the Maya within which had flourished the scribes, the painters and sculptors, and the *its'at'ob* (the sages). The final devastation wrought by the conquistadores and

friars had been presaged seven hundred years earlier by the century-long collapse of Classic Maya civilization, when the royal cities must have seen the slaughter of the ruling elite, the mutilation of monuments celebrating that elite, and the torching of codices, perhaps by the thousands.

Archaeology and art history have however been able in the past few decades to restore at least a semblance of that lost world of the Maya scribes as it must have existed in Classic times, thanks first of all to the recent decipherment of the hieroglyphic writing system and, secondly, to the analysis of a very large sample of pictorial ceramics delineating in extraordinarily graphic detail that long-disappeared universe.

WHO WERE THE SCRIBES?

A perusal of dictionaries from the Colonial epoch and the nineteenth century will show that the Yucatec Maya vocabulary related to the production of books, sculptures, paintings, and other works of art and intellect is amazingly rich. The first thing to know about this lexicon is that the term *ts'ib*—found not only in Yucatec but in most Mayan languages—means both "writing" and "painting"; the title *ah ts'ib*, "he of the writing," was applied to both calligrapher *and* painter. There is every reason to believe that, as among the great wielders of the brush pen in the East Asian tradition, the Classic period *ah ts'ib* was expected not only to produce written texts, but to paint the pictures to accompany them [see e.g. *Fig. 44*]. One of he most significant epigraphic advances in recent years has been the discovery by David Stuart—then a Princeton undergraduate—of the hieroglyphic forms of both *ts'ib* and *ah ts'ib* on painted Maya ceramics from Classic tombs,

37 Hunahpú is depicted on this Late Classic plate writing in an open codex with jaguar-skin covers. Repeated twice around the sides of the plate is the hieroglyph of his father, the Young Maize God; since plates of this sort usually held maize tamales, the symbolism was apt.

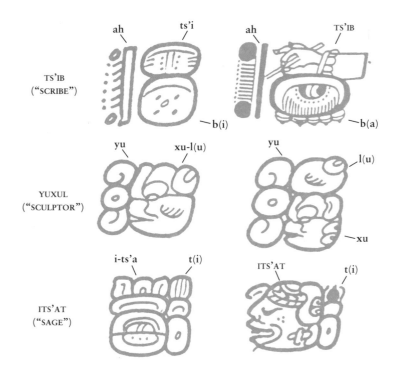

44 The eighth-century Altar de Sacrificios Vase represents the acme of Late Classic vase painting. Here an old way *spirit dances with a boa constrictor. The figure's arm and the snake partly obscure the fine calligraphy of the PSS text above, indicating that the painter and the scribe were one and the same.*

45 Scribal titles: (a) ah ts'ib, "scribe"; (b) yuxul, "the carving of..."; (c) its'at, "sage." Two glyph compounds for each word are shown here among the variants from which the scribe was free to choose.

usually occurring within the formulaic PSS, and referring to both the scribe/painter *and* his product (the text and the scene on the vessel) [*Fig. 45, top,* and see e.g. *Figs. 31, 32*].³

While engaged on this ground-breaking research, Stuart found that on relief sculpture [*Fig. 3*] and on pottery that had been carved or incised rather than painted, instead of the *ts'ib* glyph the relevant expression was a bat head followed by, or infixed with, a sign now read as the syllabic sign *lu*, the whole compound preceded by the glyph standing for syllabic *yu* [*Fig. 45, centre*]. Since both *ts'ib* (usually in possessed form as *u ts'ib*, "his writing/painting") and the "*yu-bat-lu*" expression are followed by nominals, Stuart was able to draw the conclusion that these were the personal names —and sometimes titles—of painters and sculptors (and carvers of clay), respectively. Thus, the Classic Maya became the only New World people known to have signed their works of art, a testimony to the high sophistication of the culture. The implications of Stuart's discovery will be examined below. Within the last few years, after much speculation and argument on the part of epigraphers regarding the correct reading interpretation

of the "*yu*-bat-*lu*" expression, Nikolai Grube of Germany and Alfonso Lacadena of Spain found in a sixteenth-century dictionary the phrase *yuxul nahal*, glossed as "his sculpting," suggesting that the bat head is a syllabic *xu*, and that "*yu*-bat-*lu*" is therefore to be read *yuxul(u)*.⁴

Shortly before the time that Stuart was pioneering the study of artists' titles and signatures, the present writer recognized the supernatural patrons of artists and scribes on Classic ceramics, and perhaps more importantly, identified the paraphernalia and even some of the costume that accompanied depictions of painters and calligraphers. The scribal deities most commonly encountered in Classic Maya art turned out to be a pair of Monkey-man Gods [e.g. *Pls. 30, 32, 33, Figs. 73–75*], half-brothers of the Hero Twins, and it was not long before Stuart determined that a "were-monkey" head with its characteristic headband, accompanied by phonetic-syllabic indicators, acted as a logograph for *its'at*. In the 1980 Cordemex Dictionary of Yucatec Maya—itself a grand compendium of various Colonial and later vocabularies—*its'at* is glossed as "astute, cautious, skillful, artist, diligent for good and for bad, and wise as such."⁵ Thus, there is now no question that this honorific was bestowed on some of the scribal artists of the Classic lowlands. Perhaps it was actually the name of an office, but whether it was an office separate from that of *ah ts'ib* or from what may be the most important scribal title and office of all, *ah k'u hun*, remains to be seen.

THE "AH K'U HUN"

It was not so very long ago that Mayanists had
almost nothing concrete to say about the costumes
and accoutrements worn or brandished by individuals
in scenes depicting doings in Classic-period palaces.
While it was recognized that a human seated in a position
of authority on a throne was probably a ruler, perhaps
even a king (*ahaw*, in Maya), and the other figures his
subordinates, no-one had the slightest idea of who these
other personages were. At one time, in fact, robed figures
present in the scenes were thought to be male priests, but
that notion was dropped when Tatiana Proskouriakoff
proved that they were royal or noble women.[6] Likewise,
Mayanists were hard put to explain what was really meant
by the headgear they wore, and the objects held in their
hands. Thanks to recent research, it has now become
apparent that these palace subordinates were all nobles who
played well-defined roles in the city-state's civil or military
service, and that their gorgeous apparel was not chosen for
its decorative value, but functioned to define those roles. In
other words, the paintings and reliefs of the Classic Maya
show not fancy dress, but real uniforms.

Before examining a "uniform" (and thus a role) which is
fundamental to the understanding of the Maya scribal artist
and his role in Classic society, we must describe a crucial
decipherment made in 1995 by Nikolai Grube.[7] This
concerns a scribal title occurring on both ceramics and
monuments, which consists of the male proclitic *ah* ("he of
the..."); the head of so-called God C (now proven to be read
as logographic *k'u*, "god," or *k'ul*, "holy"); and the syllabic
sign for *na* ("house"). Although one would suppose at first
glance that this concatenation could be read as *ah k'u na*,
"he of the holy house [i.e. temple]," Grube showed that a
knot-like element was often present above the *na*, and that
the two together should be read as *hu-n(a)*—that is, after
dropping the final vowel, as *hun*, the universal Maya word
for "book." This title is, therefore, *ah k'u hun*, "he of the
holy books," apparently sometimes elided in Classic times
(the *h* being a weak consonant) to a simple *ah k'un*. Grube
quite logically interpreted such a personage as keeper of
the royal library, a most exalted role, to be sure. But it will
be seen that the *ah k'u hun* was something more than this.

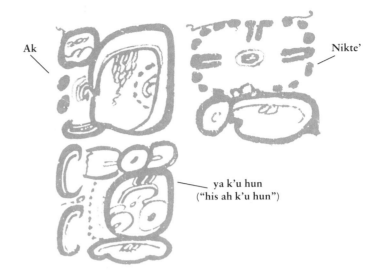

46 *Signature of the* ah k'u hun *Ak Nikte' ("Turtle
Flower"), on a Late Classic plate from the Petén.*

A beautifully painted text on a black-on-white plate from
the northern Petén [*Pl. 104, Fig. 46*] throws some light on
the status of the *ah k'u hun*. In it, an individual called Ak
Nikte' ("Turtle Flower")—probably the calligrapher
himself—is named as the *ah k'u hun* of a Maya lord, one
Chak Tsul Ha. That an *ah k'u hun* could be a vassal of a
ruler is also apparent on a magnificently incised travertine
vase at Dumbarton Oaks [*Fig. 101*]. This has three seated
figures on it: (1) the lord himself, who is named as a *kalom*,
a kind of warlord; (2) a woman, who is probably his wife;
and (3) a man with the personal name of Yiban, who is
specifically tagged as the *ah k'u hun* of the *kalom*. Now let
us examine Yiban's costume [*Fig. 48*]. Although he is seated
cross-legged, it is clear that he is wearing a sarong with the
top folded up around his waist; his somewhat unkempt hair
is held by what appears to be a headcloth, while fixed to his
forehead by a strip wrapped around the headcloth is what
looks like a bundle of sticks with some sort of curved
instrument protruding from it. What could this "stick
bundle"—superficially reminiscent of the phylacteries or
amulet boxes traditionally worn on the forehead by adult
males during Jewish prayers—actually be? Whatever its
nature, it, along with the headcloth hair-wrap and sarong,
is present on *all* known painted or carved figures which are
glyphically identified as *ah k'u hun*s; and on all of these, the
hair is either worn short and somewhat unkempt (the most
common style) or else tied up in a long hank.

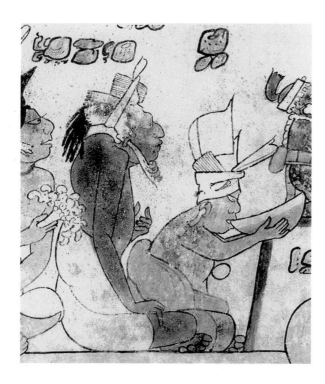

This, then is the "uniform" of the *ah k'u hun*:
- short hair with jagged ends, wrapped in a headcloth; alternatively, a long, bound hank protruding from the headcloth
- a "stick bundle" held to the forehead by a cloth or paper strip tied around the headcloth and fastened with a large knot—the same knot that has been interpreted by Grube as the logograph *hun*, "book"
- occasionally, one or more brush pens, and/or a stick-like instrument with curved end (probably a carving or painting tool of bone, but perhaps a tool to burnish paper), are thrust into the headdress; a waterlily may sometimes substitute for the pen [e.g. *Figs. 49, 56*]. There are a few instances in which the curved "tool" (if that is what it is) appears in headresses without the "stick bundle" [e.g. *Fig. 49*]
- a wrap-around sarong bundled at the waist, which may extend to the knees or even to the ankles

In most cases, this costume is worn by humans rather than supernaturals; contrariwise, much of the costume detail of deities, such as the so-called "Deer's Ears" or the "Number Tree" (see p. 105). seems to have been forbidden to humans. In other words, almost all of the *ah k'u hun*s in Classic art may be said to represent mortal beings, not gods.

47 *Two* ah k'u huns, *from a court scene on an eighth-century vase from the Petén. The person on the far left may be a marriage negotiator, carrying a bunch of "ear flowers," used in flavoring chocolate.*

48 BELOW *The* ah k'u hun Yiban, *on a Late Classic travertine vase of which he was the artist/scribe (see Fig. 101).*

And what of the "stick bundle"? I have long suspected that the sticks were writing instruments. Not long ago, an Apple engineer from India, when shown this object by Justin Kerr, said that when he was a boy in India and starting school, the children were given bundles of reeds with which to write. And in a communication to the present writer, Linda Schele said of the objects in the pack: "Personally, I think they're blanks for pens. When the scribes needed them, they used obsidian to sharpen them." On polychrome vases, the "sticks" are clearly white in color, suggesting quills rather than reeds; and, contrary to what Schele suggests, most of them already have sharpened ends (see the carefully delineated "stick bundles" in *Pls. 26* and *33*, and *Fig. 47*). For reasons that I will give below, I believe that these really *are* quill pens, and that they were very important items in the calligrapher's toolkit. However, I know of one stucco portrait head and one vase on which "stick bundles" are delineated in such a way that the sticks appear to be brush pens, but these are rare instances.

ah k'u hun

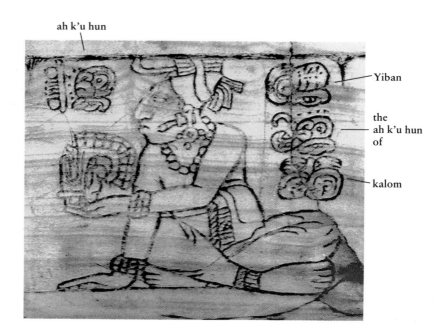

Yiban

the
ah k'u hun
of

kalom

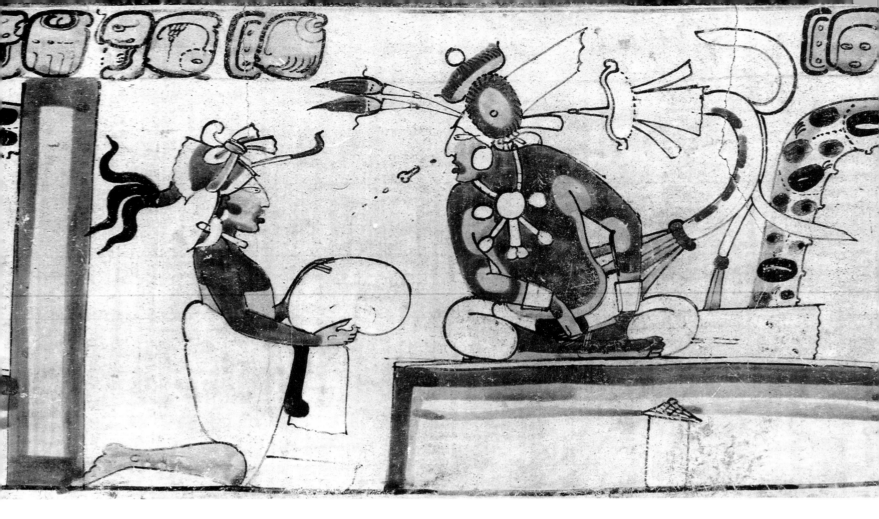

49 *An* ah k'u hun *kneels before a ruler with brush pens (or budding waterlily flowers) in his headdress. Rollout from a Late Classic polychrome vase.*

I have been able to identify two stone monuments and twenty-two published vases with depictions of these high-ranking scribes, along with paintings of them at Bonampak and in the cavern of Naj Tunich [*Fig. 50*], from which it is possible to derive a picture, albeit a sketchy one, of their roles and responsibilities in Late Classic Maya society. First of all, the *ah k'u hun*s must have gone through a rigorous training, perhaps in schools like the Aztec *calmecac* (a seminary for noble youths aspiring to become priests or administrators). Such a scenario is graphically depicted on a unique Codex-style vase [*ill. pp. 2–3, Fig. 70*] which shows pairs of young *ah k'u hun*s (complete with "stick bundles" on forehead) receiving instruction from two figures of the scribal Pawahtún god; one of the aged deities gestures with a pen towards an open codex while reciting to his pupils the book's mathematical contents—in the form of bar-and-dot numbers. The censorious text being uttered by the other of these Pawahtúns to his apprehensive listeners suggests that we are in a pedagogical environment: Justin Kerr notes that it ends with *tatab(i)*. According to the sixteenth-century Motul Dictionary, the word *tataah* refers to writing which has been done badly and in a hurry!

It may not have been only producers of painted texts who received the title of *ah k'u hun*: in the name phrase—or signature—on the magnificent lintel in Structure 6 at Bonampak, the sculptor places himself in this category.

If the testimony of the pictorial ceramics can be believed, the *ah k'u hun*'s role was not confined to the production of books, paintings, and carvings. The *ah k'u hun* was more than just an *ah ts'ib*, exalted though that position might be.

50 *Seated* ah k'u hun *with a conch-shell inkpot, from Naj Tunich cavern.*

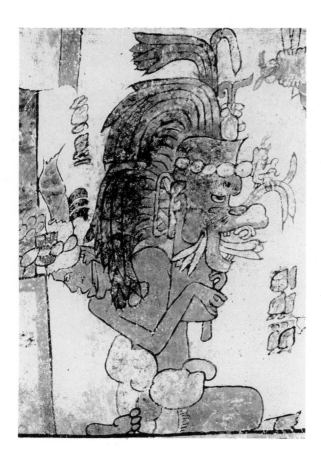

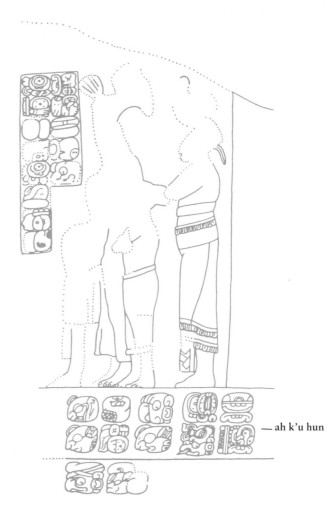

— ah k'u hun

On one polychrome vase [*Fig. 51*], an *ah k'u hun* is involved in the costuming of a ruler for a ceremonial dance, holding aloft a huge, frightening, feather-decorated mask representing a Monkey-man God; this act suggests a function as Master of Ceremonies. There is a parallel to the scene on another polychrome vase, in which a female *ah k'u hun* carries the mask of an old god with which to array the lord [*Fig. 54*]. In the two monumental representations of *ah k'u huns*—both on panels from Piedras Negras—they stand on one side of an elaborate ceremonial scene (missing on the fragmentary "Lintel" 1 [*Fig. 53*], but shown in great detail on "Lintel" 3 [*Pl. 7, Fig. 52*]), as though witnessing the unfolding of a drama that they had planned. We are reminded of the *nim chokoj*, the Master of Ceremonies in the royal courts of the highland Quiché, a princely title that, according to Dennis Tedlock, was held by one lord in each of the three ruling Quiché lineages; Tedlock has even suggested that the author of the *Popol Vuh* may actually have been a *nim chokoj*—in other words, acted both as organizer of ceremonies and as royal scribe.[8]

To that of scribe and Master of Ceremonies must be added yet another function: that of marriage negotiator, a role that scribes in general, and not just the *ah k'u hun*s,

51 *ABOVE LEFT* Ah k'u hun *holding up a Monkey-man God mask and headdress, while engaged in costuming a ruler, from a Late Classic vase.*

52 *ABOVE* Detail from "Lintel" 3, Piedras Negras, eighth century: the saronged figure on the right is an ah k'u hun *watching a royal banquet scene.*

53 *Figure of an* ah k'u hun, *from the fragmentary "Lintel" 1, Piedras Negras.*

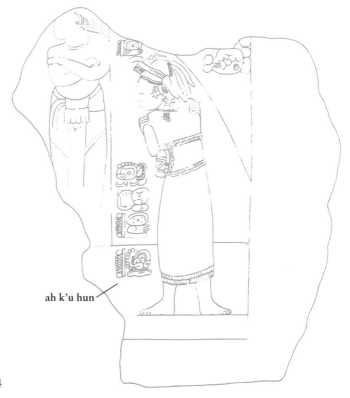

ah k'u hun

ah k'u hun

chilam
("interpreter")

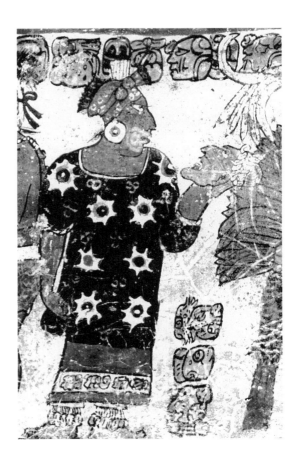

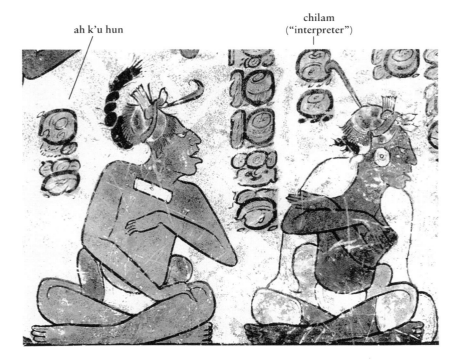

54 LEFT *A female* ah k'u hun *holding the mask of an old god, from a Late Classic polychrome vase.*

55 ABOVE *Two seated* ah k'u huns, *from a Late Classic vase depicting a night scene in a scribal court (see Pl. 28). The glyphs on the far left read* ah k'u hun; *the individual on the right is a* chilam, *"interpreter."*

may have played. It was Dorie Reents-Budet who first identified the flower in the bouquets sometimes held in the hands of subsidiary figures in palace scenes [e.g. *Figs. 47, 56*] as *Cymbalopetalum penduliflorum*, the "ear flower" that was so prized by Mesoamericans as a chocolate flavoring.[9] These flowers actually look like tiny ears, and the Maya artist has so depicted them. Now, the chocolate drink was a necessary accompaniment for all phases of Maya marriage negotiations, and for the wedding itself, throughout Maya history in both highlands and lowlands, and Reents-Budet, followed by Tedlock, convincingly suggests that such negotiations are going on here. In a doubled throne scene on one vase [*Pl. 27*], on one side the *ah k'u hun* offers the ruler what may be perfume or an ointment, while on the other, wearing a substitute scribal headdress rather than the more typical one, he proffers the ear-flower bouquet to the same royal individual.

The *ah k'u hun*—or any class of scribe, for that matter—would have been the logical choice for such delicate matters, for it was surely his task to compile, write, and keep the genealogies; it would have been he who would have been charged with producing the Classic Maya equivalent of the *Almanach de Gotha* at critical junctures of the negotiations.

A final part which these scribes played on the Maya stage was that of tribute recorder. In her study of Maya painted ceramics, Reents-Budet noted that many of the scenes do portray tribute, often in the form of textiles displayed at the foot of the throne or on the top of a stepped platform leading to it.[10] On an outstandingly beautiful and elegant polychrome vase [*Pl. 28*], two torchbearers provide light for a scene which takes place at night: an enthroned lord, bearing the *ah k'u hun* "stick bundle" on his forehead, receives tribute being handled by an *ah k'u hun* scribe on the far left, while before him are seated two further *ah k'u huns*—one of them labeled with the title *chilam*, "interpreter" [*Fig. 55*], suggesting that this tribute came from a foreign land where a different tongue was spoken. I suspect that many of the codices in the royal library were tribute lists similar in content to the two extant Aztec ones, the *Matrícula de Tributos* (in Mexico's National Museum of Anthropology) and the *Codex Mendoza* (in the Bodleian Library, Oxford).

How can one explain the "stick bundle" worn by the king in this scene? The occurrence is by no means isolated in the Maya ceramic corpus: the standard *ah k'u hun* headgear is displayed by seated rulers on other vases, most notably by

the lord on what surely the loveliest of all polychromes, the small cylinder at Dumbarton Oaks [*Pl. 26*], on which the principal figure's headcloth and "stick bundle" tie-band are touched with brilliant Maya Blue (an absolutely color-fast pigment compounded by mixing an inorganic clay with indigo dye). To explore this question, it will be necessary to look at evidence for the social status of the scribe among the Classic Maya.

"AH NAB" AND OTHER SCRIBAL TITLES

Other Classic period scribal titles are known to exist, or suspected to exist, although considerably less is now known about these than about those that have been considered above. One is *ah nab*. Now, the *ah* here is the male proclitic (even though, as has been seen, some *ah k'u hun*s could be women), with the general meaning of "he of the…" or "the keeper of…," but what does *nab* mean? In the dictionaries of Colonial Yucatec, there are four main glosses. One is "sea," which has no application. The same can be said of the second, which is "a measure by palm widths," or to measure thusly: this may explain the appearance of the *nab* collocation along with a bar-and-dot prefix on rubber balls as seen in representations of the ballgame in Classic Maya art—*nab*s are measures of the circumference of the ball. A third gloss for the word is "to daub" or "to smear something on," so perhaps here we are getting closer to the world of the scribes and painters.

But perhaps the real clue to the significance of *nab* is in the fourth meaning: "waterlily." In the next chapter, attention will be drawn to the numerous more-or-less realistic representations of brush pens thrust into the headdresses of individuals on Late Classic polychromes. At the same time, many figures wear in a similar position what have been identified as waterlilies, shown as mature flowers [*Pl. 26*] and as buds [*Figs. 49, 56*]. Yet, on closer examination, the stems of the open and unopened flowers are depicted by thin, straight lines (unlike the thick, floppy stems of real waterlilies), and the buds themselves, while painted red as the flowering parts should be, are in reality the "business ends" of brush pens. I now believe that when worn in headgear, waterlily blossoms in both bud and

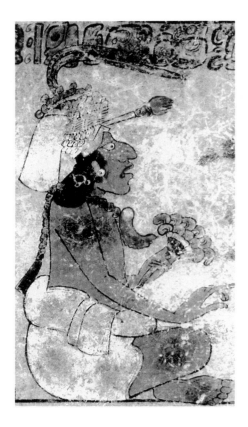

56 Seated scribe with a waterlily/brush pen in his headdress; in one hand he has a nosegay of "ear flowers," a probable marker for marriage negotiations. Detail of a Late Classic polychrome vase.

open form are a punning metaphor for brush pens, based on the double meaning of *nab*: the persons on whom these flowers are bestowed were also versed in the scribal arts.

Nikolai Grube has recently sent me the following observations, which not only suggest the existence of a special title for sculptors, but also give an idea of the methodology employed by epigraphers to reach new readings and understandings:

I have forgotten to tell you about another artist title. This is found, as so many artist titles [are], on monuments from Piedras Negras. On Stelae 12 and 13, for example, the last glyph of some of the scribal signatures consists of the *po* syllable combined with a variant of Thompson's 596 main sign. The same main sign occurs in verbal position at Chichén Itzá on the lintel from the Akab Dzib building. Here it has an *u* pronoun and a "*K'an*" sign (T506) as a suffix. We

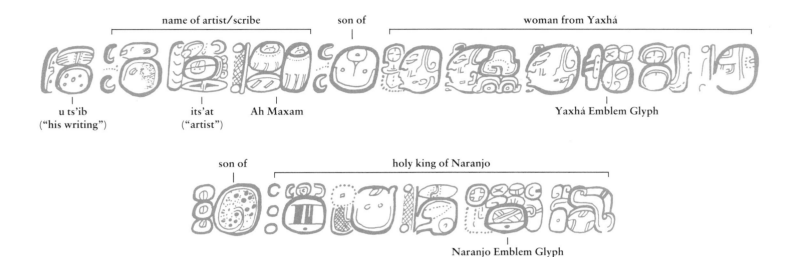

name of artist/scribe son of woman from Yaxhá

u ts'ib its'at Ah Maxam Yaxhá Emblem Glyph
("his writing") ("artist")

son of holy king of Naranjo

Naranjo Emblem Glyph

know from many other substitution patterns that the
"*K'an*" sign is polyvalent, and besides reading *K'an* as
a day sign, it stands for the word *ol*. If *po-* and *-ol* are
two phonetic complements for the 596 main sign, the
conclusion is that the main sign represents the word
pol, a word which is translated [in Spanish] as *esculpir,
labrar madera; carpintero; en otros algunos oficiales,
anadiendo el obra de piedras, etc.* ["to carve, to work
wood; carpenter; with some artisans, it includes work
in stone, etc."]. This glyph, then, in scribal signatures
refers to those artists that were the carvers, the actual
sculptors. I wonder whether the majority of the "artist
signatures" contain more specific descriptions of the
actual task in the last glyph.

PRINCES WITH PENS

Present-day scholarship has shown that the scribes,
including the *ah k'u hun*s, were at the apex of Maya society,
or very near it. A crucial piece of evidence was provided by
David Stuart's decipherment of the text on a black-on-white
Late Classic vase which, while lacking provenance, was
surely painted at Naranjo [*Pl. 50, Fig. 57*].[11] In this, the
calligrapher/painter Ah Maxam names himself as an *its'at*
(a wise man, an artist), and as son of a princess from the
city of Yaxhá and of a well-known king of the even larger
city of Naranjo—a claim of royal parentage which he would
not have dared to make if it were not true. Reents-Budet[12]
cites a report from Utatlán, the Late Post-Classic capital of
the Quiché Maya, where specialized artists came from royal

*57 Text from a cylindrical vase from Naranjo (see Pl. 50),
giving the scribe Ah Maxam's name and royal parentage.*

lineages: these, the younger sons and other close relatives
of lords, occupied the highest sociopolitical offices, but
they were not in a direct line to inherit the throne. The
same custom prevailed in Yucatán on the eve of the
Conquest, for Bishop Landa reports that the priests (as
shall be seen, the exact counterpart to the Classic scribes)
were recruited among the second sons of the lords; and the
linguist and ethnohistorian David Bolles[13] has discovered
that among the Colonial Yucatec *winal* prognostications is
one pertaining to those born on the day Kawak:

> Kawak [spelled *Cauac* in the original]: quetzal is his
> bird, cacao is his tree, scribe, offspring of kings [*al
> mehen ahau* in the original]…

As in feudal Europe, Classic Maya warfare seems largely
to have been an affair of those born to royal or noble estate,
so that all the prisoners shown on monuments are likely to
have been elite members of society. Several reliefs suggest
that high-ranking scribes and artists may have been prime
targets for captive-seekers, for they would have enhanced
an ambitious court with their prestigious knowledge and
artistic prowess. Consider the Kimbell Panel [*Pl. 91*], for
example, which bears a Calendar Round date in the year
AD 783: on it, a *sahal*—a secondary war leader—has
brought three bound captives before his lord (himself a
sahal of the Yaxchilán king); the foremost of the captives
has a *hun* knot in his headdress and holds what appears to

 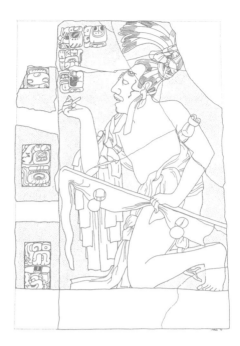 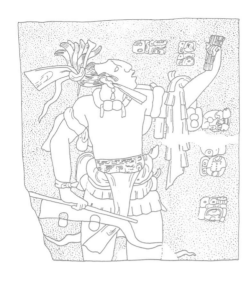

be a bunch of quill pens, thus in all likelihood is an *ah k'u hun*. The other two have similar headband knots, and probably are also scribes of some sort. At Palenque, three well-known tablets with kneeling figures bearing hole-punched banners have long been recognized as showing prisoners. On one of the two tablets from the Southwest Court of the Palace [*Fig. 59*], the captive holds what is surely a brush or quill pen in his right hand (the figure is even known popularly as "The Scribe"—rightly, I think); and on the tablet from Temple XXI [*Fig. 60*], the captive brandishes the "stick bundle" in his left hand. On the other tablet from the Southwest Court, the so-called "Tablet of the Orator" [*Fig. 58*], the individual depicted holds the palm of his hand in front of his face—as does one of the Kimbell scribes— and may well have been a *chilam*, or translator (though he could also have functioned as an orator, as his popular name suggests); perhaps he was an artist, too, for what seems to be a sculptor's bone awl is thrust through his bound hair.

Again, in the same vein, Grube has called my attention to one of the seated captives so graphically depicted at the bottom of Piedras Negras Stela 12, celebrating the victory of the city's seventh king over Pomoná. This unfortunate individual carries the glyphic phrase *ba che-b(u)* on his leg, which translates as "First *Cheb*." I will anticipate my argument in the following chapter by saying that there is ample evidence that codex writers used the quill pen or *cheb*. Grube therefore suggests that this is a title referring

to "First Scribe" or "First Pen-user," and mentions that Mary Miller and Linda Schele have long suspected that artists and scribes were among the nobles from Pomoná taken prisoner by the ruler of Piedras Negras.

The visual evidence from Classic reliefs and ceramics suggests that the kings themselves—the *ahaw*s—could have been trained as scribes. At Copán, on Stela 63, carved about AD 435, the ruler Popol Hol ("Mat Head"), son of the city's dynastic founder, Yax K'uk' Mo, proclaims himself to be an *its'at ahaw*, a "lettered person king" (using the glyph in *Fig. 79*). I have already called attention to the king on the Dumbarton Oaks vase [*Pl. 26*], but equally striking is another enthroned, tribute-receiving *ah k'u hun* ruler [*Pl. 28*]. And not only the ruler but several of the lesser figures bear the "stick bundle" on their heads on an even more famous and more complex Dumbarton Oaks polychrome vase [*Fig. 61*]. Now that brush pens can be recognized, they can be seen proudly displayed in the headdresses of kings who, while not themselves *ah k'u hun*s, nevertheless were probably proud of their scribal abilities— much as talented Chinese rulers like the Sung dynasty emperor Hui-tsung cultivated their considerable skills as calligraphers and painters. Finally, as Reents-Budet has noted,[14] in the tomb of king Hasaw Ch'an K'awil beneath Tikal's Temple I, the ceramic inkpot [*Fig. 118*] placed just to the north of the ruler's head implies that he, also, was skilled in the scribal arts.

OPPOSITE
58, 59 Tablets from the Southwest Court of the Palace, Palenque. Left, "The Orator." Right, "The Scribe."

60 Tablet from Temple XXI, Palenque. The kneeling figure is holding up the "stick bundle."

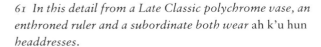

61 In this detail from a Late Classic polychrome vase, an enthroned ruler and a subordinate both wear ah k'u hun *headdresses.*

Perhaps the "stick bundle" was not the exclusive perquisite of *ah k'u hun* scribes, but could be displayed by all high-ranking persons as an emblem of their literacy. In the murals in Rooms 1 and 3 of Structure 1 at Bonampak, a total of twenty-four dignitaries stand in the upper registers, and all wear floor-length cotton capes (mostly white, but a few are tan), each with three *Spondylus* shells at the neck band. While their headgear is variable, three (possibly four) have the "stick bundle" of the *ah k'u hun*, but not the sarong. In Room 3, below them in the middle register are nine seated individuals who lack the capes and shells, but three of them also have the *ah k'u hun* headgear; and even further below, among the trumpeters, are two who have the "stick bundle" attached to their foreheads—so conceivably the ability to read and write was more widespread than has been surmised, for musicians do not seem to have been of particularly high rank. But of course it should be remembered that scribes, artists, musicians, and even dancers were under the patronage of the same supernaturals, the Monkey-man deities (see p. 106).

Were the royal scribes of the Classic Maya exclusively men? Epigraphers have noted that the *ah k'u hun* title is appended to several women's names on the monuments, notably at Yaxchilán. A female *ah k'u hun* on one painted vase has already been noted [*Fig. 54*]; immediately on her left, standing before the throne, a robed figure bears brush pens in her headdress. Surely these examples imply that

noble, even royal, women could be scribes, and that the *ah k'u hun* title was basically "gender blind" in spite of the male proclitic *ah*. The same holds true of the title *ah ts'ib*, "he of the writing": Michael Closs[15] has pointed out a pottery text in which the vessel's patron, a *sahal* (secondary war chief) names both his father *and* his mother as *ah ts'ib* scribes. Could queens have been scribes, too? I call attention to a polychrome vase [*Pl. 8*] on which a kneeling woman (identified as a royal lady from Tikal) sways in dance before the king of a city-state known only by its "Ik"-sign Emblem Glyph; both wear the "stick bundle" headgear, so both are *ah k'u hun*s. The answer to the question is thus "yes."

It is known that the scribes had their own gods, a subject that will be subsequently explored. It seems conceivable that they had their own organization, too, perhaps a kind of guild similar to that of the *pochteca* or long-distance merchants in Aztec Mexico, with their special patron deities and feast days. Bishop Landa tells us that in late pre-Conquest Yucatán, the priests (who, it must be emphasized, from a functional point of view were virtually identical with the Classic-period scribes) celebrated a major festival during the month Wo, the purpose of which was a ritual purification of the books with prayers, incense, and the anointing of the books' covers with Maya Blue dissolved in water.[16] At the conclusion of the ceremony, after prognostications for the year had been made by a

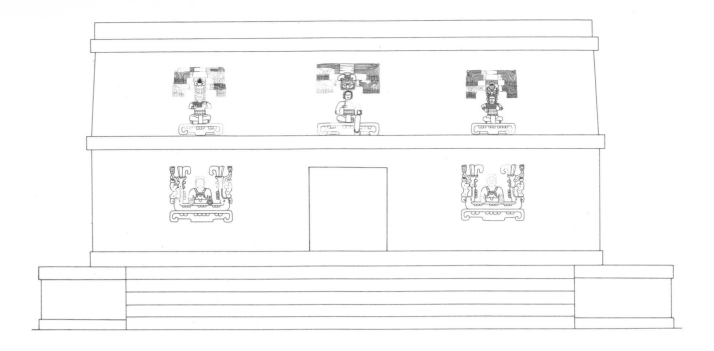

particularly learned priest, the participants consumed all the food that had been brought as gifts, and "drank until they were sacks of wine." A particularly graphic Late Classic vase [Pl. 29], on which virtually all of the figures seem to be scribes of one sort or another, may show just such a feast: on the seated lord's throne is a bowl filled with codices and "waterlily pens" (see above, p. 96), and below him is a stack of paper; the lesser individuals are not writing, however, but engaged in drinking *balché* (the Maya mead or "wine"), while the seated scribe on the lower left appears to be thoroughly inebriated.

Some of the vase scenes that have been interpreted as taking place in the palace of the *ahaw*, the divine ruler, may actually depict the palace of the chief scribe of a city-state. Such palaces certainly existed, for a particularly grand one has been excavated at Copán, in a zone known to archaeologists as "Las Sepulturas"; this large suburb is strung out along an imposing causeway leading in a northeasterly direction from the Main Group of the city. Within it is a building complex labeled as Group 9N-8 by its excavators, consisting of six masonry structures arranged around a plaza, five of them on a single platform shaped like a squared "U." Epigraphic and artifact analysis show that in its final form it dates to the reign of the ruler Yax Pas, late in the eighth century, and near the end of the city's Classic existence.[17]

This group's most important building (nicknamed "House of the Bakabs") is placed on the south side of the plaza, and consists of three rooms and a central doorway. On the façade [*Fig. 62*], to either side of the entrance, are now-headless busts [*Fig. 63*] each holding a conch-shell

inkpot in the left hand, within framing jaws of a grotesque serpent which must be the ophidian avatar of the great god Itsamná (see p. 102); framing each serpent-niche below is a gigantic *na* glyph, the last syllable in *Itsamná*, so that the entire motif must represent a scribe appearing from the mouth of Itsamná, the inventor of writing. On the upper entablature of the façade are three additional individuals, each with a feathered headdress and each seated on his own *na* glyph; the central one is enthroned (indicated by one leg extending to the ground), and to William Fash—the excavator of the building—he is the scribal protagonist

62, 63 Reconstructed front façade of the Scribal Palace (Structure 9N-82 C), Copán, and detail showing the scribal figure emerging from the left-hand niche.

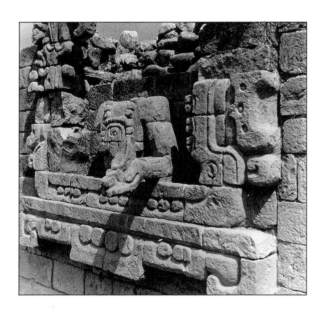

64 *Incised shell from a scribal residence in Aguateca. The incising on the interior (left) depicts an* ah k'u hun. *On the exterior (right) is a text containing the* its'at *("sage") title.*

named on an extraordinarily beautiful sculptured bench (or throne) still extant in the back of the central room.[18] But the honor of supreme Copán ruler belongs to his superior Yax Pas, as is made clear by the inscription on the bench.

The flanking figures alone would be sufficient to identify this building as a scribal palace, but Fash discovered in the remains of an earlier phase of the "House of the Bakabs" one further clue which confirms his assessment: a full-round figure of a supernatural scribe holding a conch-shell inkpot in one hand and a pen in the other [Pl. 30]. While his facial features ally him with the Monkey-men scribal gods of Maya mythology, the netted headdress (standing for phonetic *pa*) and *tun* body markings identify him as Pawahtún (see the subsequent discussion of this god). So, the building was the living and administrative quarters of a man who may have been second in power only to the actual *ahaw* of the city, Yax Pas, and one can imagine that the complex might have housed not only his courtiers, dancers, harem, and servants, but also academies for the teaching of the scribal and visual arts. We even know the name of this man, from the very beautiful, full-figure inscription carved on the front of the bench inside the central room: he was Mak Chanal, a courtier of Yax Pas, who is named as the reigning king. Mak Chanal himself was surely an *ah k'u hun*, for in the same text one of his predecessors was so designated by the earlier Copán ruler "Smoke Shell."

Placed on the edge of an escarpment overlooking a broad section of the Petexbatún drainage of the Petén, the far more modestly sized city of Aguateca had a prosperous existence until its sudden destruction along with its twin capital, Dos Pilas, at the beginning of the ninth century. Excavations by Takeshi Inomata[19] have shown that the central part of the city was burned to the ground, forcing its inhabitants to flee, leaving most of their belongings behind—unfortunate for them, but lucky for the archaeologists, who found a "Pompeii situation" so far unique for the Maya lowlands. One three-roomed, centrally-located structure (Str. M8-10) proved to be the household and workshop of a prominent scribe, for on the floor of one room were not only shell ink containers but also the stone pestles and rectangular mortars used to grind paints; nearby was a human skull with a long text containing the name of an Aguateca ruler, arranged in a mat design. Perhaps even more significant was the find of a shell ornament [Fig. 64] incised on the interior with the head of an *ah k'u hun* scribe; the text on the exterior has a personal name, followed by the scribal title *its'at*. While admittedly the structure, by comparison with the Sepulturas Palace at Copán, is unpretentious, for a site the size of Aguateca it is indeed impressive: the scribe must have been one of the leading men in his community, a real prince.

THE SCRIBES AND THE SUPERNATURAL

I was initially led into the wonderful world of the scribes on Classic Maya ceramics by their supernatural patrons:[20] it was the recognition on these vases of Hun Batz and Hun Chouen, the mischievous Monkey-men, half-brothers of the Hero Twins in the *Popol Vuh*, that provided the first clues about scribal gods and scribal tools during the Classic period. Although there may be several minor deities involved, at the present time it seems reasonably certain that the following were the principal gods of the scribes and other practitioners of the visual arts:

- Itsamná
- Pawahtún
- the Monkey-man Gods
- the Young Maize God (or Gods)
- Hunahpú (one of the Hero Twins)
- the Vulture God
- the Fox God

Let us look at each of these in turn.

Itsamná (God D)

According to ethnohistoric sources, Itsamná was the inventor of writing as well as the patron of the priesthood; he was, in fact, considered as the "first priest" by the Yucatec Maya, which would have made him "first scribe" among the Classic Maya. In Classic iconography and in the Post-Classic Dresden Codex [*Fig. 66*], Itsamná (God D in the Schellhas classification[21] used by generations of Mayanists) is almost always seated upon a celestial throne, as befits the supreme deity of the Maya pantheon, and he is shown as an aged divinity with a headdress extension displaying the glyph *its* as an indicator of his name. His role as a scribe is made clear at the Terminal Classic site of Xcalumkin, where he bears the title of *ah ts'ib*, "he of the writing";[22] and there are several images of Itsamná as scribe in the Madrid Codex. From the Late Classic period comes the famous incised bone from the tomb of Hasaw Cha'an K'awil at Tikal, on which the artist has depicted a hand with a brush pen coming from the jaws of a grotesque reptile [*Fig. 65*]: this creature is the "Bearded Dragon," the animal avatar of Itsamná which often spews deities—and, at Copán, scribes [*Figs. 62, 63*]—from its mouth in the weird and wonderful Maya supernatural world.

65 *A hand holding a brush pen emerges from the jaws of Itsamná in the guise of a serpent/dragon; from one of the incised bones in Hasaw Cha'an K'awil's tomb underneath Temple I, Tikal.*

66 BELOW *Itsamná, from page 15 of the Dresden Codex. He can be identified by his aged appearance, Roman nose, and large eye; and by the its glyph attached to the front of his headdress. Here, the god holds a flower (nikte') in his hand.*

OPPOSITE

67 *Itsamná, seated on a sky-band throne. The glyphs above are part of an elaborate Primary Standard Sequence, by a hand of which so far this appears to be the unique work. (The complete scene, on a cylindrical polychrome vase, shows him facing his grandchildren the Hero Twins, Hunahpú and Xbalanque.)*

68 *Itsamná on a jaguar-cushion throne, from a Late Classic red-background vase.*

69 *Itsamná, seated on a celestial throne, reaches for an offering of tamales.*

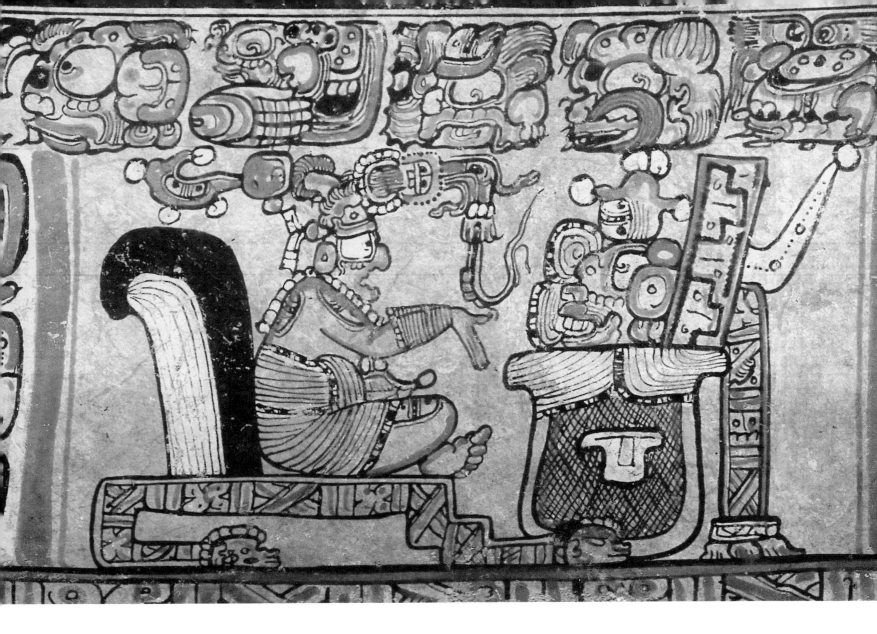

Pawahtún (God N)

Another aged god, Pawahtún, is far more widespread than
Itsamná on Maya ceramics dealing with scribes. As befits
Pawahtún's exalted status in the Maya pantheon, he too is
almost always enthroned, but never on a throne with "sky-
band" markings, and on some vases he shows deference to
his superior, Itsamná, by grasping his own upper arm with
the opposite hand. Pawahtún is a directional god, and thus
fourfold, which has led to the unsubstantiated claim by
some scholars that he is to be identified with the four
directional Bakab deities talked about in Landa's *Relación*;
but the phonetic reading of his glyphic name is clear: a
syllabic *pa* (represented by a netted element), a syllabic
wa (first detected by Karl Taube), and a logographic *tun*
sign. (As far as is currently known, the only mention of
Bakab in the inscriptions is as a title for rulers and other
high officials, and their spouses; Landa's Bakabs await
identification.) Iconographically, Pawahtún is distinguished
by his aged features and by his floppy, netted headdress,
possibly a rolled-up carrying bag made of agave fibre; this
is often worn by other supernaturals when they play the
role of scribal patron [see e.g. *Pl. 30, Fig. 82*]. Pawahtún is
very commonly depicted in both pottery and stone as an
old divinity wearing a snail shell on his back, or sometimes
crawling from it [*Pls. 78–80, Fig. 71*]. One of the most
compelling scenes on Codex-style Maya ceramics shows
Pawahtún twice (or perhaps in two of his quadruple
manifestations) as the teacher in a scribal school [*ill. pp.
2–3, Fig. 70*]. In both tableaux, brush pens are shown thrust
into his headgear, and the master is engaged in lecturing his
attentive pupils—an action indicated by the curlicue "breath
sign" connecting his mouth to the text. In the tableau in
which Pawahtún is pointing to an open codex with his pen,
he is reciting a series of bar-and-dot numbers: "7, 8, 9, 12,
13, 11," as if this were a lesson in mathematics.

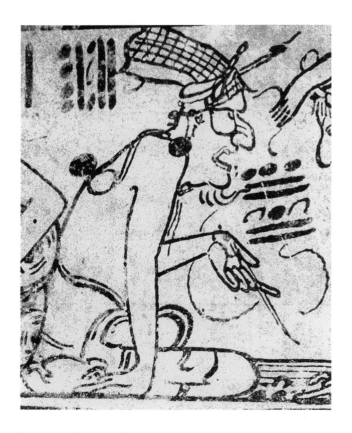

70 *Pawahtún teaching mathematics; bar-and-dot
numbers emanate from his mouth. A brush pen is thrust
into his netted headdress. Detail from a Codex-style vase,
eighth century.*

71 *Carved red-on-brown vase showing Pawahtún
emerging from his snail shell, within a palace marked by
a swagged curtain. The glyphs form part of a modified
Primary Standard Sequence. Late Classic, Guatemala.*

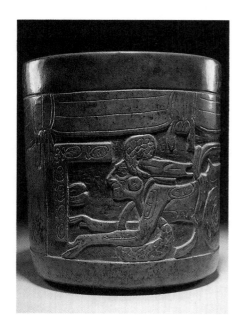

Insignia of the divine scribes

Other scribal deities are clearly subordinate to the all-powerful Itsamná and Pawahtún; while they are permitted to wear some of their superiors' insignia, such as Pawahtún's net-roll, the lesser supernaturals have headgear identifying them both as scribe and as *its'at*, "learned one." They may also be arrayed with their their own distinctive headdresses. First and foremost among this headgear is the "Spangled Turban" [*Pl. 4, Fig. 72*]. This is not really a wrap-around turban but some kind of padded element, presumably covered with small shell disks, which is tied at the back of the head with a cord; its use seems (with some exceptions) to be largely confined to supernaturals. Often thrust into it are brush pens and other artistic instruments such as the enigmatic curved tool. At the front of the Spangled Turban may appear the head of the Jester God in either fleshed or fleshless form, or a waterlily blossom. Sometimes present at the rear is Pawahtún's net-roll.

Another extremely significant element in the headgear of these divine scribes—and one *never* worn by mortals—is what has mistakenly been termed "Deer's Ears," thrust vertically or at a slight backward angle into the hair near the individual's "real" ears [*Figs. 72, 85*]. While they are vaguely shaped like the ear of a deer, when the latter item is shown in Maya art it almost always has the T120 ("question mark") glyph within it; by contrast, the scribal "ear" is never infixed with that, but almost always with the T504 "Akbal" sign standing for darkness (or, in a few examples, the T617 glyph, meaning "mirror" or "brightness"). Is what we are seeing even an animal ear at all? Justin Kerr has noted its resemblance to the cut conch-shell inkpot in Classic Maya art, and suggests that scribes may have sometimes thrust the small end of this container into their headgear [*Fig. 116*].[23] The writer feels certain that it is a feather pen held behind the scribe's ear by its quill. He bases

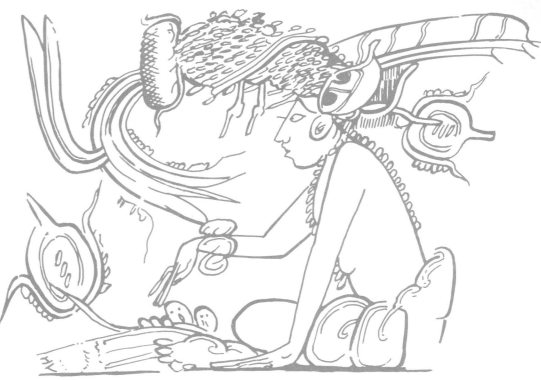

72 *Youthful god with Spangled Turban headdress and Deer's Ear or Feather Pen. From a Nakbé-style vase.*

his reasoning on a few examples on Classic ceramics [e.g. *Fig. 78*], where the object is shown in a less stylized, more realistic form, and is clearly a flight feather, and not a deer's ear—or a paint- or inkpot. This object will therefore be referred to here as the "Feather Pen." This is not to say, however, that in the kind of punning so common in Maya art, the painter could not have sometimes converted the quill pen (the existence of which will be argued in the next chapter) into the container into which it was dipped for its sustenance (ink).

A third element is what Maya iconographers have called the "Number Tree." Generated like a computer printout from beneath the armpit of some, but not all, of these deities, it is most common with representations of the Young Maize God acting as scribe [*Fig. 78*]. The Number Tree appears to be a sheet of paper on which is written a vertical column of bar-and-dot numbers, ending in branches with individual leaves, and occasionally stylized flowers. There can be little doubt that this is a symbolic representation of the *amate* tree, the source of the bark paper from which codices were made.

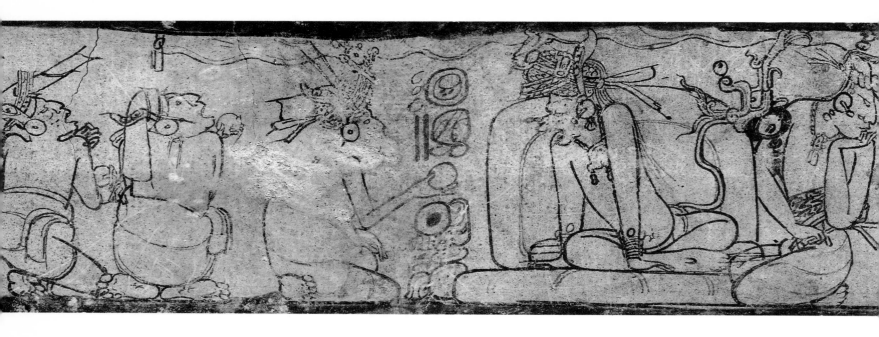

The Monkey-man Gods

The most striking of the lesser gods consist of a pair of beings with human bodies but simian or part-simian heads [*Pls. 30, 32, 33, Figs. 51, 73–75*]. These are the Monkey-men, known in the Quiché-language epic, the *Popol Vuh*, as Hun Batz and Hun Chouen—both calendrical names signifying the day 1 Monkey in the 260-day count; they are the malevolent half-brothers of the Hero Twins, turned by them into monkeys. Scribes *par excellence*, they are often shown on Codex-style and other ceramics actually writing in codices, or reading from them, and are frequently pictured with the Spangled Turban headdress into which pens and other writing instruments are thrust. On one Codex-style vase, there are not merely two, but four, Monkey-men in their own palace [*Fig. 73*]; three of them wear the "starched-napkin" headdress of apprentices, along with the Feather Pen, and pay homage to the fourth, who sports a Spangled Turban and is attended by a humanoid woman, apparently his wife.

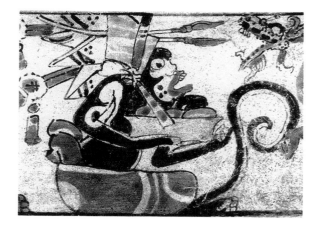

73 Monkey-man Gods in their own palace. Three of them hold what may be paper-polishers. The fourth, enthroned, wears the Spangled Turban headdress. Rollout from a Codex-style vase.

74 Monkey-man God with brush pens in his headdress, from a Late Classic polychrome vase.

75 Monkey-man Gods seated before a codex, from a polychrome vase.

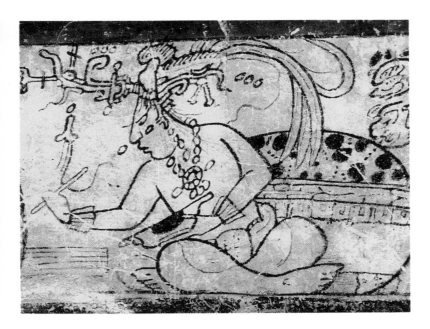

The Young Maize God (or Gods)

Rivalling the Monkey-men in frequency as a scribal patron
is the Young Maize God, the father of the Hero Twins
[*Pl. 12, Figs. 76–78*]. He is recognized, as Karl Taube has
shown,[24] by the elongated, tonsured head which seemingly
imitates the appearance of an ear of maize with its
surmounting cornsilk. Other identifying iconographic
elements can be the Jester God now and then affixed to the
front of the headdress [*Figs. 76, 77*; cf. *Fig. 106*]; sometimes,
as on a polychrome vase which shows the Young Maize God
engaged in painting the idol of the Bat God, the *its*- prefix
of Itsamná's name replaces the Jester God head [*Fig. 117*].
One might well ask, what led the ancient Maya to make an
agricultural deity a patron of scribes and writing? The
answer might well lie with the mode of paper preparation
practiced in ancient Mesoamerica; as shall be detailed in
the following chapter, this entailed soaking *amate* bark
fibres in a manner identical to that used to process maize
kernels before they could be ground into dough, and
involved boiling in the very water in which the maize had
been treated during the nixtamalization process. In the
conceptual world of the Maya, there must have been an
equivalence between their staff of life—their bread, if you
will—and the paper on which knowledge was recorded.

Somewhat disconcertingly, the Young Maize God very
seldom appears just once, but usually twice in the scenes
painted or carved on Late Classic ceramics. In the *Popol
Vuh* narrative, where he is called One Hunahpú, he has a
twin brother, Seven Hunahpú. Both make the descent into
Xibalbá, the Underworld, both lose their lives there, and
both are resurrected by the Hero Twins; so similar are they
that even the narrator seems at times to be undecided on
which particular brother he is talking about. Thus, we are
seeing here a pair of undifferentiated and, in fact, identical
twins depicted as handsome young princes. Perhaps to the
ancient Maya both fulfilled the same function as divine
patrons of maize and writing.

*76 The Young Maize God, with pen in right hand and
conch-shell inkpot in the left, painting a codex (shown
as a stack of sheets on the ground). His headdress is
a variant of the Jester God diadem.*

*77 The Young Maize God writing a codex bound in
Jaguar skin, on a Nakbé-style vase. He too wears a
version of the Jester God diadem.*

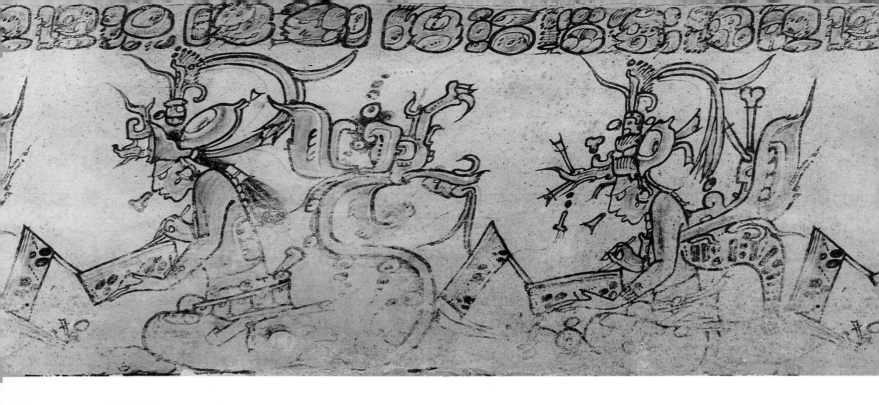

Hunahpú

The *Popol Vuh* tells us that the Hero Twins, Hunahpú and Xbalanque, were fathered by the disembodied head of the Young Maize God One Hunahpú as it hung in a tree in Xibalbá. In Classic Maya iconography, each of these offspring is easily distinguished from the other by body and facial markings: Hunahpú has black spots on the body and cheek, while his sibling Xbalanque bears patches of jaguar skin in the same places (and often has chin whiskers) [*Fig. 9*].²⁵ It is Hunahpú who was, along with Itsamná, the deity most closely associated in the Maya mind-set with the idea of kingship, for his image—in head or full-figure form—was frequently used as a substitute for the more usual glyph standing for both the day sign Ahaw and for logographic *ahaw*, "king" or "ruler" [*Pls. 34, 35, 37, 45*]. Both twins may wear a kind of broad headband with a Jester God frontal element, but when only one of the pair is so shown, it is likely to be Hunahpú rather than his brother.

There can be little doubt that Hunahpú was a very important patron of the scribes and artists—in spite of the fact that the malicious half-brothers of the Hero Twins (the Monkey-man Gods) were even more closely associated with the arts than he. On Copán's Stela 63, the *its'at* glyph consists of the head of Hunahpú with the Feather Pen thrust through the headband in front of the ear [*Fig. 79*]; this remains an acceptable logographic form for the word all through the Classic period, but sometimes it may be replaced by the head and Spangled Turban of a Monkey-

man scribe. Yet Hunahpú may act not just as an *its'at* but also as an *ah k'u hun* scribe, as on a black-background polychrome vase [*Pl. 34*] where he is enthroned, presumably in his own palace. And on a fine Nakbé-style vase [*Fig. 78*], he appears with his father—the Young Maize God whom he had brought back to life—in a scene in which both deities (complete with Number Trees and Feather Pens) are busily writing in open screenfold books [cf. also *Fig. 115*].

78 Hunahpú and the Young Maize God writing codices with quill pens. Rollout from a Nakbé-style vase, eighth century. (For the PSS band, see Fig. 32.)

79 An Early Classic glyph representing Hunahpú as an its'at *("sage"); the object thrust into his headband may be a stylized quill pen. From Stela 63, Copán, set up about 435.*

80 Hunahpú holding a conch-shell inkpot and what may be a paper-polisher, from a polychrome vase.

81 *The Vulture God, writing by night in a scribal palace presided over by Hunahpú (see Pl. 34).*

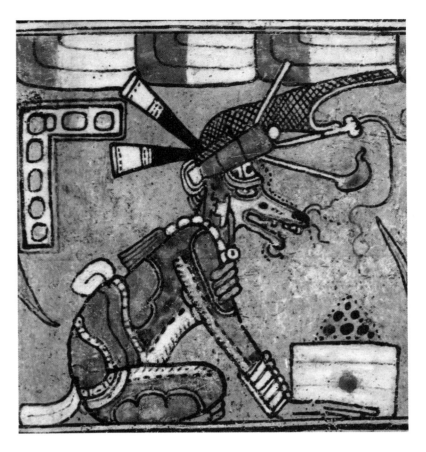

82 *The Fox God appears in the center of this rollout from a polychrome vase, seated before Itsamná in the latter's palace; he wears the netted headdress of Pawahtún, from which protrude various carving tools.*

The Vulture God

Less easy to deal with in Classic Maya iconography is the Vulture God: although we have a number of images of him from both the Classic and Post-Classic (for instance, in the Dresden Codex), there is little in the way of recorded mythology to explain this imagery. But the Vulture God must be connected in some way with royalty, for in Classic inscriptions a vulture head is another acceptable logographic substitute for *ahaw*. Be that as it may, there is no room for doubt that the Vulture God was also a scribal patron, for on the same black-background polychrome referred to above [*Pl. 34, Fig. 81*], he wears the Spangled Turban; is seated before a codex with jaguar-skin cover; and is about to dip his pen into a conch-shell inkpot.

The Fox God

I have dubbed a supernatural with human-like body and head of a fox "the Fox God." Not very frequent in Maya art of any period, when he does appear he wears the distinctive netted headdress of Pawahtún and would seem to have been a subordinate of that aged but powerful divinity. On one vase in the collection of Dumbarton Oaks [*Fig. 82*], thrust into his headgear are various bone instruments which it will be suggested in the following chapter were used for sculpting and writing in malleable materials like clay and stucco. If the Fox God fails to rank as a patron of those who wrote on paper, at least he seems to have been involved with the plastic arts.

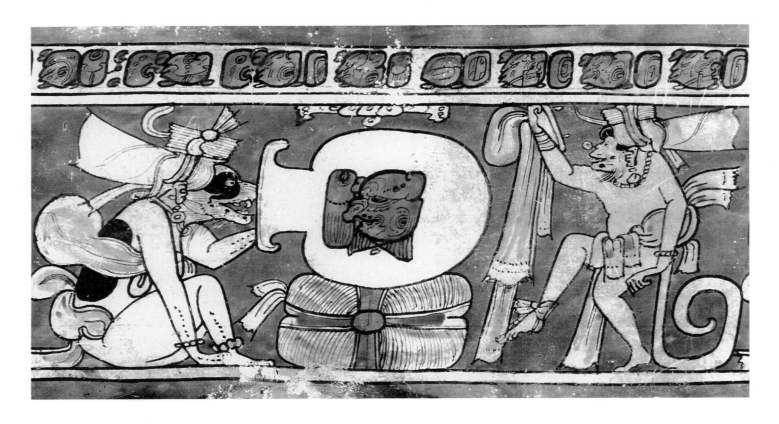

Other divinities

Of far less significance than all of the above described deities are "one-of-a-kind" appearances of other supernaturals in scribal or artistic roles.

The much-illustrated little Rabbit God writing a codex on the Princeton Vase [*Fig. 84*] makes only one showing as a scribe in the art of the Classic Maya. He must be the same rabbit that the Maya saw on the face of the moon, and is iconographically linked with the Moon Goddess, who often is depicted holding him in her arms [*Fig. 89*]. And on another polychrome vase [*Fig. 83*], the artist has painted a dancing Monkey-man God along with a black-

spotted Dog God, both wearing the characteristic headdress—complete with "stick bundles"—of the *ah k'u hun* scribe.

With this supernatural inventory, the survey of what is presently known about the social, political, and mental world of the scribes is complete. The following chapter will describe the materials upon which they wrote, the tools with which they wrote, and how they wrote.

83 ABOVE The Dog God attired as an ah k'u hun. *Balancing him, in this rollout from an eighth-century polychrome vase, is a Monkey-man God with similar attributes.*

84 The Rabbit God writing a codex with what appears to be a quill pen. Detail from the Princeton Vase, eighth century.

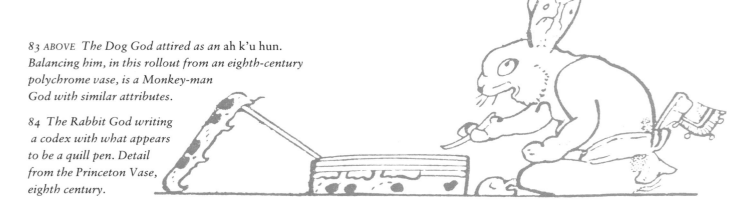

HOW THE MAYA WROTE: SURFACES, TOOLS, AND CALLIGRAPHIC TECHNIQUES

4

38 Marine and freshwater shell was a prized material for Maya scribes and artists. The nacreous interior of this shell was carved in the Late Classic period with the figure of a woman appearing in a mountain cave; the lightly incised text is too fragmentary for a reading.

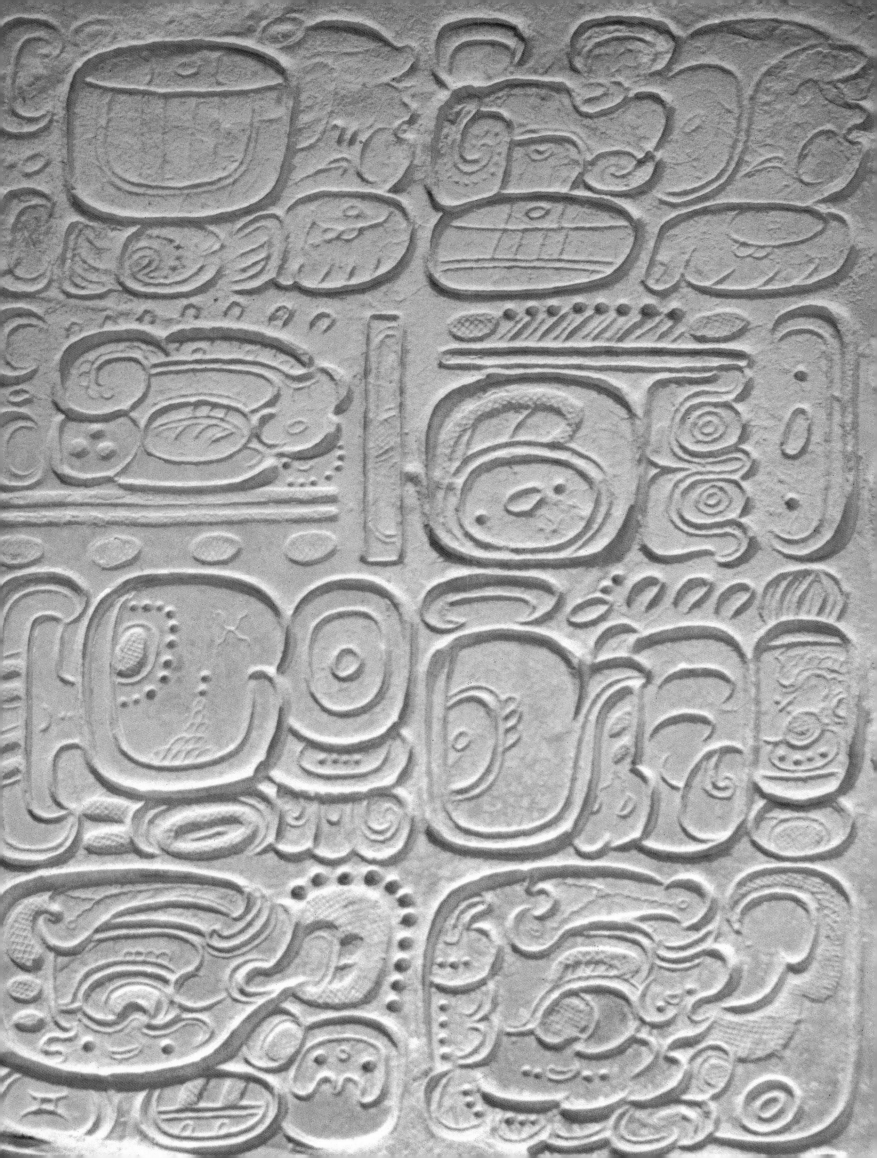

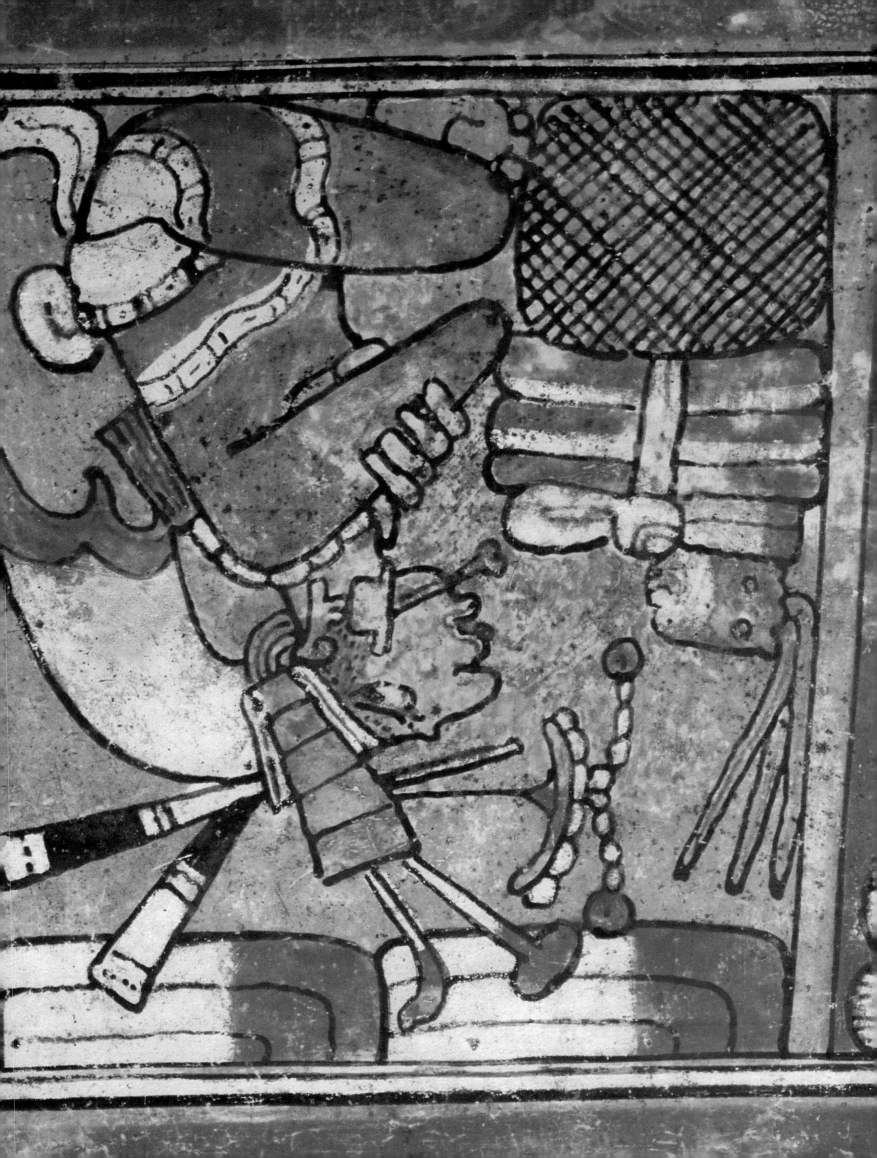

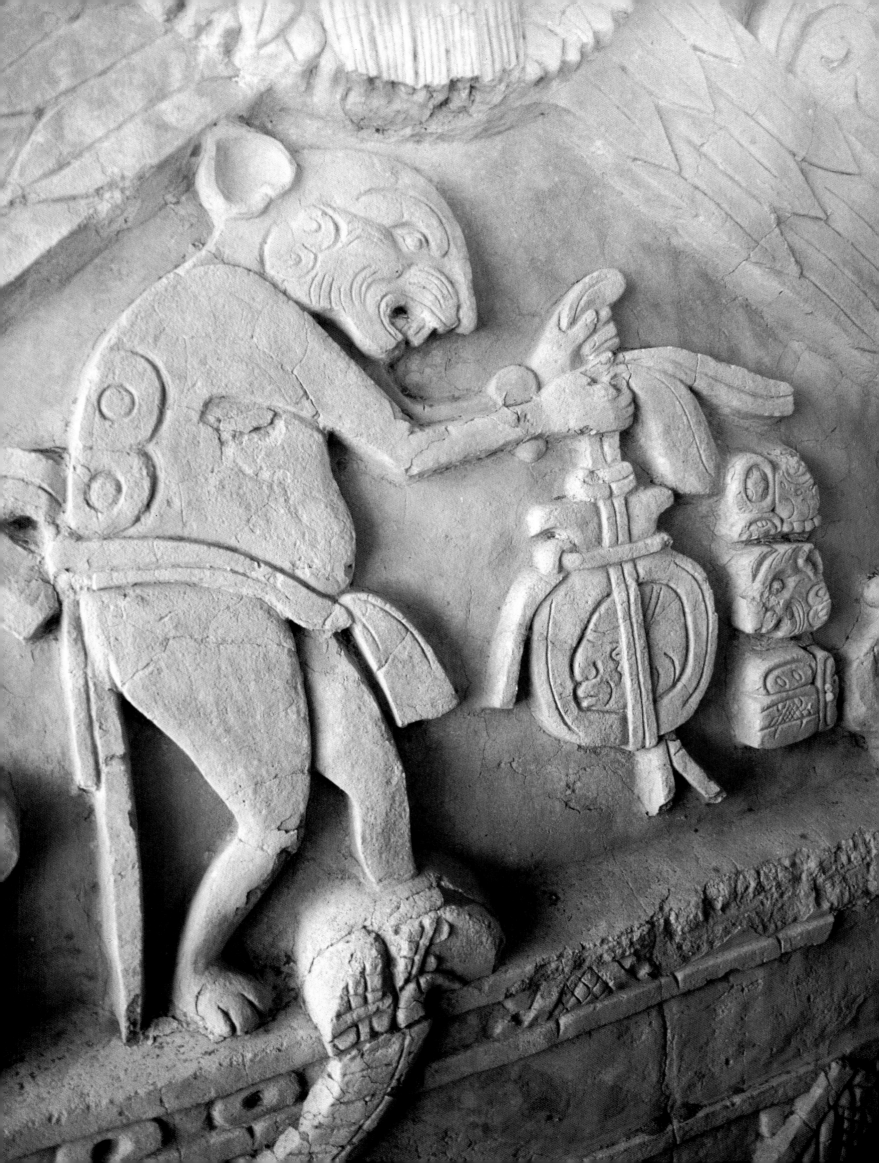

In the Late Classic cities of the eastern Petén, some outstanding calligraphy strongly resembling the style of Naj Tunich cave (Figs. 2, 96) appears on black-and-white vases; in lieu of painted scenes, diagonal texts often appear below the PSS.

49 ABOVE Vase with the name of the ruler of Ucanal.

50 RIGHT Vase painted by Ah Maxam, a distinguished scribe of Naranjo. Circling the rim is the PSS, indicating that this was a vessel for chocolate drink; along the base is a second text giving Ah Maxam's name, titles and royal descent (see Fig. 57).

51 OPPOSITE The boldly painted glyphs of the PSS and the still-undeciphered text on this eighth-century polychrome vase from the Petén (see also Pl. 116) have been rubbed with light pink color produced by mixing red and white slips, resulting in a "blush" effect. For the sequence in which these individual glyphs were drawn, see Fig. 123.

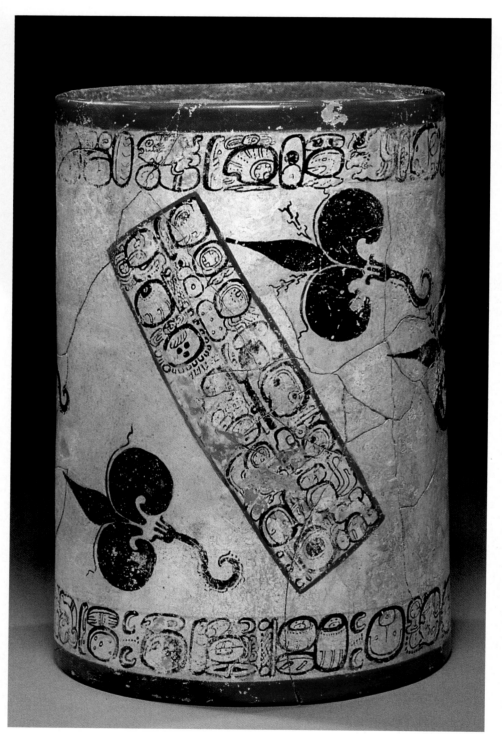

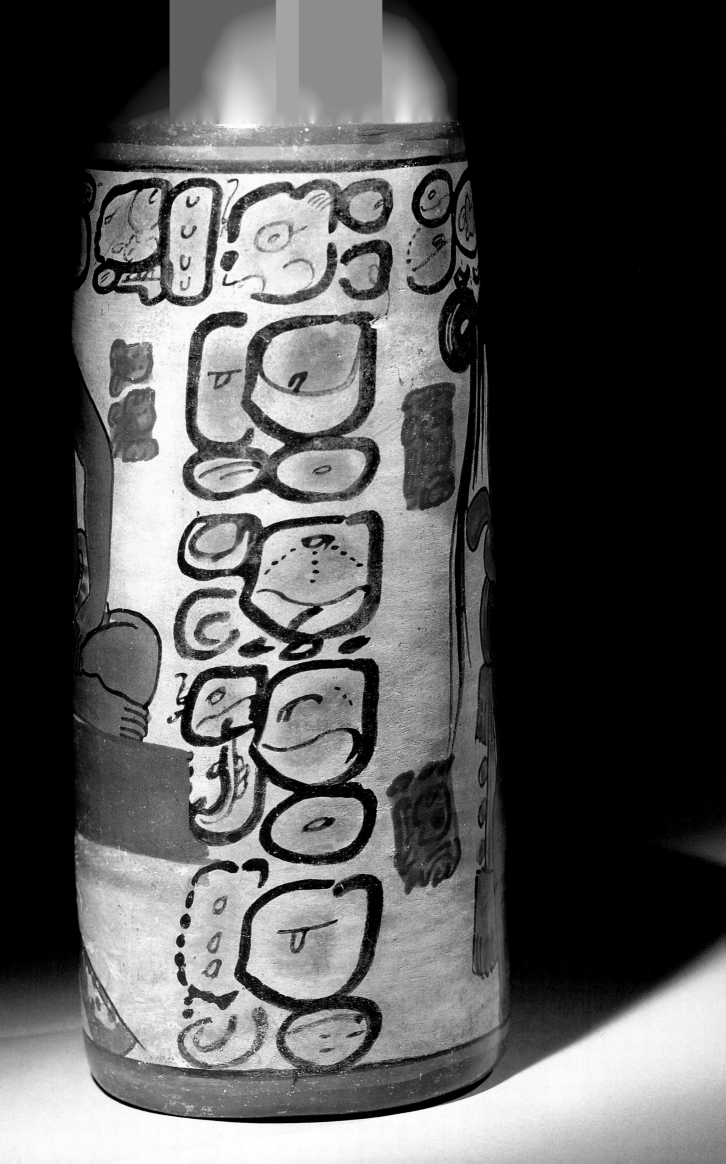

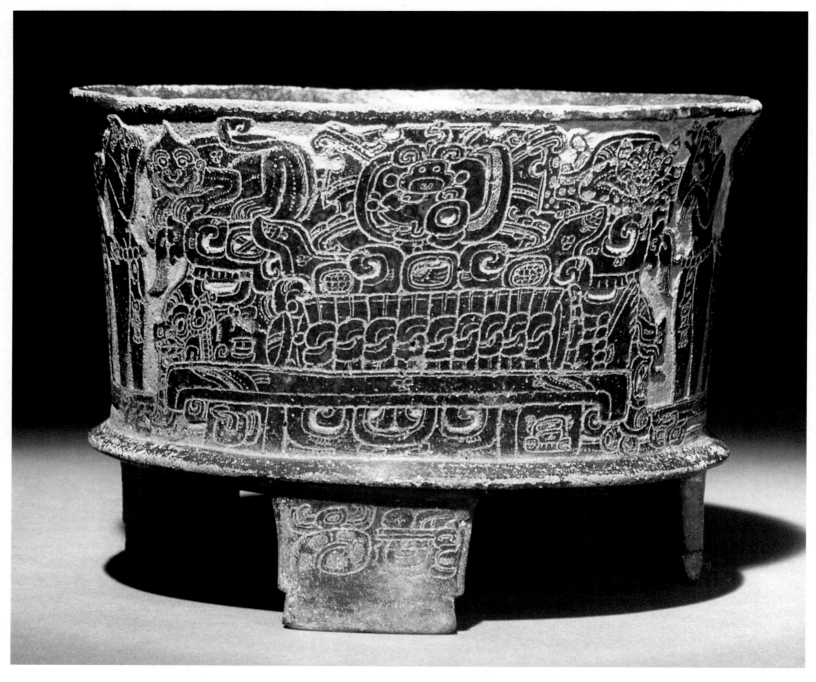

52 During the Early Classic in the Petén, powerful influence from the Central Mexican city of Teotihuacan resulted in the production of many carved and incised vases with slab legs, but which usually lack written texts. On this example, the corpse of a dead ruler, wrapped in knots, is displayed on a throne beneath a monkey and a jaguar representing his animal counterparts. The incised writing is confined to the feet.

53 OPPOSITE Hundreds of these small clay flasks from the Late Classic appear in private collections, but their function is unknown. They often have moldmade scenes impressed on one or both sides. This example illustrates a scene in the *Popol Vuh*: during the ballgame, the ball turns into a rabbit. The glyph on the creature's body seems to give the size of the ball.

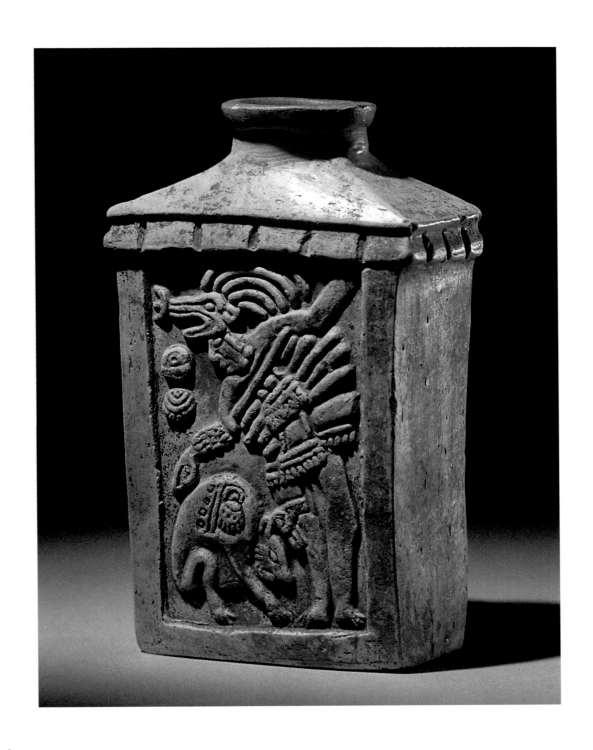

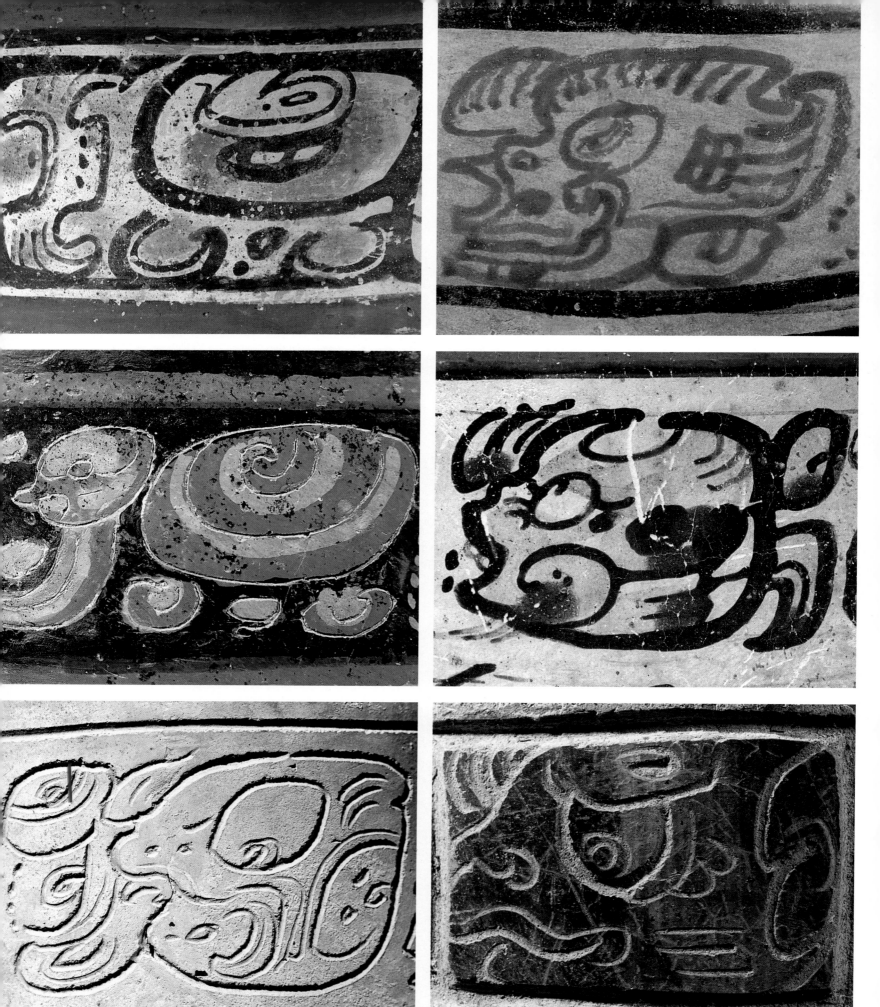

Many different calligraphic styles and hands can be detected in texts on Classic ceramics, particularly in the ubiquitous Primary Standard Sequence or PSS, seen in all but Pls. 64 and 65.

54-56 LEFT COLUMN The Initial Sign. The central one appears on a vase painted in a complex, four-color resist technique (see Pl. 113); that at the bottom, incised, is a variant form.

57, 58 RIGHT, TOP AND CENTER Versions of *kakaw(a)*, "cocoa."

59 RIGHT, BOTTOM An unknown sign, incised (see Pl. 101).

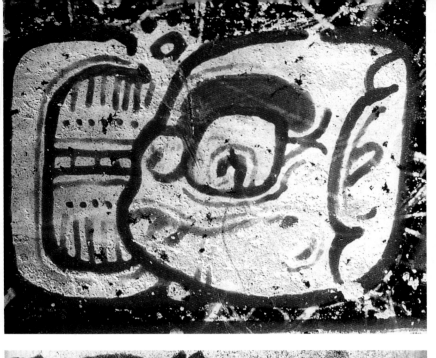
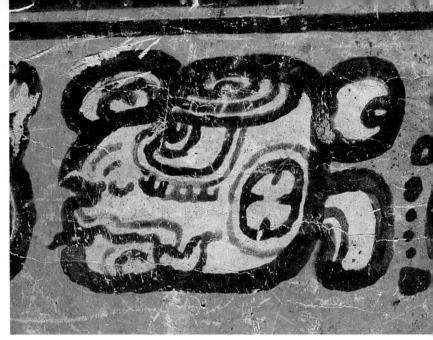
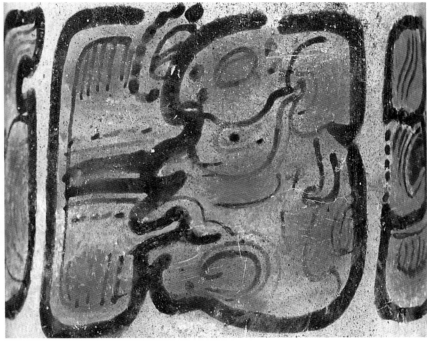

60, 61 LEFT, TOP AND CENTER Versions of *ts'ib*, "writing."

62 RIGHT, TOP Glyph for *kinich ahaw*, "the sun-eyed king," on a Chamá vase.

63 RIGHT, CENTER "Bat" glyph (phonetic *ts'i*), on a vase from the eastern Petén.

64 BOTTOM LEFT Glyph compound incised on an Early Classic travertine bowl from Burial 48 at Tikal.

65 BOTTOM RIGHT Glyph compound with the god Pawahtún on the right: Late Classic carved and incised shell.

The basic tools of the Maya painter/scribe were pens and a conch-shell inkpot; of those responsible for carving and incising clay, various sculptor's implements of bone and perhaps obsidian.

66 BELOW Conch-shell inkpot with remains of *ch'oben*, hematite paint; the underside (see Fig. 119) is incised with a Calendar Round date corresponding to 17 March 761. The right-handed scribe held such objects in his left hand while writing.

67 BOTTOM A scribal patron deity, probably Hunahpú, emerges from a waterlily (symbolic of the brush pen), holding a conch-shell inkpot topped with what may be a paper-polisher. Late Classic.

68 OPPOSITE Enlarged detail of a rollout from a Late Classic vase. An unidentified scribal deity with sculpting tools in his headdress faces what may be a packet of folded paper (or cloth) atop an offering bundle. The text to the left of the scene was written with a brush pen; it superficially resembles a Long Count inscription with its Introductory Glyph, but although glyphs of several gods can be recognized, it cannot be deciphered.

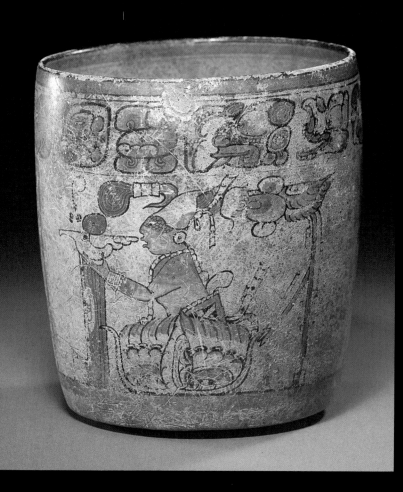

46 The living-rock walls of this Early Classic tomb at Río Azul, in the northeastern Petén, were painted in black and red by an artist-scribe with a large brush. On the rear wall is a Long Count inscription giving the birth date of the defunct, corresponding to 29 September 417.

47 Almost four centuries later, a team of Maya artists and scribes produced the splendid murals of Bonampak, Chiapas. Although the texts are sadly deteriorated, these figures of musicians still retain their brilliant colors and suggest the splendor of Maya court life.

48 OPPOSITE Almost all Classic Maya buildings of any importance had vast amounts of carved and painted stuccowork on the exterior, but most has disappeared. This recently discovered Late Classic stucco relief at Toniná illustrates an episode in the *Popol Vuh* epic, where a rat brings to the Hero Twins the rubber ball of their father and uncle. Three glyphs on the right name this creature.

45 All of this cut conch-shell object, carved in the Late Classic period, is a single glyph, the day
Ahaw—the last of the twenty named days in the Maya "week." The bust of its patron deity, the
Hero Twin Hunahpú, appears within the day-sign cartouche.

42-44 Jade was always the most precious substance known to ancient Mesoamericans, and the Maya were no exception. Notwithstanding its hardness, it was often incised by scribes. An Early Classic pendant (TOP) represents a god of decapitation, and bears on its reverse six glyphs which seem to record Tikal's conquest of Uaxactún. Two Early Classic ear flares (ABOVE, seen on a mirror) are incised with a text stating that they belong to a lord of the Río Azul city-state.

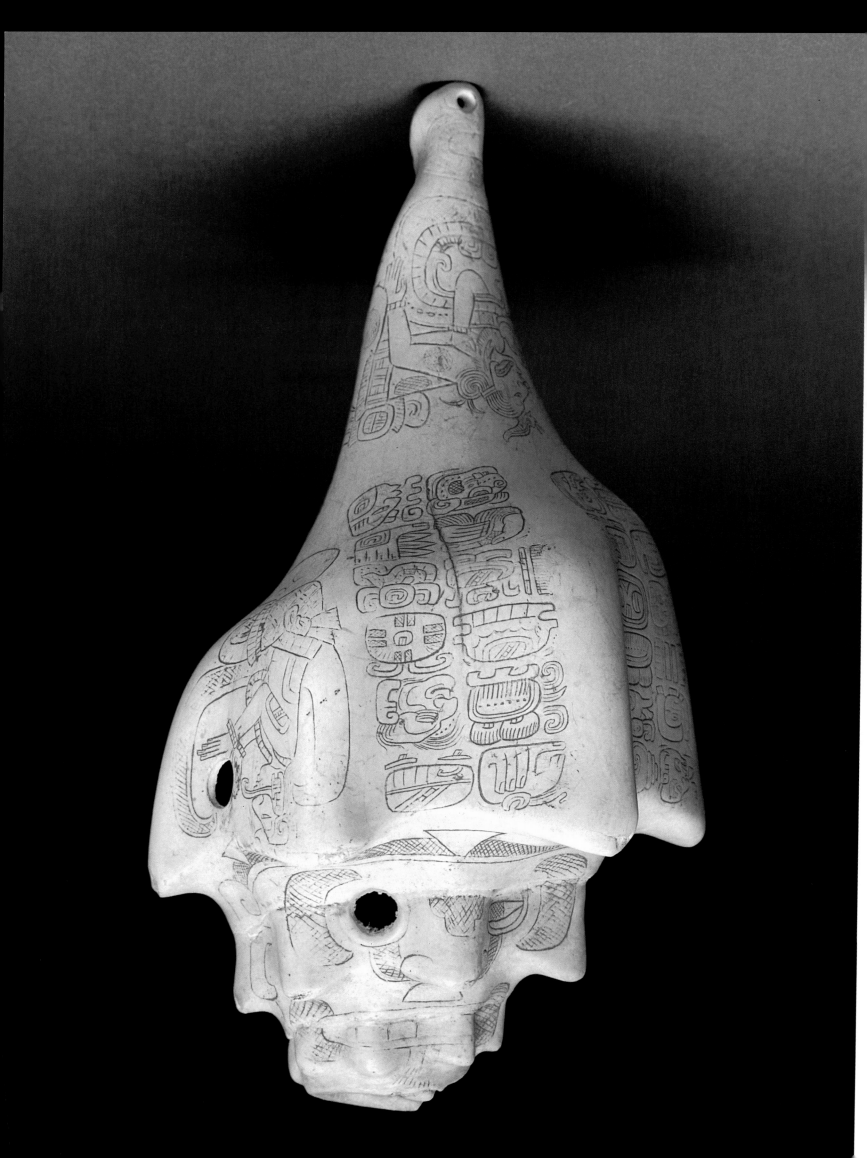

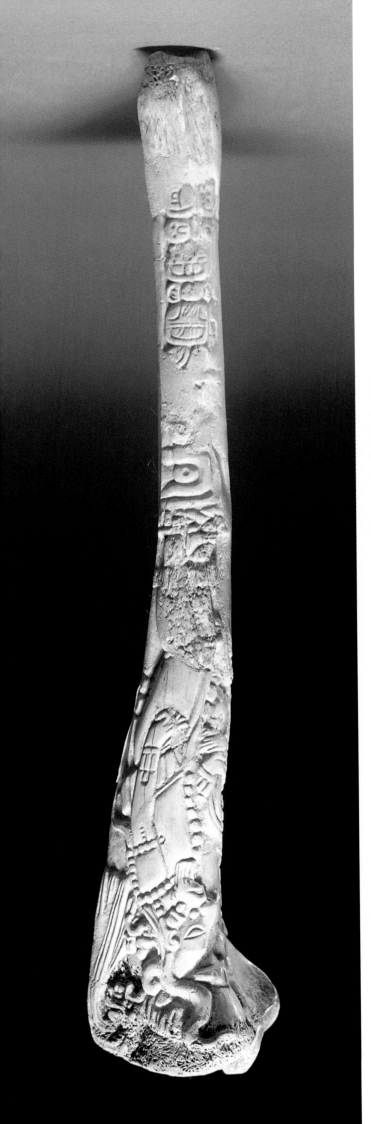

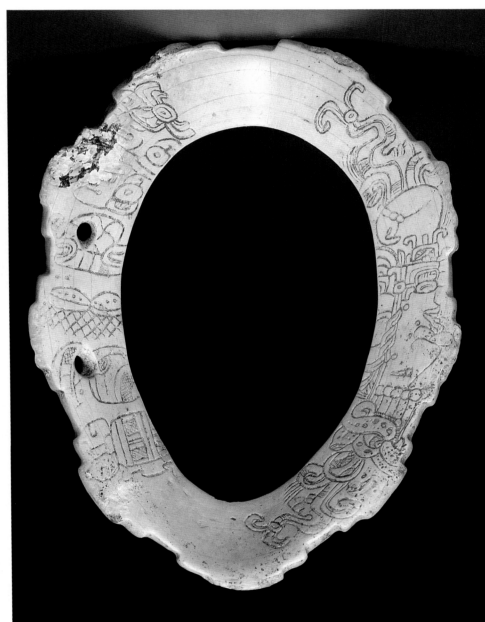

39 ABOVE An Early Classic pendant cut from a conch shell; to the left is
the figure of a king or youthful god, and to the right a six-glyph text,
which reads the other way up.

40 RIGHT Classic artists also sculpted scenes and texts on long bones
from animals and humans. This human femur, a trophy from a high-
ranking captive, bears the Late Classic portrait of his royal captor,
as well as a short text carved in monumental style.

41 OPPOSITE Plain conch-shell trumpets were common offerings in
elite Maya tombs, but this elaborately incised Early Classic example
is unique for its fine text and representations of a Moon God (on the
right) and the Hero Twin Hunahpú (below). The text includes a
reference to ceremonial bloodletting.

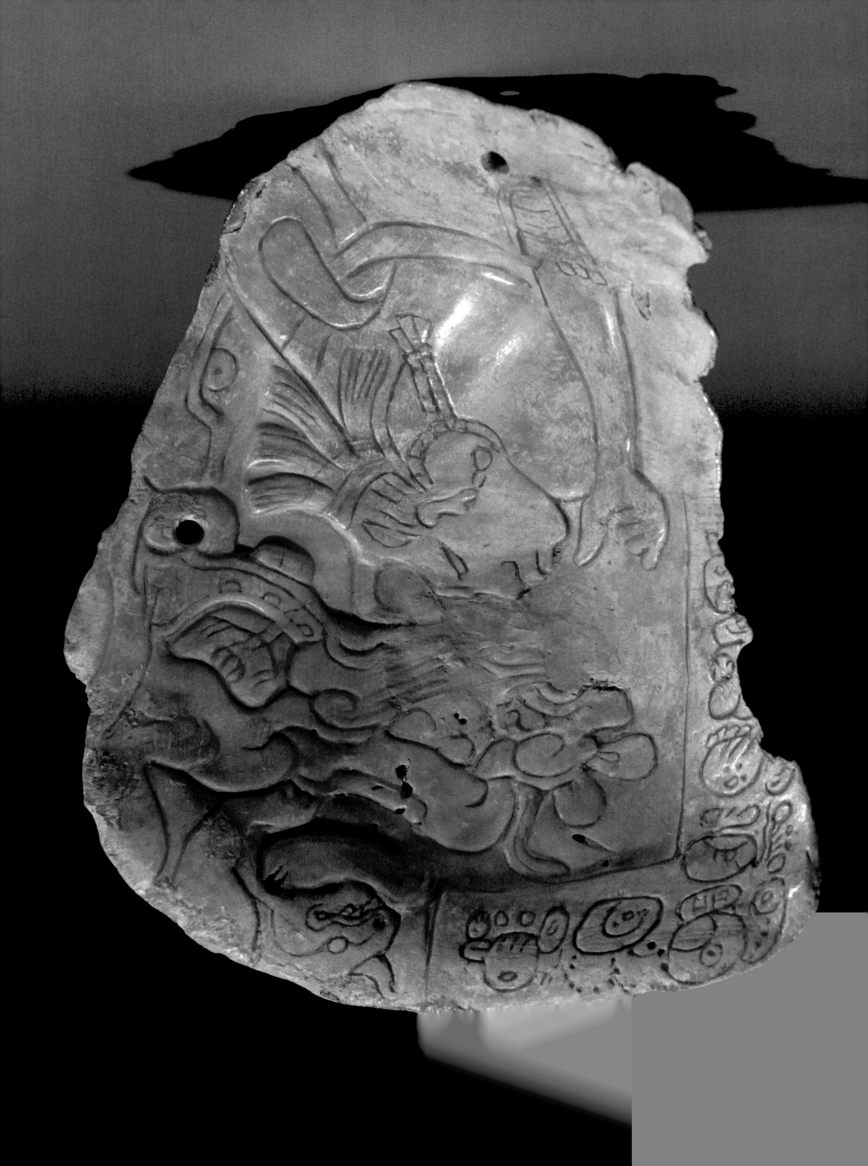

HOW THE MAYA WROTE: SURFACES, TOOLS, AND CALLIGRAPHIC TECHNIQUES

An Islamic author once said that writing is "the language of the hand, the idiom of the mind, the ambassador of intellect, and the trustee of thought, the weapon of knowledge and the companion of brethren in the time of separation."[1] And to the ancient Greek thinkers Euclid, Galen, and Plato the Islamic world variously attributed the statement, "Handwriting is spiritual geometry by means of a corporeal instrument."[2] This intimate link between mind, hand, and writing instrument is one recognized wherever writing was practiced as a fine art, and in this respect the world of the Maya scribes—particularly in the Classic period, the apogee of Maya calligraphy—could have been no different. Yet the testimony of these great Maya artists of long ago is lacking: it is only through a detailed analysis of their works, and from pictorial representations on ceramic vases and the like, that the tools, techniques, and attitudes of the ancient masters of the calligraphic art in southeastern Mesoamerica can be reconstructed.

Just as the use of parchment, paper, and the reed pen have guided the course of Islamic calligraphy over the past twelve centuries, and paper, silk, and the flexible brush pen that of China over a far longer period, so have the materials available to the Maya scribes—the surfaces and the writing implements—conducted them to graphic solutions that are uniquely theirs. Although other tools were used by the painters and carvers of texts, it is the brush pen that eventually came to dominate the Classic Maya calligraphic style, much as it did the calligraphic traditions of the Far East; as will be shown, even the most three-dimensional sculpting of stone or incising of extremely hard materials like jade took on the fluid characteristics imposed by the brush as it was manipulated by the skilled hand of the accomplished Maya scribe. But it will also become clear in the course of this chapter that even the brush pen had its limits, and this particularly applies to the production of screenfold books, where minuscule scripts seem to have called for the same kind of quill pens in use among the scribes of medieval Europe.

SURFACES

Even though there are literally thousands of extant Maya texts available for study, these surely constitute only a tiny fraction of what once must have been the total corpus. With a few notable exceptions (such as the magnificent carved lintels of Tikal, just about everything carved or written on wood in the humid lowlands has irrevocably disappeared. Undoubtedly, on the testimony of the Bonampak murals, glyphic texts were painted on, or woven into, textiles that were used not only for clothing but for temple hangings as well. The loss of the vast libraries that must have existed in Classic Maya centers has already been alluded to. But a disappearance on what may have been an even larger scale consists of the texts carved, painted, or molded in stucco on the exteriors of major structures—and perhaps even minor ones—within each Classic city. These were highly visible surfaces for public display, and would no doubt have played a role equal to or even at times surpassing that of the open-air stone monuments in promulgating the political and religious messages formulated by the rulers and "learned ones" of the Maya city-state. Sadly, apart from the extensive texts on Temple VI at Tikal and Temples 11 and 18 at Copán, and on various structures at Xcalumkin in Yucatán, only ruined fragments of architectural texts have survived eleven centuries of neglect, vandalism, and erosion.

69 The pinnacle of Maya monumental calligraphy was reached during the Late Classic at Palenque. Carved and incised on lithographic-quality limestone by a master scribe in 783, the Tablet of the 96 Hieroglyphs–shown here in a detail–is one of the latest inscriptions at the site (cf. Fig. 86).

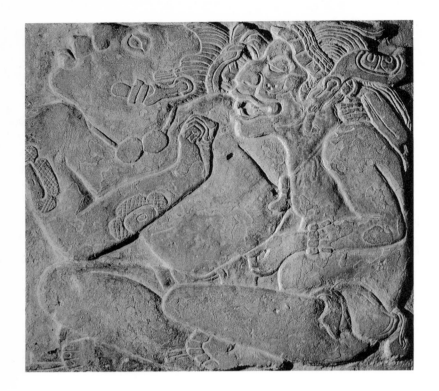

85 *Full-figure glyph from the Tablet of the Palace, Palenque. It appears in the final position of a Long Count date; the figure on the left represents the number zero, while the right-hand figure (the Monkey-man God with Deer's Ear or Feather Pen) stands for k'in, "day."*

86 *Detail from the Tablet of the 96 Hieroglyphs, Palenque, one of the outstanding examples of Classic calligraphy. Dating from 783, it contains the dynastic history of the city from Pakal (d. 683) until the current king. The glyph seen here reads "K'inich Hanab Pakal," the full name of the great Palenque ruler.*

Nevertheless, Maya writing appears on a surprising range of materials, which include limestone, volcanic tuff, sandstone, stucco (used for sculptural writing as well as to coat walls and pottery surfaces to be painted), wood, jade and other hard stones (such as obsidian), bone, shell, ceramics, and, last but not least, paper.

MONUMENTAL STONE

The raw material from which Maya artisans roughed out the stelae, altars, thrones and benches, lintels, and panels on which trained sculptors and scribes were to work had first to be quarried, then transported to the artists' ateliers. Because most of the Petén-Yucatán peninsula consists of limestone, that material was available almost everywhere, but it did vary in suitability and quality. At one end of the scale is the limestone used for the standing monuments of

87 *Detail from the Lápida de la Creación, Palenque, another calligraphic masterpiece carried out on lithographic limestone. Such texts were surely painted on the stone's surface by an ah ts'ib before carving and incising took place.*

130

88 Inscribed column from Xcalumkin, northwest
Yucatán, eighth century. Although northern scribes
did sign their works, the calligraphic quality of their
inscriptions is far inferior to that of their colleagues
in the southern lowlands.

88 Inscribed column from Xcalumkin, northwest
Yucatán, eighth century. Although northern scribes
did sign their works, the calligraphic quality of their
inscriptions is far inferior to that of their colleagues
in the southern lowlands.

Calakmul, which is porous and highly subject to erosion,
hence the extraordinarily poor state of preservation of its
numerous carved stelae (most of them now illegible). At the
high end of the scale, the accomplished artist/calligraphers
at Palenque had available to them a remarkably fine,
yellowish-tan limestone of lithographic quality, which was
quarried from layers exposed in nearby stream beds; small
wonder that the acme of Classic period calligraphy is to be
found on panels from this city [Pl. 69, Figs. 85–87]. The
limestone used in the cities of the northern part of the
peninsula (as, for instance, at Xcalumkin [Fig. 88], Uxmal,
and Chichén Itzá) falls somewhere between these two
extremes, although when exposed to the elements it also
deteriorates rapidly; and the texts themselves, while
interesting and informative about northern Maya politics,
are of little aesthetic value.

When freshly quarried, limestone is relatively soft and
would have been easily worked with the stone tools available
to Maya stonemasons [see Fig. 111]; it hardens on exposure
to air. For this reason, and for its near-universal availability,
it was the raw material of choice throughout the lowlands
for monumental carvings and inscriptions, except at Copán
and Quiriguá. Yet, on account of its friability, limestone is
far more suitable for reliefs than for in-the-round sculpture.
It is true that much harder rocks like granite or andesite
could be obtained from sources in the highlands and in
the Maya Mountains of Belize, but other than the Late
Pre-Classic monuments of Kaminaljuyú (perhaps not even
Maya!) [Fig. 38] and other early sites, these were ignored by
Maya masons and artists: they were just too hard to work,
and the highly calligraphic and brush-based Maya style
called for more malleable surfaces. The ancient lowland
Maya did use granite, but only for utilitarian *metates*
and *manos* (grinding stones for maize preparation).

The geologic situation of Copán, on the southeastern
frontier of Mesoamerica, is very different from the rest of
the lowlands.³ The rocks of the Copán Valley are largely of
volcanic rather than sedimentary origin, and consequently
limestone is rare to absent (this made the production of
the lime mortar and stucco so important in other Classic
cities nearly impossible). In its place, the stonemasons and
sculptors of Copán substituted a green volcanic tuff of local
origin, which was remarkably suitable both for building
stone and for carving, with excellent durability under the
wet, tropical conditions prevailing in the Valley. In the hands
of the great sculptor/calligraphers of the city, it became

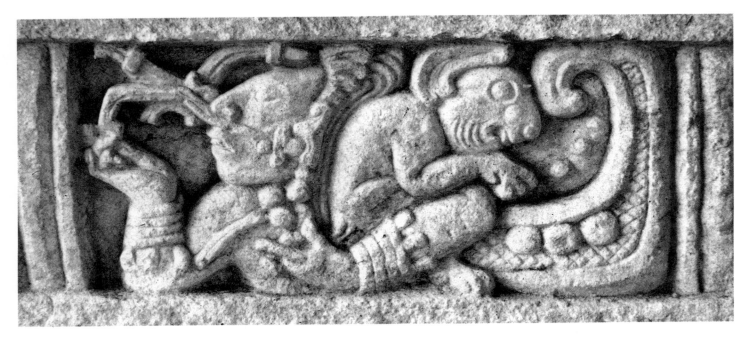

the vehicle for a notable, almost baroque, style of three-dimensional sculpture, accompanied by some of the most complex texts ever created by the Classic Maya [*Figs.6, 89, 90*].

Even more striking than Copán's monuments are the gigantic stelae and zoomorphs of Quiriguá [*Figs. 91, 92*], which lies to the north of Copán in the Motagua Valley (the major source of jade to the Classic Maya, and perhaps the basis of this modest-sized city's wealth and power). The art historian Andrea Stone, who has made a study of these monuments, tells us that except for Zoomorphs M and N, which are of rhyolite, and some small Early Classic stelae, all of them were fashioned from a locally quarried, brownish sandstone of high quality and durability.[4] The size of the stelae—the largest known for the Maya—has astonished archaeologists and travelers since the days of Stephens and Catherwood: Stela E, for example, is no less than 10.7 m. (35 ft.) high. On both stelae and zoomorphs the sculptural scribes surpassed themselves in the production of the most intricate, imaginative public texts ever devised—rivals to the great architectural calligraphy of the Islamic world.

There is every reason to believe that all Maya monumental texts were first painted on the prepared stone surfaces, before the carver or carvers took over; the most compelling evidence is the nature of the writing itself, which

89 Glyph of the Moon Goddess with the Rabbit God (Mesoamericans, like the Chinese, saw a rabbit on the lunar surface), from a bench in the scribal compound of Copán. Late Classic.

90 Full-figure glyph from Stela D, Copán, a monument dedicated on 26 July 736. The baroque-sculpted figures express the dedication event, the "planting" of the stela by the king "18 Rabbit" (who was to be defeated by Quiriguá and beheaded less than two years later).

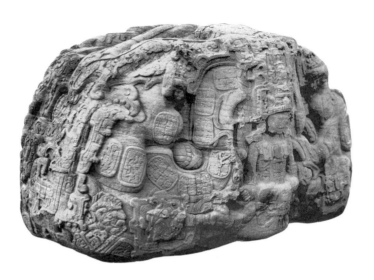

91 *Monument 16 (Zoomorph P), Quiriguá, dedicated in 795. A young ruler appears in the mouth of a zoomorphic mountain cave; the extensive and complex text has been arranged in cartouches and panels around the convoluted surface.*

92 BELOW *The full-figure glyph "7 Ahaw" on Stela D (east side), Quiriguá, dedicated in 771. On the left is the God of Number Seven; on the right, the day Ahaw is represented by the bust of Hunahpú within a cartouche (cf. Pl. 45).*

93 RIGHT *Sculptors' signatures on Stela 31, El Perú. Each begins with the* yuxul *expression denoting carving (see Fig. 45), and each is in a different "handwriting."*

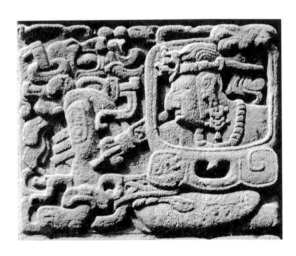

clearly mimics in stone the movement of flexible brush tips. The *ah ts'ib*, or artist/calligrapher, would first have covered the surface with the gridline network within which the hieroglyphic blocks were arranged [cf. *Fig. 15*], then painted the glyphs themselves. This was a practice known also in the Old World—for example, on the evidence of the lettering it is thought that the magnificent public inscriptions of ancient Rome were first painted on the marble surface with a chisel-like or flat brush before being cut into the surface of the stone. In the case of the Classic Maya, what we do *not* know is the relation between the painter and the sculptor, since on signed reliefs it is only the name of the latter that appears after the initial statement *yuxul*, "the carving of..." [*Figs. 3, 45*]; were the painter and sculptor one and the same? A further mystery is posed when there are the signatures of several carvers on the same relief (no less than eight, all in different "typefaces," appear on Stela 31 from El Perú [*Fig. 93*]):⁵ exactly who was responsible for what? It is almost as if some carvings with their accompanying texts were carried out by a committee, not a recommended way to produce great art! Nonetheless, in the case of truly beautiful texts, like those incised on some of the panels at Palenque [*Pl. 69, Figs. 85–87*], there can be little doubt that the writing was both painted and then cut by one and the same master.

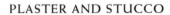

94 *Personal name of a military officer depicted in the mural of Room 1, Bonampak, late eighth century. The glyphs are painted in red against a cream background; because of his subordinate status, this individual lacks any kind of title, as well as the royal Emblem Glyph.*

95 *Stucco glyphs from Temple XVIII. Palenque. The entire text of approximately 130 glyphs was found fallen and in pieces, so the reading order is uncertain.*

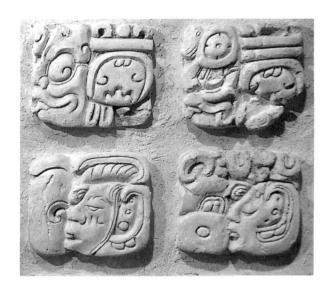

PLASTER AND STUCCO

The staggering amounts of mortar, plaster, and stucco that must have gone into constructing the average Maya city [*Pls.* 2–4] boggle the mind. The exterior of every building, every room in that building, every roof-comb, and every plaza floor was coated with a thick layer of plaster and often painted; the structures themselves, except at Comalcalco where brick [*Fig. 14*] substituted for stone, had interior cores of broken limestone rubble bonded with cement-like mortar. To produce this vast quantity of material required an equally vast amount of firewood to convert the limestone (or shell, as at Comalcalco) into quicklime which, slaked with water, became hydrated lime. The severe deforestation that is now known to have taken place throughout the southern lowlands in the Late Classic may have been in large part the unfortunate result of this culturally necessary but ecologically wasteful practice.

Mortar is a bonding material and need not concern us here. Plaster (calcium carbonate), as defined by the chemist Edwin Littmann,[6] is "an essentially flat, external coat over a monolithic mass, used primarily as a protective medium or as a surface for mural painting." Elsewhere in the world, plasters generally have an aggregate of quartz sand mixed in; but in the Maya area, the only aggregate is a naturally sand-like, calcareous material known as *sascab*. In the early part of the twentieth century, Carnegie Institution archaeologists working in Yucatán were told by their Maya laborers that they mixed honey or an extract from the bark of certain trees with wet lime plaster to give it extra strength and toughness, and that may have been what their ancestors had done in the past. By thin-sectioning ancient plaster samples, Littmann found that the Classic Maya had applied a wash coat over the original plaster surface of walls, probably by brushing on a thin plaster slurry; this constituted the actual surface upon which the artist-scribes worked.

According to recent studies of the murals of Bonampak [*Pl. 47, Figs. 12, 94*] and other sites by Diana Magaloni and her associates,[7] all Maya wall-painting was done *a secco* rather than *a fresco*: that is, applied in an aqueous or tempera-like medium on a dry surface, and not on a damp one as had been the case with the great muralists of ancient Rome and Renaissance Italy. The advantage of the *fresco* technique is that the pigments make an excellent bond with the plaster as it dries, and need not be mixed with a binding material—water is sufficient. On the other hand, painting *a fresco* demands that the work be done in sections day by day, with fresh plaster being prepared for each session; each

section must form a seamless whole with its neighbors. By contrast, in *secco* or dry-wall painting as practiced by the Maya, the entire surface may be worked on at one time, as much or as little as the artist chooses. While chemical analysis has revealed a great deal about the pigments the Maya used, and while it is clear that one or more organic substances were mixed in with them, these binders have not yet been identified. Given the unfavorable climatic conditions and severe deterioration of the buildings in which they are housed, as well as the ineptitude of would-be restorers, the surviving Classic Maya murals—at least until their discovery in modern times—have held up remarkably well.

Stucco—usually a mixture of lime, gypsum (hydrous calcium sulphate), and fine sand—has been used the world over to cover architectural exteriors and interiors, and to fashion ornamentation and figures that often approach real sculpture, as in the Hindu-Buddhist art of Central and Southeast Asia, or the amazing Baroque stuccowork of the brothers Asam in Munich. In the western hemisphere, the great masters in stucco were to be found among the Classic lowland Maya. The vast bulk of their work, however, has fallen into unredeemable ruin; the best surviving examples are in the southwestern part of the Maya area—at Palenque [*Fig. 95*], Comalcalco, and Toniná [*Pl. 48*].

As Merle Greene Robertson has demonstrated,[8] the more three-dimensional of the stucco figures at Palenque were molded over a mortar-and-stone armature, but there was no need for this reinforcement when only writing in stucco was involved. She has also illuminated two other aspects of Palenque practice, which were probably present at other Classic sites: (1) before the stucco was actually molded on the flat supporting surface, the artist brushed in the figures and probably the glyphs, too, on it, in a black-line undersketch; and (2) after the stuccowork had been completed, portions of the surface were usually painted according to a definite scheme: blue for supernaturals, red or yellow for the skin of mortals, and so on. However, because so much has fallen from its original position, and suffered considerable erosion, it is not always possible to be definite about the presence or absence of paint, and some loose glyphs from Palenque now appear totally white. Much of this painted stuccowork was applied to the roof-combs,

roofs, and façades, and might well have included long texts. With all this colored embellishment, the structures in the center of a Classic Maya city surely bore little resemblance to the gleaming, all-white temples and palaces that are depicted in the average modern reconstruction, or to what tourists see when they visit heavily restored centers.

CAVES AND TOMBS

Thanks to recent research and to the explorations of dedicated archaeologists skilled in speleology, it is apparent that underground caves were symbolically as important to the ancient Maya as what they built on the surface of the earth. The Petén-Yucatán peninsula is mostly water-soluble limestone, and is permeated with caves and caverns—some of immense dimensions—largely formed by percolating rainwater. In the Maya mindset, these are entrances to Xibalbá, the Underworld, and to the land of the dead ancestors; for this reason, they were and still are important foci of Maya pilgrimages and worship. At least twenty-five such caves have paintings, and some (in particular, the great cavern of Naj Tunich [*Figs. 1, 2, 96*]) have written texts on the walls, usually painted but sometimes incised. As Andrea Stone tells us in her masterly 1995 study of the subject,[9] the

96 Drawing 52, Naj Tunich, painted in black pigment with a brush pen directly on the cave wall, on a Maya date corresponding to 30 June 741. The final three glyphs apparently identify the scribe as a hun nab ("book painter") of a patron who was also an its'at ("sage").

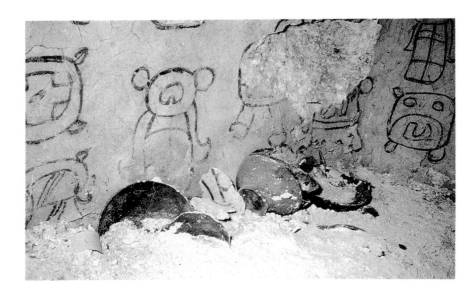

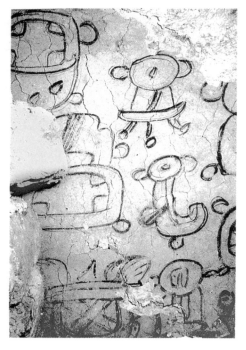

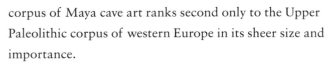

97, 98 *Glyphs painted on the plastered living rock of Burial 48, Tikal, with pottery offerings below. This was the tomb of the fifth-century ruler nicknamed by scholars "Stormy Sky." The glyphs are logographs, possibly based on flowers (which had various esoteric meanings for the Maya). They were carried out in great haste, probably because of the decomposing corpse.*

corpus of Maya cave art ranks second only to the Upper Paleolithic corpus of western Europe in its sheer size and importance.

The Classic period *ah ts'ib* was faced with an especially daunting task when placing his texts on cave surfaces. First of all, he necessarily worked by the light of pine torches which probably flickered and gave off clouds of acrid smoke. Secondly, he had to paint on rough, unprepared surfaces. And thirdly, he had to make his texts of large enough size so that they could be seen and read by groups of pilgrims. When possible, he chose sections of wall that were smoother than others, and had fewer inconvenient inclusions, and applied his paint—usually *sabak* (carbon black pigment)—with fairly large, well-loaded brushes. The most beautiful of all Maya cave texts, Drawing 82 of Naj Tunich [*Fig. 2*], was painted on a smooth overhang by an exceptionally skilled scribe. As far as we can see, all these texts were executed without the benefit of any kind of preliminary guidelines or sketches, or the network of red-wash gridlines that characterize Maya manuscript calligraphy.

The very few tombs of the southern Maya lowlands with wall-paintings and hieroglyphic texts are confined to the Early Classic period; significantly, these are sepulchers excavated into the living rock, and thus are, in effect, artificial caves. The most elaborate of these appear at Río Azul, in the northeastern Petén, and are brush-painted in red and black pigments directly on the cut limestone surface [*Pl. 46*].[10] However, in Tomb 48 at Tikal [*Figs. 97, 98*], the walls of the tomb were lightly plastered, and the glyphs or symbols which were to embellish it were lightly sketched in while the plaster was still damp; the final form of the glyphs was then hastily executed in black with a large brush.[11]

WOOD

Sculptures of carved wood may well have outnumbered those of stone and other materials in the Classic Maya cities, but most of these, along with other perishable objects, are now gone. Nevertheless, the few surviving examples of the art show that highly accomplished artists and calligraphers worked in this medium. The wood of

99 The Young Maize God carving a wooden mask with a hafted celt, from page 96 of the Madrid Codex.

100 Sapodilla-wood lintel from Temple I, Tikal (see Pl. 3), showing the enthroned Hasaw Cha'an K'awil; above him towers a Waterlily Jaguar god, probably his way *spirit. The text in the upper right commemorates his victory over Calakmul on 5 August 695.*

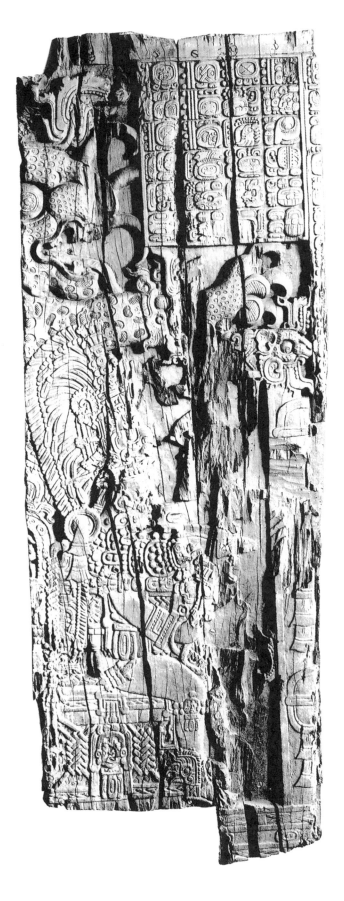

preference was the reddish-brown, extremely durable *chicozapote* or sapodilla (*Manilkara zapota*), carved in low relief when it was still green, for it becomes iron-hard on curing. So tough and strong is this wood that it was employed by Maya architects for lintels to span the doorways of rooms in temples and palaces—in place of limestone, which is liable to cracking under pressure. Its long-lasting properties can be appreciated at Tikal, where sapodilla-wood lintels have survived for over eleven centuries under the most adverse conditions [*Pls. 92, 94, Fig. 100*]. And it is in the rooms atop the towering temple-pyramids of Tikal that we see the best surviving examples of wood-carving—preserved by the enormous thickness of the walls, and fashioned from several adjacent sapodilla boards, the lintels have not only very fine figural reliefs of Tikal kings but also very long texts detailing their history which are among the best examples of Classic Maya calligraphy in the standard monumental style.[12]

In the last chapter, the word *yuxul* was mentioned as a likely title for sculptors of stone and carvers of clay. In addition, in dictionaries of Colonial Yucatec there is another word, *pol*, glossed as a root with the primary meaning "to carve or hew wood." The Madrid Codex shows gods busily carving wooden idols with small hafted axes [*Fig. 99*], but no written texts in wood are known for the late pre-Conquest Maya.

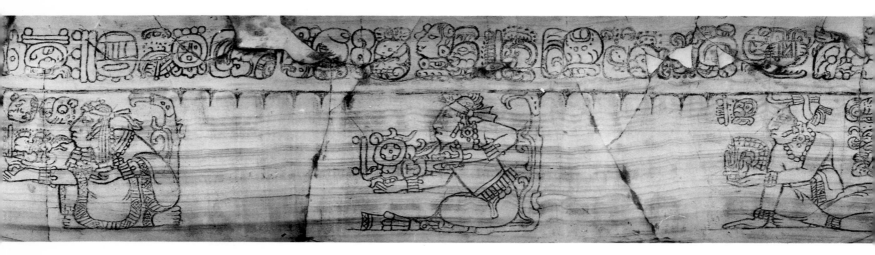

JADE AND OTHER HARD STONES

Mineralogically, most Mesoamerican jade is jadeite, a silicate of sodium and aluminum (as opposed to nephrite, the other jade variety, which is a calcium-magnesium silicate). Extremely tough and resistant to breakage, jadeite is also very hard: it measures between 6.5 and 7 on the 1 to 10 Mohs scale. Although the source or sources of the blue-green jade which had been favored by the Pre-Classic Olmec [Pl. 19] have never been discovered, it is certain that the Classic Maya found their apple-green jade as river boulders in the Motagua Valley of Guatemala. While the Maya probably knew the difference in quality, they also carved and incised other hard green stones such as green quartzite [Pl. 17] and chloromelanite and treated them as personal jewelry.

The laborious, Stone Age methods employed by Maya craftsmen to shape this intractable material into ear flares, beads, plaques, and the like [Pls. 42–44, Fig. 102] have been outlined by Adrian Digby of the British Museum,[13] and need not be gone into here. Suffice it to say that these included sawing, drilling, and abrading using materials such as quartz sand and crushed jadeite; final polishing was perhaps carried out with a substance like hematite powder (rouge). Of more interest here is how the scribes dealt with jade. Not surprisingly, instances of relief carving of texts are

extremely rare—one of the few excavated jade objects with such treatment comes from a tomb at Altún Ha in Belize.[14] There are many fine examples of incised texts, from the Late Pre-Classic on [Pl. 20]. Here the scribe would necessarily have worked with a tool which had a hardness equal to or greater than that of the stone's surface; jade itself, or quartz, which has a hardness of 7 on the Mohs scale, would have qualified for this purpose, and perhaps that is what the scribe used. Nonetheless, few of these texts have any great depth (in the physical sense), and most amount to little more than light scratching of the polished surface.

Visitors to Mexico's tourist centers are familiar with so-called "Mexican onyx," sometimes also called "onyx marble," fashioned into ashtrays and other souvenirs. This is actually a variety of travertine: a dense, banded, whitish form of calcium carbonate, deposited by hot and cold spring waters. It has been quarried since Olmec times in

101 Rollout from a signed travertine vase, Late Classic period. In the center is the ruler, to the left his consort, and to the right his ah k'u hun Yiban (see pp. 91–92), who produced both text and figures by incision and abrasion.

102 Jade bead from Ocosingo, Chiapas. The incised glyph is the name of Ruler 1 of Dos Pilas, whose long reign lasted from 645 to 698. Only the last part of his name (Cha'an K'awil) can be read.

Mexico, and worked into vessels and small sculptures by some of the same hard-stone techniques that were used to work jade. Since such springs are absent in the Maya lowlands, travertine objects are rare at all times among the Classic Maya; yet accomplished scribes and artists had occasional access to this material (which may have been imported from Oaxaca). In the collection at Dumbarton Oaks there is an Early Classic carved travertine bowl of a Palenque ruler, with accompanying text, as well as a remarkably fine incised travertine bowl of Late Classic date [*Fig. 101*]; on the latter are depicted a ruler, his wife, and his *ah k'u hun* [*Fig. 48*], along with an important hieroglyphic inscription, all carried out by a combination of incision and abrasion.

While easy to shape by flaking, obsidian—a dark, semitranslucent volcanic glass—is so hard and brittle that it is a wonder the Maya and other Mesoamerican peoples were able to shape it by grinding into objects of personal adornment like ear flares, but shape it they did. Skilled scribes incised, or rather scratched, short texts onto these, and there are at least two sets of obsidian ear flares known which have such embellishment. Modern glass engravers in Europe use diamond points and power-driven wheels of copper armed with abrasives for this purpose, but exactly what tools were available to the Maya obsidian-inscriber is unknown. A.V. Kidder suggested that they might have used a splinter of quartz, whose hardness is slightly greater than that of obsidian; and he quotes T. A. Joyce of the British Museum, who stated that he was able to produce lines on obsidian with a bit of Petén flint.[15]

BONE AND SHELL

Some of the very finest Maya calligraphy was incised on relatively small objects of bone and shell, almost surely using engraving tools made up of hafted flakes or chips of flint, chalcedony, or obsidian. Marine shells were highly prized, and imported into the lowlands from both the Caribbean and Gulf Coasts, to be placed as valuables in important tombs and graves, and in dedicatory caches. Conch-shell trumpets were often included as funerary furniture in elite burials [*Pl. 41*],[16] and several Classic period

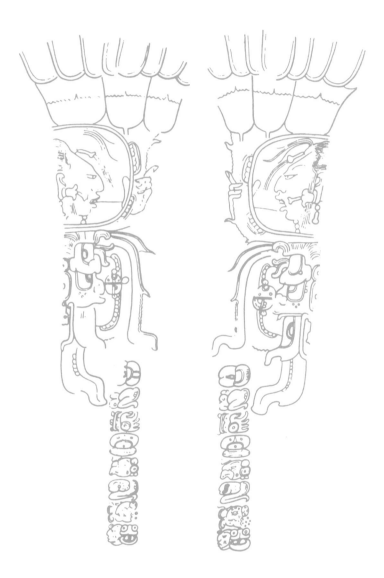

103 Texts incised on a pair of bone bloodletters from the tomb of Hasaw Cha'an K'awil, Tikal. The head of the Young Maize God appears above a bloodletting deity on both bones.

104 Text incised on a bone tube from Hasaw Cha'an K'awil's tomb, Tikal. It contains three Calendar Round dates as well as death expressions, perhaps relating to the king's own demise.

examples of such objects survive with glyphic texts incised on them; and there is a glyphic text on the underside of one cut conch-shell inkpot [*Fig. 119*]. Sections of conch shell and smaller shells, both marine and freshwater, were occasionally embellished with calligraphy, sometimes of breathtakingly beautiful delicacy [*Pls. 38, 39, 45*].

It was usual to rub hematite or vermilion into the incised lines of shell texts, both to enhance their legibility and to render them more beautiful. This was the case, too, with bone, as testified by the major collection of texts incised on human bone and placed near the right foot of Tikal's great ruler Hasaw Cha'an K'awil on his death and interment [*Figs. 103, 104*; see also *Fig. 65*].[17] Bone, which is relatively easy to work when fresh, could also be carved with relief texts as though it were stone, and such objects were produced throughout the Classic period [*Pl. 40*]. While bone from a wide variety of human and wild-animal sources could be used (including trophy skulls from slain enemies), it is likely that the most valuable material was the dense, ivory-like bone from the manatee, a docile aquatic mammal which in Bishop Landa's day was harpooned in tidal creeks and shallow waters.

POTTERY

Well-fired clay is nearly indestructible under most circumstances. It is thus little surprise that under the hot and wet conditions that prevail in the Maya lowlands, the texts painted or incised on Classic ceramics vastly outnumber those on all other materials, including monumental stonework. If the bark-paper books had survived, this situation might have been different, but the fact of the matter is that the bulk of the written corpus, as well as the best testimony to the scribe's craft, is now to be found on clay vessels. One can say with some confidence that the study of this material during the past quarter-century has opened up new vistas in our understanding of the mental and artistic life that prevailed in the Classic cities.

There must have been many, many workshops throughout the Maya area producing elite pictorial (and inscribed) ceramics, for in examining any collection of such objects, one sees a number of regional styles, which diverge from each other far more than, say, the pottery styles of Classical Greece or the modern Pueblos of the American Southwest. Yet in terms of vessel manufacture and decoration, and of the problems faced by artist/scribes in embellishing these vessels, there are some common themes.

Firstly, all of this luxury pottery is unglazed, low-fired earthenware manufactured by building with coils of wet clay, not by throwing on a wheel (even though the primitive *k'abal* or foot-turned wheel used by contemporary Yucatec potters may have occasionally been employed, perhaps for non-luxury wares). Secondly, all painted scenes, texts, and other slip-based embellishments relied on a relatively few available pigments, along with manipulation of the firing atmosphere. One should add that in some extremely sophisticated workshops, through the use of resist techniques, this manipulation could produce some very complex results that we still do not understand in their entirety.

When the amount of oxygen used during the firing of the pottery exceeded that necessary to consume the fuel, this resulted in an oxidizing process with certain definite effects, such as a generally pale surface. If it was insufficient for complete combustion of the fuel, reduction took place—

carbonaceous material in the paste remained unburned, and at certain temperatures, the iron oxides in the paste turned grey [cf. *Pl. 101*] instead of remaining red. Master potters were able to control the firing atmosphere of their wares with considerable sophistication. They also had to make sure that their paints and slips fired to the right color, and that they adhered to the underlying clay after firing.

As the late Anna Shepard, a longtime student of Native American ceramics, has stressed,[18] the color range of pre-wheel, unglazed pottery is extremely restricted, since more exotic colors would have been destroyed by the firing process. For example, malachite, which was used to produce greens in Maya mural painting, if used on pottery would have been altered to a powdery black oxide of copper (this may actually have happened with some Maya polychromes, where slips which should have represented quetzal feathers are now a dull, dark grey).

According to Shepard's study, the blacks or brownish blacks on Maya pottery are mostly produced by manganese or iron-manganese paints, which would have retained their color even after an oxidizing firing; these were the principal vehicle of painted ceramic calligraphy on the part of the Classic artist/scribe. Iron oxide paints, for which the general Yucatec Maya word was *k'ankab*, also played their role: limonite (hydrous iron oxide) was used for painting in yellowish (i.e. yellow ochre) or brownish colors, and hematite (*ch'oben* in Yucatec Maya)—particularly in specular form—for reds. Clay paints were equally important, the red and yellow ones deriving their color from iron oxide impurities, and the white ones either from pure kaolin or from a mixture of clay and calcite. Their spreading quality—so important to the calligrapher—was determined largely by particle size and dispersion: the finer the clay particles, the easier to apply and manipulate with the brush.

While inept potters—and inept artist/scribes—did exist in the Classic cities (I like to think in the less affluent settlements), the level of sophistication achieved on many Classic painted vessels with such limited technological resources is truly astonishing. Those involved in the production of Codex-style and Nakbé-style pots achieved all of their effects by the clever manipulation of at the most

105 Glyphs painted in a negative-resist technique on a Late Classic Chamá-style vase; an orange, glaze-like slip was applied over the resist material. The glyph at top is the head of Pawahtún, an important scribal deity.

two slips or colorants, diluted to a greater or lesser degree [e.g. *Pls. 108, 115*]. Some of the greatest polychromes [e.g. *Pl. 26*] rival the Bonampak murals [*Pl. 47*] in the brilliance and beauty of their painting, even though the range and vividness of the muralist's colors were not available to the potters. Perhaps technically the most advanced vessels were those in which the potter and the artist/scribe manipulated various slips, a yet-unknown resist material, and firing atmospheres to create scenes and glyphs recalling the intricacy and polychromatic hues of Russian or Ukrainian Easter eggs [e.g. *Pls. 110, 113*].

It has long been realized that although glazing was unknown to the Classic Maya potter, he/she achieved a high degree of surface gloss, and surface protection on luxury wares, by applying a post-firing coat of some kind of clear, organic material, perhaps a lacquer-like substance or a resin. Archaeologists call this effect "Petén gloss" [see, e.g., *Pls. 114–116*]; its nature remains a mystery.

Incising and carving of damp or leather-hard surfaces required less technological know-how than painting with a brush, and seem to have been carried out by the same individuals who were responsible for sculpting stone.

There is ample reason to believe that the artist responsible for scenes on pictorial Maya pottery and the

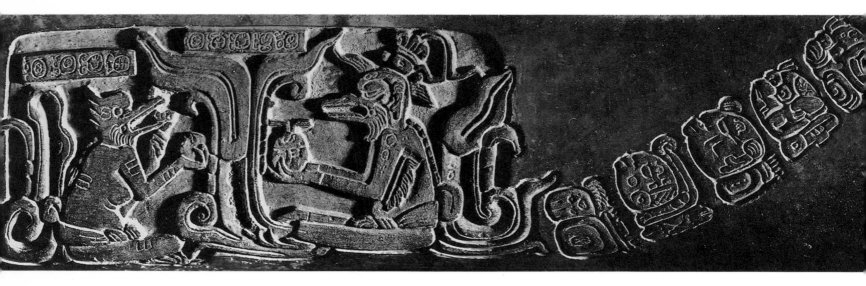

106 *Rollout from a Chocholá-style carved vase, northwest Yucatán. The text contains the name and title of an individual, presumably the vessel's patron.*

107 *Detail of glyphs on an incised cylindrical vase from Xcalumkin (see Fig. 13). Both picture and text on this vase are underlain by a lightly scratched preliminary sketch.*

calligrapher who produced texts were one and the same person [see *Fig. 44*]. Whether that individual also acted as the potter is an insoluble problem; yet this was probably true in the case of complex, resist-produced polychromes, as well as the five-color Uaxactún polychromes, for in both of these wares, the artist and/or calligrapher would have had to have been involved with the process from start to finish [see, e.g., *Pl. 113*].

The major challenge faced by the producers of pictorial and calligraphic ceramics was how to adapt what may have started out as a two-dimensional, flat scheme (perhaps originally painted or drawn in a screenfold book) to a geometrically complex surface, only part of which could be viewed at any one time. Remember, the rollout camera used by Justin Kerr to take many of the images in this book was unknown to the Classic Maya! The Greek pottery artists of Classical Athens solved this problem by first sketching in freehand the entire scene on the still-damp clay surface with a blunt stylus, before applying the finished design.[19] To my knowledge, there are only a few examples of such under-sketches on Classic Maya vessels, and these are confined to incised ceramics of the Chocholá-Xcalumkin area of Yucatán [*Fig. 107*]. It could be that the artist lightly drew the representation and the text in some substance like charcoal, which would completely disappear in firing, but that is pure supposition. What *is* apparent is the use of guidelines to contain the horizontal and vertical lines of writing; sometimes these are so light as to be barely visible.

142

108, 109 The space fillers which separate the end and beginning of some PSS texts could be either vertical bars or pairs of dots, as in these details from Late Classic polychrome vases.

Yet the problem remains: how is it that the scenes, no matter how ambitious and complex, as well as the texts, all come out "right" in spite of the fact that they are painted or drawn on curved surfaces? From time to time one does see the effect of compression near the end of lengthy Primary Standard Sequence texts, or the use of space fillers where the line of glyphs does not quite "make it to the end" [*Figs. 108, 109*], but in general cases like this are rare. We have much to learn about the artistic and calligraphic process as applied to ceramics.

PAPER

At the beginning of the twentieth century, most scholars thought that *amate,* the paper used by the Pre-Columbian peoples of Mesoamerica to make books (including the Dresden Codex), maps, and the like was manufactured from maguey fiber. It is now known that this is completely erroneous: all surviving examples of pre-Conquest paper were made from the inner bark of one or more species of *Ficus,* a wild fig of the order Moraceae. In the case of the Dresden Codex [*Pls. 72, 73*], the crucial analysis was done by Dr. Rudolph Schwede in 1910;[20] through microscopic analysis of some of the fibers of the paper supporting the

surface of the book, he found these to be identical with specimens from living fig trees. Later he had the opportunity to study samples from the Madrid [*Pl. 76*] and Paris [*Pls. 74, 75*] codices, as well as pre-Conquest documents from central Mexico, and came to the same conclusion about them. As for the fourth Maya book, the Grolier Codex [*Pls. 70, 71*], the present writer was able to make a close examination in 1972, and there is no doubt in his mind that the primary material is also processed inner bark from a species of wild fig.

In the Maya lowlands the tree in question is *Ficus cotinifolia,* to which the Yucatec Maya gave the name of *hu'un* or *hun,* a name which they also applied to paper and to the books made from it (*amate* is a Mexican term derived from the Nahuatl *amatl*).[21] Although we have no information on how the Maya themselves turned tree bark into paper, native *Ficus* paper from another species is still manufactured by the Otomí in central Mexico and by various Nahuatl-speaking villages in Guerrero; and there is also an account by the royal botanist Francisco Hernández,[22] writing in the late sixteenth century, who describes paper-making as it was practiced by the Colonial period descendants of the Aztec. There is no reason to believe that Maya paper-manufacture was different from that of non-Maya Mesoamerica.

In contemporary Mexican villages, the entire process of making paper from a tree involves six steps:

1. Fig branches over 1.5 m. (5 ft.) in length and about 25 mm. (1 in.) in diameter are harvested.
2. The freshly cut branches are slit lengthwise, and the bark (outer and inner) is stripped off in one piece.
3. The outer bark is peeled off from the strips, and the inner bark soaked in running water; the latex (present in all *Ficus* species) is allowed to coagulate, and scraped off.
4. *Nixtamalization* is then carried out on the bark fibers; this is directly comparable to the way dried maize kernels are converted into a hominy-like substance, *nixtamal,* by alkalizing the kernels in lime mixed with water. In the case of bark paper, the inner bark fibers are first dried and then boiled in a pot containing the same water in which maize

110 Roots and trunk of an amate *tree (*Ficus petiolaris*) growing on a rock face at Chalcatzingo, Morelos. The inner bark of this wild fig and its relatives was the source of the paper used in Mesoamerican screenfold books.*

kernels had been left to soak, along with more lime or lye from wood ash.

5. The now pliable bast-fibers are removed from the solution, rinsed in cold water to remove traces of the alkali, and placed in a large gourd for further processing.

6. The nixtamalized fibers are cut to conform to the dimensions of a flat, wooden drying-board and laid on it in a grid formation, with the first fibers laid lengthwise, and the next laid crosswise—in other words, the constituent fiber layers are at right angles to each other, exactly as in the preparation of papyrus in Egypt. Then, with the goal of felting the loose fibers together, the whole is pounded with a striated beater; this instrument is now totally of wood, but in pre-Columbian times beaters were of stone held in wooden hafts.

Finally, the material is dried in the sun and peeled off. The resulting paper is smooth on the board side, and rough on the other. Hernández tells us that polishing was carried out with smooth stones, which were probably heated; more will be said about them in the context of scribal tools (pp. 152–53). The color of the paper varies: maize water with lime produces yellow paper, while wood-ash lye results in whiter fibers. The paper in the two codices that I have examined personally varies from a nondescript grey in the case of the Dresden Codex—rather like cheap cardboard—to a light to brownish tan in the case of the Grolier Codex, but that may be a result of the aging process.

The thickness of the paper of the Dresden Codex makes it certain that there are two layers which have been felted or glued on top of each other, and the same holds for the Grolier. Moreover, there must have been some kind of glue to fasten together numbers of sheets horizontally to form these codices: the Dresden alone is some 3.5 m. (12 ft.) long, and the Madrid almost double that in length. In central Mexico, analysis has shown that the native *Mapa de Quinatzin* of 1546 consists of two sheets of bark paper glued together. Francisco Hernández saw a vegetable glue (interestingly, he calls it "papyrus glue"!) in use among papermakers of the Nahua settlement of Tepoztlan to fasten sheets together; this was manufactured from the roots of *amatzauhtli*, a species of orchid.[23]

On the surface of all four Maya codices, on both sides, is a fine white coating of what is either plaster or gesso, or a mixture of both. On examining the Dresden, Schwede concluded that it was a form of calcium carbonate, which would make it similar to the plaster surfaces upon which Maya artists painted their murals. In contrast to the Maya bark-paper codices, the surviving pre-Conquest books of non-Maya Mesoamerica were made of leather, but were also coated with a fine white layer as a paint base; tests on the Selden Codex, a Mixtec manuscript in Oxford's Bodleian Library, showed this substance to be a mixture of calcium sulphate (gesso), calcium carbonate, and animal glue.[24] If a real technical analysis were to be carried out on the surfaces of any of the surviving books of the ancient Maya, it is a sure bet that they would be similar.

What this comes down to is that the scribes actually never wrote *directly* on paper at all, but on miniature mural surfaces laid over that paper: uncoated bark paper would simply have been too rough and porous for their delicate calligraphy, and for the instruments they were using. In the western part of the Old World, the introduction of "real" paper from China brought the possibility of truly artistic writing, for which papyrus had also been too irregular, even with reed pens. But the great Islamic calligraphers, unlike their Chinese counterparts, used not brush but reed pens, and untreated paper was too absorbent for their purposes, so, like the Maya scribes, they coated the paper before writing with a special substance called *ahar*, a mixture of rice powder, starch, and quince kernels, along with egg white and other ingredients. This *ahar* was pressed into the paper to coat it, then it was burnished with a stone (preferably agate). I am sure that the Maya *ah ts'ib* burnished his surfaces likewise.[25]

Of course, the coated paper which was to make up a Maya screenfold book or *hun* had to be divided into pages which would neatly fold, and that is a part of the operation that is not yet fully understood. But once this was done, the scribe—or, more likely, consortium of scribes—would lay out the network of light red gridlines to which all of the text and all the pictures were to conform. But more of this in Chapter 5, when the codices are dealt with in detail.

WRITING TOOLS

CARVING AND INCISING TOOLS

There is absolutely no information on the instruments used by the Maya to carve and incise their monuments; the only sure fact is that metals of any sort were totally absent from their toolkits. The only depiction known to Mayanists of an artist actually working on a sculpture is on a limestone panel now in Emiliano Zapata, Chiapas, but certainly manufactured in the Palenque region [*Fig. 111*]. It shows the sculptor Tu Xok Pat seated before a monument labeled as a *k'an tun* ("yellow stone"), which he is engaged in carving with a strange instrument resembling an oversize feline claw with phalange attached; David Stuart[26] has noted

the resemblance of this to a scene in the Mixtec Codex Vindobonensis, in which one of two standing individuals uses a similar tool to cut open the Tree of Creation.

It seems unlikely that Tu Xok Pat's instrument is anything other than symbolic, for jaguar claws would have been capable of working only the softest stones. Rather, the technique to produce Maya monuments, from start to finish, was stone-on-stone. The initial working of the limestone, trachyte, or sandstone, once quarried, was by pecking and pounding with roughly shaped tools of white flint, probably in conjunction with wooden mallets. After the text and pictures had been laid out on the smoothed surface with paint or ink, the sculptor must have gone to work with small, polished stone chisels and hafted cutting tools (probably with blades of flint or quartz, since obsidian— being a glass—would have been too subject to fracture). Occasionally, especially on the better-preserved reliefs from Yaxchilán and Palenque, the actual marks of these cutting tools can be seen; but usually the sculptor took great care to give the finished work a final abrading and smoothing, to remove all traces of the manufacturing process. In the hand of a major calligrapher working the lithographic-quality limestone of the Palenque region, the intaglio texts

111 Late Classic limestone panel in Emiliano Zapata, showing a sculptor at work on a stone monument (labeled in the text as a k'an tun, *"yellow stone").*

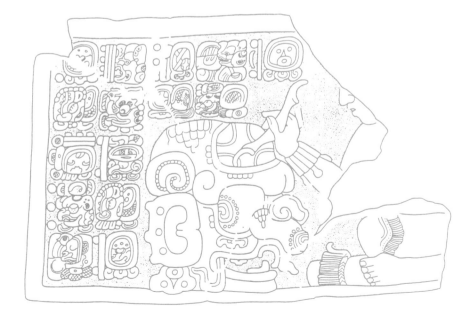

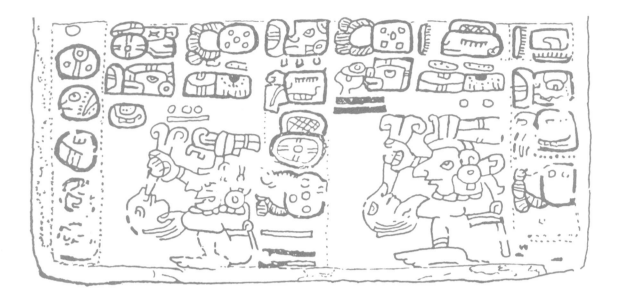

*112 Gods working clay masks with bone awls, from page 99
of the Madrid Codex.*

produced by such tools represent the very acme of Classic Maya calligraphy [*Pl. 69, Figs. 85–87*].

On wood [*Pls. 92–94, Fig. 100*], the major carving could have easily been accomplished with hafted obsidian blades [see *Fig. 99*], for these would have been as sharp as modern surgical scalpels, and capable of slicing through the hardest materials. The same probably holds true with bone and shell [*Pls. 38–41, 45, Figs. 103, 104*], the raw material of some of the finest Classic calligraphy yet known; the extreme delicacy of such texts argues for very small engraving tools of high sensitivity when held in the hand of an accomplished scribe.

In the very late Madrid Codex, in addition to wood-carving, gods are shown working on what seem to be clay masks with bone awls, which were probably the ideal instrument to work wet clay [*Fig. 112*]; certainly the texts incised on Late Classic vessels which I have examined appear to have been worked with them [e.g. *Pl. 56, Fig. 107*]. Yet in scenes on painted pottery, other, more enigmatic instruments are held by artists for the modeling of clay (apart from the brush pens or paintbrushes with which they are giving the masks their final touch). These may be the same as the sticks with curved ends which are sometimes thrust into the artist's or scribe's headdress [*Pl. 68*], but in some instances we may be dealing with penis bones from animals like raccoons or dogs. This is a subject that needs further investigation. Actually, the three-dimensional writing on pottery vessels goes all the way from mere impressing with a sharpened tool [e.g. *Pl. 56*] to carving and intaglio engraving in which the surface of the leather-hard clay is actually cut away, presumably with something like a hafted obsidian blade or small flake [e.g. *Pl. 84, Fig. 106*].

The affinity of incising and carving of clay to relief sculpture was recognized by the Classic Maya, who assigned the same designation, *yuxul* ("his carving"), to both categories, in complementary distribution to *ts'ib*, "painting" (or "writing").

BRUSH PENS

The major tool of the Maya scribe and painter was the brush pen. None have survived, but a fairly good idea of what they looked like can be gained from numerous representations on Classic pictorial ceramics, and on the already cited incised bone from the tomb of Hasaw Cha'an K'awil at Tikal [*Fig. 65*]. Most of those shown have an almost identical appearance to the traditional Chinese brush pen: a tube-like handle made of reed, bamboo, or the like, into which a tip made from animal hairs has been inserted. In the majority of cases, the tip of the Maya instrument seems to have been bound and then inserted and glued *inside* the handle, but some pottery images show a tying up of the hairs *outside* the end of the handle. Clearly, the artist/scribe had different sizes at his disposal, depending on the nature of the task: for very fine work, particularly in codices (see the pen held by the Young Maize

God on one painted vase [*Fig. 114*]), the tips would have been very slender, while for painting texts on bare, relatively rough, rock walls in tombs and caves [*Figs. 2, 96–98*], much coarser brushes were called for.

A great deal is known about the use of brush pens in Chinese and Japanese calligraphy, and a digression on the subject will illuminate certain aspects of Maya calligraphy. In China, the tips are always composite.[27] Early on (until he end of the tenth century), they consisted of several concentric layers of hair—a "heart," a "belly," and a "coat"—all bound with silk threads, and inserted and glued in a handle of bamboo or other material; the ink collected in the cavities between these layers. Later on, in the interests of durability, longer and shorter hairs were combined in the brush tip so that the ink was retained in thousands of minute pockets throughout the homogenous tuft of hairs. The result of this improvement was that the amount of ink released, and the thickness of the brushstroke, became proportional to the pressure applied. In China, a good writing brush has a fine tip, and can bend in any direction without splitting; it is resilient, and regains its original shape as soon as pressure is relaxed. Centuries of experimentation went into the selection of the materials used. The most highly prized are brown hairs of male wild marten shot in autumn; goat hair is used for white brushes, and though it has less resilience than marten, it is easier to handle. At present, "mixed hair" is the commonest, in some cases with equal parts of goat, marten, and wildcat hairs; in the higher quality brushes, the longer hairs are marten. It is impossible even to guess what materials went into Maya brush tips, but the rich lowland fauna would surely have supplied hairs of the highest calibre.

As Jean François Billeter[28] informs us in his masterful study of the subject, "The secret of Chinese calligraphy is knowing how to maneuver the brush tip"; in a way, the tip—being flexible and loaded with ink—almost has a life of its own. The master holds the brush vertically, with arm raised above the table (on which the paper lies flat), and brings his whole body into play with the brush tip. Now, the vertical position gives the Chinese calligrapher the ability to move in all directions, and there is no obvious bias or slant to his "characters." Contrariwise, the Western custom of holding

113 The northeast-southwest slant characteristic of Classic Maya writing appears in this detail from a PSS text on a painted vase. For the order in which the strokes in the glyphs are likely to have been made, see p. 155.

114 BELOW The Young Maize God holding a fine-tip brush pen over a codex. Detail from a Nakbé-style vase.

writing instruments at an angle, with the hand supported on the actual writing surface, tends to dictate sequences of slanting strokes, all leaning at the same angle (for right-handed writers, this means slanting in a northeast to southwest direction). A perusal of the Classic Maya texts presented in the next chapter will demonstrate the same general northeast-southwest bias in painted or incised glyphs and glyph blocks [see *Fig. 113*], indicating that Maya scribes also held their pens at an angle to the writing surface, rather than vertically; this is confirmed by a number of representations of scribal deities on Codex-style ceramics [e.g. *Fig. 114*].

While this angle probably meant that Maya scribes had slightly less control than their Chinese counterparts,

nevertheless the most accomplished practitioners produced writing of an elegance and freedom that rivals the finest calligraphic art of the Far East. And it is clear that the brush-produced calligraphy of those great scribes was the model for all other writing in the Classic Maya lowlands, whether painted, incised, or sculptured.

There is still much research to be done on brush pen imagery and iconography. I have already stated in the last chapter (p. 96) my belief that there was a symbolic linkage between such pens and both the bud and mature forms of the waterlily, based upon the homonymity of the words *nab*, "waterlily," and *nab*, "to daub." This is a subject that needs further exploration.

QUILL PENS

The Yucatec Maya word *cheb* is glossed in Colonial dictionaries as *pluma para escribir* ("pen/feather for writing"), *pluma o péndola con que se escribe* ("pen/feather or quill with which one writes"), and *pluma tajada para escribir* ("pen/feather trimmed for writing"). Initially, I had thought that the term referred to a cultural item introduced by the Spaniards as a replacement for the indigenous brush pen, but several lines of evidence have convinced me that the pre-Conquest Maya did, in fact, use quill pens to write codices. The evidence comes firstly from the presence of the word *cheb* in an ancient text and its accompanying picture; secondly, from scribal imagery on pictorial ceramics; and thirdly, from a close examination of the Dresden Codex.

It was Nikolai Grube who pointed out to me a glyph block in a text carved diagonally on a Chocholá-style vase from Yucatán, which he reads as *cheb* [*Fig. 115*]. Next to this, in a swirl of foliage or smoke, are two seated figures; one is the Hero Twin Hunahpú, and the other seems to be his father the Young Maize God. The latter holds a cut conch-shell inkpot in his hand, while the former holds a sharply pointed, narrow, pen-like implement to his father's head. One could, it is true, interpret the scene as Hunahpú painting his father's face, but Grube and I think that he is actually holding a *cheb*, a quill pen.

I have been led to re-examine representations on painted Classic vases, and have concluded that quill pens

are sometimes shown in use there, too. For example, the Rabbit God of the Princeton Vase [*Fig. 84*] holds a stubby tube or stick lacking a hair tip, and I suggest that this is a typically curved quill shaft stripped of its barbs and barbules, being applied to the surface of a codex. Likewise, the figures of Hunahpú and the Young Maize God painted on a Nakbé-style vase [*Fig. 78*] are writing in codices not with brush pens, but again with what must be quill pens. This does not mean, however, that imagery showing fine brush pens being employed to the same end does not exist—it does (see another Nakbé-style vase [*Fig. 114*]). Lastly, I think that there are compelling reasons to believe that the "stick bundles" tied to the foreheads of *ah k'u hun*s [see e.g. *Figs. 47, 48*] are bundles of quills; and that at least *some* of the alleged "Deer's Ears" on the sides of supernatural scribes' heads are feathered quills.

But it is the Dresden Codex that offers the most convincing testimony for the quill (and possibly the reed) pen. A close examination of the original manuscript led me to the conclusion that there is no way that it could have been produced with a brush pen [*Pls. 72, 73, Figs. 137–39*]. The relevant observations are as follows: (1) the network of reddish or reddish-tan gridlines (which will be described in Chapter 5) was laid down with the aid of a straight-edge or ruler, in lines that are extremely straight and long, something that a brush, no matter how fine, cannot accomplish [*Fig. 133*]; (2) extremely fine lines which do not expand or contract were used to delineate both the interior details of glyphs (inside wider formlines) and all of the figures of deities; and (3) examination of digitized details of the codex in Adobe Photoshop, under great magnification, has shown that the ends of the bars of bar-and-dot numbers are perfectly squared [cf. *Pl. 73*], something impossible to achieve with small brushes of any quality; in fact, it is apparent that a writing tool with a squared end was employed.

Could that tool have been a reed pen? If the Dresden glyphs were larger, and the fine lines wider or heavier, this would have been possible. But according to the art historian James Watrous, reed pens have serious drawbacks for very fine calligraphy:

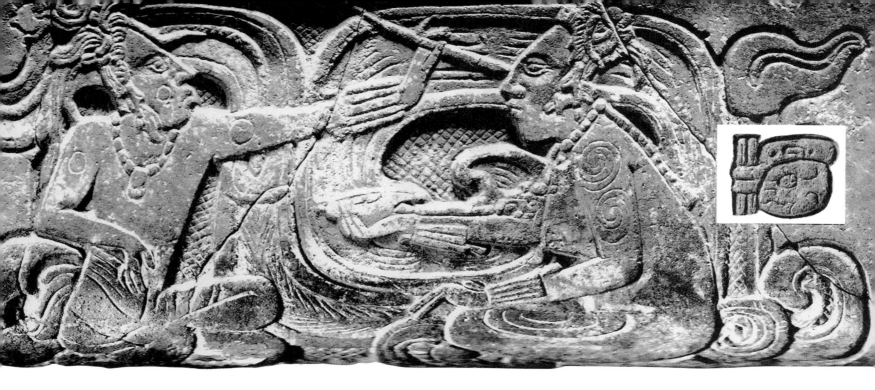

*115 Hunahpú holding a quill pen; inset in this rollout from a Chocholá-style
vase is the* cheb *("quill pen") glyph from the associated text.*

The nibs, although they may be cut into a square, stublike end or to a somewhat pointed shape, will not satisfactorily retain a very fine point. This is because the wall of the barrel is thick, sometimes exceptionally so, and will not allow the cutting of a delicate tip; or if one attempts to diminish this thickness by shaving down the wall to the thickness of a quill, the fibrous structure tends to break down. This fibrous feature of the reed induces a rapid absorption of ink, and a delicately trimmed pen whose point is reduced to a few fibers becomes saturated with the fluid, soon loses its structural strength, and is transformed into a pulp-like nib.[29]

Albertine Gaur[30] notes that quill pens, which replaced the older reed pens in western Europe after AD 400, were far tougher and more flexible, and needed to be resharpened less (but still as often as sixty times a day when in heavy use!). In contrast to their reed predecessors, quill pens could produce crisp strokes and fine hairlines—exactly what we find in the Dresden Codex. Reed pens could, however, have been used there for the gridlines.

In Western calligraphic practice, the best quills are produced from the primary flight feathers of goose or swan, although it is acknowledged that turkey feathers (always available to Maya scribes) are also satisfactory. It has been claimed that the microscopic scripts of some early European scribes were produced with crow or raven quills, but holding such pens would have led to discomfort. To process feathers

into pens, the barbs are stripped from the shaft, and the membrane scraped from the length of the barrel. Next, the quill must be hardened and clarified by a process involving soaking overnight, and then applying heated sand. After that, oblique cuts are made to produce the shoulders and nib of the pen, a slit is made in the nib, and the nib is given a final shaping on a smooth, hard surface.

If we can rely on representations on ceramics, the Maya scribe dispensed with *all* of the barbs and barbules on the pen, and held it differently from his European counterpart, with the concave, rather than the convex, side upward [*Figs. 84, 115*].

I do not contend that all four codices were written with a quill: there is little doubt that the Grolier, Paris, and Madrid codices, which are far cruder in execution, were by and large the product of brush pens [see *Pls. 75, 76* and *Figs. 134, 140*]. But only quill pens could have resulted in the calligraphy and drawing of the Dresden Codex and probably many or most of its Classic predecessors. The tiny size and delicacy of the majority of the textual materials in the Dresden manuscript have to be seen at first hand to be appreciated, for none of the reproductions other than the remarkable early nineteenth-century copy made by Agostino Aglio for Lord Kingsborough does them full justice [*Fig. 133*].[31] The glyph blocks are on average about 13 mm. (½ in.) wide, and 7.5 mm. (5/16 in.) high [see *Fig. 137*]. But in the five Venus pages of the codex, they become truly minuscule: at the top of these pages, the day signs average 5 mm. (3/16 in.) in width, and 4 mm. (5/32 in.)

in height [*Fig. 139*]. It is inconceivable that anything but a quill instrument would have been capable of resulting in such virtuoso penmanship.

INKPOTS AND INKS

In his 1977 study of the patron gods of Maya scribes,[32] the present writer was able to recognize that these supernaturals sometimes held a writing implement in one hand and in the other an ink or paint container consisting of a conch shell cut in half lengthwise [*Pl. 67, Figs. 76, 115, 117; and cf. Figs. 80, 81*]. The shell would have made an ideal "inkpot" since the several compartments produced by cutting could have contained pigments of different colors. In subsequent years, knowledge of this container has been extended by new archaeological and iconographic research: the statue of the Monkey-man God found in the scribal palace at Copán, for example, has just such an inkpot in its left hand [*Pl. 30*], as do the scribal figures in the niches of the building exterior. And in her 1994 exhibition

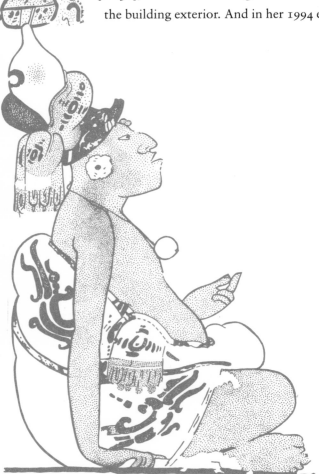

"Painting the Maya Universe," Dorie Reents-Budet put on display two surviving examples identified as conch-shell paintpots [*Pl. 66, Fig. 119*], as well as a ceramic effigy cut conch-shell container found in the Late Classic tomb of the Tikal ruler Hasaw Cha'an K'awil [*Fig. 118*].[33]

A large hieroglyph consisting of an affix above a main sign painted within the bottom of the ceramic effigy has been read by several scholars as *ch'oy*, which they have suggested was the ancient Maya word for these inkpots or paintpots. But Nikolai Grube points out that *ch'oy* means "bucket," not "inkpot," in Colonial Yucatec; and he indicates that in the very early Motul Dictionary, there is an entry reading *u kuchil sabak*, glossed in Spanish as *tintero*, "inkpot." The word *sabak* appears in the Motul as "black ink from the smoke of a certain tree, before or after dilution." The initial *s-* of *sabak* is a Yucatec innovation; the proto-Maya word would have been **ab'äk*, with a basic meaning of "powder, soot, grime," and the Classic lowland word something near it. Based on this and upon technical epigraphic arguments, Grube would read the affix as *kuch*, "container," and the main

OPPOSITE

116 Scribe with an inkpot in his headdress; it points towards the glyph for "inkpot" (cf. Fig. 118). From a polychrome vase.

117 The Young Maize God holding a conch-shell inkpot and what looks like a quill pen, from a Late Classic polychrome vase. He is working on an idol of the Bat God. Protruding from his head is the its glyph, the identifying device of Itsamná (pp. 102–3).

118 Ceramic inkpot in the shape of a cut conch shell, from the tomb of Hasaw Cha'an K'awil, Tikal; on the bottom is the glyph for kuch abak, *"inkpot"—a good example of name-tagging.*

119 Conch-shell inkpot. The interior (see Pl. 66) still has abundant traces of ch'oben, *the red hematite pigment used by Maya scribes. On the underside, seen here, are twelve glyphs giving a Calendar Round date corresponding to 17 March 761, the period-ending rites celebrated on it, the name of the celebrant, and possibly the name of the* ah k'u hun *who used this container.*

sign as *abak,* with the complete collocation to be read as *kuch abak,* "inkpot."[34]

How would the soot used in black ink have been produced by the burning of wood? A clue may again be furnished by early Yucatec dictionaries, in which there is an entry *pok,* glossed as "soot, lampblack," as well as a more complete phrase *u pokil kum,* "soot from a cooking-pot," suggesting that the soot was scraped from the bottoms of kitchen *ollas* and mixed with water to produce ink. Such an ink, whether called *abak, sabak,* or *pok,* is the most permanent one known, since it is virtually pure carbon, and has survived remarkably well on the walls of temples, caves, and tombs, as well as on the pages of the extant Maya codices.

The Aztecs knew of the Maya lowlands as the "Land of the Black and the Red," i.e. the land of the codices, and it is true that both black and red pigments were employed to write the hieroglyphic texts in the manuscripts. I can say from personal examination that the red used in the Dresden, Madrid, and Grolier codices is hematite. Hematite is an iron oxide pigment that is far superior to red ochre, but it

was probably far more costly as it does not occur naturally in much of the Maya lowlands. In the Dresden and Grolier codices, it has a slightly bluish tinge as compared with ochre, and sparkles with occasional specular flecks. Under magnification in Adobe Photoshop, it is apparent that the scribes of the Dresden Codex had much more difficulty with red than with black ink [see *Pl. 72*]; being thicker, and less uniform in consistency, hematite ink probably would have clogged quill pens, so that they were forced to resort to brushes to write with it. This may not have mattered, since it was applied only after the bulk of the text had been written in black, and then only as thick formlines, in bar-and-dot numbers, and as page borders. It was used in highly diluted form to produce the gridlines in the codices, obviating the problem of clogging.

Finally, it should be said that while many other colors (such as Maya Blue) were put to use in drawing the pictorial illustrations, particularly in the Dresden Codex [*Pl. 73*], the glyphic texts were executed exclusively in black and red, as the Aztec epithet for the Maya realm had implied.

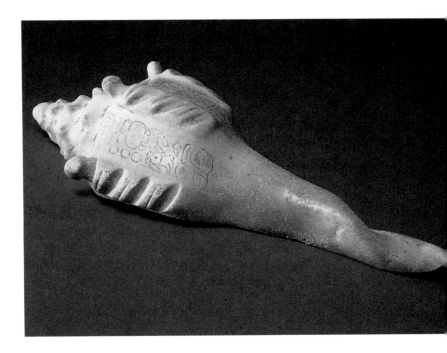

PAPER-POLISHERS?

It will be recalled that among Islamic calligraphers, paper is always sized and then polished before being written upon. I have recently examined such paper-polishers in the exhibited collections of the Topkapi Museum and the Museum of Islamic and Turkish Art in Istanbul. Most of them are smooth stones; one consists of smoothed chalcedony or flint mounted on a haft. Two others are egg-shaped glass objects, probably "gathers" broken off from the end of the glassblower's blowpipe before being shaped or blown.

With these examples from the Islamic world in mind, and conscious of the obvious need of the Maya scribe to smooth the newly applied gesso coating the paper of his intended book, I began searching the iconographic record for similar objects, and found possible candidates on scribal scenes in pictorial ceramics. On a Codex-style vase that we have already noted, where three lesser Monkey-men pay homage to an enthroned Monkey-man God [*Fig. 73*], each holds out to him in one hand a small ball-like object; could these be polishing stones? In another court scene [*Fig. 120*], the principal figure—perhaps the Young Maize God—opens a codex, while before him sit two Monkey-man Gods, one bearing two small, round objects, and the other holding up an offering of paper tied with a band. Similarly suggestive is a scene on a Nakbé-style vase [*Fig. 121*] with two identical

ah k'u hun scribes, each holding a stack of bound paper; atop each stack is what I believe to be a "stick bundle"— i.e. a bundle of quill pens—decorated with quetzal feathers; and on top of one of these bundles is a further object which I feel sure is a round, stone paper-polisher (there can be no doubt that these personages are scribes, as the glyph collocation *ts'ib*, "writing," appears next to them).

If these really *are* paper-polishers, then they are quite common in scribal situations on Classic pottery. For example, on one polychrome vase [*Pl. 67, Fig. 122*] a round object with a dot in its center appears atop a cut conch-shell inkpot being held by a supernatural who appears to be Hunahpú; and on another Hunahpú [*Fig. 80*] and a Monkey-man God hold inkpots with the same objects on them. A search of the ceramic corpus would probably turn up many similar scenes.

While I acknowledge that depictions of alleged paper-polishers actually in use are absent in the record, I feel that that the association with known scribal paraphernalia, including paper, is sufficient to establish at least a circumstantial case for their function. It is also a possibility that the instruments with curved ends that appear in scribal headresses [see e.g. *Pl. 68, Fig. 55*] were really paper-polishers rather than tools for carving clay; but at present there is no way to determine their true function.

OPPOSITE

120 *Monkey-man Gods offering paper-polishers (?) and stacked paper to a scribal ruler, perhaps the Young Maize God. Rollout from a Late Classic polychrome vase.*

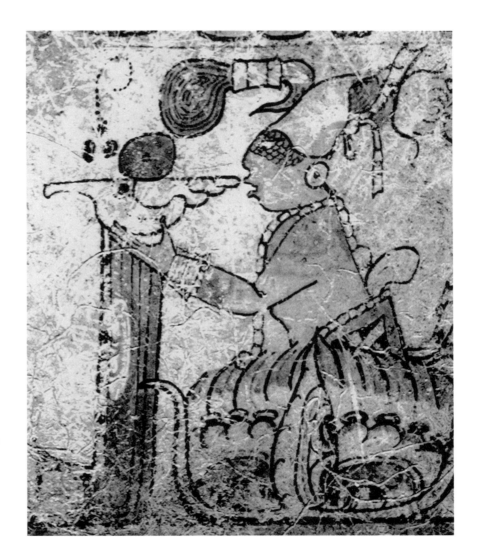

121 *Two ah k'u huns offering stacked paper, quill pens, and a possible paper-polisher. Rollout from a Nakbé-style vase.*

122 *Hunahpú (?) with conch-shell inkpot and what may be a paper-polisher. Detail from a Late Classic polychrome vase.*

CALLIGRAPHIC TECHNIQUES AND PRACTICE

Although there is no real functional difference between the two, epigraphers have generally distinguished between "main signs" and "affixes" in Maya writing: the latter are smaller and more flattened, and may be attached to one or both sides, top, and bottom of the former. Nevertheless, in the practice of Maya calligraphy, the glyph compound or block is definitely "ruled" by the main sign, and it is *its* form—which I here call the *sign-form*—which is basic to the art of Maya writing, from the Classic period on [see e.g. Figs. 123, 128–130]. The sign-form is dictated by the Maya abhorrence of circles, simple arcs, squares, rectangles, and even right angles in their art and writing. To conceptualize it, imagine a parallelogram leaning slightly to the right; now round off its two obtuse angles into wide curves, and its acute ones into small curves. But lest this turn into a visually boring geometric shape, the calligrapher always introduced small variations into the sign-form, to produce a shape with definite rhythm. Whether the main sign be a human or animal head, a hand, or something more abstract, as a rule it conformed to the sign-form.

In texts produced by brush or quill pens, or in carved monumental inscriptions which had first been painted on with the brush, the line bounding the sign-form, as well as that outlining the affix, is the *formline;* the formline is always relatively wide, although subjected to artistic thickening and thinning in the hands of accomplished calligraphers. Within the formline, that is, inside the sign proper, details to be added are carried out in delicate *finelines*, which unlike the formlines never vary in thickness, at least intentionally.

I wish that I knew and understood more of the rules mandating the order in which strokes were made in individual glyphs and glyph groups. In Oriental calligraphy, this order has been established for centuries, and is taught to Chinese and Japanese children while they are still very young. For Maya writing, apart from microscopic examination of the Dresden Codex (at present impossible), probably the best opportunity to establish writing order and the direction of strokes is presented by unrestored Classic

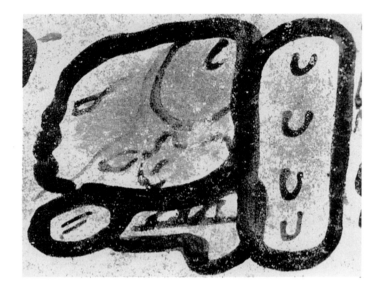

123 Glyph compound from a polychrome vase (see Pl. 51), showing the painting order of elements; here the order was (1) main sign, upper left; (2) subfix, below; (3) postfix, right.

ceramics in private and public collections; by using a loupe handglass, and turning intact surfaces under various kinds of light (including direct sunlight), it is possible to see overlapping of painted or incised strokes in pottery texts, particularly in the PSS so common on these objects. I have actually done this with a small number of vases at the Foundation for Mesoamerican Studies, Inc., in Crystal River, Florida.

I have determined that the basic stroke to produce the sign-form begins at the upper right, curved angle of the sign, or just to the left of this point, then continues left and down to the lower left angle; from there it either continues, or begins as a new stroke, in a rightwards direction to curve on the lower right, then up to where it started; however, complete closure of the final with the initial stroke is sometimes not carried out, and a gap is left on the upper right of the sign-form.

As for the question of the order in which the affixes vis-à-vis the main sign were drawn, the evidence from the vases is equivocal. On the very beautiful and extremely well-preserved "Calakmul Dynasty Vase" [*Pls. 114, 115*], with a

long glyphic text painted in Codex style, the affixes to the left were painted *first*, followed by the main sign (with the exception of the "smoke" affix, which was painted later); postfixes and subfixes were drawn *after* the main sign, as were, somewhat surprisingly, the bar-and-dot coefficients for the calendrical glyphs. Even more detailed information is available on a tall polychrome cylinder with an execution scene [*Pls. 51, 116, Fig. 123*]; although no one glyph contains *all* elements (main sign and all possible affixes), the writing order for any glyph in the PSS is (1) left affix, i.e. prefix, (2) superfix, (3) main sign, (4) subfix, (5) postfix. The more usual sequence was main signs first, and affixes later.

There is enormous stylistic variation, especially in painted and incised ceramic texts, in the calligraphy of any particular point in time, across the long span of Maya history. Glyphic texts could be drawn in a highly formal manner, sometimes approaching stiffness, especially on important public monuments like stelae. At the other end of the spectrum, above all in Nakbé-style painted vases (see below), writing seems to have been carried out with great speed and with proportionally great skill. Yet no matter how rapid the execution, there was never any attempt at joining or fusing glyphs or glyph blocks to each other to

form truly cursive writing (as in Europe and the Orient): there is no such thing as a Maya "running hand." There was conflation of individual glyphs, to be sure, but the distinctive integrity of the glyph block was always maintained.

This variation extends through time and across space, and apparently sometimes within cities and even within individual scribal households. There is indeed reason to believe that particular calligraphers were able to write in more than one hand (the scribe Ah Maxam of Naranjo produced some texts in a negative, white-on-black style; others in a positive black-on-white style; and still others in red and orange on white—the more usual mode favored by that city's ruling family, into which he was born [*Pl. 50, Fig. 124*]).

As we have seen in Chapter 2, the style of Pre-Classic texts, at the dawn of Maya writing, was highly linear—almost scratchlike—and only seldom were the glyphs arranged in more than isolated vertical columns. On this early time level, there was no existing canon of sign-forms, the various glyphs appearing without any regular outline at all [*Fig. 41*]. By the Early Classic, there was an increasing tendency to restrict glyphs, especially calendrical ones,

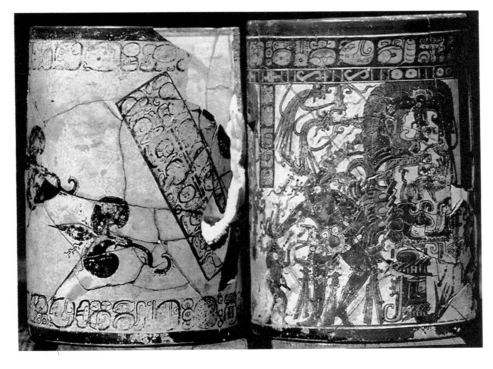

124 Two vases painted by Ah Maxam of Naranjo, photographed side-by-side. They show remarkable similarity in size and shape, as well as in calligraphy, but great difference in their painting styles. Left, black-on-white style (see Pl. 50); right, red-and-orange-on-white style.

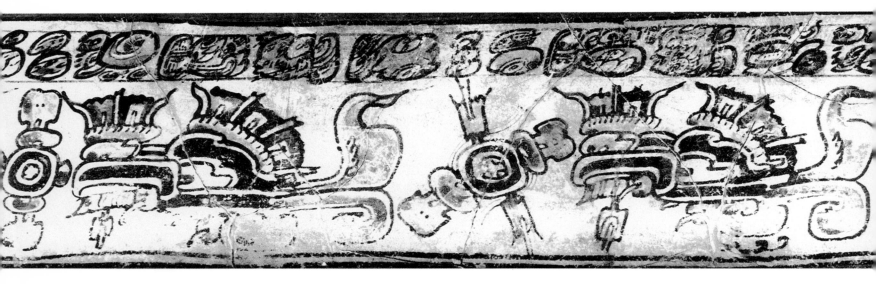

within sign-forms, and to group them in paired columns. This implies the use of gridlines for both painted and carved texts. Concurrently, the use of formlines as contrasted with finelines became an established canon.

There are unmistakable stylistic differences between Early and Late Classic calligraphy, in large part the result of experiments carried out with the brush pen after AD 600 by great masters in the art of writing. The slanting bias so typical of the best Maya calligraphy appears after this date, but perhaps the greatest innovation is that of the "Maya line," in both painting and calligraphy [e.g. *Fig. 127*]: this is produced by manipulation of the brush pen, and is directly

comparable to the "whiplash line" of European Art Nouveau. In it, the line undulates in a series of diminishing and increasingly attenuated waves, ending in a tendril-like final flick of the ink-laden pen. Such "Maya line" flourishes occur in the formlines of painted texts, as well as in pictorial scenes.

Calligraphic flourishes are found especially on the Late Classic style of ceramics I am calling "Nakbé" [e.g. *Pl. 108, Fig. 125*], after the site in the northern Petén where archaeologists have found abundant sherds in this style in looters' trenches. Carried out in black to light brown slips on a cream or tan-cream background, Nakbé-style vases are

125 Rollout from a Nakbé-style vase, characterized by a calligraphic flair in the texts and repetitive, non-narrative pictorial elements. Shown here are two war headdresses seen in profile.

126 Rollout from a Codex-style vase, with spider-monkey and turkey way *spirits.*

characterized by beautifully painted motifs or figures which are repeated twice on the same vessel. In a band above them is always a PSS text of the utmost elegance, the very acme of Maya calligraphy. Eventually, by comparing the same PSS glyph as it occurs on different vessels [*Figs. 128–130*], it might be possible to isolate and describe separate hands working within the same scribal tradition (or school), and even to see diversity in one person's production.

Nakbé ceramics have usually been grouped within the larger category dubbed the Codex style,[35] but that term is better restricted to similar ceramics with truly narrative scenes; on these, the glyphic texts are connected with Calendar Round dates (probably largely mythical) and are less calligraphic and more traditional [*Fig. 126*]. The style of writing, as Andrea Stone has noted, is very similar to the cave texts of Naj Tunich [*Figs. 2, 96*]; it probably is close to what would have appeared in Late Classic codices. Yet even here, as Barbara and Justin Kerr have concluded in a pioneering study,[36] several distinct hands are to be noted—not only in the way figural details (such as hands and eyes) are painted, but also in glyphs.

Of course, away from these truly remarkable ceramics, across the Classic Maya realm there were a multitude of pictorial pottery styles and schools, and many different techniques—some of great complexity and sophistication—for producing scenes and texts. The differences between PSS

127 The Flowing "Maya line" appears in the drawing as well as in details of calligraphy on this Codex-style vase. The subject is the Rain God Chak, splitting a house with an axe.

texts as they appear on a Chamá vase [*Pl. 62*], on a red-and-orange-on-white vase from the eastern Petén [*Pl. 63*], and on a Nakbé-style vase [*Pl. 58*] are far greater than anything known for the manuscript schools of medieval Europe. On the other hand, we have no Classic Maya manuscripts: if we did, we might well find them to be calligraphically more uniform than what is painted on the ceramics, perhaps not so very unlike texts on those vases I have been calling Codex style, or the handwriting of the Naj Tunich scribes.

The near-total breakdown of the old order that took place across the southern Maya lowlands after the eighth century saw the downfall of most of these calligraphic and artistic schools, and possibly the migration of some scribes to less devastated regions within the Maya area. The tradition of elite pictorial ceramics disappeared forever, and probably so too did the artist-scribes who produced them. In the northern lowlands, the Terminal Classic saw a continued production of monumental carved texts (above all, in the lintels of Chichén Itzá [*Fig. 27*]), but these are blocky and crude compared to the earlier calligraphic styles of the southern cities. The texts in three of the four surviving codices [*Pls. 70, 71, 74–76*] are rustic productions compared to the magnificent writing of the Classic Petén masters of the art; yet the network of gridlines employed to lay out these texts, and the distinction between formlines and finelines, show that a bit of the old tradition persisted. The anomaly is the extremely late Dresden Codex [*Pls. 72, 73, Figs. 133, 136–139*], proof that on the very eve of invasion by the Spaniards, not only Classic learning and science, but also purely Classic canons of fine calligraphy, had survived through the centuries in at least one center—though the location of that center remains a mystery.

128–130 Comparison of the same glyph (yich, "the surface of...") from three different PSS bands on Nakbé-style vases. Slight variations suggest three separate but closely related hands.

5
THE MAYA BOOKS

70 Maya books were screenfolds painted on bark paper coated with gesso. Of the four that survive, the fragmentary Grolier Codex is the oldest, dating to the thirteenth century AD. It deals with the movements of the planet Venus, each phase of which is dominated by a sinister deity. In this detail from page 2 we see the Death God. The light reddish-brown undersketch, characteristic of this codex, is clearly visible.

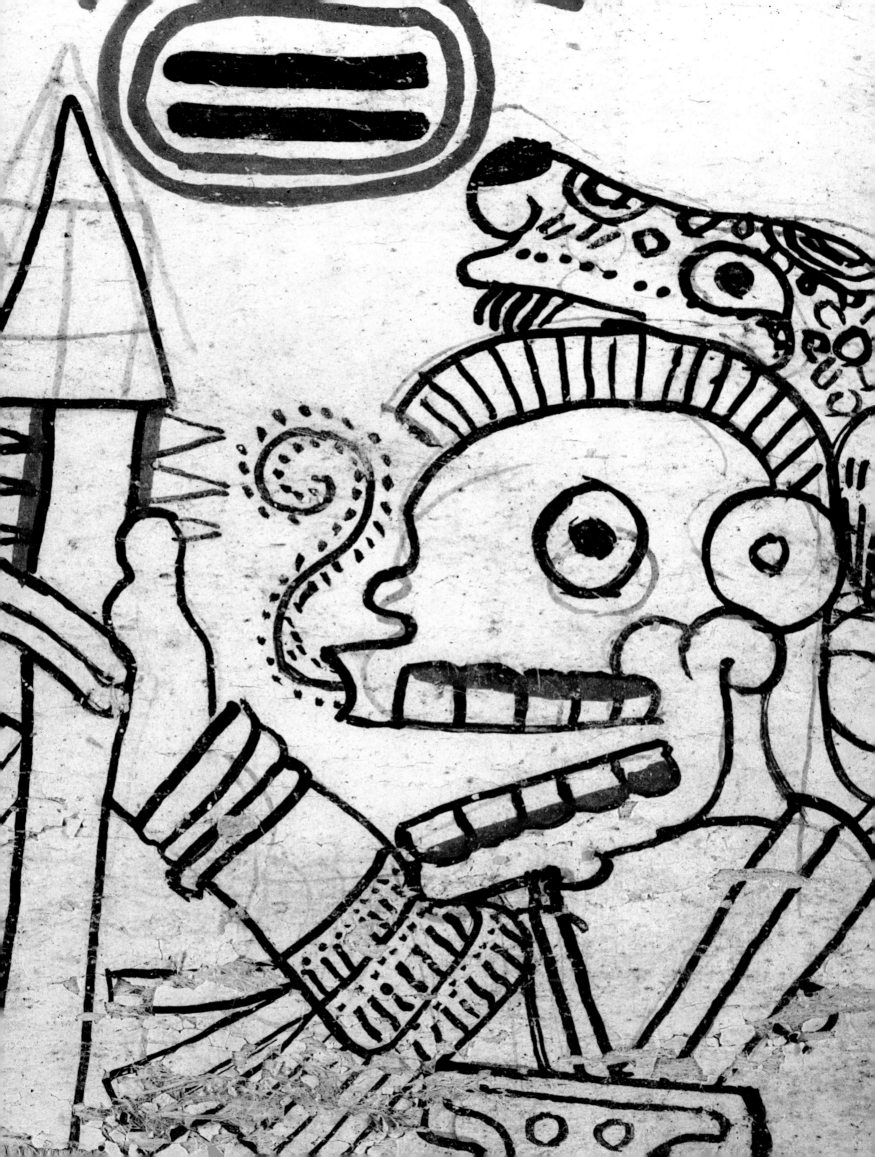

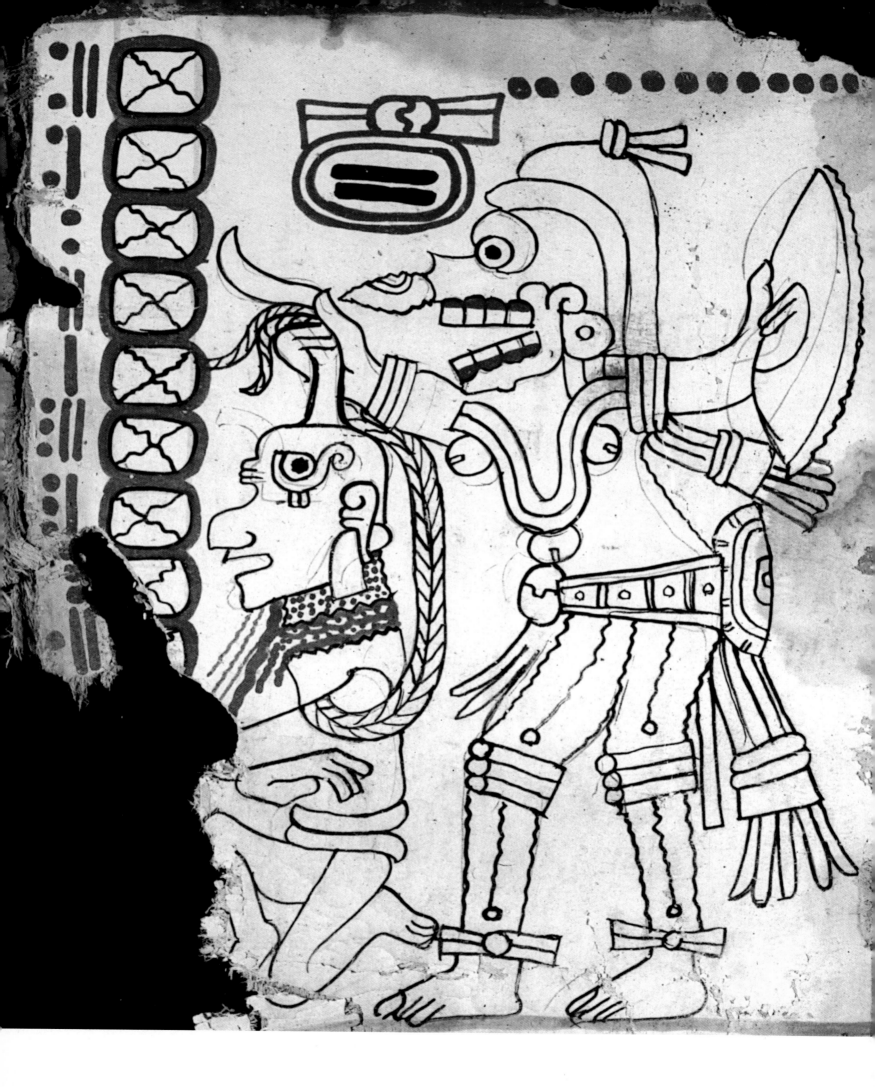

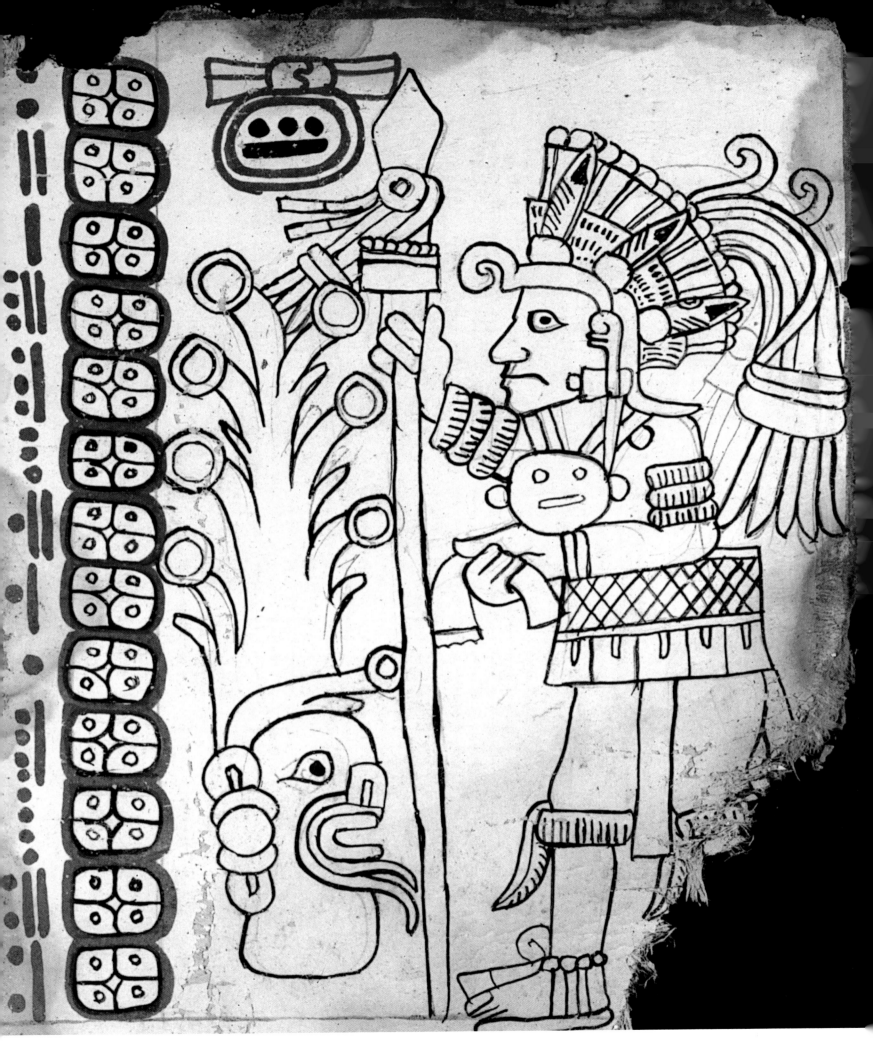

71 Pages 6 and 7 of the Grolier Codex (enlarged). The Death God on the left, in the act of decapitating a captive, represents Venus as the Evening Star. (In Mesoamerican eyes, all aspects of the planet were ill-omened, which may account for the triple appearance of this god in the Grolier.)

The spear-wielding god on the right represents an 8-day disappearance of the planet. Both are accompanied by columns of day signs. The style of all Grolier pages is heavily influenced by the Early Post-Classic art and iconography of central Mexico.

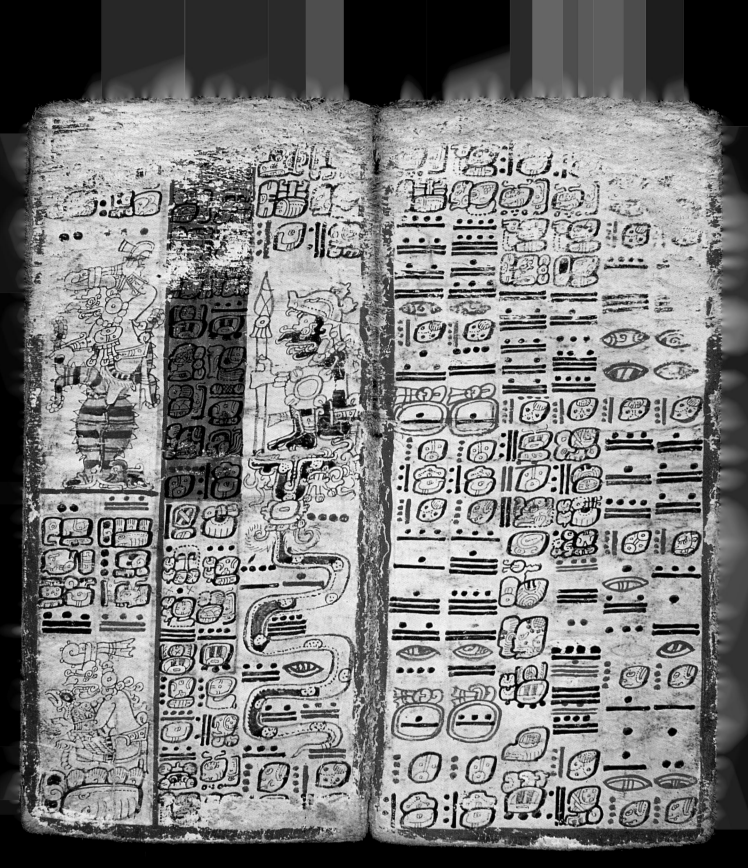

By far the most important, beautiful, and complex of the Maya books is the Dresden Codex; although it dates to the final decades before the Conquest, it presents many features of what Classic codices must have looked like. Writing with quill pens in black and red inks within a network of red gridlines, at least five and possibly as many as eight scribes laid out its contents.

72 ABOVE Seen here approximately actual size are pages 69 and 70, which present very long calendrical calculations and multiplication tables. The figures are of the Rain God Chak in various aspects.

73 OPPOSITE Enlarged detail of page 49, showing a Mexican Venus god hurling darts at a victim. For an idea of the actual size of the individual glyphs in the Venus pages, see Fig. 139; they could only have been carried out with quill pens, which would also account for the squared ends of the bar coefficients, visible here under great magnification.

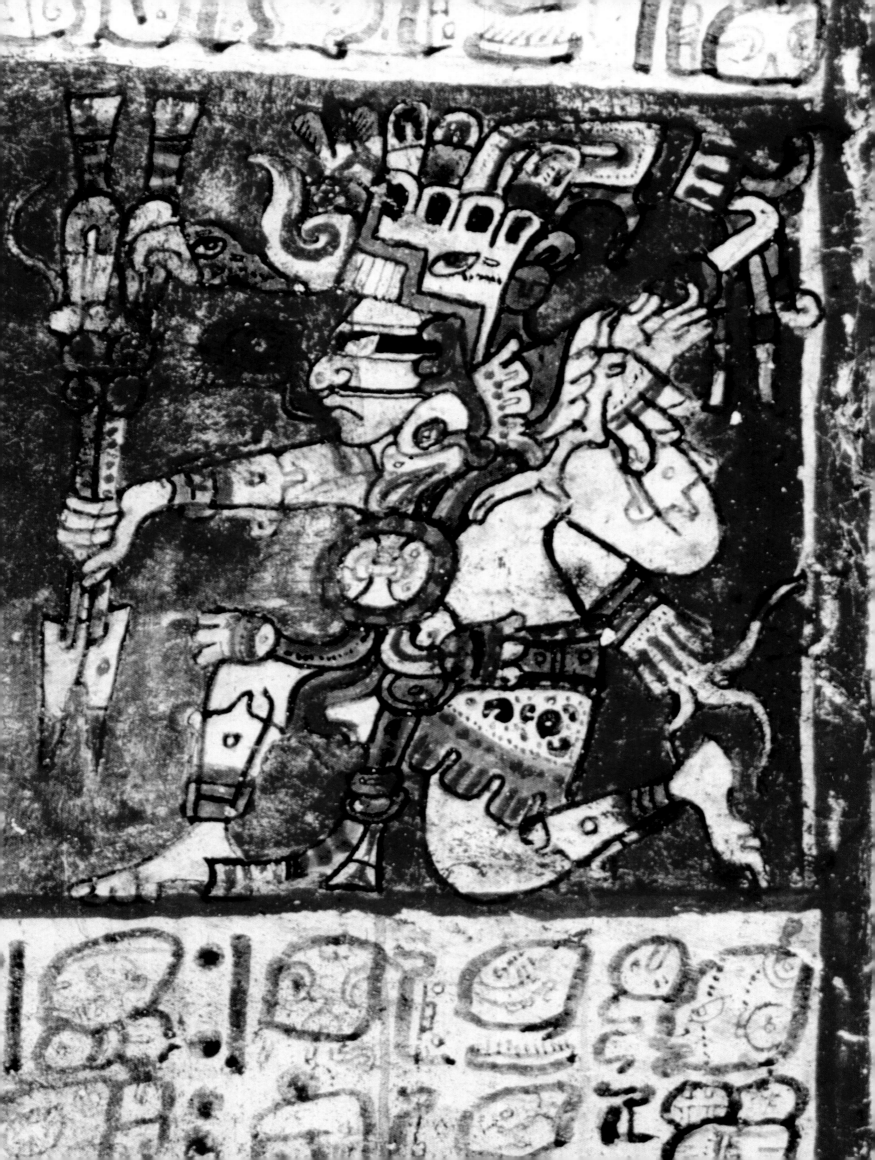

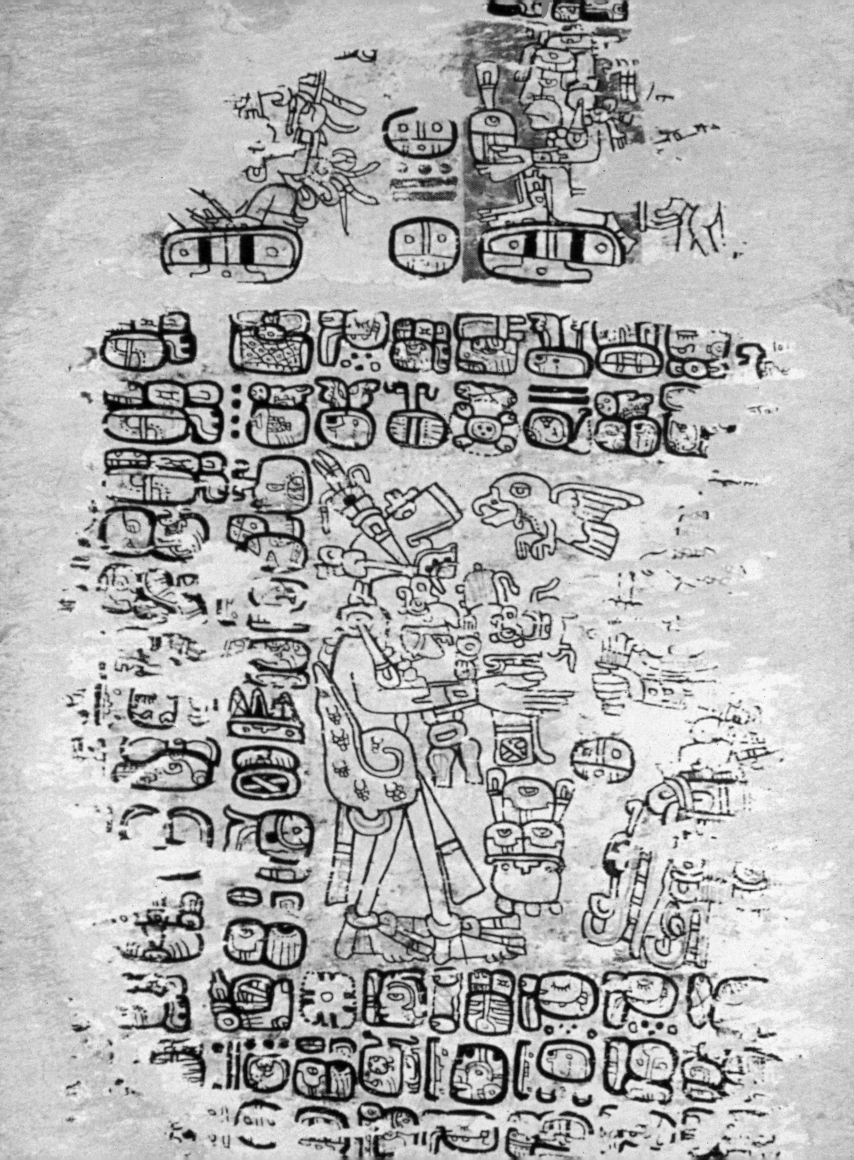

The poorly preserved Paris Codex may have been produced at Mayapán in the fifteenth century. Far cruder in execution than the Dresden, it nevertheless has calendrical-ritual information of great interest.

74 OPPOSITE In a detail from page 6, the god Pawahtún, here recognizable by the snail shell from which he sometimes emerges (cf. Pls. 78–80), presides over one of a cycle of 13 *k'atuns* (20-year periods).

75 RIGHT Page 24 (about actual size) showing Maya constellations (Scorpion, Turtle, and Rattlesnake) pendant from a sky band; curiously, the glyphs in this section are reversed from their usual left-facing orientation.

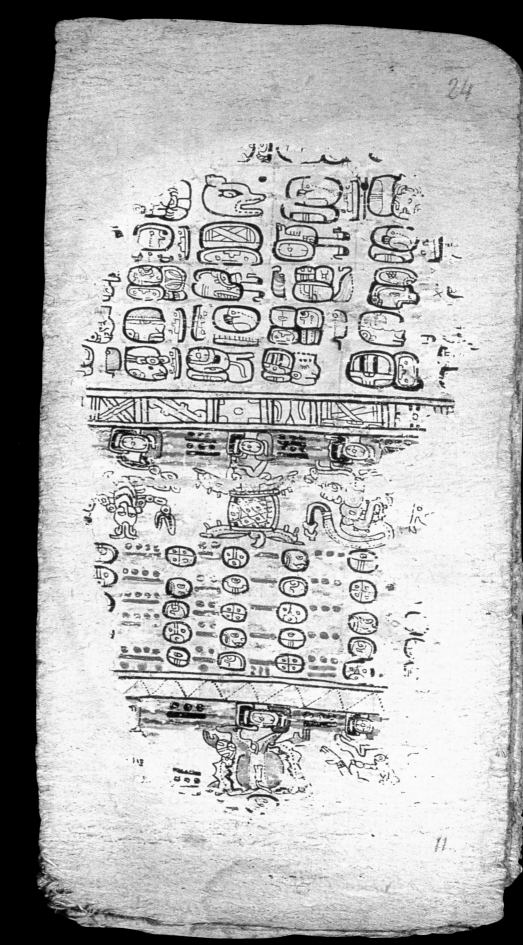

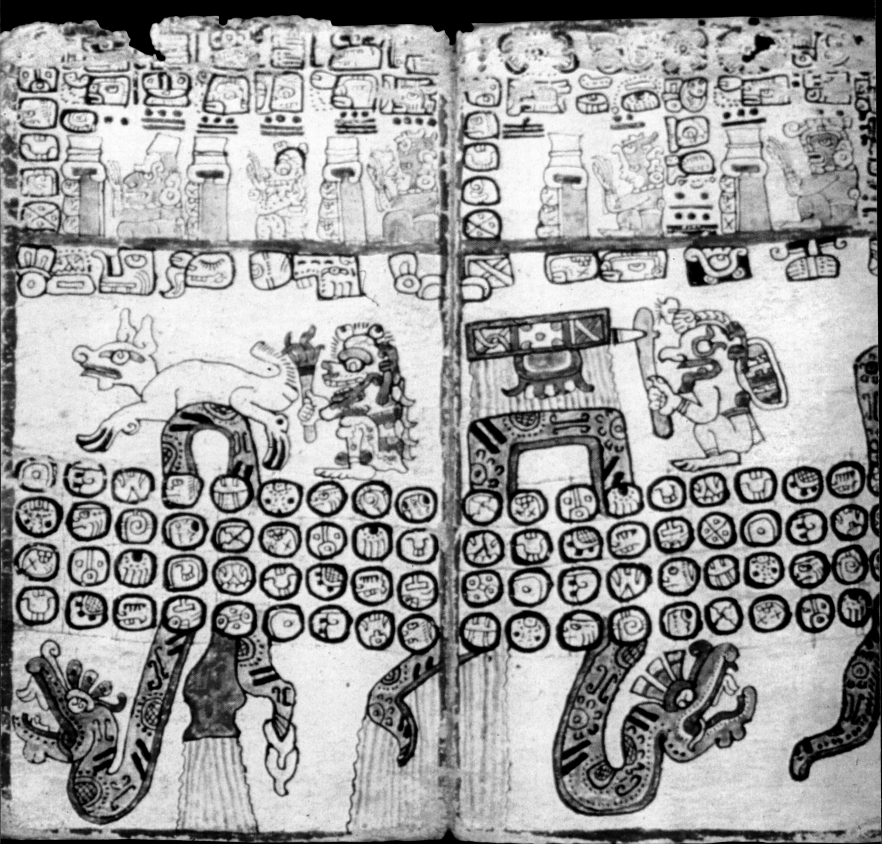

THE MAYA BOOKS

At one time, most Maya calligraphy must have been contained in books. But out of the thousands, perhaps tens of thousands, of manuscripts once extant during the Classic Maya apogee, none remain. For the Post-Classic period, we can again only guess at the total number produced, but it was doubtless greatly diminished from what it had once been before the Classic downfall. There is no way of knowing how many were burned by Franciscan missionaries like Diego de Landa, but the act of destruction was remarkably complete: we have only four surviving pre-Conquest native Maya books, one of them (the Grolier Codex) having come to light in relatively recent times. For only one other calligraphic tradition—that of ancient Greece and Rome—has the loss of contemporary manuscripts been as severe.

Small as our sample of Maya codices is, one can yet draw some conclusions about the art of Maya writing from them. And one of these books, the beautiful screenfold preserved in the State Library of Saxony, in Dresden, is a true masterpiece of book-making and calligraphy.

EYE-WITNESSES

Their books were written on a large sheet doubled in folds, which was enclosed entirely between two boards which they decorated, and they wrote on both sides in columns following the order of the folds. And they made this paper of the roots of a tree and gave it a white gloss upon which it was easy to write. And some of the principal lords learned about these sciences from curiosity and were very highly thought of on this account although they never made use of them publicly.[1]

Thanks to his inquisitorial activities, which resulted in the infamous "burning of the books" in Maní in 1562, Bishop Landa had a first-hand knowledge of Maya screenfold codices, but it is apparent from the above excerpt from his *Relación de las Cosas de Yucatán* that he had never witnessed the actual manufacture of either paper or native books: although he did realize that codex pages received a white coating which was then polished, paper itself was made from the bark, not the roots, of wild fig trees, through a lengthy and complex process. If screenfold books were still being created in Landa's day by native priests, scribes, or artists, this would have been an act conducted far from the eyes of the Spaniards, in the utmost secrecy and at great personal peril.

Landa was surely not the only early missionary to see Maya codices. For instance, Antonio de Ciudad Real, quoted in a *relación* of 1588, was convinced that the possession of writing and of books raised the Maya of Yucatán above the rest of the native peoples of New Spain, because

in their antiquity they had characters and letters, with which they used to write their histories and ceremonies and methods of sacrifices to their idols, and their calendar, in books made of a certain tree and they were very long strips of a *cuarta* or *tercia* in width that were folded and gathered in such a way that they looked more or less like a book bound in quarto.[2]

In late pre-Conquest Yucatán, these screenfolds were treated with the utmost reverence by their royal, noble, or sacerdotal possessors. Based on the recollection of his Maya informants, Landa[3] describes a ritual purification of the books during a festival called *Pokam*, held in the second

76 Pages 14 and 15 of the Madrid Codex, the longest and probably the latest of all the Maya books. The procession of day signs crossing the rain serpents forms part of a 260-day count. In the top third of these pages are two 260-day "almanacs," in which gods perform ritual acts.

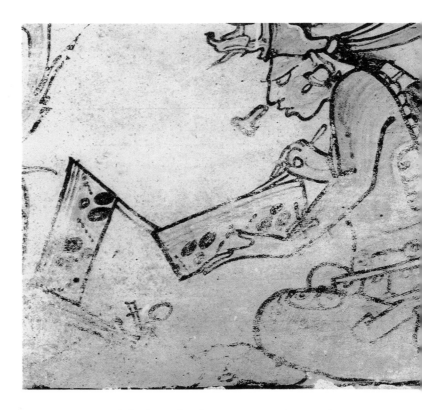

131 *Logograph for* hun, *"book," representing leaves of paper between jaguar hides.*

132 *Hunahpú painting an open screenfold book with jaguar-skin covers. Detail from a Nakbé-style vase.*

month (Wo); this was celebrated by "the priests, the physicians and sorcerers, who are all the same thing." After these had assembled at the house of the lord, and following an exorcism of evil spirits, the books were spread out on fresh boughs. Kinich Ahaw Itsamná ("The Sun-eyed Lord Itsamná"), supreme patron of writing and the first priest [see *Figs. 66–69*], was then invoked with prayers, devotions, and the burning of balls of incense in newly kindled fire. Next, the participants dissolved in "virgin water" (*zuhuy ha*, drip water gathered in caves) "a little of their verdigris"—without any doubt the pigment known as Maya Blue [cf. *Pl. 26*]—"with which they anointed the boards of their books so as to purify them." The most learned of the priests opened a book, and gave prognostications for the year from it. As a finale, the celebrants ate all the gifts of food and "drank until they were sacks of wine."

What this account tells us is that in very late Post-Classic times, the codices had wooden covers which were coated with Maya Blue. Although none of the four surviving Maya books have any covers at all, such covers are known for central Mexican examples: thus, the surely pre-Conquest Vaticanus B codex, preserved in the Vatican's Apostolic Library, is contained between polished boards elegantly embellished with a few tiny disks of jade.

THE CLASSIC VISUAL RECORD

Whenever codices are depicted on Maya vases from the Late Classic period—and there are many such representations—they are always shown in various forms of profile, usually with cover and first page tilted up [e.g. *Pl. 32, Figs. 75–77, 132*]. Artistic license has led to a considerable degree of exaggeration, for these books are almost always vastly oversize, certainly not the compact "quarto-sized" books described by the Spanish sources, or what we see in the extant manuscripts [e.g. *Pls. 72, 75, 76*]. And in place of the wooden covers described by those same sources, we see covers of jaguar skin, emphasizing the regal nature of these precious books. Artistic imagination again? I doubt it, for the books in royal libraries could well have had such protection. In fact, it is now recognized that Thompson's glyph 609, labeled by him "jaguar pelt," is actually a logograph for *hun*, "book" [*Fig. 131*]; this takes the form

of a highly stylized stack of paper leaves, with jaguar hide (recognized by the black markings and by the side tabs used to tack the skin out for drying) on top and bottom.[4]

BOOK PREPARATION: INITIAL STAGES

The various steps in the manufacture of a Maya screenfold book have been touched upon in the previous chapter (pp. 143–45). The process began with the making of bark paper. Once each dried sheet had been peeled from the board on which it had been beaten out, it was necessary to attach it to others like it. Each sheet had to be fixed on top of another sheet to produce book leaves of the necessary thickness, either by felting or gluing (or both together). And each sheet had also to be attached horizontally to its neighbor until there were enough sheets to make a continuous length suitable for creasing into the leaves that were going to make up the accordion-like screenfold. It is not clear which of these processes came first, but the fact that Spanish paper has been incorporated into two leaves of the Madrid Codex (see below and *Fig. 141*) suggests that horizontal attachment preceded the thickening operation.

Next, the leaves of the screenfold were formed by creasing, perhaps with a wooden straight-edge or something like a weaving batten. This had to be carried out before the plaster or gesso sizing or coating was applied, otherwise that surface would crack or flake off when subjected to folding. How the coating was applied, and its exact composition, will remain a mystery until modern laboratory analyses of the extant codices can be carried out. Presumably, after the entire blank codex had been completed by specialists in these matters, and suitably polished, it was ready for inscribing by the *ah ts'ib*—the scribe or scribes.

The dimensions of these blanks must have been daunting.[5] Even in their present somewhat fragmentary states, the surviving books are of impressive length when spread out flat. The Dresden is now 20.5 cm. (8¹/₁₆ in.) high and 3.56 m. (11 ft. 8½ in.) long; since both sides of each leaf had been prepared, the scribe, or scribal team, was faced with 74 pages totalling at least 2,268 inches of unpainted, white surface. But this is nothing compared with

the Madrid: 23 cm. (9¹/₁₆ in.) high, it measures no less than 6.82 m. (22 ft. 6 in.) in length, offering its scribe 112 pages covering slightly under 5,000 inches of available surface. The dimensions of the double-sided leaves—and hence the individual pages—resulting from the creasing process vary somewhat from screenfold to screenfold. (They also vary from leaf to leaf, to a greater or lesser extent, because of wear.) Although it is demonstrably extremely late pre-Conquest in date, based on its content, the Dresden Codex probably most closely resembles the books of the Classic period; its pages are only 9 cm. (3½ in.) wide, in contrast to the 12.2 cm. (4¹³/₁₆ in.) of the Madrid, and the 12.5 cm. (4⅞ in.) of the Paris and Grolier. The small, calligraphically elegant writing of the Dresden is in perfect harmony with the comparatively small size of its pages.

BOOK PREPARATION: FINAL STAGES

From this point on, the scribe or scribes were in total control of the preparation of a particular book. From imagery on some pictorial Maya vases, we might suppose that the codex rested at floor level, perhaps on a protective mat, and the scribe sat crosslegged before it, writing instrument in hand [e.g. *Pl. 30, Fig. 76*]. One peculiarity of these Classic images, though, is that the codex is always shown in the "wrong" position: the opened book is depicted in profile, as if it were turned 90 degrees clockwise, so that the *ah ts'ib* appears to face not its bottom edge but the right edge of the second page. This is, of course, a Maya artistic convention, emphasizing the folding-screen aspect of the book, and thus—along with the jaguar-skin covers—enhancing its identification in the eye of the beholder.

It is possible that the blank codex was propped up on some kind of lectern, so that the seated scribe would not have been obliged to view the pages on which he was working at an acute angle. In illuminated manuscripts of medieval and early Renaissance Europe, scribes are often depicted before such lecterns seated on chairs or stools; it is doubtful that the Maya scribe—like his counterpart in the world of ancient Egypt—sat anywhere but crosslegged on the floor or on a low platform when working on manuscripts. The paper or silk surfaces on which Chinese

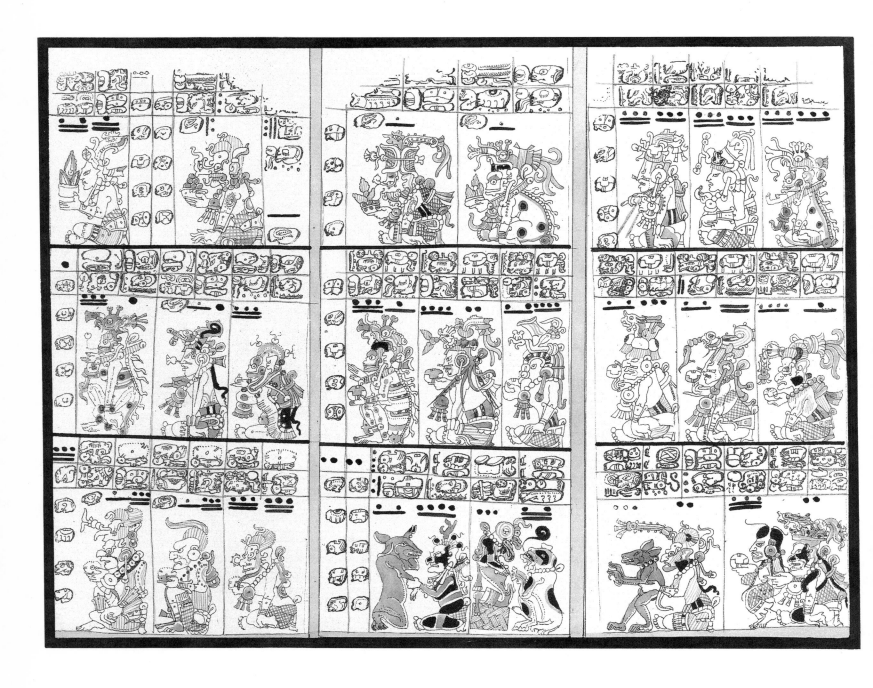

133 *Pages 12–14 of the Dresden Codex as they appear in the
Kingsborough edition of 1831. Agostino Aglio's copy clearly shows
the gridlines of the original.*

and Japanese calligraphers write are laid flat on a table, to be sure, but the artist either sits in a raised chair or stands up, giving him sufficient height over the surface for the brush to be held in the desired vertical position. But this Oriental verticality is absent in the Maya script: the northeast to southwest bias of Classic painted and incised texts shows that the scribe held the pen on a slant, and probably leaned slightly forward over the writing surface while he worked. In other words, the *ah ts'ib* may not have needed a lectern at all.

As I have said before, the first task of the *ah ts'ib* was to lay out a network of gridlines in thin red or reddish-tan wash over those pages on which he was to place his text and accompanying pictures. Internal evidence indicates that never more than four pages were laid out at any one time: the thicker red horizontal lines which were brushed over the fine gridlines dividing up individual sections of each page join up with similar lines over two, three, and four pages, but never in excess of four (not even in the case of the five-page Venus Table of the Dresden). Most commonly, two adjacent pages will have linking lines; thus, the scribe/artist usually had the codex open to just two pages at a time. Unfortunately, because of fading and other vicissitudes of time, the gridline system of the Dresden Codex is now almost invisible, and barely appears in most modern facsimiles, but some idea of what it once looked like can be gained from the excellent copy made by Agostino Aglio in the early nineteenth century, and published by Lord Kingsborough in Volume 3 of his monumental *Antiquities of Mexico* [*Fig. 133*]. From this, and from an examination of the original manuscript in Dresden, it is apparent (1) that these lines were produced with a quill or reed pen and a straight-edge, and (2) that the *ah ts'ib* knew exactly what he was going to write, and where he was going to place the relevant illustrations to his text. He took great care to leave a special box for almost every glyph (excepting single vertical columns of day glyphs, which were simply bounded with a pair of vertical lines) and occasionally even for the bar-and-dot coefficients, as well as one for every single picture—nothing was left to chance. For such a methodology to work, he must have had another codex at his side to guide him in this task. When we look at a codex

like the Dresden, we can be confident that we are looking at a compendium based on older sources, some of them perhaps harking back to the period before the Classic Collapse. The only pages of this book that lack gridlines are those with the New Year's Table, but, as shall be seen, these stand apart from the calligraphic canon employed by the rest of the Dresden scribes.

Faint brownish-red gridlines are still visible throughout the Madrid Codex [*Pl. 76*], but they are very crudely and hastily drawn by comparison with those in the Dresden; they were executed with a brush pen, rather than a quill. It is also obvious that when it came time to lay down the written text and the pictures, the artist/scribe of the Madrid often ignored his own gridline boundaries. As for the Paris Codex, because no truly reliable facsimile in color has yet been published, it is difficult to say much about the gridline system, but lines are faintly visible in some editions and in the transparencies published here [*Pls. 74, 75*]. Even though the very fragmentary Grolier lacks an overall gridline network, its columns of day signs are bounded by light reddish-brown lines as in the other three codices; but it is unique among these in that the same finely brushed lines were used to sketch in the pictorial part of each page— in this case, a series of Venus divinities [*Pls. 70, 71*].

WRITING THE BOOKS

Each of the four codices is different from the rest both in content and in style, leading to the sensible conclusion that they were produced in different places and at different times. Even within the Dresden, there are stylistic variations between sections which point to the participation of different individual scribes [*Fig. 136*]. But, regardless of this diversity, all four share in a common Maya glyphic, artistic, and intellectual tradition. I shall examine each manuscript in turn.

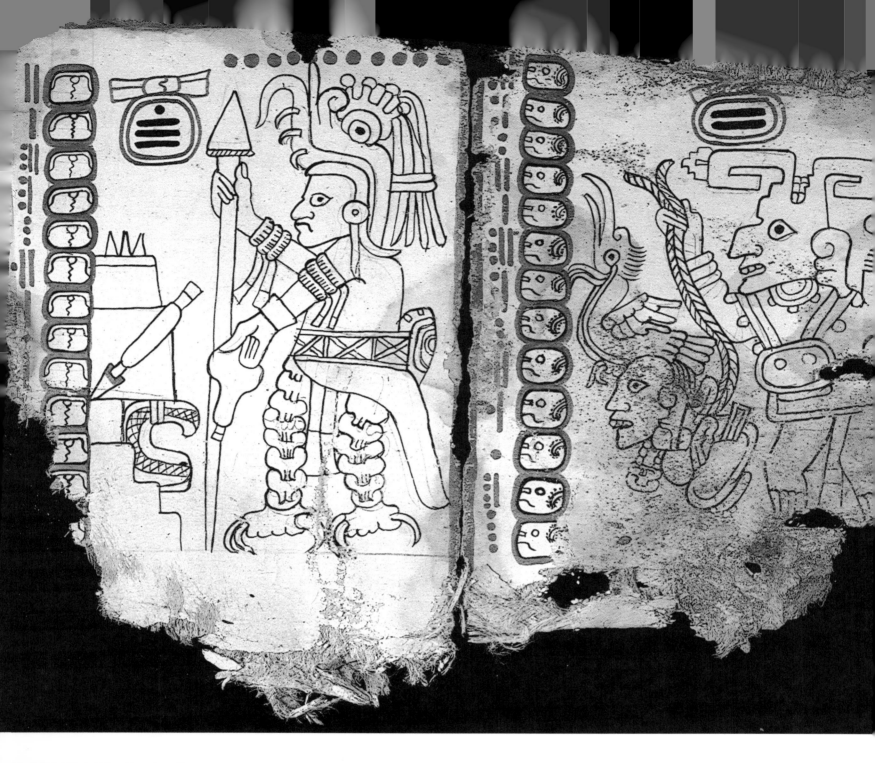

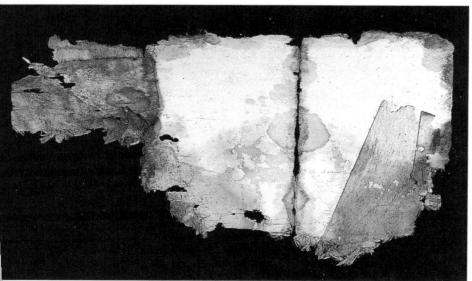

134 Pages 8–9 of the Grolier Codex, about actual size.
Like other pages from this screenfold, these depict
various Venus deities in a hybrid Toltec-Maya style.
(The codex takes its name from the fact that it was first
exhibited at the Grolier Club, New York, in 1971.)

135 The blank reverse of pages 8–10 of the Grolier
Codex. Here and on the obverse, damage to the pages
reveals the fibrous structure of bark paper.

The Grolier Codex[6]

With a radiocarbon date of AD 1230 ± 130, the Grolier [Pls. 70, 71, Figs. 134, 135] is the oldest extant Maya codex, perhaps even Early Post-Classic in date—the [14]C age agreeing with the Toltec-Maya nature of its religious iconography, which shows strong influence from central Mexico. It is only one half of a manuscript which dealt exclusively with the 584-day synodic cycles of the planet Venus. The entire Venus calendar would have covered 65 x 584, or 37,690 days (slightly under 104 solar years). The fragment with which we are left consists of 10 pages of what must have been a 20-page original, painted on only one side of the screenfold (the reverse is coated white, but blank); each page concerns one part of the Venus cycle in succession—Morning Star, Superior Conjunction, Evening Star, Inferior Conjunction—with its associated deity.

The Grolier Codex bears all the hallmarks of a provincial work, created in some place far from the major Maya Post-Classic centers such as Chichén Itzá. Even though it turned up during the 1960s in a Mexican private collection, there is some reason to believe that it was originally found in a cave near Tortuguero, Chiapas, preserved in a wooden box [Pl. 93] along with a mosaic mask, a wooden-handled sacrificial knife, and other items. Thus, it could have been painted in Chiapas or in neighboring Tabasco, a region with long-standing commercial ties to central Mexico.

Certainly the Grolier exhibits hasty execution: the artist-scribe confined his freehand gridlines to a base line on which the deities were to stand, and to a pair of vertical lines destined to contain the 13 day-signs of each page, then carelessly sketched in with his brush the figures themselves. Next, again using a brush pen, he drew in sabak (black ink) the column of day-signs and the deities in their final form, adding a few details in light brown or Maya Blue washes (the latter for water on page 10, now much faded). Then, using ch'oben (red hematite paint), he outlined the day signs with heavy lines, added their bar-and-dot coefficients, and picked out details on the deity figures, such as the red gums of the Death God. Perhaps the final scribal act was to provide a thick ch'oben border to each page, something also found in the other three codices.

There is nothing particularly "calligraphic" about the writing of the Grolier: the day-signs are chunky and block-like, more similar to the style of the Madrid than to the Dresden. It must be admitted that in comparison with longer codices, there is little intellectual content other than details of the Venus cycle. But such brief or truncated astronomical manuscripts may once have been common in the Maya area during the Post-Classic, in both lowlands and highlands, as aides-mémoire for local priests to conduct their ceremonies.

The Dresden Codex

The justly renowned Dresden Codex [Pls. 72, 73, Figs. 133, 136–139] is by far the best-known and most studied of all the extant Maya books, due in part to its long post-Conquest history.[7] Possibly picked up by Cortés on Cozumel in 1519, it later turned up in Vienna and was transferred to the Royal Library in Dresden in 1739; four of its five Venus pages were published by Humboldt in 1813; Kingsborough presented the entire manuscript in Aglio's exemplary copy in 1831 [Fig. 133]; and the first complete photographic facsimile (and still the best) was published by Ernst Förstemann in 1880, along with his commentary. With his researches into the Dresden, Förstemann worked out most of the details of the incredibly complex Maya calendar and associated astronomy. It is thus no surprise that the literature on this manuscript is enormous, and that there have been many subsequent editions and facsimiles. I will therefore confine myself to the calligraphic aspect of the Dresden, a subject that has generally been ignored due to the overwhelming interest in its astronomical and epigraphic content.

Notwithstanding the presence of subject matter that is demonstrably of Classic-period origin, the Dresden has been shown by the researches of Karl Taube and Gordon Whittaker[8] to be very late pre-Conquest in date—in fact, contemporary with the Aztecs, since Aztec gods and names (transcribed from Nahuatl into Maya syllabics) appear on some of its pages. In style, though, it bears little resemblance to the inartistic exactness of the Paris, or the crude and sloppy execution of the Madrid, both

Dresden Seite:	2	3-23	24, 45-63 29-44	65-69	69-74	25-28	32-35a	42-45c
126 (Gott E)								
1324-1321 (A 4)								
1330 (A 6)								
152 (A 1)								
148 (Gott A)								
169 (Gott B)								
1340								
128								
1362 (A 22)								
1317								
1337								
1								
76								
80								
61								
60								
79								
63								

demonstrably late manuscripts [Pls. 74–76]. An exhaustive iconographic study of the codex by Meredith Paxton[9] failed to indicate any particular major Post-Classic center as a possible origin point, but she felt sure that it was carried out in a relatively short time. If it *was* initially discovered on Cozumel, it seems unlikely that such an elegant, refined, and deeply esoteric work of art could have been produced in such an isolated place. Yet it is known that Cozumel Island was a pilgrimage center for the entire Maya lowlands in the Late Post-Classic, so this great book could have been brought there as an offering to its major shrine, that of Ix Chel, the Maya goddess of medicine and childbirth.

The vicissitudes through which the codex must have passed until its safe deposition in Dresden's Royal (subsequently, State) Library are insignificant compared to what happened to it near the close of World War II. On the night of 13 February 1945, Allied bombers flattened 80 per cent of Dresden in one of the most lethal and devasting air raids of all time. The codex, sandwiched between protective glass layers, had been stored in a saferoom along with other outstanding manuscripts; the room ended up under water, but, miraculously, the Maya screenfold survived alone, albeit somewhat water-damaged. It is currently exhibited under very low light in the Library's treasure room, along with such rarities as the opening pages of Bach's Mass in B-Minor, and Dürer's manuscript on human proportions.

I had the opportunity in April 1996 to examine the original codex, in line with my well-founded belief that no facsimile, not even Förstemann's, does it full justice. The Dresden manuscript has been separated into two sections for at least a century, and is displayed as such, although at one time in its history it was one continuous screenfold; it almost certainly had covers when it was in use—possibly the Maya Blue-decorated boards described by Landa—but these were gone by the time it was purchased in Vienna. In content, like the other three codices, the Dresden is entirely

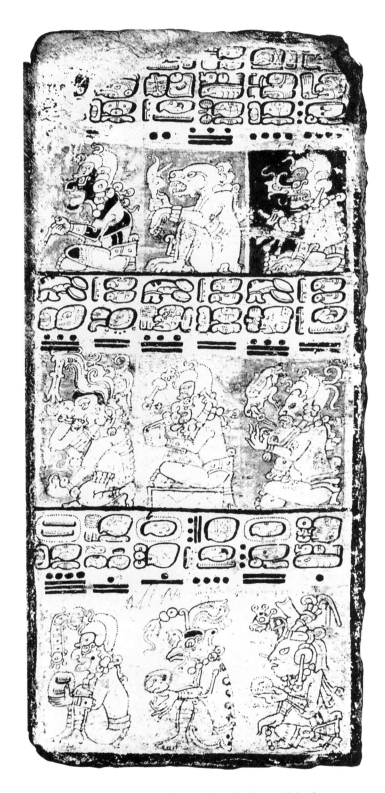

136 OPPOSITE *Table by Günter Zimmermann, identifying eight scribal hands in the Dresden Codex. In the column at left, "Gott E" is the Young Maize God, "Gott A" is the skeletal Death God, and "Gott B" is Chak; Seite means "page"; the numbers identify glyphs in Zimmermann's 1956 catalogue.*

137 *Page 7 of the Dresden Codex, the finest of the four surviving Maya books, shown about actual size. We see here various "almanacs" based on the 260-day count; above each seated god is a block of 4–6 glyphs describing a ritual action, and naming the god as the actor.*

ritual-astronomical, and tied to the workings of the complex Maya calendrical system. While much of it is made up of 260-day "almanacs" divided up in various ways, with accompanying rituals and divinities, there are also very important Venus, Mars, and eclipse tables; multiplication tables; and pages devoted to the New Year rites, which closely parallel an ethnographic description of the same rites given by Bishop Landa.

The gridline network of the Dresden Codex [see *Fig. 133*] has been carried out in a very thin, and now faint, reddish or reddish-tan wash. The lines are extremely straight, sometimes appearing as a double stroke, and quite long;

as I have said, they can only have been laid out with a straight-edge, which precludes the use of a brush pen. I thus concluded in Chapter 4 that a quill or perhaps reed pen was in use here. Such gridlines were also employed to delineate the border strips which later were to be filled with red hematite pigment.

It is agreed by those who have carefully examined the Dresden (or at least its better facsimiles) that more than one scribal hand can be detected in its 74 pages. Based on the form of common glyphs such as those for the first-person possessive *u*, the Maize God, the Death God, the Rain God Chak, and others, the late epigrapher Günter

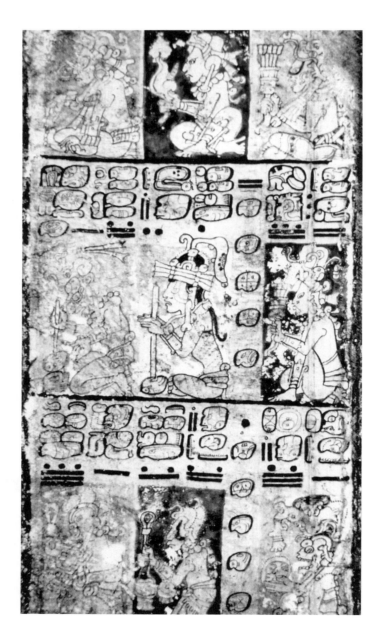

138 Page 6 of the Dresden Codex (detail about actual size): various gods are engaged in ritual actions tied in to the 260-day "almanac." In the middle register, Itsamná and an unidentified deity make fire by drilling. The actions and the names of the gods are given in the text blocks immediately above each picture.

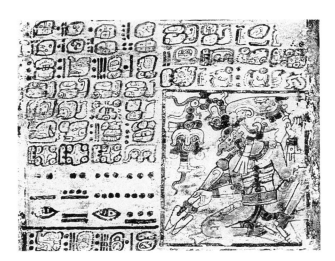

139 Detail of the Venus Table on page 47 of the Dresden Codex, about actual size; the Morning Star deity pictured is Lahun Chan ("Tenth Heaven"), hurling his spear at a victim. Glyphs this tiny must have been written with quill pens.

Zimmermann[10] distinguished no less than eight hands [*Fig. 136*]. A later art-historical study by Meredith Paxton, which included drawn figures as well as texts, defined five "style-sections" with "potential chronological significance," suggesting five artist/scribes.[11] One might conclude that this was a codex designed by a committee, but, as I have already noted, there is a Classic precedent: multiple hands were involved in the production of single monuments, as is known from signatures on some stelae from the Usumacinta River region. The most aberrant section consists of the New Year's Table on pp. 25–28, which not only lacks gridlines and red page borders, but has unusually wide glyphs—up to 16.6 mm. (⅝ in.) in breadth—with formlines up to 1.2 mm. (³⁄₃₂ in.) in thickness. I assume that an *ah ts'ib* from another center, one who specialized in such matters, was called in to produce these four pages, while local scribes were responsible for the bulk of the texts and pictures.

There is no other Maya book with such elegant calligraphy. As has been described previously (pp. 149–50), the glyph blocks, especially in the Venus Table [*Fig. 139*], are relatively small: this is true miniscule writing. The formlines and the bars of the black coefficients were produced by a chisel-edged quill pen, while the finelines of the glyph interiors and the deity figures were carried out with a quill pen with a very narrow tip. In fact, I have never seen fineline drawing of this delicacy in any other manuscript, from any other culture. For these reasons, I totally rule out the possibility that the Dresden was drawn with brush pens.

The mere fact that the Dresden Codex is a very late production demonstrates that Classic-style calligraphy survived all through the Post-Classic period, and that when the Spaniards arrived, this tradition was as strong as ever in Yucatán, probably kept alive in royal courts of the most powerful centers. The relative coarseness of the calligraphy in the other Maya books by no means represents the capabilities and artistry of *all* Maya scribes on the eve of the Spanish Conquest.

The Paris Codex

By contrast with the Dresden, the Paris Codex [*Pls. 74, 75*] is no work of art, but its content has long been of great interest to students of Maya religion and astronomy. In all likelihood only a fragment of a much longer original, it now consists of only 11 leaves, all painted on both sides by a single scribe. Each page is much worn or abraded around the edges, so that parts of the texts and the scenes have disappeared, along with the white coating that underlay those areas. A peculiarity of this manuscript is that several of the pages are written from right to left [*Pl. 75*], instead of the usual left to right; like Leonardo da Vinci, the Paris scribe could write in two directions!

Bruce Love, who has made a detailed study of the codex,[12] has advanced cogent reasons for pointing to Mayapán, the metropolitan walled capital of the Itzá until its overthrow in the late fifteenth century, as the probable place of origin of the Paris, and gives its possible date as

140 *Page 6 of the Paris Codex. The old god Pawahtún, complete with his snail shell, appears in his role as lord of a k'atun (a period of some 20 years), in a cycle of 13 k'atuns. He holds the head of the divinity K'awil in his hands. The upper part of the page is concerned with a series of tuns (periods of 360 days each).*

AD 1450; but, as he says, this remains a hypothesis. How it got to Europe after the Conquest is not known, but it has been at the Bibliothèque Nationale (formerly Impériale) since 1832. Regrettably, no accurate color facsimile of it has yet been issued (the colors in the Graz edition[13] are only an approximation), and the entire codex is not on public view, so my remarks on its calligraphy are perforce based on black-and-white reproductions and two Ektachrome transparencies kindly loaned me by George Stuart.

The usual "almanacs" occur in the Paris Codex, as in the Dresden and Madrid, but they are of minor importance compared to the unique presence of a series of pages connected with sequences of *k'atuns* (7,200-day periods, approximately 20 years each) and *tuns* (360-day periods). In the quasi-historical records of late post-Conquest and Colonial Yucatán, history and prophecy were firmly intertwined in terms of these periods, the grand cycle being one of 13 *k'atuns*, when history would once again repeat itself. Love has shown how closely related the relevant Paris pages are to this rich material, and to the gods who were thought to have ruled each period [*Fig. 140*]. Other pages concern the sequence of four "Year-Bearers" and the New Year's ceremonies. But most intriguing are pages 23 and 24 [*Pl. 75*], which delineate a sequence of 13 constellations of the night sky—perhaps even a zodiac, as some (but not Love) have claimed.

Given its sorry state, it is no surprise that the gridline system of the Paris can only be faintly seen in a few places. The individual glyph blocks were positioned within it with some care (more so than in the case of the Madrid), and each glyph was conscientiously drawn in black with a brush pen, but without any calligraphic flair; there is no trace of the northeast-southwest bias or slant of Classic Maya calligraphy. The overall impression that I have of this scribe is one of pedantic exactness but little artistry. But we should be thankful for the existence of any ancient Maya book.

The Madrid Codex[14]

The Madrid Codex [*Pl. 76*] seems to have been the work of just one *ah ts'ib*, working with a brush pen. Having completed the 56 pages of one side, the scribe turned the

manuscript over to the other side and inverted it, beginning his page 57 on the back of page 1.

There is a peculiarity to these first and last leaves (containing pages 1/57 and 56/112) which few seemed to have noticed. This is that fragments of European paper with Spanish writing are sandwiched or glued between layers of bark paper, and can be seen where the latter has been worn away. The hand appears to be early seventeenth-century. On page 56 most of the writing appears in reverse, because what is visible is the back of a sheet through which the ink has seeped. Looking at the Graz facsimile in a mirror [*Fig. 141*], it is possible to make out something that looks like "*prefatorum*" and, in the line above it, "...*riquez*." Stephen Houston has pointed out to me that there was a Franciscan missionary named Fray Juan Enríquez, who was killed by the Maya of Sacalum in 1624, along with Captain Francisco de Mirones Lezcano, during Lezcano's ill-advised and abortive attempt to conquer Tayasal and open a road between Yucatán and Guatemala.

This is indeed a mystery. The Maya writing on these pages is identical with that in the rest of the manuscript; and the Western paper appears not to have been a mere repair, but to have been incorporated in the codex during its manufacture. Thus the Madrid would necessarily be later than the conquest of Yucatán, probably even post-1624, and could even have been made at Tayasal, which did not fall to the Spaniards until 1697. Could the intrusive paper have been looted from Sacalum following the massacre of Mirones and his party, and carried off to Tayasal? We do not know.

The Madrid is the longest and in most respects the best preserved of the four Maya codices. It consists of 56 leaves, painted on both sides (with the exception of page 1 of the first leaf, which seems never to have been painted); the grand total of painted pages is thus 111. The layout is roughly similar to that of the Dresden, with a gridline network, and the pages divided horizontally into sections by thick red lines, with red borders to each page. "Almanacs" based on the 260-day cycle make up most of the texts, with some of them devoted to occupations like beekeeping, hunting, and trade (mundane subjects which seem to have been spurned by the scribes of the more

esoteric and aristocratic Dresden) as well as carving and painting [*Figs. 99, 112*]. Several pages are devoted to the world-directions and their associated gods, and the scribe assigned four pages to the New Year's rites; but otherwise, the astronomical sophistication of the Dresden is absent. The Madrid is clearly provincial in comparison.

A glance at the Madrid will show that the scribe had his deficiencies: the formlines of the glyphs, like those of the Grolier, are blocky and drawn with haste with a brush pen. Even the fineline details within the glyphs are carelessly brushed in. The elegance and regularity of the Dresden glyph blocks are totally absent, and as in the Paris the "Classic slant" is absent. Unique to the Madrid is the way the red number coefficients were usually delineated: they were first outlined with a black fineline, which was then filled in with a fairly thick red wash. But the defects of this *ah ts'ib* went even further. It has been noted by epigraphers that he often made mistakes in his use of the Maya syllabary, sometimes inverting the order within glyph blocks, or, in a sequence repeating the same phrase or sentence, substituting incorrect but superficially similar syllabic signs for the correct ones.[15] I feel that this was a sign of haste—the scribe was probably copying out one or more codices under time pressure. The original or originals from which he was drawing would probably have been more like the Dresden, that is, compiled carefully over a substantial period by several highly trained scribes. Unfortunately, the Madrid scribe was more a Fleet Street hack than a producer of masterpieces of the calligrapher's art.

141 European paper incorporated within page 56 of the Madrid Codex. The original image has been digitally reversed in Photoshop, to make the words more legible.

THE SPLENDOR OF MAYA CALLIGRAPHY

77 Although Early Classic calligraphy lacks the fluidity and elegance that characterized Late Classic writing, it already shows the baroque complexity of fully developed Maya script. Incised around this unusual stone sphere are three glyphs in cartouches expressing the name of a ruler of an unknown polity; his portrait head appears in relief on the upper surface.

92, 94 Much Classic Maya calligraphy must have appeared carved on wood. The finest surviving examples of the genre are the splendid sapodilla-wood lintels from Tikal. Lintel 3 (ABOVE), from a doorway in Temple IV, depicts the enthroned King Yax K'in during a celebration of a great military victory on 26 July 743. The long text (shown OPPOSITE in detail) must have been first painted within grid lines laid out on the smooth panel, and then carved with hafted obsidian blades.

93 RIGHT Small carved wooden box, said to have been found together with the Grolier Codex, but of Late Classic date. It commemorates a king of Tortuguero (not far from Palenque) who died in the late seventh century; the glyphs resemble those of the Tikal lintels.

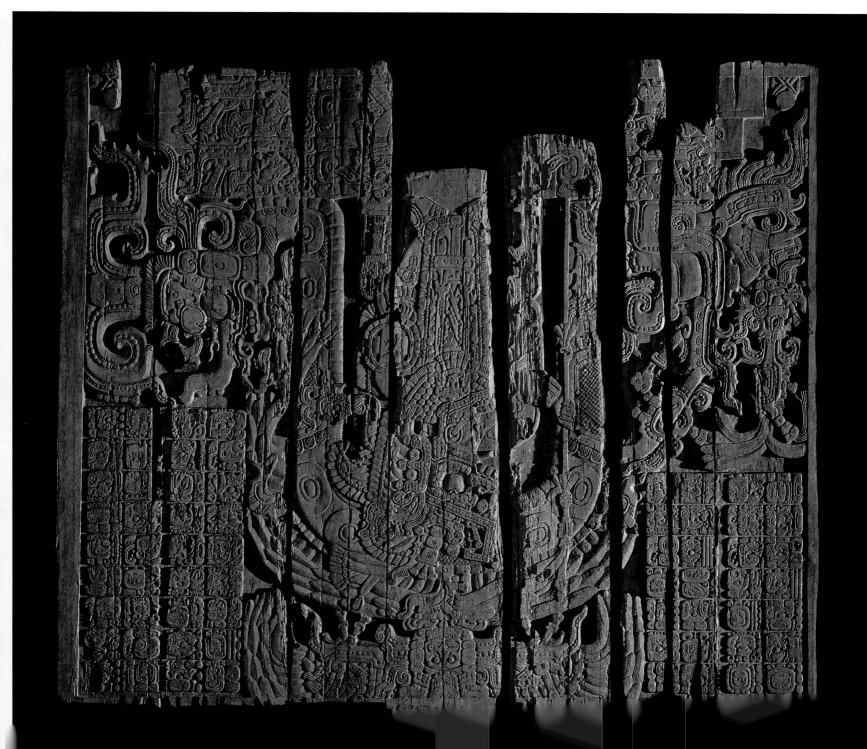

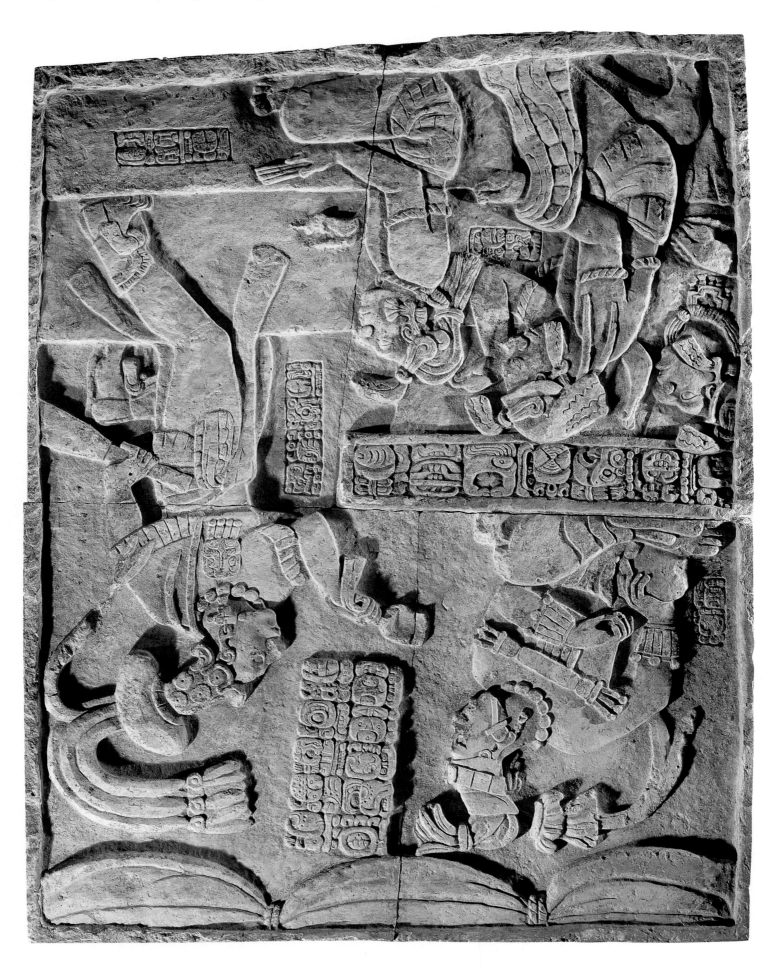

90 OPPOSITE Lintel 24 from Yaxchilan depicts a night scene of royal bloodletting occurring on 28 October 709. The king Itsam Balam ("Shield Jaguar") holds a torch while his principal wife draws a thorn-studded rope through a hole in her tongue. The date, and their names and titles, are in high relief, while the carver's name (only partially deciphered) appears in a lightly incised text behind the ruler's right leg.

91 ABOVE The Kimbell Panel. Seated in a palace beneath a swagged curtain, a lord gazes at his *sahal* (a war leader), who presents three bound prisoners; these may be scribes from a captured city, as one holds the "stick bundle." The sculptor's name is given in low relief to the left of the *sahal*. The event took place in 783.

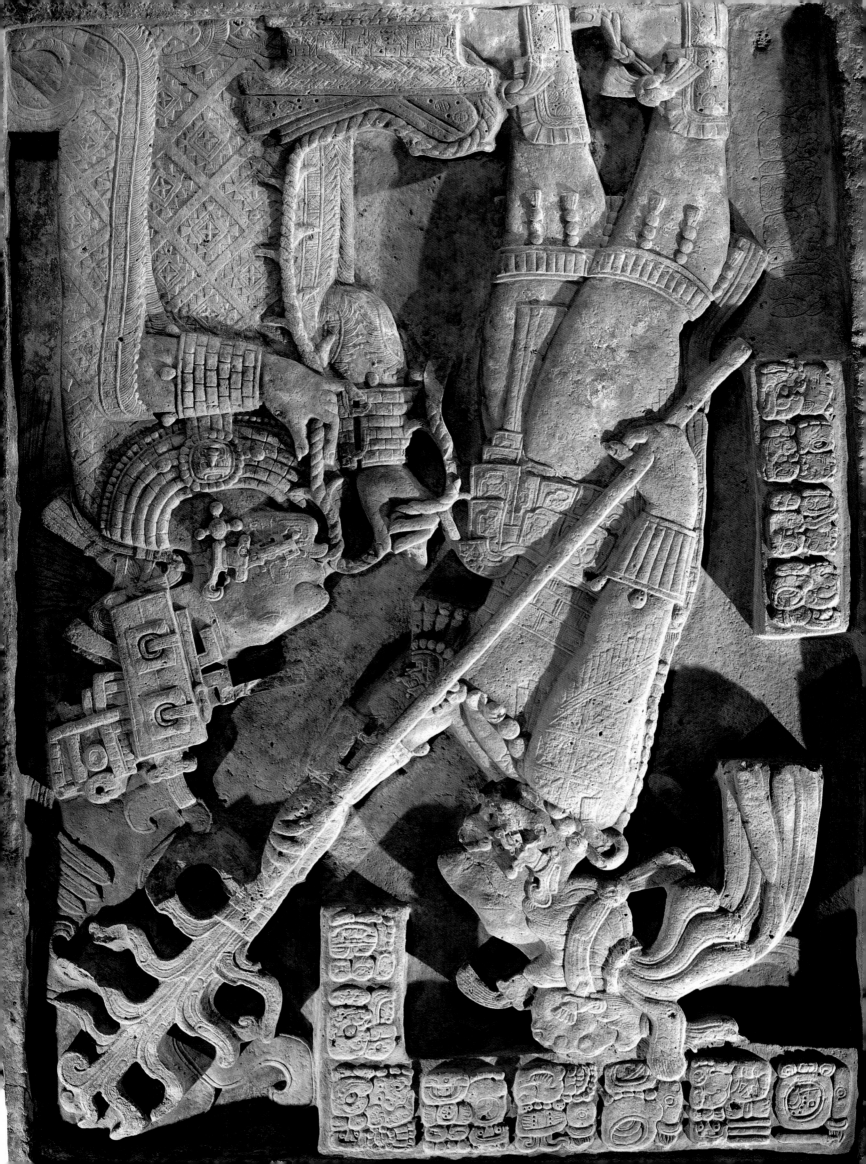

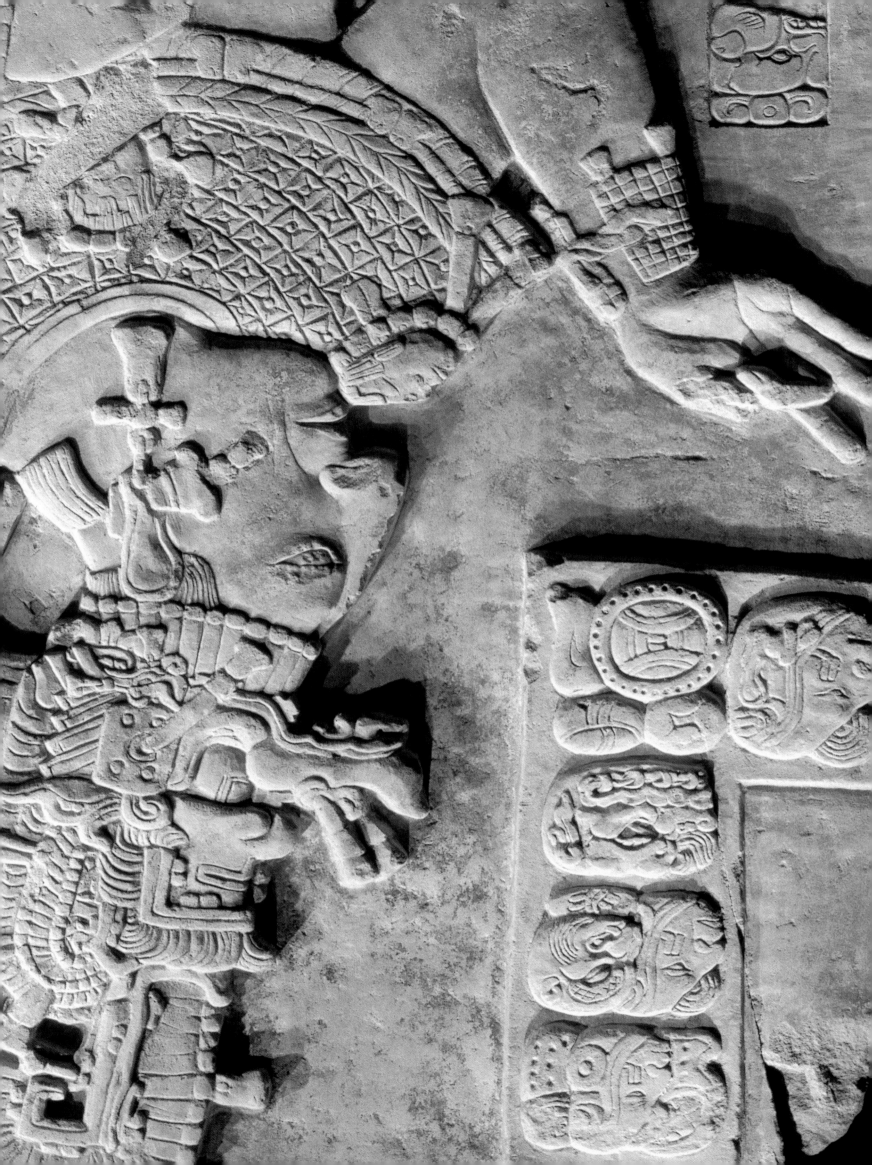

88, 89 Late Classic stela of Ok-Ain ("Alligator Foot"), a Maya queen from the yet-to-be-located city of Yomop, attired in the costume of the Young Maize God. According to the inscription, two sculptors were responsible for the relief and text of the monument, which probably dates to the late eighth century. Interestingly, the glyphs with her name (OPPOSITE) are in high relief, while those of the artists are in the low-relief panels to the left and right of the figure—a contrast found at other Maya sites (see e.g. Pl. 91).

85-87 One of the greatest Maya scribal sculptors was responsible for these extraordinary
glyphs from an unknown Late Classic site in the Usumacinta area, but no other
inscription has appeared in the same style or hand. Two of the glyphs seen here
(OPPOSITE) name a ruler, while one is read *ahau*, "king," (ABOVE).

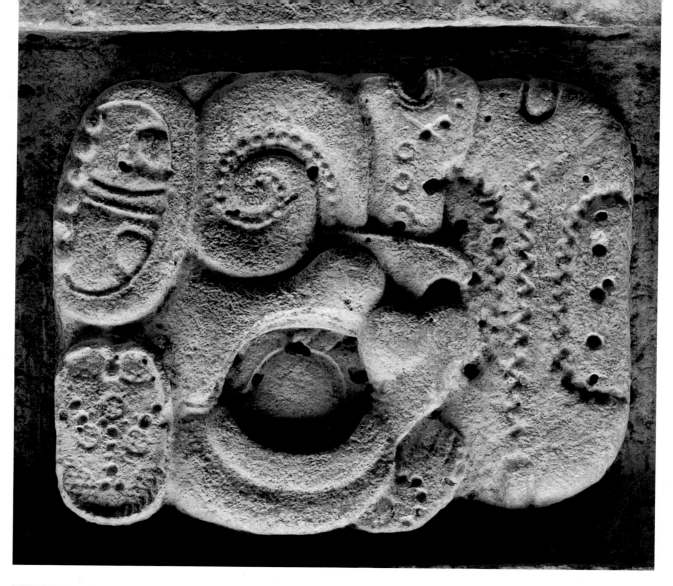

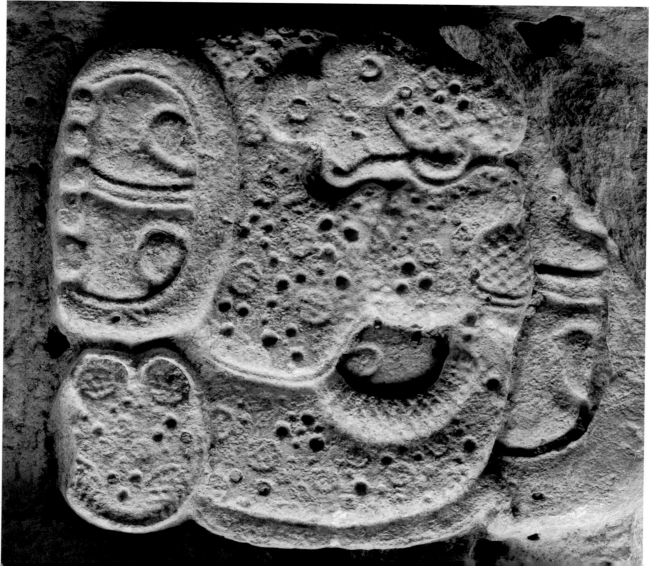

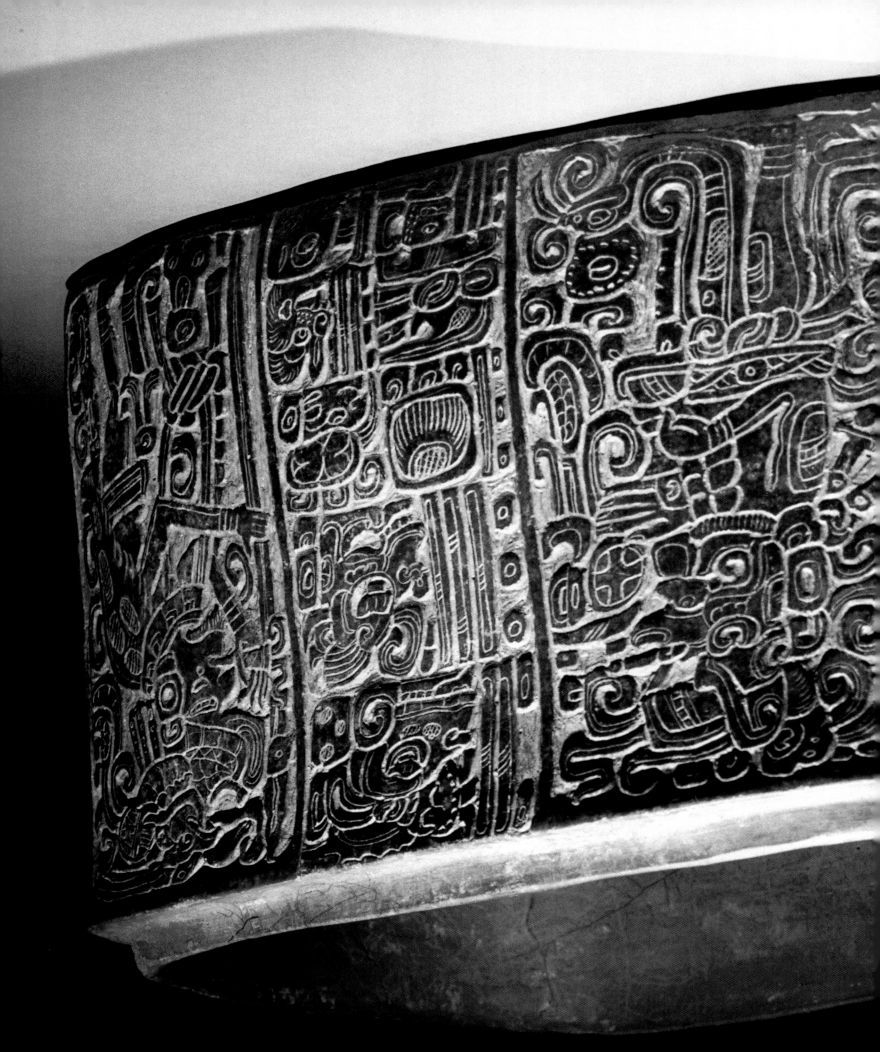

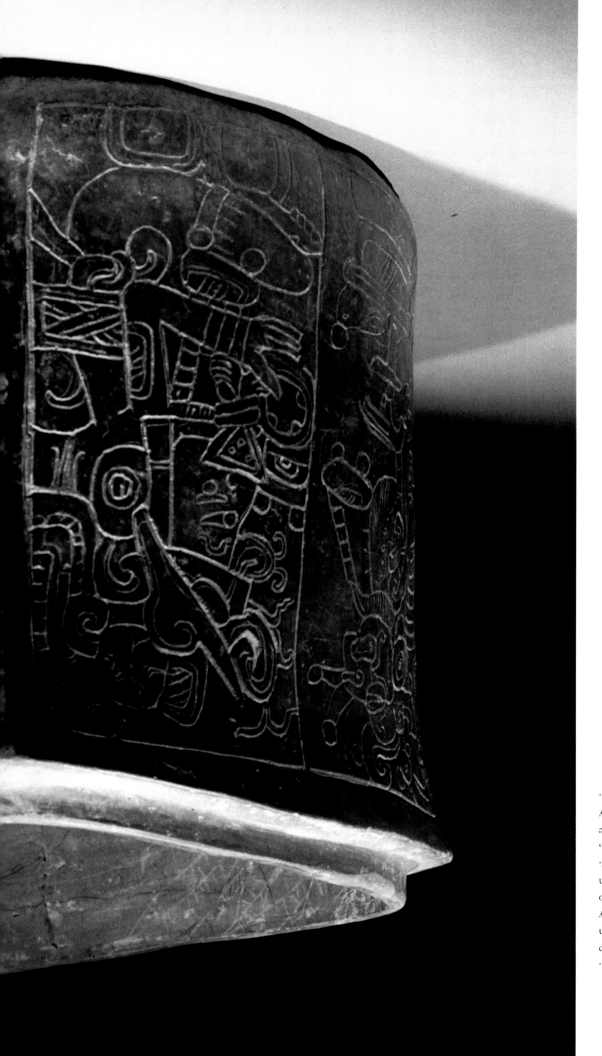

84 Carved pottery box from the northern Petén. The missing cover would have carried the top glyphs of the inscription in the center. Although the remaining Long Count calendrics imply a date corresponding to 7 July 446, that is two days prior to the Calendar Round date which follows; this may or may not be a scribal error. To the left is the god K'awil, to the right God L, the patron of merchants. The artist/scribe responsible for this object was probably a stela-carver.

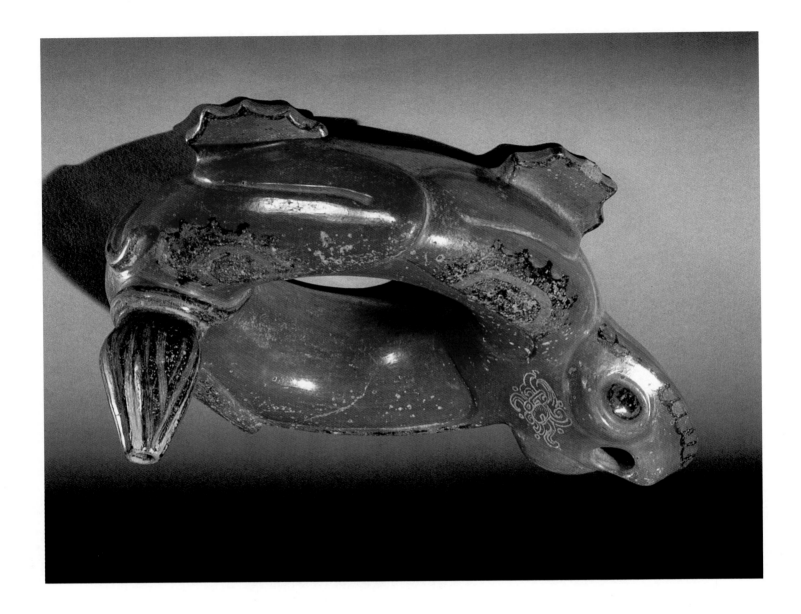

82 OPPOSITE Lidded tetrapod
cylinder from the Mundo
Perdido complex at Tikal, Early
Classic. The style of its vertical
columns of glyphs recalls the
paintings on the walls of
contemporary tombs at Tikal
(Figs. 97, 98) and Río Azul (Pl.
46). Rather than making up a
coherent text, they consist of
early forms of Maya day signs.

83 After this Early Classic
vessel in the form of a toad
had been fired, a glyph (so far
undeciphered) was incised like a
graffito on the back of its head.

OPPOSITE

78, 79 LEFT, ABOVE AND BELOW Two small Early Classic effigies
of Pawahtun, an important supernatural patron of the scribes. Since
Pawahtun was quadripartite, arrayed to the four directions, there
once may have been four of these objects. As with the stone ball,
there are both carved and incised glyphs.

80 RIGHT The glyph on the top of Pawahtun's shell (see Pl. 79)
is probably a personal name.

81 BELOW Early Classic pottery bowl with carved glyphs. The surface
has been treated as though it were stone, highlighting the fact that to
the ancient Maya sculptors there was no important difference between
the two materials.

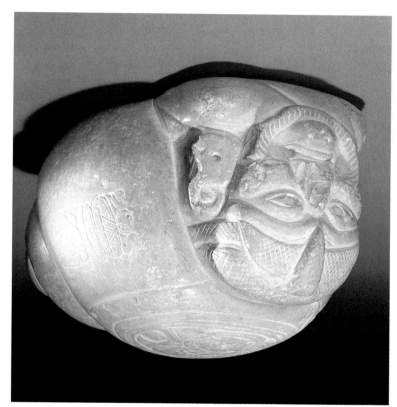

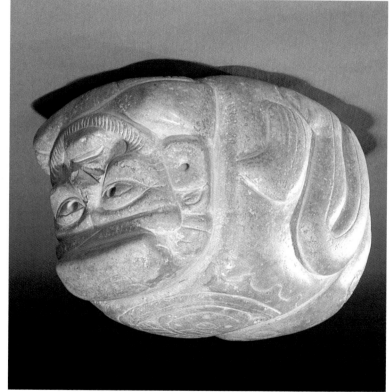

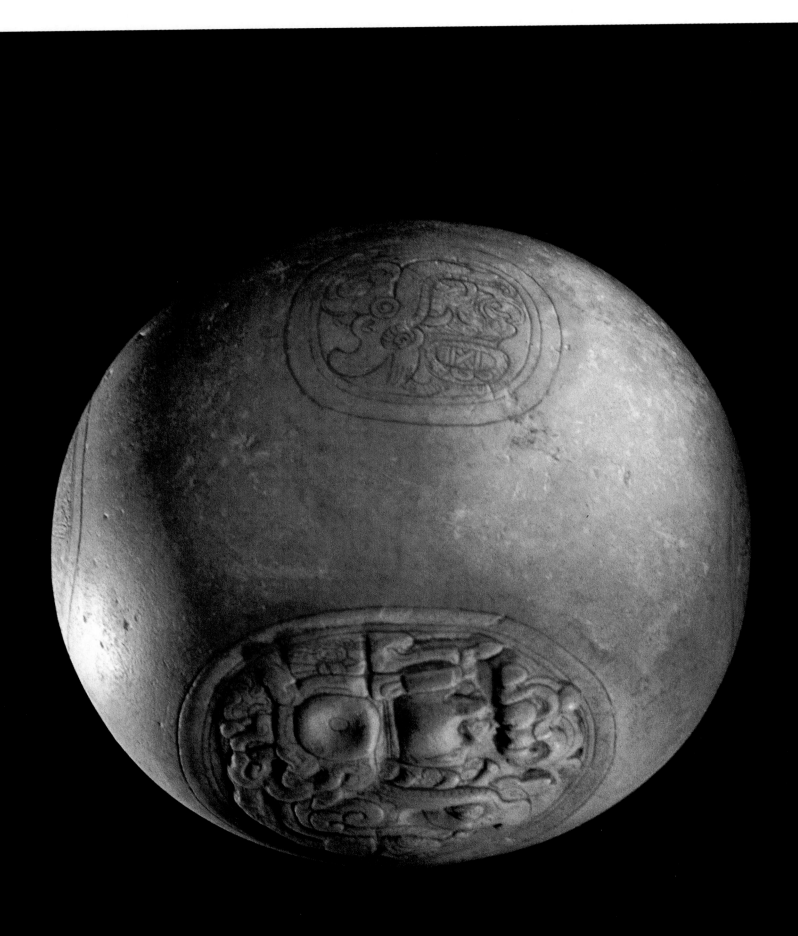

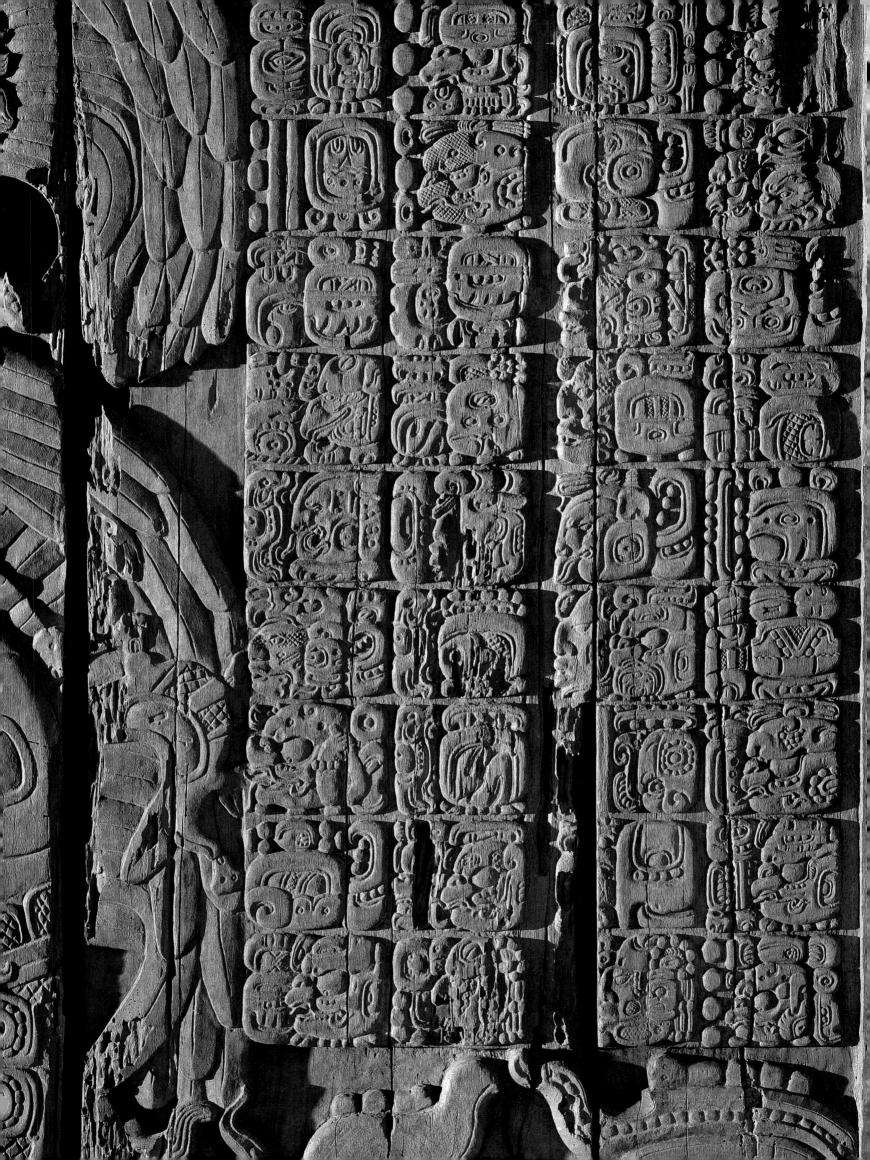

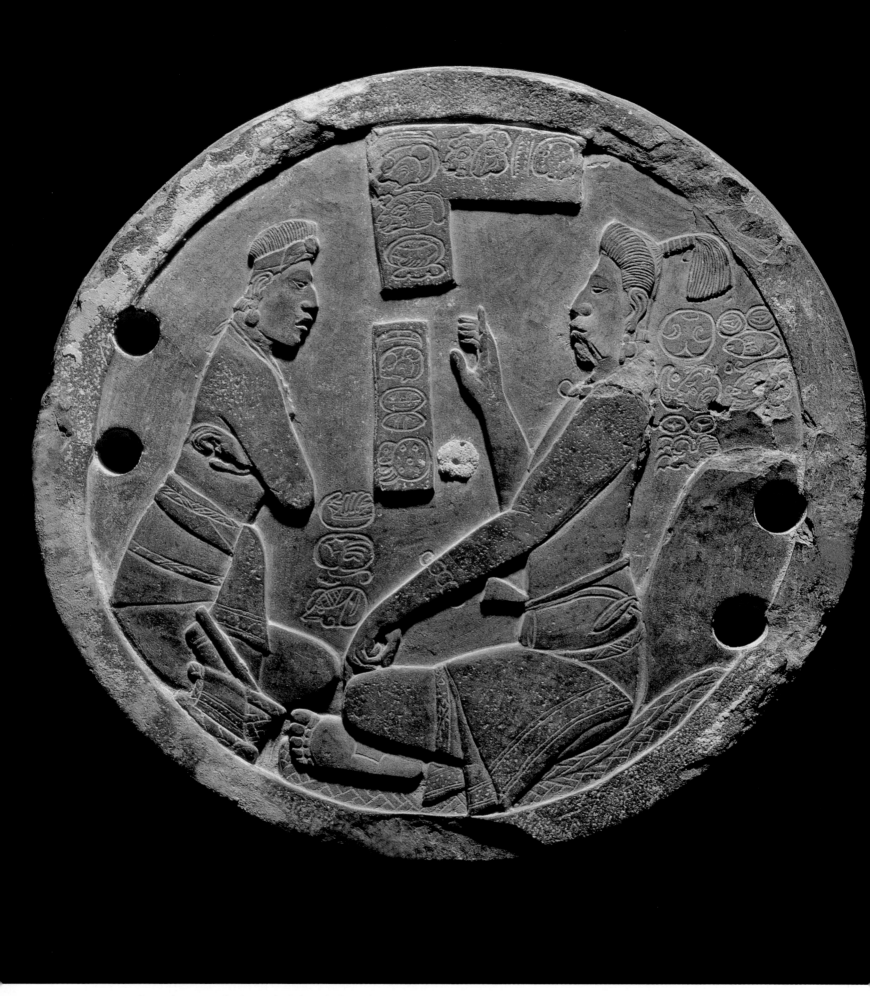

95 Late Classic slate mirror back. On the right is the king of an
unknown Petén site; facing him is his younger brother, attired as an
ah k'u hun, with books lying in a basket by his side.

96 OPPOSITE This Late Classic incised conch-shell section shows a cigar-
smoking *ah k'u hun* crowned with a deer head; the text at the left states
that he is the object's owner, an example of "name-tagging."

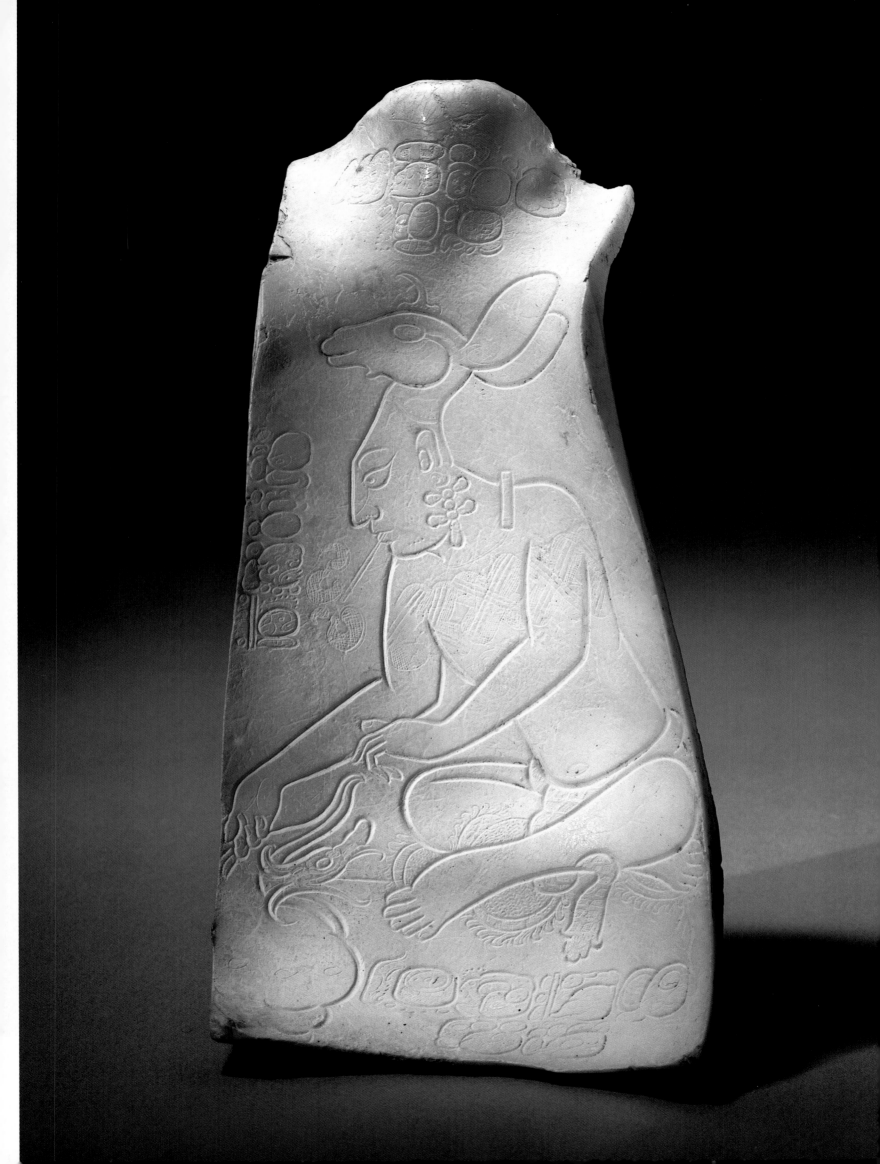

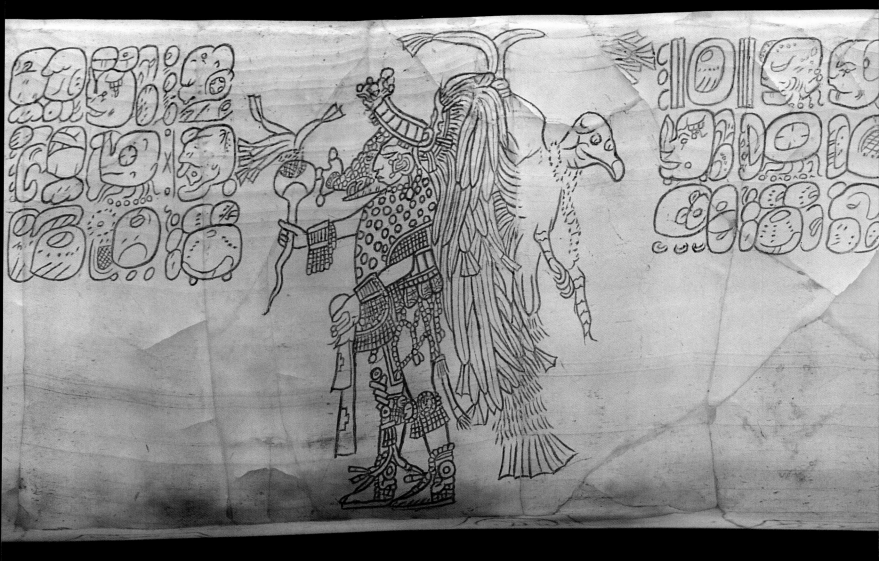

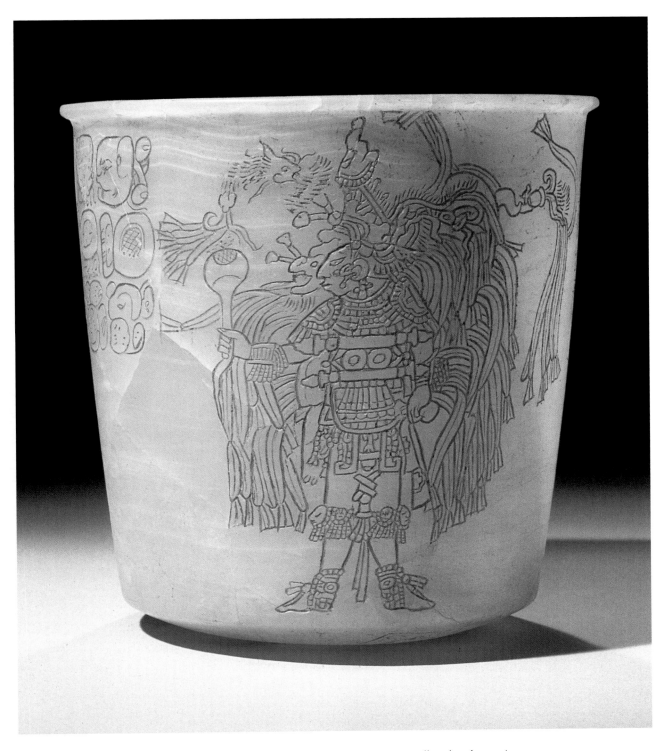

97, 98 The texts carefully incised on this fine travertine vase tell us that the two images are of Yax Pas (sixteenth king of Copán, reigned from 763 until 822), attired as an *ah pits*, "ballplayer." The sinister sceptre borne in his hand is in the form of an eye with its attached nerve stalk, a symbol of death by sacrifice. As here, the scribes usually filled incised lines with red hematite or cinnabar to enhance their beauty and legibility.

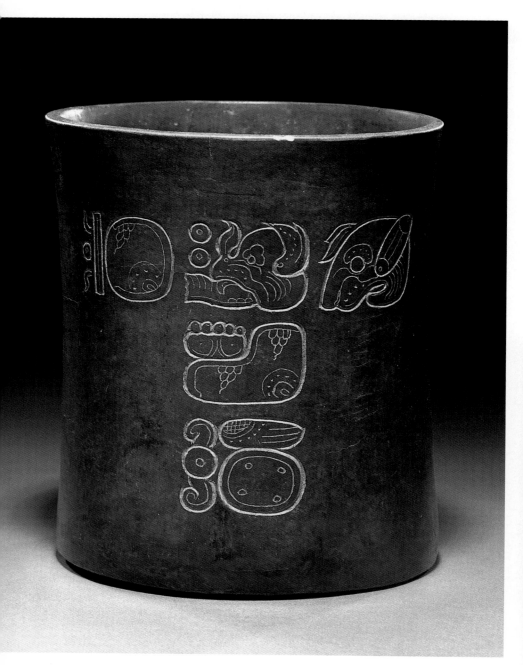

99, 100 LEFT AND BELOW The abbreviated "Short Count" date on this carved and incised pottery vase from northwestern Yucatán corresponds to 24 March 669; within the cartouche of the "11 Ahaw" date glyph is the Young Maize God holding a pen in his hand. The rest of the text names the noble owner of this container for the chocolate drink.

101 OPPOSITE Although hastily executed by a far less skilled hand, this Late Classic carved and incised pottery vase is enhanced by bands of Maya Blue applied over stucco. The principal figure is probably the Young Maize God; between the bands is the PSS.

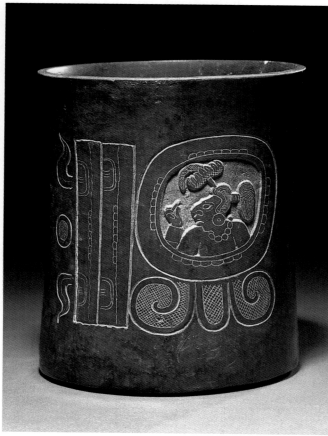

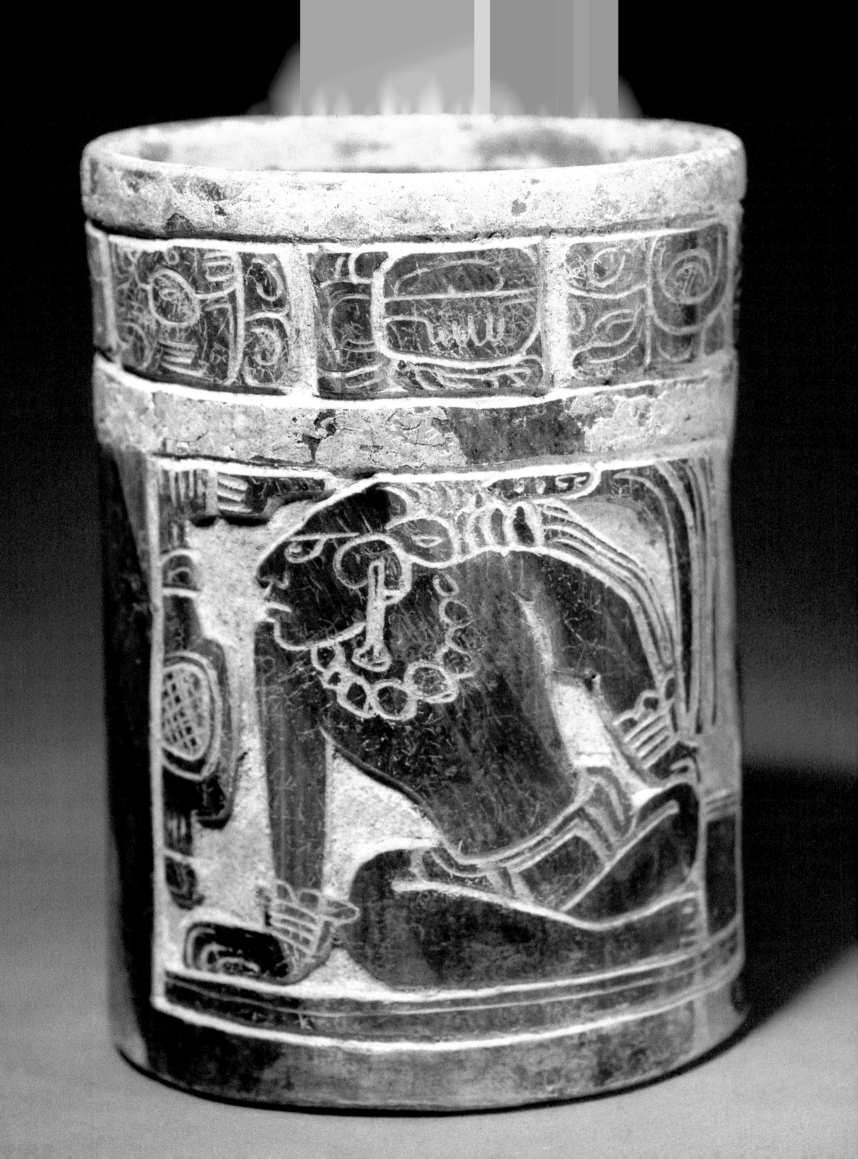

Three Late Classic ceramics in the black-on-white style of the eastern Petén; the scribes responsible for these texts drew glyphs with bold formlines.

102 RIGHT Bowl for drinking *ul* (white maize gruel); the patron of this vessel was a ruler of Ucanal, as stated in the diagonal text below the PSS. (For an explanation of this PSS text, see Fig. 31.)

103 BELOW Another Ucanal bowl, with heads of an unknown god adorned by fantastic foliage. The PSS text appears in the band above.

104 OPPOSITE Dish with a fine text, probably painted by Ak Nikte', "Turtle Flower"; according to the inscription, he was the *ah k'u hun* of a lord named as Chak Tsul Ha (see also Fig. 46). There is a close stylistic resemblance to the cave texts of Naj Tunich (Figs. 2, 96).

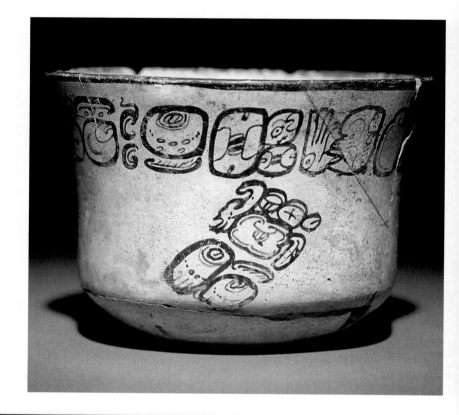

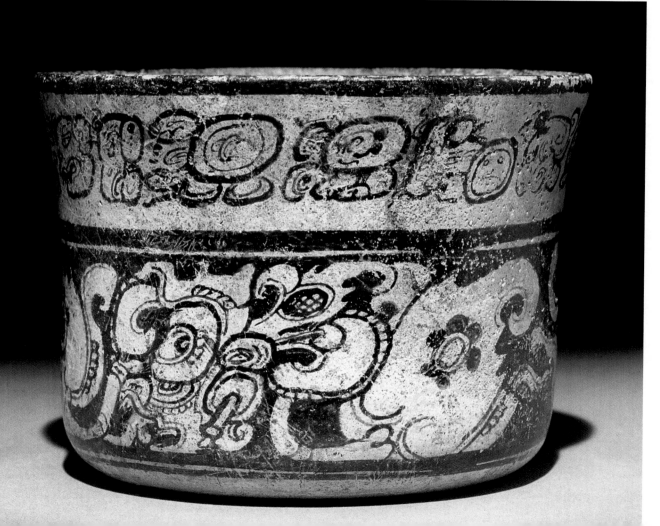

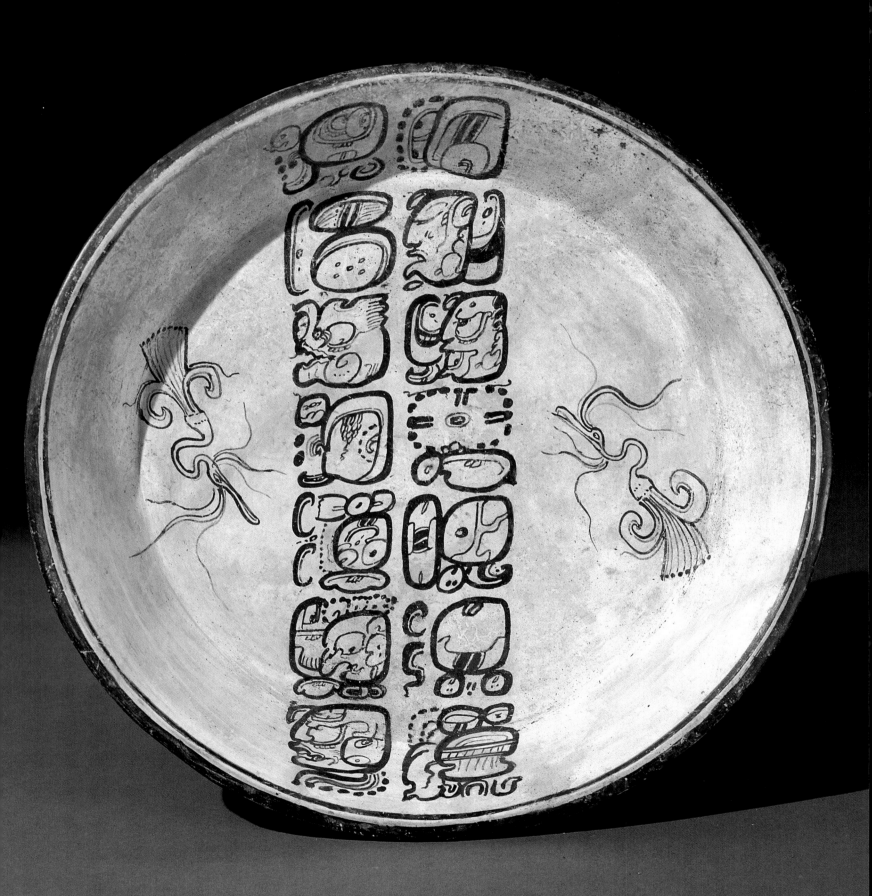

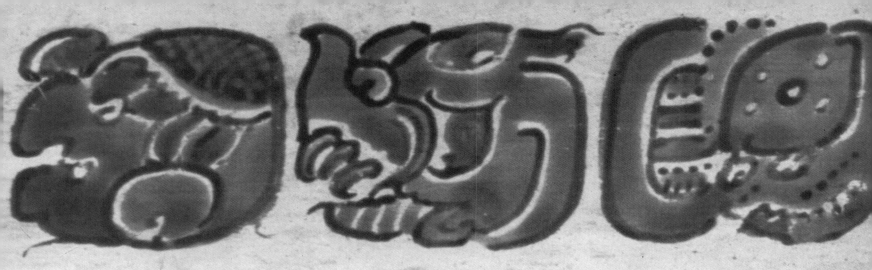

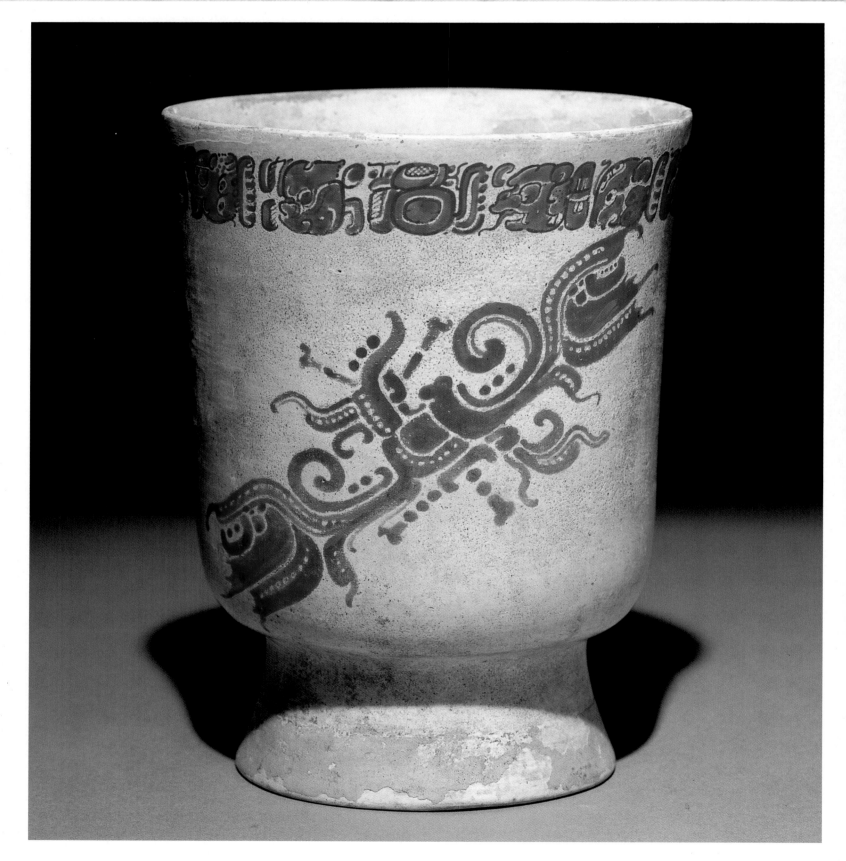

Contemporary with the black-on-white style in the eastern Petén, and sometimes produced by the same artist/scribes, was a white- or cream-slipped ware with painting in red and orange.

105, 106 OPPOSITE This elegant footed cup shows the head of the "Jester God" (a deity of royal power) below a PSS band, seen in detail above.

107 BELOW Baroquely painted water birds—symbolic of the watery surface of the Underworld—often appear in this style; in the PSS band, the glyph above the bird's neck reads "his/her drinking vessel."

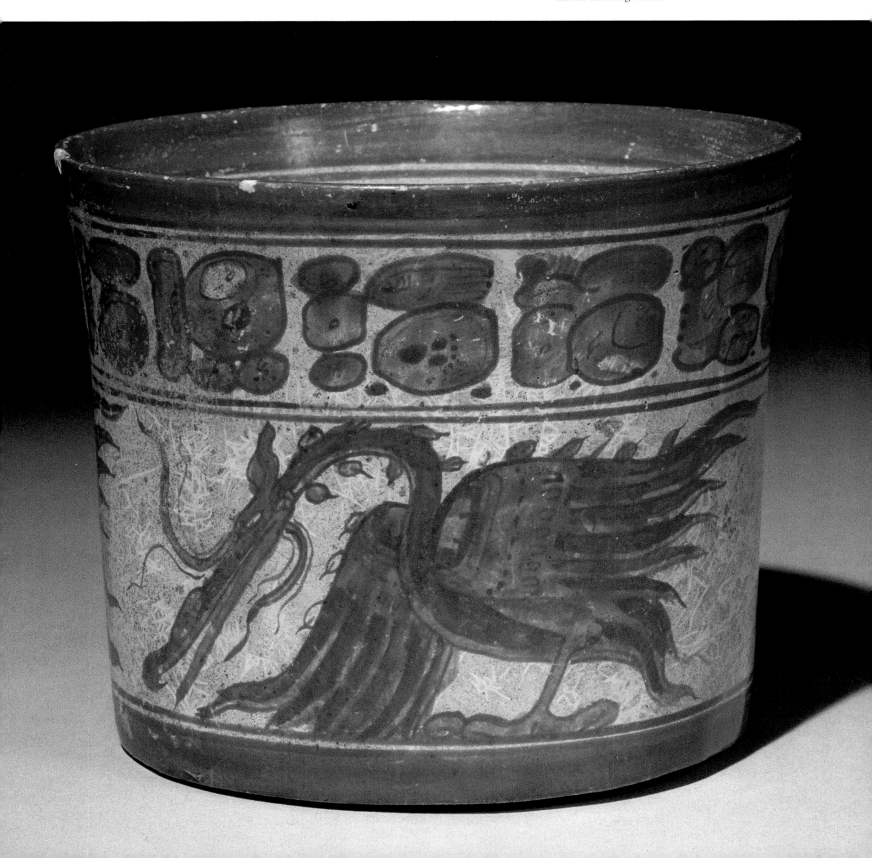

108 RIGHT A Late Classic vase in Nakbé style, painted with repeated war headdresses; Nakbé PSS texts contain some of the freest and most stylish of all Maya calligraphy.

109 BELOW Cylindrical vase in a style related to Nakbé ceramics; two enfoliated heads of an unknown deity encircle the vessel below the PSS.

110 OPPOSITE Detail from a Late Classic five-color polychrome cylinder, carried out by a complex technique involving resist painting and multiple firing. The Death God raises up a stylized long bone.

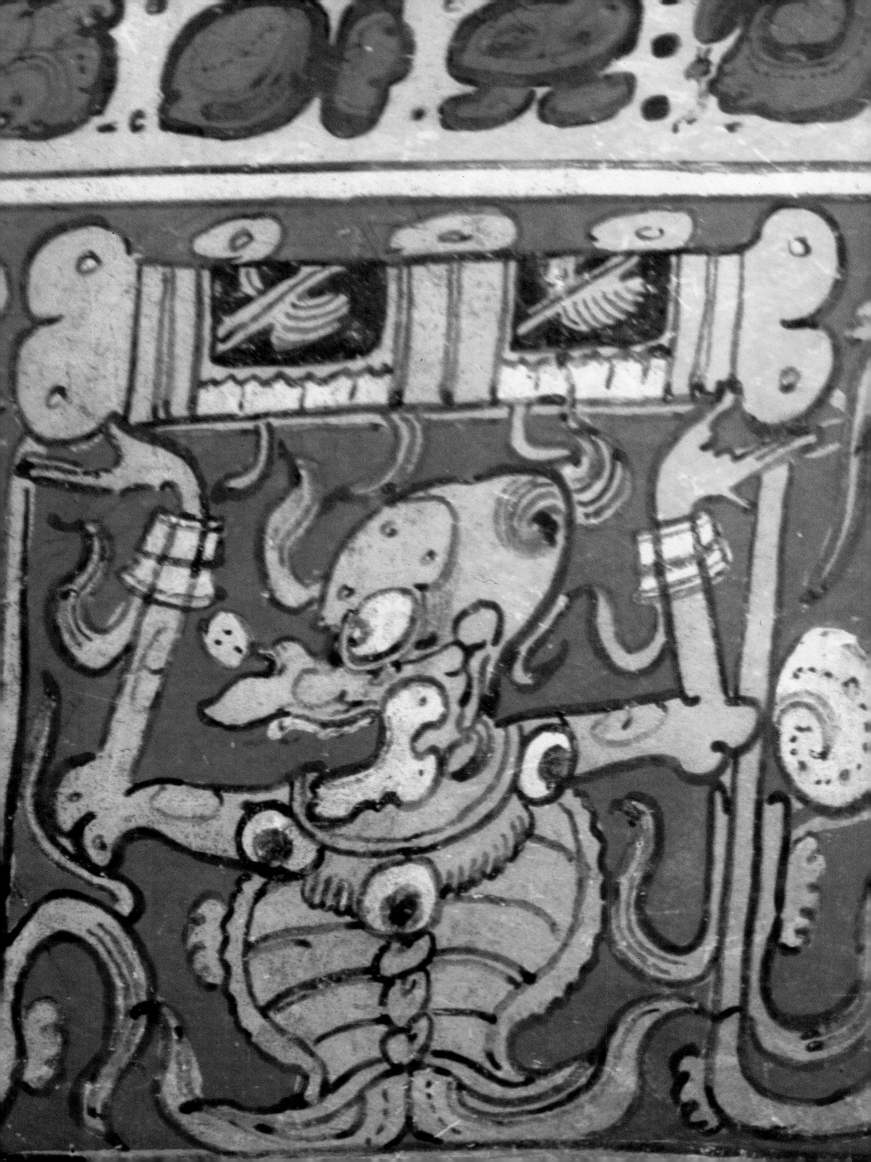

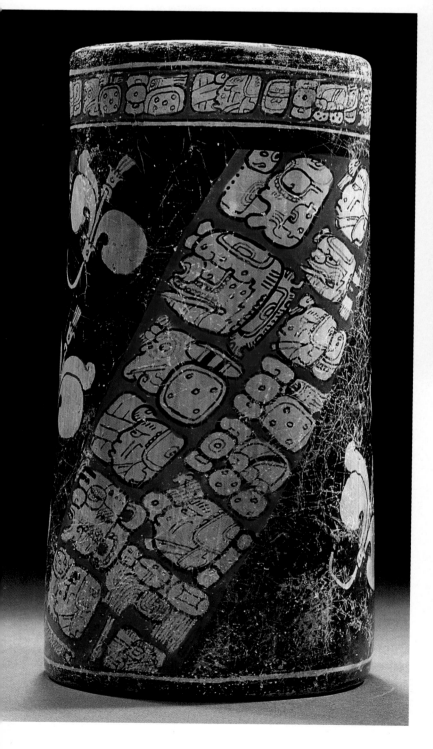

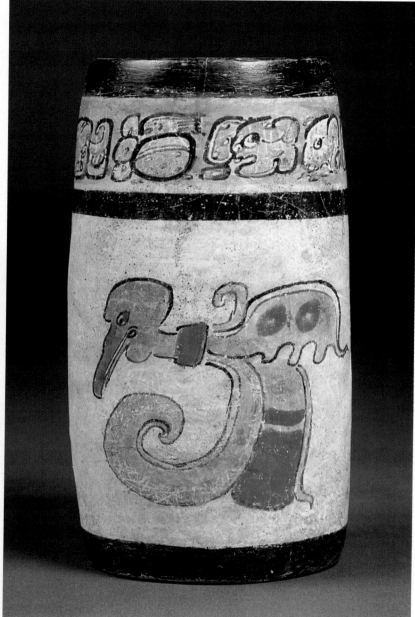

111 Polychrome vase with a disembodied vulture head below a PSS band.

112 LEFT Tall cylinder produced in the eastern Petén. Around the rim is the usual PSS, but the two-column diagonal text below is highly aberrant in that adjacent glyphs are not paired; most of them belong to the PSS formula.

113 OPPOSITE On the lid of this unique resist-painted Late Classic vase is the war headdress, but the meaning of the great black hand on the body of the vase is unknown; the glyphs in the PSS band have been carried out by resist painting followed by light incising. It is clear that this calligrapher was also a master potter.

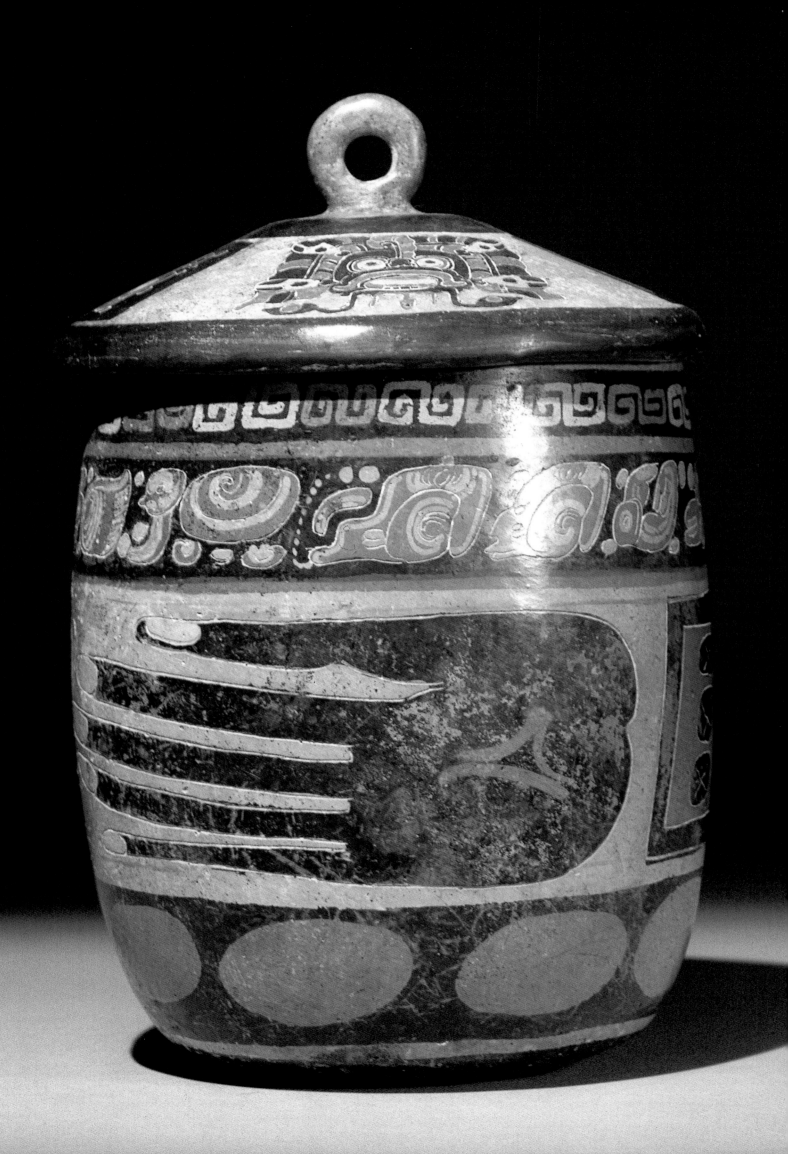

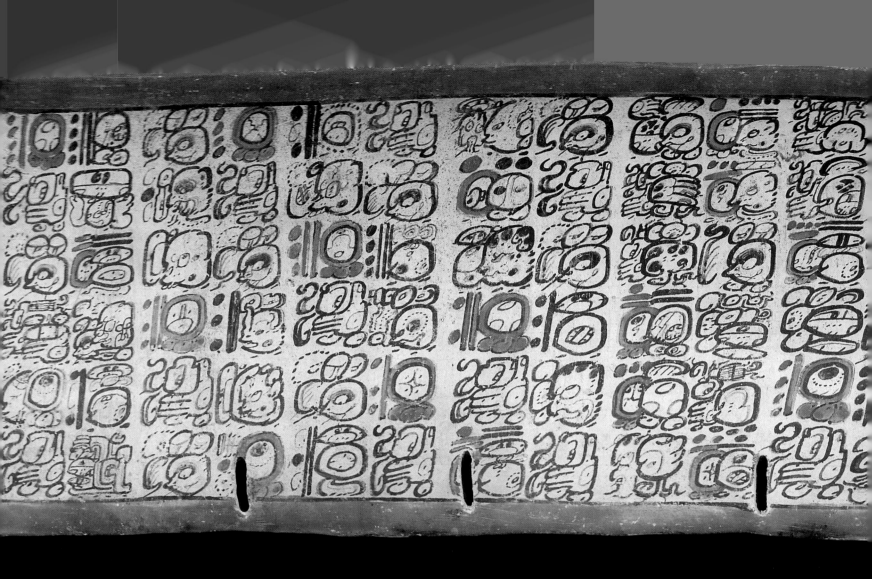

114, 115 The "Calakmul Dynasty Vase" is the finest of a handful of eighth-century vases in Codex style which have extensive texts containing the very earliest history of the rulers of that polity. The long inscription lists the dates and accession events of successive Calakmul kings, none of whom are known from the extant monuments of the city. The rollout (ABOVE) affords a good idea of what the pages in a Classic Maya codex might have looked like.

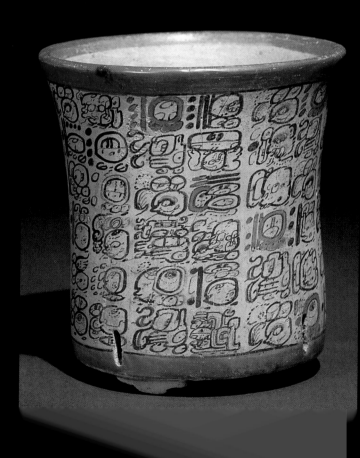

116 OPPOSITE Tall polychrome vase from an unknown site in the Petén. The somewhat fearsome enthroned ruler is witnessing the sacrifice of a captive (depicted on the other side). The boldly outlined glyphs in the PSS have been rubbed with slip to produce a "blush" effect (see Pl. 51).

OVERLEAF
117 Detail from a Codex-style vase, eighth century. A young goddess—possibly the Moon— is gripped by the coils of a dragon-serpent. The text above her begins with a Calendar Round date, followed by the birth of a deity. The scribal artists who painted such texts and scenes must also have been responsible for writing and illustrating the long-disappeared screenfold books of the Classic Maya.

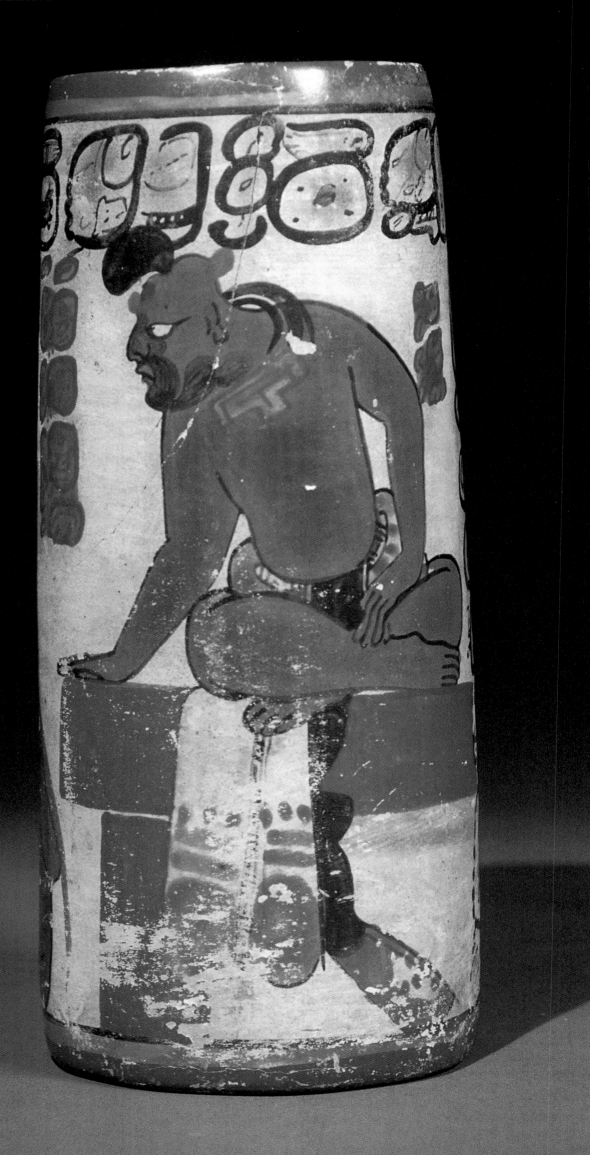

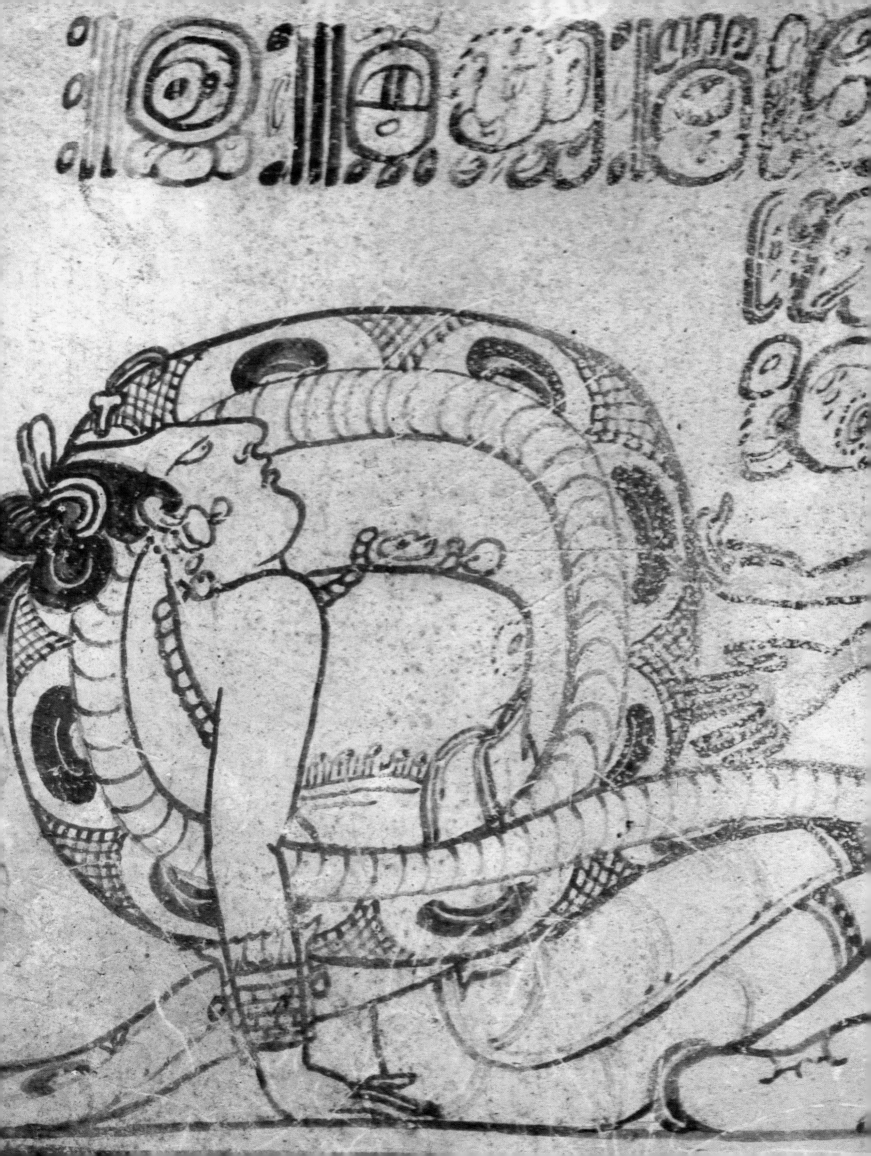

6

THE END OF THE CALLIGRAPHIC TRADITION

THE END OF THE
CALLIGRAPHIC TRADITION

...these priests of ours were to come to an end when misery was introduced, when Christianity was introduced by the real Christians. Then with the true God, the true *Dios*, came the beginning of our misery. It was the beginning of tribute, the beginning of church dues, the beginning of strife with purse-snatching, the beginning of strife with blow-guns [the Colonial Maya word for firearms], the beginning of strife by trampling upon people, the beginning of robbery with violence, the beginning of forced debts, the beginning of debts enforced by false testimony, the beginning of individual strife, a beginning of vexation, a beginning of robbery with violence. This was the origin of service to the Spaniards and priests, of service to the local chiefs, of service to the teachers, of service to the public prosecutors by the boys, the youths of the town, while the poor people were harassed. These were the very poor people who did not depart when oppression was put upon them.

Prophecy for K'atun 11 Ahaw,
in the Book of Chilam Balam of Chumayel[1]

No one knows how many Books of Chilam Balam are in existence, but at least a dozen are known. All of these are compilations of native Maya texts, including annals in which history and prophecy are woven together seamlessly, and in which each age is named for the day (always Ahaw) on which a particular *k'atun*—the approximately 20-year cycle of the Long Count—ended. While these books (some of them still jealously guarded by the Yucatec Maya community in which they were compiled) are in Maya, all are written on European paper using the modified Spanish alphabet taught to the natives by the early friars. *Chilam* or *chilan* means "interpreter," in this case interpreter of what the gods say. Chilam Balam, "Jaguar Interpreter," was said to have predicted the arrival of the Spaniards and a new

religion, and thus to him was traditionally ascribed the authorship of these books. Yet although the Chilam Balam books are largely eighteenth-century in date (the Chumayel manuscript [*Figs. 142, 143*] reached its final form in 1782), Mayanists agree that many of the materials in them are based on much earlier works, and that the most archaic of them are probably transcriptions of hieroglyphic originals.

The question that must be asked is, following the immense trauma and disruption of the Spanish Conquest, how long did the knowledge of Maya hieroglyphic writing last, and among whom? When were the last hieroglyphic codices written, and who could read them?

I must first of all stress the fact that the conquest of Yucatán and the lowland Maya was a long-drawn-out, piecemeal process, not the sudden cataclysm that was visited among the more centrally organized Aztecs in 1521. The Maya of the east coast were first contacted by the Spaniards in 1517, and Cortés landed on Cozumel Island in 1519. But it was not until 1527 that the first phase of the conquest of Yucatán began, again on the east coast. The Maya, ferocious fighters skilled in jungle warfare, proved to be a tough nut to crack, and their continued resistance to the invaders meant that it was as late as 1546 that the Spaniards considered them pacified and were able effectively to impose their massive program of cultural destruction, forced conversion, and reorganization of the native masses into labor- and tribute-producing serfs.

Notwithstanding these apparent successes, tens, perhaps hundreds, of thousands of Maya "voted with their feet," by fleeing into densely forested areas far from the eyes of the hated Spaniards.[2] The entire wilderness region of southernmost Yucatán and the Petén of Guatemala remained in independent, still-pagan Maya hands; particularly powerful was the Petén Itzá state, which maintained its cultural and political viability from its island capital, Tayasal, under a succession of kings named Kanek'.

219

In Tayasal, right up until it finally fell to Spanish arms in 1697, Itzá Maya priests continued to conduct their rites aided by hieroglyphic, screenfold books.[3] I have already called attention to the European paper with Spanish writing incorporated into two leaves of the Madrid Codex, strongly suggesting that that particular screenfold—by far the longest of the four extant Maya books— was manufactured in Tayasal some time between the 1620s and the fall of the Itzá capital in 1697 (above, p. 181). It could well postdate the founding of Harvard College!

That Maya codices survived into the seventeenth century in the Petén is not surprising, but what *is* unexpected is that they seem to have also done so in Yucatán, in spite of the overwhelming Spanish presence there. One piece of evidence is this. In 1696, Fray Andrés de Avendaño was briefly among the Itzá at Tayasal; upon his arrival from Yucatán, he was able to identify a mask set in a stone column as the god Ah Kochamut (believed to be an aspect of the supreme deity Itsamná). Avendaño assures us, "I came to recognize it, since I had already read about it in their old papers and had seen it in their *anahtes* which they use, which are books of the barks of trees, polished and covered with lime, in which by painted figures and characters, they have foretold their future events."[4]

It is generally assumed that it was the Franciscan friars, in particular Bishop Diego de Landa, who extirpated all knowledge and vestiges of indigenous Maya writing in Yucatán, but the actual situation is somewhat more complex than this. It is true that all education of native youths was in the hands of the Franciscans; by 1585, there were no less than twenty-two Franciscan missions in the peninsula engaged in teaching the Catholic faith and observances, and training boys to read and write Maya using the Spanish script.[5] Now these boys were the sons of native *principales*, and belonged to the old nobility, which was expected to supply all the leading figures in the local ecclesiastical hierarchy. At the head of this hierarchy was a Maya official called in Spanish *maestro cantor* or "choirmaster," a somewhat misleading title, as he was in charge not only of the choir, but also of all other native church officials. The *maestro cantor* acted as parish secretary, keeping notes for entry into registries of births, marriages, and deaths; he

supervised the catechism; selected and taught youngsters to be trained in reading, writing, and church duties; and he controlled who would become church functionaries, *escribanos* (scribes), and his own successor in the office.

In short, the *maestro cantor* of colonial Yucatán fulfilled the role that had been taken by the priest or *ah k'in* of the late pre-Conquest Maya.[6] And the latter, I believe, was the Post-Classic counterpart of the Classic *ah k'u hun*, "keeper of the holy books." Thus, the equation

$$\textit{ah k'u hun} \; > \; \textit{ah k'in} \; > \; \textit{maestro cantor}$$

is probably not too far off the mark. As the colonial historian Nancy Farriss says,

> The *maestros cantores*, if not originally all "converted" *ah k'ins*, had, as nobles, close ties with the Maya priesthood, and they also continued to be the repositories of whatever indigenous sacred lore survived. The versions of the Chilam Books and other holy texts that have survived must all have been the work of colonial *maestros* or their protégés, the *escribanos*. Who else could both read the ancient glyphic texts and transcribe them into Latin script?[7]

Small wonder that as late as 1579, *maestros cantores* were being accused of being idolaters and of keeping idols in their schoolhouses. Behind the Catholic cult of the saints lay a host of pre-Conquest gods, their memory kept fresh by those very officials charged with promulgating the Christian faith!

Initially, the friars, anxious to keep their newly won flocks from being contaminated by the blatantly sinful conquistadores and settlers, sought to keep them culturally and socially isolated by teaching only in Yucatec Maya. At least some of the missionary priests must have learned hieroglyphic writing to do this, since the Franciscan Antonio de Ciudad Real has these words, incorporated in Alonso Ponce's 1588 *Relación*, on the native books:

> Afterwards some of our friars understood and knew how to read them, *and even wrote them* [my emphasis], but because in these books were mixed many things of idolatry, they burned almost all of them...[8]

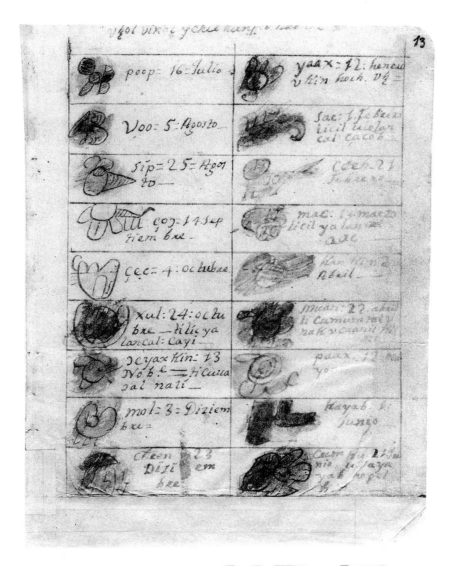

142 Folio 13 of the Book of Chilam Balam of Chumayel, written at the end of the eighteenth century. The "glyphs" for the eighteen months of the Maya calendar have by now lost all semblance of their Classic or Post-Classic forms.

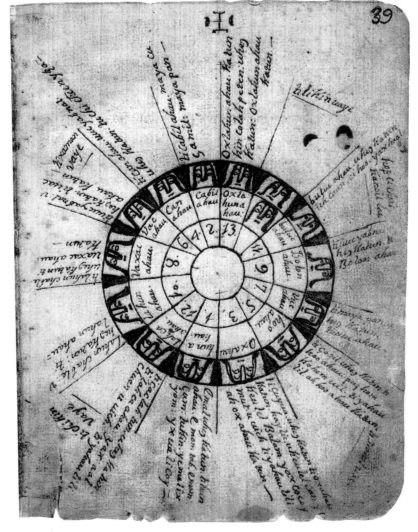

143 Folio 39 of the Book of Chilam Balam of Chumayel, with the calendric cycle of 13 k'atuns. Each k'atun was named from the day on which it ended, given here by the numbered coefficient and by the Ahaw sign (the heads in the wheel). For Classic forms of Ahaw, see Figs. 18, 21 and Pl. 45.

Both the *maestros cantores* and the Franciscan friars must have been literate in both writing systems in those days, before the great reaction took place.

This brings me to Bishop Landa and the events culminating in the famous (or infamous) Auto da Fé of 12 July 1562. Early in that year, it had become clear to Landa that many of his converts, particularly among the nobility and the *maestros cantores*, had apostasized, and were practicing their own native rites in secret, including human and animal sacrifice. In his righteous rage, the disillusioned Landa instigated his own Inquisition (illegal, according to some of his Spanish enemies).⁹ Those accused of idolatry were imprisoned, and questioned under the most exquisitely painful tortures—which included "the torture of the pulley"; fastening the mouth open with a stick and pouring in water until the abdomen was inflated, after which someone would stand on the victim until water mixed with blood issued from the mouth, nose and ears; whipping with up to two hundred lashes; and scorching with wax tapers. It was later testified that 157 Maya died during or after this treatment, out of thousands arrested.

During the culminating Auto da Fé in the town of Maní, there was a great public burning of the hieroglyphic books, as reported by Bernardo de Lizana in 1633:

> Then he [Landa] collected the books and the ancient writing and he commanded them burned and tied up. They burned many historical books of the ancient Yucatán which told of its beginning and history, which would be of much value if they had been translated in our own writing, because today there would be something original. At best there is no great authority for more than the traditions of these Indians.¹⁰

(In similar vein, Antonio de Ciudad Real lamented the burning, commenting that "thus was lost the knowledge of many ancient matters of that land which by them could have been known."¹¹) There is no authentic account of the exact number of codices sent to the flames by this formidable man, but they must have been many. In all events, the word went out: the writing and possession of native books was absolutely forbidden under threat of severe punishment. This surely marked the end of any

attempts by missionaries to learn the script themselves, but probably numerous *maestros cantores* kept up the calligraphic tradition in secret, and could probably both read and write codices and other glyphic documents until the close of the seventeenth century.

After these events, the knowledge of the native writing system must have dwindled rapidly. By 1782, when Don Juan Josef Hoil (surely a *maestro cantor*, although we have no surviving biographical data) wrote and signed his name to the Book of Chilam Balam of Chumayel, that learning had entirely perished among the lowland Maya. Folio 13 of Hoil's manuscript [*Fig. 142*] purports to illustrate the eighteen month signs of the Maya calendar, but they are little more than meaningless scrawls; on folio 39 [*Fig. 143*] are more carefully drawn heads in European style each standing for the last day, Ahaw, in the twenty-day "week." I infer from this that Hoil knew nothing of the glyphic script. Thus, a tradition reaching back almost two thousand years into the Maya past had utterly perished by the final decades of the eighteenth century.

Yet dead though the calligraphic tradition was, hidden in the alphabetized sentences of these late Maya-language documents is something patently Maya. The linguist and Maya specialist Victoria Bricker¹² has discovered in the Spanish orthography of the Books of Chilam Balam of Chumayel and Chan Kan certain traits that could only have originated in the peculiar character of Maya hieroglyphic writing which, as we have described in Chapter 2, is logosyllabic in nature. Among these are consonant insertion, vowel insertion, and consonant deletion. This implies that the Spanish friars who devised the colonial orthography would necessarily have understood the spelling rules of the glyphic script; and that the early *maestros cantores* instructed in both writing systems would have had little difficulty in making their transcriptions from hieroglyphic originals.

The *maestros cantores* and the lesser *escribanos* were the true inheritors of the Maya scribal tradition, and their offices survived into the next century and even into our own day. During the Caste War of 1847–53, the oppressed Maya peasantry and hacienda workers rose up against the Whites who kept them in poverty, and came close to taking back all

of Yucatán for their people. The role that these scribal and religious specialists played in the uprising can be seen in the approximately two hundred Maya-language letters which have survived the conflict; most of these are tactical communications, written by trained scribes, between native Maya officers.[13]

The ideological center of the Caste War was the community of Chan Santa Cruz in Quintana Roo, locus of the cult of the Talking Cross; in the cult, a pivotal role was played by a mysterious individual named "Juan de la Cruz" who is said in oral traditions to have served as interpreter (i.e. *chilam*) or scribe for it. In spite of centuries of colonial Spanish and Republican Mexican attempts to stamp it out, the cult still continues in Chan Santa Cruz, and its *maestro cantor* is still the custodian of a "holy book" in which the ancient traditions of the Maya people are recorded and preserved.[14]

Maya hieroglyphic calligraphy may have disappeared over two hundred years ago, but the Maya scribe lives on.

144 The 85-year-old Cecilio Can Canul, a gifted scribe of the Cruzo'ob Maya, photographed in 1986 in his home village of Chanchen Comandante. He holds in his hands one of the Santo Hu'uno'ob ("holy books"). Written by him in Yucatec Maya, but using the Spanish alphabet, this book records prophecies of the Holy Cross of Tixcacal Guardia, the ceremonial center of the region.

EPILOGUE

by Justin Kerr and Michael D. Coe

Following the internecine wars of the Late Classic, the southern lowland bureaucracies that had needed and supported the scribes disappeared. The scribes no longer had the function of recording the history of powerful rulers or war chiefs (*sahal'ob*) whose names and deeds were carved into stone monuments and buildings. Vase painters also faced a crisis. The elite were no longer in the position of being able to send gifts of painted vessels to their subordinates and allies, nor were such beautifully fashioned objects, filled with food and drink, and illustrated with their most sacred mythology, placed any more in high-status graves. The need for this sacred pottery was over; writing on the vases became mere decoration. By the time of the Collapse, the role and scope of writing had diminished, so that the corps of scribes that survived into the Post-Classic was greatly reduced from what it had been in its days of glory.

Under the heel of the Spanish conquerors and missionaries, the writers of glyphic texts were eventually forbidden to practice their craft, as we have seen, and instead were forced to learn and use the Latin characters of the Old World. Except for a few Maya communities well isolated from the Christian overlords, particularly the kingdom of Tayasal, glyphic literacy lasted through the close of the seventeenth century. But beyond this, little or nothing passed. By the time explorers like John Lloyd Stephens and Frederick Catherwood traveled through the the jungle-covered ruins of the Maya area, none of the natives could tell them anything about the hieroglyphic texts found in them. They had become as mysterious to the Maya as they were to the first explorers of the ancient Maya cities. "Who shall read them?" asked Stephens.

Well, at last they *can* be read. But what about the Maya themselves? In recent years, there has been a remarkable cultural resurgence among the various Maya peoples, who find themselves scattered across five modern nation-states, but without a single voice. In Guatemala, for example, with a population that is at least 50 per cent indigenous Maya (the figure may actually be much higher than that), until the past few years the Maya had few human rights, least of all to have their own languages acknowledged as of equal status with Spanish. Here, and in Yucatán, the Maya are striving to preserve their own culture and glorious past in the face of centuries of domination by Whites and other peoples of Spanish heritage.

The time has come to return to the Maya some of that knowledge that has been gained by a century and a half of archaeological and anthropological research. Ethnologists and linguists have been in the vanguard of this movement, but, sadly, archaeologists—with a few notable exceptions— have not.

The exceptions are almost all epigraphers, specialists in the hieroglyphs. In 1987, the ever-dynamic Linda Schele, who has played a crucial role in the great decipherment, began classes in Antigua, Guatemala, to teach the ancient Maya script to the modern Maya. Other instructors on her team were the linguists Kathryn Josserand and Nicholas Hopkins, and her Guatemalan associate in epigraphic

research, Federico Fahsen. Somewhat later, Nikolai Grube and Simon Martin joined her group, and a second hieroglyphic workshop was started in Valladolid (the old Maya Sakí) in Yucatán, a town long known for its role in the preservation of traditional Maya culture.

These are in effect scribal schools. The participants in the highland workshops have adapted the ancient script to write their languages. According to Linda, "Now they are putting up monuments with glyphs, writing their own textbooks, making diplomas, and a bunch of other things." A seven-year-old, the son of one of her students, brings his homework to school signed with his name in the ancient glyphic writing of his ancestors. In Yucatán, a Maya writes a story in Yucatec about a *bah* (gopher) and then puts it into glyphs. And far to the south, a highland Maya woman in Antigua, dressed in the traditional costume of her native village, turns to a computer and enters a tourist's birthday. She then arranges wooden blocks of glyphs so that she may accurately record, on a miniature stela, the Maya date for the visitor.

One of the great writing traditions of the world has returned to the people who created it.

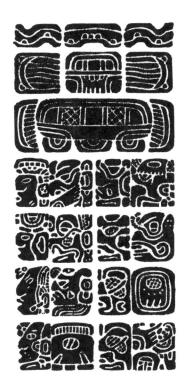

145 This block-printed stela setting out the Long Count equivalent of the wedding date of two English visitors to Mexico was produced for them at Chichén Itzá in 1993. In the traditional pattern (cf. Fig. 21), the inscription begins with the Initial Series Introductory Glyph. Numbers are represented not by bar-and-dot coefficients but by heads (cf. Fig. 20). To perform the complex calculations, CECIJEMA ("Cybernetic Center of Maya Hieroglyphs") used one of the dozen or more computer programs which now allow non-Maya—as here—and the Maya themselves to generate glyphs.

BEFORE EPIGRAPHY:
FORERUNNERS OF THE GREAT DECIPHERMENT

NOTES

BIBLIOGRAPHY

LIST OF ILLUSTRATIONS

INDEX

de las partes otro, y assi viene a hazer in infinitum como
se podra ver en el siguiente exemplo. Le, quiere dezir laço
y caçar con el, para escriuirle con sus caracteres auiendo
les nosotros hecho entender que son dos letras lo escriuiã
ellos con tres puniendo a la aspiracion de la l, la vocal, e,
que antes de si trae, y en esto no yerran aunq vsen el si
quisieren ellos de su curiosidad. Exemplo.

despues al cabo le pegan la parte junta. Ha. que quiere dezir
agua porq la hache tiene a.h. ante de si lo ponen ellos al
principio con a. y al cabo desta manera Tambiē
lo escriuen a partes, de la vna y otra manera nera y
no pusiera aqui ni tratara dello sino por dar cuenta entera
de las cosas desta gente. Mainkati quiere dezir no quiero, ellos
lo escriuen a partes desta manera.

Syguese su a,b,c.

De las letras que aqui faltan carece esta lengua
y tiene otras añadidas de la nuestra para otras
cosas q las ha menester, y ya no vsan para nada destos
sus caracteres especialmente la gente moça q an aprendido
los nros

BEFORE EPIGRAPHY:
FORERUNNERS OF THE GREAT DECIPHERMENT

A crucial page in Bishop Landa's *Relación*, written during his recall to Spain, is as close to a Maya Rosetta Stone as one is likely to get. As seen in this later copy, Landa presents an "A, B, C" which we now know is a partial and somewhat flawed syllabary, along with two words and a sentence written with it. Long scorned as worthless by Mayanists, it was reinterpreted in 1952 by the Russian epigrapher Y. V. Knorosov, and became the basis of the modern decipherment.

Of their letters I will give here an A, B, C, since their ponderousness permits nothing more, for they use one character for all the aspirations of the letters and, later, they unite with it part of another and thus it goes on *ad infinitum,* as will be seen in the following example. *Le* means *noose* and *to hunt with it;* to write *le* with their characters (we having made them understand that these are two letters), they wrote it with three, placing for the aspiration of *l* the vowel *e,* which it carries in front of it, and in this way they do not err even though they might use [another] *e* if, out of curiosity, they so wish.

Example:

e l e lé

Afterwards, at the end, they affix the part which is joined.

Ha means water, and because the *h* has a before it, they put it at the beginning with *a,* and at the end in this fashion:

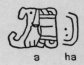

a ha

They also wrote in parts, but in one way or another that I shall not give here nor will I deal with it except by giving a full account of this people's affairs. *Ma in kati* means *I don't want to* and they write it in parts in this fashion:

ma i n ka ti

There follows their A, B, C:

A A A B B C T E H

I CA K L L M N O O

Λ PP CU KU X X U U Z Λ P

Of the letters which are missing, this language lacks them and has others added from our own for other things of which it has need, and already they do not use these their characters at all, especially the young people who have learned ours.

146 Detail from a manuscript of Bishop Diego de Landa's Relación de las Cosas de Yucatán, *written in the 1560s and copied about 1661, showing what he believed to be the Maya alphabet.*

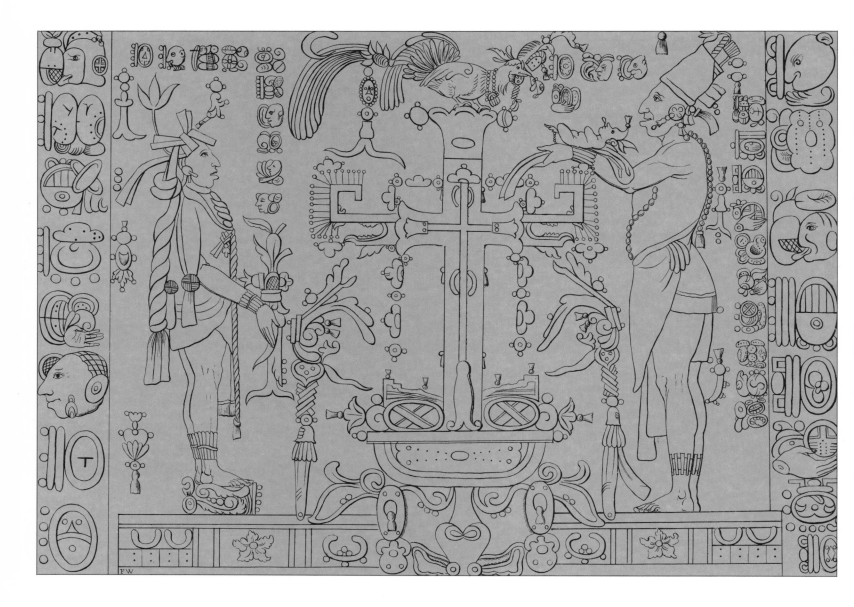

Following the discovery of the ancient Maya cities in the late eighteenth and nineteenth centuries, the script written on the monuments aroused curiosity, but its decipherment was long hampered by poor publication of the visible record; until the introduction of photography and methods of taking accurate casts, scholars were forced to rely on more or less imprecise, patchy, and often fanciful drawings of the inscriptions.

147 Tablet in the Temple of the Cross, Palenque, engraved by Waldeck after Almendáriz, from del Río, Description of the Ruins of an Ancient City, London 1822.

Maya inscriptions on stone first appeared in print in 1822, through the plates in an English translation of the report of Antonio del Río, who had explored Palenque in 1787 with the artist Ricardo Almendáriz. Many of Almendáriz's drawings had, however, been engraved by the flamboyant and unscholarly Jean Frédéric Waldeck. The great Tablet in the Temple of the Cross shows Kan Balam (right) and his dead father, Pakal, worshipping a world-tree. The real inscription uses more than two hundred glyphs to trace the rulers' ancestry to a divine origin. Waldeck has reduced this to a few examples, chosen at random from the text, and so loosely drawn that they are almost unrecognizable.

The standards set by Frederick Catherwood, the English topographical artist who accompanied the American diplomat John Lloyd Stephens during the epic journey that revealed the lost civilization of the Maya to the outside world, were far higher. Even though his drawings still lacked the precision necessary for decipherment (and in any case, far too few texts were yet recorded), they enabled Stephens to compare the text on top of Altar Q at Copán with a passage from the Venus pages of the Dresden Codex and to conclude that they were in the same writing system. Stephens was the first to argue that the ruined cities were built by ancestors of the modern Maya, not by a long-vanished people, and that a single writing system was in use throughout the southern lowlands.

148 The script on Altar Q, Copán (top, engraved after Catherwood), compared with that of the Venus pages of the Dresden Codex (below, after Humboldt's facsimile of 1816), from Stephens, Incidents of Travel in Central America, Chiapas, and Yucatán, *New York 1841.*

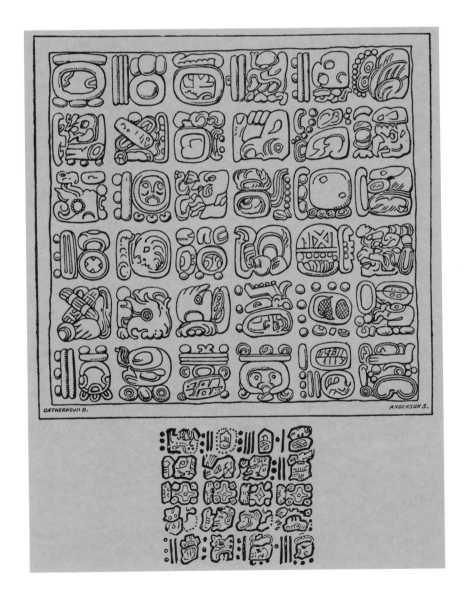

231

NOTES

CHAPTER 1 (pp. 25–38)

1　For a general view of Maya culture history, see Coe 1993. Aveni 1996 discusses Maya achievements in astronomy.
2　Campbell 1984 has an overview of the history of Mayan languages.
3　See Menchú 1984 for a vivid account of the military terror in Guatemala.
4　Joralemon 1971.
5　Matheny 1980.
6　See the various essays in Culbert 1973.
7　This subject is fully treated in Schele and Miller 1986.
8　The definitive edition of the *Popol Vuh* is Tedlock 1996.
9　Taube 1985.
10　Martin and Grube 1995.
11　Ibid.: 46.
12　Tozzer 1941: 62.
13　The problem of Maya literacy is addressed in Houston 1994.
14　Goody 1977.
15　Houston 1994.

CHAPTER 2 (pp. 49–70)

1　See Brunhouse 1973 for an account of Stephens and Catherwood's momentous discoveries.
2　De Rosny 1876.
3　A complete discussion of these matters can be found in Lounsbury 1978.
4　Rafinesque's career and pioneering work in Maya epigraphy are given in Coe 1992: 89–91 and D. Stuart 1989.
5　Humboldt 1816.
6　For Knorosov's discoveries and methodology, see Coe 1992: 145–66.
7　Tozzer 1941.
8　Thompson 1950: 16.
9　This monument was first illustrated in D. Stuart 1989, fig. 14.
10　Kelley 1962.
11　Proskouriakoff 1960.
12　Proskouriakoff 1961a.
13　Tozzer 1941: 19.
14　Grube 1994.
15　A complete description of the monuments of Aguateca and other cities in the Petexbatún region can be found in Houston 1993.
16　Mathews 1979.
17　Houston and Taube 1987.
18　Stuart and Houston 1994.
19　First described in Coe 1973. Later studies are Grube 1986, and MacLeod and Reents–Budet 1994.

20　D. Stuart 1989.
21　Houston and Stuart 1996.
22　Reents-Budet 1994: 294–309.
23　Coe and Diehl 1980.
24　See Joralemon 1971 and Reilly 1990.
25　Sampson 1985: 26–45.
26　DeFrancis 1989.
27　This was kindly called to my attention by Douglas Bradley.
28　Personal communication.
29　Flannery and Marcus 1983.
30　Cahn and Winter 1993.
31　Coe 1976.
32　For an extensive treatment of this script, see Méluzin 1995.
33　Winfield Capitaine 1988.
34　Méluzin 1995.
35　Personal communication.
36　Graham, Heizer, and Shook 1978.
37　Coe 1976: 115.
38　Hansen 1992.
39　Grube 1995.
40　Ibid.: 2.
41　This order was established by Tatiana Proskouriakoff in her 1960 article.
42　In Schele and Miller 1986: 191.
43　Coe 1966.
44　Illustrated and described in Coe 1973.

CHAPTER 3 (pp. 89–110)

1　Tozzer 1941: 169.
2　Ibid.: 78, n. 340.
3　D. Stuart 1989.
4　Personal communication from Linda Schele.
5　Barrera Vásquez 1980: 273.
6　Proskouriakoff 1961b.
7　Schele and Grube 1995: 18–20.
8　Tedlock 1996: 57.
9　Reents-Budet 1994: 78. There is a thorough discussion of this flower's use as a chocolate flavoring in Coe and Coe 1996: 90–91.
10　Reents-Budet 1994: 85.
11　D. Stuart 1989: 33–35. This vase was first published as No. 47 in Coe 1973.
12　Reents-Budet 1994: 55.
13　Personal communication.
14　Reents-Budet 1994: 56–57.
15　Closs 1992.
16　Tozzer 1941: 153–54.
17　Fash 1991: 160–62.
18　Ibid.: 162.
19　Inomata n.d.
20　Coe 1977.
21　Schellhas 1904.
22　Grube 1994: fig. 3.
23　Kerr n.d.
24　Taube 1985.
25　Coe 1989a.

CHAPTER 4 (pp. 129–58)

1　Schimmel 1984: 1.
2　Welch 1979: 33.
3　For a general description of the Copán Valley, see Fash 1991: 37–46.
4　Personal communication.
5　D. Stuart 1989: 44.
6　Littmann 1957.
7　Magaloni 1996: 22–23.
8　Robertson 1983–91.
9　Stone 1995.
10　Adams 1986.
11　The process can be seen when slides commercially distributed by the University Museum are enlarged.
12　Jones and Satterthwaite 1982.
13　Digby 1972.
14　Pendergast 1979.
15　Kidder 1947: 21.
16　The presence of conch-shell trumpets along with turtle carapaces (a percussion instrument throughout Mesoamerica) suggests that elite funerary processions and rites must have been accompanied by music.
17　Trik 1963.
18　Shepard 1956: 31–43. See also Rice 1987: 148–51.
19　Richter 1923.
20　Schwede 1912. On the study of Mesoamerican bark-paper manufacture, Von Hagen 1944 is invaluable. In the preparation of this section, I have been greatly aided by Wylie 1994.
21　Barrera Vásquez 1980: 246.
22　Cited in Von Hagen 1944: 35–38.
23　Ibid.: 63.
24　Dark and Plesters 1959.
25　Schimmel 1984: 16.
26　D. Stuart 1989: 41.
27　Billeter 1990: 51–54.
28　Billeter 1990.
29　Watrous 1957: 58.
30　Gaur 1994: 25–26.
31　Kingsborough 1830–48. Aglio's watercolor copy was made between 1825 and 1830.
32　Coe 1977.
33　Reents-Budet 1994: 317.
34　Grube n.d.
35　The Codex style was first defined in Coe 1973.
36　Kerr and Kerr 1988.

CHAPTER 5 (pp. 169–82)

1　Tozzer 1941: 28–29.
2　Ibid.: 28, n. 154.
3　Ibid.: 153–54.
4　Thompson 1961: 232. Unfortunately, in his catalogue Thompson combines the "codex" glyph with another similar one which represents a cushion-like throne covered with a jaguar pelt.
5　I have based the dimensions which follow on those given in Lee 1985.
6　The Grolier Codex was first published in Coe 1973, in a slightly reduced scale; and then in Lee 1985 in true scale. It is currently in a vault in Mexico's National Museum of Anthropology, and has never been on public view in its country of origin.
7　The history of the Dresden Codex is given in Thompson 1972; Deckert 1989; and Lee 1985: 31–37. I have argued that it might have been collected on Cozumel by Hernán Cortés himself, and shipped back to Spain as part of the "Royal Fifth" (Coe 1989b).
8　Taube and Bade 1991; Whittaker 1986.
9　Paxton 1989.
10　Zimmermann 1956: Tafel 5.
11　Paxton 1989: 176.
12　Love 1994.
13　Anders 1968. The most reliable and useful reproduction is still de Rosny 1888.
14　The best facsimile editions of the Madrid Codex are Anders 1967 (the Graz edition) and Lee 1985.
15　A typical example of inverted order appears on Madrid 96c (i.e. the bottom section of page 96), a scene with gods hewing wooden masks, where the scribe has spelled the verb *pol* (to hew or carve wood) with the syllabic signs *lo-p(o)* instead of *po-l(o)*.

CHAPTER 6 (pp. 219–23)

1　Roys 1933: 79.
2　Jones 1989.
3　Thompson 1951.
4　Roys 1943: 91. The god is probably Ah Kokah Mut or Yax Kokah Mut, described in other sources.
5　Collins 1977.
6　Ibid.
7　Farriss 1984: 341.
8　Tozzer 1941: 78, n. 340.
9　Ibid.: 79, n. 342.
10　Ibid.: 78, n. 340.
11　Ibid.
12　Bricker 1989.
13　Bricker 1977.
14　Personal communication from Nikolai Grube.

BIBLIOGRAPHY

ADAMS, Richard E. W. 1986 "Archaeologists explore Guatemala's lost city of the Maya, Rio Azul." *National Geographic* 169 (4): 420–52. Washington, D.C.

ANDERS, Ferdinand 1967 *Codex Tro-Cortesianus (Codex Madrid)*. Graz: Akademische Druck- u. Verlagsanstalt.

——— 1968 *Codex Peresianus (Codex Paris)*. Graz: Akademische Druck- u. Verlagsanstalt.

——— 1975 *Codex Dresdensis*. Graz: Akademische Druck- u. Verlagsanstalt.

AVENI, Anthony F. 1996 "Astronomy in the Americas." In *Astronomy before the Telescope*, ed. C. Walker, 269–303. London: British Museum Press.

BARRERA Vásquez, Alfredo (ed.) 1980 *Diccionario Maya Cordemex*. Mérida: Ediciones Cordemex.

BILLETER, Jean François 1990 *The Chinese Art of Writing*. New York: Rizzoli International Publishers.

BRICKER, Victoria R. 1977 "The Caste War of Yucatán: the history of a myth and the myth of history." In *Anthropology and History in Yucatán*, ed. G. D. Jones, 251–58. Austin: University of Texas Press.

——— 1989 "The last gasp of Maya hieroglyphic writing in the Books of Chilam Balam of Chumayel and Chan Kan." In *Word and Image in Maya Culture*, ed. W. F. Hanks and D. S. Rice, 39–50. Salt Lake City: University of Utah Press.

BRUNHOUSE, Robert L. 1973 *In Search of the Maya. The First Archaeologists*. Albuquerque: University of New Mexico Press.

CAHN, Robert, and Marcus Winter 1993 "The San José Mogote danzante." *Indiana* 13: 39–64. Berlin.

CAMPBELL, Lyle 1984 "The implications of Mayan historical linguistics for glyphic research." In *Phoneticism in Mayan Hieroglyphic Writing*, ed. J. S. Justeson and L. Campbell. Albany, N.Y.: Institute for Mesoamerican Studies.

CLOSS, Michael P. 1992 "I am a *kahal*; my parents were scribes." *Research Reports on Ancient Maya Writing* 39: 7–22. Washington, D.C.

COE, Michael D. 1966 "An early stone pectoral from southeastern Mexico." *Studies in Pre-Columbian Art and Archaeology* 1. Washington, D.C.: Dumbarton Oaks.

——— 1973 *The Maya Scribe and His World*. New York: The Grolier Club.

——— 1976 "Early steps in the evolution of Maya writing." In *Origins of Religious Art and Iconography in Preclassic Mesoamerica*, ed. H. B Nicholson, 107–22. Los Angeles: UCLA Latin American Center/Ethnic Arts Council of Los Angeles.

——— 1977 "Supernatural patrons of Maya scribes and artists." In *Social Process in Maya Prehistory*, ed. Norman Hammond, 327–47. London: Academic Press.

——— 1989a "The Hero Twins: myth and image." *The Maya Vase Book* 4: 161–84.

New York: Kerr Associates.

——— 1989b "The Royal Fifth: earliest notices of Maya writing." *Research Reports on Ancient Maya Writing* 28. Washington, D.C.

——— 1992 *Breaking the Maya Code*. London and New York: Thames and Hudson.

——— 1993 *The Maya* (5th ed.). London and New York: Thames and Hudson.

———, and Richard A. Diehl 1980 *In the Land of the Olmec*. 2 vols. Austin: University of Texas Press.

COE, Sophie D., and Michael D. Coe 1996 *The True History of Chocolate*. London and New York: Thames and Hudson.

COLLINS, Anne C. 1977 "The *maestros cantores* of Yucatán." In *Anthropology and History in Yucatán*, ed. G. D. Jones, 233–47. Austin: University of Texas Press.

CULBERT, T. Patrick (ed.) 1973 *The Classic Maya Collapse*. Albuquerque: University of New Mexico Press.

DARK, Philip C., and Joyce Plesters 1959 "The palimpsests of Codex Selden: recent attempts to reveal the covered pictographs." *Cuadernos Americanos* 33 (2): 530–39.

DECKERT, Helmut 1989 *Die Dresdener Maya-Handschrift*. Graz: Akademische Druck- u. Verlagsanstalt.

DEFRANCIS, John 1989 *Visible Speech*. Honolulu: University of Hawaii Press.

DIGBY, Adrian 1972 *Maya Jades*. London: British Museum.

FARRISS, Nancy M. 1984 *Maya Society under Colonial Rule*. Princeton: Princeton University Press.

FASH, William L. 1991 *Scribes, Warriors and Kings*. London and New York: Thames and Hudson.

FLANNERY, Kent V., and Joyce Marcus 1983 "The growth of site hierarchies in the Valley of Oaxaca. Part I." In *The Cloud People: Divergent Evolution of the Zapotec and Mixtec Civilizations*, ed. K. V. Flannery and J. Marcus, 53–64. New York: Academic Press.

GAUR, Albertine 1994 *A History of Calligraphy*. London: The British Library.

GOODY, Jack 1977 *The Domestication of the Savage Mind*. London and New York: Cambridge University Press.

GRAHAM, John A., Robert F. Heizer, and Edwin M. Shook 1978 "Abaj Takalik 1976: exploratory investigations." *Contributions of the University of California Archaeological Research Facility* 36: 85–110. Berkeley.

GRUBE, Nikolai n.d. "Is T709, the main sign of the glyph for the Fourth Lord of the Night, a logogram for abak/yabak 'powder, ink, charcoal'?" (Privately circulated unpublished paper.)

——— 1986 "An investigation of the Primary Standard Sequence on Classic Maya ceramics." In *Sixth Palenque Round Table, 1986*, ed. V. M. Fields, 223–32. Norman and London: University of Oklahoma Press.

——— 1994 "Hieroglyphic sources for the history of northwest Yucatán." In *Hidden among the Hills: Maya Archaeology of the Northwest Yucatán Peninsula*, ed. H. J. Prem, 316–58. Möckmühl: Verlag von Flemming.

——— 1995 "Transformations of Maya society at the end of the Preclassic: processes of change between the predynastic and dynastic periods." In *The Emergence of Lowland Maya Civilization*, ed. N. Grube, 1–5. Möckmühl: Verlag Anton Saurwein.

HANSEN, Richard D. 1992 "El proceso cultural de Nakbé y el área del Petén nord-central: las épocas tempranas." In *V Simposio de Investigaciones en Guatemala*, 81–96. Guatemala City.

HOUSTON, Stephen D. 1993 *Hieroglyphs and History at Dos Pilas: Dynastic Politics of the Classic Maya*. Austin: University of Texas Press.

——— 1994 "Literacy among the Pre-Columbian Maya: a comparative perspective." In *Writing without Words: Alternative Literacies in Mesoamerica and the Andes*, ed. E. H. Boone and W. D. Mignolo, 27–49. Durham, N.C., and London: Duke University Press.

———, and Karl A. Taube 1987 "'Name-tagging' in Classic Mayan script: implications for native classifications of ceramics and jade ornaments." *Mexicon* 9 (2): 38–41.

———, and David Stuart 1996 "Of gods, glyphs and kings: divinity and rulership among the Classic Maya." *Antiquity* 70 (268): 289–312.

HUMBOLDT, Alexander von 1816 *Vue des Cordillères, et monuments des peuples indigènes de l'Amérique*. Paris.

INOMATA, Takeshi n.d. "Archaeological research at the fortified center of Aguateca, Guatemala." Paper presented at the 59th Annual Meeting of the Society for American Archaeology, April 1994.

JONES, Christopher, and Linton Satterthwaite 1982 "The monuments and inscriptions." *Tikal Reports* 33 (A). Philadelphia: University Museum.

JONES, Grant D. 1989 *Maya Resistance to Spanish Rule: Time and History on a Colonial Frontier*. Albuquerque: University of New Mexico Press.

JORALEMON, P. David 1971 "A study of Olmec iconography." *Dumbarton Oaks Studies in Pre-Columbian Art and Archaeology* 7. Washington, D.C.

KELLEY, David H. 1962 "A history of the decipherment of Maya script." *Anthropological Linguistics* 4 (8): 1–48.

KERR, Barbara, and Justin Kerr 1988 "Some observations on Maya vase painters." In *Maya Iconography*, ed. E. P. Benson and G. G. Griffin, 236–59. Princeton: Princeton University Press.

——— (eds.) 1997 *The Maya Vase Book*. Vol. 5. New York: Kerr Associates.

KERR, Justin n.d. "Where do you keep your

paint pot?" (Privately circulated paper.)
———— (ed.) 1989–94 *The Maya Vase Book*. Vols. 1–4 (Vol. 1 1989, Vol. 2 1990, Vol. 3 1992, Vol. 4 1994). New York: Kerr Associates.

KIDDER, A. V. 1947 *The Artifacts of Uaxactún, Guatemala*. Washington, D.C.: Carnegie Institution of Washington.

KINGSBOROUGH, Edward King, Viscount 1830–48 *Antiquities of Mexico*. 9 vols. London: James Moynes, and Colnaghi, Son, & Co.

LEE, Thomas A., Jr. 1985 *Los códices mayas*. Tuxtla Gutiérrez: Universidad Autónoma de Chiapas.

LITTMANN, Edwin R. 1957 "Ancient Mesoamerican mortars, plasters, and stuccos: Comalcalco, Part I." *American Antiquity* 23 (2): 135–40.

LOUNSBURY, Floyd G. 1978 "Maya numeration, computation, and calendrical astronomy." In *Dictionary of Scientific Biography* 15, suppl. I: 759–818.

LOVE, Bruce 1994 *The Paris Codex: Handbook for a Maya Priest*. Austin: University of Texas Press.

MACLEOD, Barbara, and Dorie Reents-Budet 1994 "The art of calligraphy: image and meaning." In *Painting the Maya Universe*, by D. Reents-Budet, 106–53. Durham, N.C., and London: Duke University Press.

MAGALONI, Diana 1996 "Técnicas de la pintura mural en Mesoamérica." *Arqueología Mexicana* 3 (16): 16–23.

MARTIN, Simon, and Nikolai Grube 1995 "Maya superstates." *Archaeology* 48, 6:41–46.

MATHENY, Ray T. (ed.) 1980 "El Mirador, Petén, Guatemala: an interim report." *Papers of the New World Archaeological Foundation* 45. Provo, U.

MATHEWS, Peter 1979 "The glyphs on the ear ornaments from Tomb A-1/1." In *Excavations at Altún Ha, Belize, 1964-1970*, Vol. I, by David Pendergast, 79–80. Toronto: Royal Ontario Museum.

MÉLUZIN, Sylvia 1995 "Further investigations of the Tuxtla script: an inscribed mask and La Mojarra Stela 1." *Papers of the New World Archaeological Foundation* 65. Provo, U.

MENCHÚ, Rigoberta 1984 *I, Rigoberta Menchú; An Indian Woman in Guatamala*. London and New York: Verso.

PAXTON, Meredith 1989 *Codex Dresden: Stylistic and Iconographic Analyis of a Maya Manuscript*. Ann Arbor, Mich.: University Microfilms International.

PENDERGAST, David 1979 *Excavations at Altún Ha, Belize, 1964-1970*. Vol. I. Toronto: Royal Ontario Museum.

PROSKOURIAKOFF, Tatiana 1960 "Historical implications of a pattern of dates at Piedras Negras, Guatemala." *American Antiquity* 25 (4): 454–75.

———— 1961a "Lords of the Maya realm." *Expedition* 4 (1): 14–21.

———— 1961b "Portraits of women in Maya art." In *Essays in Pre-Columbian Art and Archaeology*, ed. S. K. Lothrop et al., 81–90. Cambridge, Mass.: Harvard University Press.

REENTS-BUDET, Dorie 1994 *Painting the Maya Universe*. Durham, N.C., and London: Duke University Press.

REILLY, F. Kent III 1990 "Cosmos and rulership: the function of Olmec-style symbols in Formative period Mesoamerica." *Visible Language* 24 (1): 12–37.

RICE, Prudence M. 1987 *Pottery Analysis. A Sourcebook*. Chicago and London: University of Chicago Press.

RICHTER, Gisela A. M. 1923 *The Craft of Athenian Pottery: An Investigation of the Technique of Black-figured and Red-figured Athenian Vases*. New Haven: Yale University Press.

ROBERTSON, Merle Greene 1983-91 *The Sculpture of Palenque*. 4 vols. Princeton: Princeton University Press.

ROSNY, Léon de 1876 *Essai sur le déchiffrement de l'écriture hiératique de l'Amérique Centrale*. Paris.

———— 1888 *Codex Peresianus. Manuscrit hiératique des anciens Indiens de l'Amérique Centrale conservé à la Bibliothèque Nationale de Paris, avec une introduction... seconde édition imprimée en noir*. Paris: Bureau de la Société Américaine.

ROYS, Ralph L. 1933 *The Book of Chilam Balam of Chumayel*. Washington, D.C.: Carnegie Institution of Washington.

———— 1943 *The Indian Background of Colonial Yucatán*. Washington, D.C.: Carnegie Institution of Washington.

SAMPSON, Geoffrey 1985 *Writing Systems*. London: Hutchinson.

SCHELE, Linda, and Mary E. Miller 1986 *The Blood of Kings: Dynasty and Ritual in Maya Art*. Fort Worth: Kimbell Museum of Art.

———— , and Nikolai Grube 1995 *Notebook for the XIXth Maya Hieroglyphic Workshop at Texas*. Austin: Department of Art and Art History, the College of Fine Arts, and the Institute of Latin American Studies.

SCHELLHAS, Paul 1904 "Representations of deities in the Maya manuscripts." *Papers of the Peabody Museum of Archaeology and Ethnology, Harvard University* 4 (1). Cambridge, Mass.

SCHIMMEL, Annemarie 1984 *Calligraphy and Islamic Culture*. New York and London: New York University Press.

SCHWEDE, Rudolf 1912 *Ueber das Papier der Maya-Codices u. einiger altmexicanischer Bilderhandschriften*. Dresden: Technischen Hochschule zu Dresden.

SHEPARD, Anna O. 1956 *Ceramics for the Archaeologist*. Washington, D.C.: Carnegie Institution of Washington.

STONE, Andrea J. 1995 *Images from the Underworld: Naj Tunich and the Tradition of Maya Cave Painting*. Austin: University of Texas Press.

STUART, David 1989 *The Maya Artist: An Epigraphic and Iconographic Study*. Senior Honors Thesis, Princeton University. Princeton, N.J.

———— , and Stephen D. Houston 1994 *Classic Maya Place Names*. Washington, D.C.: Dumbarton Oaks Research Library and Collection.

STUART, George E. 1989 "The beginnings of Maya hieroglyphic study: contributions of Constantine S. Rafinesque and James H. McCollogh, Jr." *Research Reports on Ancient Maya Writing* 29. Washington, D.C.

TAUBE, Karl A. 1985 "The Classic Maya Maize God: a reappraisal." In *Fifth Palenque Roundtable*, 171–81. San Francisco.

———— , and Bonnie L. Bade 1991 "An appearance of Xiuhtecuhtli in the Dresden Venus pages." *Research Reports on Ancient Maya Writing* 35. Washington, D.C.

TEDLOCK, Dennis 1996 *Popol Vuh* (rev. ed.). New York: Simon and Schuster.

THOMPSON, J. Eric S. 1950 *Maya Hieroglyphic Writing: An Introduction*. Washington, D.C.: Carnegie Institution of Washington.

———— 1951 "The Itzá of Tayasal, Petén." In *Homenaje al Doctor Alfonso Caso*, 389–400. Mexico City.

———— 1961 *A Catalog of Maya Hieroglyphs*. Norman: University of Oklahoma Press.

———— 1972 *A Commentary on the Dresden Codex: A Maya Hieroglyphic Book*. Philadelphia: American Philosophical Society.

TOZZER, Alfred M. 1941 "Landa's Relación de las Cosas de Yucatán." *Papers of the Peabody Museum of Archaeology and Ethnology, Harvard University*, 18. Cambridge, Mass.

TRIK, Aubrey S. 1963 "The splendid tomb of Temple I, Tikal, Guatemala." *Expedition* 6 (1): 2–18.

VON HAGEN, Victor W. 1944 *The Aztec and Maya Papermakers*. New York: J. J. Augustin.

WATROUS, James 1957 *The Craft of Old-Master Drawings*. Madison: University of Wisconsin Press.

WELCH, Anthony 1979 *Calligraphy in the Arts of the Muslim World*. New York: The Asia Society.

WHITTAKER, Gordon 1986 "The Mexican names of three Venus gods in the Dresden Codex." *Mexicon* 8 (3): 56–60.

WINFIELD CAPITAINE, Fernando 1988 "La Estela 1 de La Mojarra, Veracruz, México." *Research Reports on Ancient Maya Writing* 16. Washington, D.C.: Center for Maya Research.

WYLIE, Cherra 1994 *How to Make an Aztec Book*. M.A. Thesis, Archaeological Studies Program, Yale University. New Haven.

ZIMMERMANN, Günter 1956 *Die Hieroglyphen der Maya-Handschriften*. Hamburg: Cram, De Gruyter.

LIST OF ILLUSTRATIONS

Unless otherwise stated, photographs are by Justin Kerr. Most of the vases with K numbers have been published in *The Maya Vase Book* (Vols. 1–4 edited by Justin Kerr, Vol. 5 edited by Barbara and Justin Kerr). Complete K number concordances to other major publications of Maya vases will be found there in Vols. 1, 4 and 5.

COLOR PLATES

Trustees. K2887.

91 Stone relief known as the Kimbell Panel. Collection Kimbell Art Museum, Fort Worth, Tex. K2823.

92, 94 General view and detail of Lintel 3 from Temple IV, Tikal. Collection Museum der Kulturen, Basel. Photo Peter Horner.

93 Wooden box with glyphs commemorating a king of Tortuguero. Collection Kislak Foundation, Miami, Fla.

95 Slate mirror-back carved with figures of a king of an unknown site in the Petén and of his younger brother, attired as an *ah k'u hun*. Photo John Bigelow Taylor.

96 Section of conch shell incised with the figure of an *ah k'un hun*. Collection The Cleveland Museum of Art, The Norweb Collection, Cleveland, O. K2880.

97, 98 Rollout and view of travertine vase incised with figures of Yax Pas, king of Copán. K3296.

99, 100 Carved and incised pottery vase from northwestern Yucatán with "11 Ahaw" date glyph. K508.

101 Carved and incised pottery vase showing the Young Maize God (?). K5060.

102 Black-on-white bowl from Ucanal. K4387.

103 Black-and-white bowl from Ucanal. K4354.

104 Black-on-white dish from the eastern Petén probably painted by Ak Nikte'. K4669.

105, 106 Detail and general view of a red-and-orange-on-white footed cup from the eastern Petén, painted with the head of the Jester God. K7524.

107 Red-and-orange-on-white bowl from the eastern Petén, painted with water birds. K5722.

108 Nakbé-style vase painted with war headdresses. K5064.

109 Vase painted with heads of an unknown deity. K5057.

110 Death God; detail of rollout from a polychrome vase. K7827.

111 Polychrome vase painted with a vulture head. K4945.

112 Vase from the eastern Petén, with a diagonal text of unpaired glyphs. K2323.

113 Resist-painted and incised lidded vase painted with war headdresses and hand. K6964.

114, 115 Rollout and view of the "Calakmul Dynasty Vase." K6751.

116 Polychrome vase from the Petén, showing an enthroned ruler and glyphs painted in "pink blush" style. K5850.

117 A goddess in the coils of a dragon-serpent, from a Codex-style vase. K5164.

TEXT FIGURES

1 Entrance chamber of the cave of Naj Tunich. Photo courtesy George E. Stuart and the National Geographic Society.

2 Drawing 82, Naj Tunich. Photo Chip and Jennifer Clark, courtesy Andrea Stone.

3 Signature of sculptor/scribe on Stela 1, Bonampak. Photo Michael D. Coe.

4 Map of the Maya area. Drawn by ML Design.

5 Lintel 17, Yaxchilán. Drawing by Ian Graham.

6 Stela B and Stela C, Copán. K7366.

7 Plan of the central zone of Tikal. After Robert F. Carr and James E. Hazard, "Map of the Ruins of Tikal, El Petén, Guatemala," *Tikal Reports*, no. 11, Philadelphia 1961.

8 Funerary crypt of Pakal beneath the Temple of the Inscriptions, Palenque. Photo Alberto Ruz L.

9 The Hero Twins holding bowls; detail of rollout from an incised vase. K732.

10 Incised travertine vase showing two bound captives. K1606.

11 Stela 11, Yaxchilán. Drawing by Linda Schele.

12 Mural in Room 2, Bonampak. Courtesy Peabody Museum, Harvard University, Cambridge, Mass.

13 Incised vase showing a ruler and his *sahal*. Photo Michael D. Coe.

14 Fired brick with graffiti from Comalcalco. Photo Michael D. Coe.

15 The Kuná-Lacanhá Lintel, showing the grid layout of the glyphs. Drawing by David Stuart.

16 Circular text on an altar from Tikal. Drawing by Linda Schele.

17 Lintel 25, Yaxchilán. K2888.

18 Schematic representation of the 260-day count. Drawing by Michael D. Coe.

19 Examples of Maya bar-and-dot numeration. Drawing by Michael D. Coe.

20 Head variants for Maya numbers. Drawing by John Montgomery.

21 How Long Count dates work. Drawing by John Montgomery.

22 Polyvalence in the reading of a single sign. Drawing by Michael D. Coe.

23 Alternative spellings for *balam*, "jaguar." Drawing by Michael D. Coe.

24 Name glyph of Kan Balam. Drawing by David Stuart.

25 Dynastic event glyphs (birth, accession). Drawing by John Montgomery.

26 Inscription on Stela 12, Yaxchilán. Drawing by Linda Schele.

27 Lintel 4, Temple of the Four Lintels, Chichén Itzá. Drawing by Ruth Krochock.

28 Stela 2, Aguateca. Drawing by Stephen Houston.

29 Examples of name-tagging. Top row: drawing by Peter Mathews. Bottom row: from L. Satterthwaite, "Note on Hieroglyphs on Bone from the Tomb below Temple I, Tikal," *Expedition* 6.1:18–19.

30 Emblem Glyphs. Drawing by John Montgomery.

31 PSS on a black-on-white bowl from Ucanal. K4387.

32 Parallel PSS texts by different scribes. Drawing courtesy Dorie Reents-Budet and Barbara MacLeod.

33 *Way* spirits on a Codex-style vase. K2284.

34 Monument 3, San José Mogote. Drawing by Mark Orsin.

35 Stela 2, Chiapa de Corzo. Drawing by Michael D. Coe.

36 Incised text on the Tuxtla Statuette. (Collection National Museum of Natural History, Smithsonian Institution, Washington, D.C.) Drawing by Miguel Covarrubias.

37 The La Mojarra Stela. Drawing courtesy George E. Stuart and the National Geographic Society.

38 Stela 10, Kaminaljuyú. Drawing by Guillermo Grajeda Mena.

39 The Hauberg Stela. K152.

40 Incised figure and text on the reverse of the Dumbarton Oaks Pectoral (see Pl. 17). Drawing by Michael D. Coe.

41 Incised text on the back of a were-jaguar figure. (Collection Peabody Museum, Yale University, New Haven, Conn.) Drawing by Michael D. Coe.

42 Reverse of Stela 29, Tikal. Drawing by Linda Schele.

43 Incised text on the reverse of the Leiden Plate (see Pls. 22, 23). Drawing by Linda Schele.

44 Detail of the Altar de Sacrificios Vase. Photo Ian Graham.

45 Glyphs for the scribal titles *ah ts'ib*, *yuxul*, and *its'at*. Drawing by David Stuart.

46 Signature of Ak Nikte', on a black-and-white dish. K4669.

47 Two *ah k'u huns*, on a polychrome vase. K1453.

48 The *ah k'u hun* Yiban; detail of rollout from a travertine vase. K4340.

49 An *ah k'u hun* kneeling before a ruler; rollout from a polychrome vase. K4169.

50 *Ah k'u hun* with a conch-shell inkpot, painted in the cave of Naj Tunich. Drawing by Andrea Stone.

51 *Ah k'u hun* holding a Monkey-man God mask and headdress, from a polychrome vase. K1454.

52, 53 Figures of *ah k'u huns* from "Lintels" 1 and 3, Piedras Negras. Drawings by John Montgomery.

54 Female *ah k'u hun* holding the mask of an old god, from a polychrome vase. K764.

55 Two seated *ah k'u huns*; detail of rollout from a polychrome vase. K1728.

56 Seated scribe with waterlily/brush pen in his headdress, from a polychrome vase. K1599.

57 Text from a Naranjo vase, giving the name and parentage of the scribe Ah Maxam. Drawing by Michael D. Coe.

58, 59 "The Orator" and "The Scribe," tablets from the Southwest Court of the Palace, Palenque. Drawings by Linda Schele.

60 Tablet from Temple XXI, Palenque. Drawing by Merle Greene Robertson.

61 Enthroned ruler and subordinate with *ah k'u hun* headdresses; detail of rollout from a polychrome vase. K2784.

62 Reconstructed front façade of the Scribal Palace, Copán. Drawing by Barbara Fash.

63 Scribal patron emerging from the east niche on the front façade of the Scribal Palace, Copán. Photo William L. Fash.

64 Incised shell from a scribal house in Aguateca. Drawing courtesy Takeshi Inomata and the Vanderbilt University Press.

65 Hand holding a brush pen, on an incised bone from the tomb of Hasaw Cha'an K'awil, Tikal. (Collection Museo Sylvanus G. Morley, Tikal.) Drawing by Andy Seuffert, courtesy University Museum, Philadelphia.

66 Itsamná, from p.15 of the Dresden Codex. (Collection Sächsische Landesbibliothek, Dresden.)

67 Itsamná, on a sky-band throne; detail of rollout from a polychrome vase. K1183.

68 Itsamná, on a jaguar-cushion throne, from a red-background vase. Photo Nicholas Hellmuth.

69 Itsamná with an offering of tamales, from a polychrome vase. K504.

70 Pawahtún teaching mathematics; detail of rollout from a Codex-style vase. K1196.

71 Carved red-on-brown vase showing Pawahtún. K3324.

72 Youthful god depicted with Spangled Turban and Deer's Ear or Feather Pen. Drawing by Jean Blackburn after K1787.

73 Monkey-man Gods in a palace; rollout from a Codex-style vase. K1180.

74 Monkey-man God with brush pens in

FLYLEAVES AND VIGNETTES

INDEX